# ARCHITECTURE AND CITY PLANNING
# IN THE TWENTIETH CENTURY

# ARCHITECTURE
# and CITY PLANNING
# in the TWENTIETH
# CENTURY

Vittorio Magnago Lampugnani

VAN NOSTRAND REINHOLD COMPANY
*New York*

*Architektur und Stadtebau des 20. Jahrhunderts*
Copyright © 1980 by Verlag Gerd Hatje
Translation copyright © 1985 by Van Nostrand
Reinhold Company Inc.
Library of Congress Catalog Card Number 84–5078
ISBN 0-442-25950-6

Printed in the United States of America
Designed by Loudan Enterprises

Published by Van Nostrand Reinhold Company Inc.
135 West 50th Street
New York, New York 10020

Van Nostrand Reinhold Company Limited
Molly Millars Lane
Wokingham, Berkshire RG11 2PY, England

Van Nostrand Reinhold
480 La Trobe Street
Melbourne, Victoria 3000, Australia

Macmillan of Canada
Division of Gage Publishing Limited
164 Commander Boulevard
Agincourt, Ontario M1S 3C7, Canada

16 15 14 13 12 11 10 9 8 7 6 5 4 3 2 1

**Library of Congress Cataloging in Publication Data**

Magnago Lampugnani, Vittorio, 1951–
    Architecture and city planning in the twentieth
century.

    Translation of: Architektur und Städtebau des
20. Jahrhunderts.
    Includes index.
    1. Architecture, Modern—20th century.
    2. City planning.    I. Title.
NA680.M2413  1984    724.9'1    84–5078
ISBN 0-442-25950-6

# Contents

# ■ Preface

At best it is a risky undertaking to reprint a historical work years after its first publication. This is more so if its subject is the twentieth century, because the topical linkage with the immediate present is necessarily broken by the advance of time, especially because in our century the guiding images have been replaced at a previously unknown breathless and frenzied rate. If the observer turns away from the events occurring around him for even a fleeting moment, he will have missed numerous rapidly succeeding or parallel new experiments.

The present *History of Architecture and City Planning in the Twentieth Century* was originally published in 1980 and written during the preceding two years. To reprint it today in 1985, almost unchanged in an English translation, would inevitably mean to publish something outdated, which would at the very least be questionable. More important is that it seems progressively less possible to write one history of architecture and urban planning in the twentieth century. The myths of linear, causal evolution of architecture have been destroyed, and in their place are numerous confusing gaps. To do justice to the diversity, complexity, and contradictions in the latest development of architectural culture we would need many different histories.

Nevertheless, this bold venture seems possible. If, in the words of Francis Bacon, "It is the true office of history to represent the events themselves together with the coun-

sels, and to have the observations and conclusions thereupon to the liberty and faculty of every man's judgment" (Francis Bacon, *Advancement of Learning, II)*, then this small book may not be quite useless. It does indeed present the events and accompanying considerations and leaves, as far as possible, the observations and conclusions to the reader. Of course, this does not mean that the book is objective (since this does not exist). It is, rather, a conscientious collection of basic information. To this extent it seems almost insignificant whether the last four years were taken into consideration or not. Gaps become legitimate where no interpretation is given. To this extent, as well, the proposition of *one* history of architecture and city planning in the twentieth century is in no way presumptuous. Where facts are collected and organized with the knowledge of the inevitable arbitrariness of these two operations, the reproach does not apply.

The arbitrariness, as inevitable as it may be, is by no means limitless. The purpose of this work was and is to give in the best way possible and in a concise and complete form an introduction to the architecture and urban planning of our century. It is intended as a primary and simplified overview to lead the way to a deeper exploration of the diverse, here only sketchily presented topics and problems. If this work is used in such a way that it subsequently is surpassed and surmounted, it will have served its purpose.

# ■ Preface to German Edition

An introduction to contemporary architecture and contemporary city planning (the two cannot be regarded as separate phenomena) raises a number of problems. First, a definition is required of the term *architecture* as used in this context. Architecture can neither be understood as the culmination of art, as defined by the ancient hierarchy, nor as an isolated and individual phenomenon. Instead, it must be seen as a cultural manifestation that is the result of, and in turn the stimulus for, new social developments. Every architecturally active person is a creative individual in conflict with processes that he endeavors to influence, guide, and even overcome. Architecture is therefore the social product created by people finding themselves under the influence of political, technological, cultural, and artistic events and trying to do justice to the ever-new demands made by them.

If architecture is viewed from this angle, a whole range of additional areas must necessarily be examined, including philosophy and ideology; politics and sociology; science and technology; and literature, theater, film, photography, painting, and sculpture. Moreover, architecture cannot be studied in isolation from its theoretical bases. The history of architecture is therefore simultaneously a history of the theory of architecture. Only against this background can a fruitful historical analysis of building be undertaken.

This book is an attempt to take these aspects into account. The brevity demanded by an introduction nevertheless allows for nonarchitectural factors as well as the actual history of architecture to be outlined. This summary is in no way comprehensive but will, it is hoped, provide a rough historical orientation and a stimulus for further research.

In addition, the time element must be taken into consideration. An analysis of contemporary architecture must go back far enough to clarify present-day architectural events. The decision as to the extent of such a retrospective survey is fraught with controversy: theoretically, it could start with the beginning of man's building activity. Since there is an obvious need for limitation, the eighteenth-century Age of Enlightenment, with its philosophical, political, social, technological, and cultural upheavals, is a suitable break, especially as fundamental changes in the relationship between architecture and society took place during that period. Equally, the Industrial Revolution, normally regarded as both impetus and root of so-called modern architecture, must be seen in the wider context of the revolutionary changes brought about by the Enlightenment. This book covers the period from about 1910 (architectural early Rationalism) to the present day. The interval between the Enlightenment and Art Nouveau, a period of over two centuries, is briefly outlined, and major events are highlighted in the introduction.

Geographically, such a study is necessarily an international one. Although the main architectural stimuli of the last two centuries have originated in Europe and, since the end of the nineteenth century, in the United States, significant contributions have also been made by other countries, and during recent decades the exchange of ideas across national frontiers has intensified.

Nevertheless, only Europe and the United States are covered in this book. This is, above all, necessary in order to better clarify the interrelations between architecture and social, technological, and cultural events. Only when European or American architects were engaged in projects in countries outside these areas have their works been included.

Finally, a history of architecture demands a high degree of comprehensiveness. In a field that to date, despite a more or less explicit claim of objectivity, has been treated highly polemically, in the sense that uncomfortable tendencies which did not fit into a preconceived system were omitted while others were preferred, it is necessary to achieve as fair a balance as possible. Naturally, this does not exempt the historian from the responsibility of personal evaluation, but his comments must be based on a comprehensive knowledge of the entire subject.

This need for completeness is met by the inclusion and the analysis of all major twentieth-century movements. Again, in order to remain within the given physical limits of this work, only the most typical representatives of architectural movements and ideologies have been included, and of these, only their most important projects and buildings. This method necessitated the omission of numerous interesting and valuable contributions. If the resulting selection at times distorts the picture, is often arbitrary, and is always a simplification, it is the price paid for the clear depiction of a complex situation.

The structure of this book is based on an attempt to present major architectural and city planning events in chronological order. For reasons of didactics and comprehensibility they have been grouped under the headings of architectural movements. Works stemming from similar roots with similar concepts have therefore been arranged together. Such a grouping is necessarily no more than an approximation within the framework of historical dialectics. It therefore only means that certain projects and buildings have a closer resemblance to one another than others and is an attempt, moreover, to introduce an overall system for the many individual aspects that are a part of architectural history. As a result, some compromises and inconsistencies arise, especially because, like all genuine artists, the majority of protagonists overcome and question their own "code." Furthermore, movements are often connected at various levels, overlap in terms of duration, run parallel to each other, or even follow divergent courses. A detailed analysis of the many-sided aspects is not possible within the present framework, and only the most outstanding points of dissent are mentioned.

A separate chapter has been devoted to each movement, and each chapter is subdivided further. The first part outlines the conditions that produced specific architectural forms. It is, after all, one of the purposes of this book to find out what lies "behind" architecture. Demographic, political, and social events are therefore briefly described, followed by technological progress in general and those advances which relate to building in particular, and finally cultural developments, especially those in the field of visual arts. These outlines are given even where no linear connection with architectural output exists, simply as a means of orientation. The second part illustrates the artistic and architectural theories that constitute the bases for the forms of building. It also gives an account, in general terms, of the actual forms of building—in other words, of the intellectual roots and theoretical foundations of architectural idiom and its charac-

teristic elements, signs, and interconnections. The third part describes architectural developments through examples of their most important representatives and projects and outlines relevant ideologies, conditions of realization, and experiences. Where applicable, connections with further developments are indicated. The last part analyzes, on the same principle, developments in the planning of cities and settlements—a further arbitrary demarcation, which can only be justified on the grounds of didactics. Depending on respective historical developments, the scope of the subheadings may vary, but their structure has been retained throughout.

Within each chapter the various works are listed, as far as possible, in chronological order in order to point out the share of original invention in each contribution and thus the function of the work in the overall picture. However, important individual developments (for example, that of a Le Corbusier) take precedence over the schematic order within a chapter and even over the superordinated movements, and are therefore incorporated into the description of the main trend and dealt within an individual chronological sequence. Only references are then made to them in related or influenced movements. National characteristics are treated within the relevant context (for example, under the heading of Neo-Classicism, or Regionalism) under discussions of the particular country.

Grateful thanks are due to all those who have made both critical and constructive contributions and without whom this book could not have been published in its present form; especially to Gerd Hatje, Axel Menges, and Klaus Merten for their extensive advice.

# Introduction: from the Age of Enlightenment to Art Nouveau

*The Enlightenment*

The rise of the Enlightenment in Europe, and in particular in France, occurred at the turn of the seventeenth to the eighteenth century. Its impulses shook the very foundations of the bourgeoisie, causing it to move away from the absolutist feudal order and leading it to regard reason as the essence of man. The origins of the Enlightenment went back to the humanist movement of the Renaissance, to the Reformation, and to the rationalist philosophies of the seventeenth century (those of Francis Bacon, René Descartes, John Locke, and Gottfried Wilhelm von Leibniz). In 1784 Immanuel Kant defined the Enlightenment as man's exodus from his self-incurred tutelage. Characterized by a scientific approach and an active desire for reform, it subjected man's understanding of nature and society, of state and religion, to rigorous rational criticism. Trusting in the world's reason in general and in man's in particular, the optimistic impetus of the Enlightenment influenced politics, science, and culture.

In the sociopolitical field are found the teachings of Francois-Marie Arouet, known as Voltaire, fighting for the cause of reason and against ignorance and superstition; David Hume, who turned against metaphysics; Jean-Jacques Rousseau, who aimed at a "natural" state of society, in which there were neither poor nor rich, neither governed nor governing; and Gotthold Ephraim Lessing, who expressed his rebellious desire for freedom through his literary work. The conviction that there exist innate, universal, and equal human rights to life, liberty, property, and the pursuit of happiness, which must be protected by the state, found its expression in 1776 in the American Declaration of Independence and in 1789 in the French Revolution, which abolished feudalism and paved the way for a bourgeois democratic republic. In science, Isaac Newton, the English physicist and mathematician, revolutionized his contemporaries' view of the world through his discoveries in the fields of experimental optics and theoretical and higher mathematics. In the realm of culture, the Abbé du Bos promoted the development of an independent philosophy of aesthetics, linking taste with the sensual nature of humanity.

*Classicism in Architecture*

In architecture, Baroque and Rococo forms were superseded in the second half of the eighteenth century by Classicism, which reflected the contemporary desire for defined rules as outgrowths of the laws of nature and rational thinking. Its philosophical basis stemmed from the Enlightenment, and the same ideas formed the foundation of the theoretical thinking of Carlo Lodoli, Marc-Antoine Laugier, Johann Joachim Winckelmann, Giovanni Battista Piranesi, and Francesco Milizia.

The buildings of Greek and Roman antiquity were the primary models for Classicist architecture; extensive archaeological discoveries, among them those of Pompeii and Herculaneum in 1748, provided detailed knowledge. "False" motifs were now rejected, and only historically accurate ones were used. At the same time the architectural

designs of the Italian Renaissance, and in particular those of Andrea Palladio, were revived, while additional stimuli were provided by the architecture of ancient Egypt. Design now aimed at monumental simplicity, uniformity, and balanced proportions, and at a strictly harmonious and controlled beauty. Plans and views were governed by exact geometry, axes, and symmetries. The organic principles of the Baroque era, which achieved unity through the interplay among individual components, were superseded by a system that added individual units side by side, at times almost abruptly. Clearly defined spaces and outlines characterized exteriors and interiors. Shape and structure reflected rational and logical principles; rows of columns fulfilled a genuine structural function. Ornaments were applied sparingly and not infrequently omitted altogether.

The longing for simplicity and for the elemental, as defined by Rousseau, was primarily reflected in the utopian designs of the French "Revolutionary Architects" Etienne-Louis Boullée, Claude-Nicolas Ledoux, and Jean-Jacques Lequeu. Their *architecture parlante*, composed of basic geometric shapes—cubes, pyramids, cylinders, and spheres—attempted to translate into architectural form Newton's scientific revolution and the political ferment preceding the Revolution of 1789. The latter brought about a fundamental change in the architect's role in society. Hitherto it had been his function to give architectural expression to the existing political power of the absolutist feudal system, whereas now he was faced with the task of catering to the needs of a bourgeois democratic society. The search for an adequate idiom for the new age brought about numerous projects, especially by Ledoux, who as the court architect of the ancien régime and a protégé of Madame Du Barry, the favorite of Louis XV, was made to feel the change when he found himself imprisoned in 1793, with time to reflect upon the role of the architect in the new society. His plan of 1774 for the royal salt works of Arc-et-Senans was subsequently transformed into the progressive utopian city of Chaux (1804). In other countries, the main exponents of Classicist architecture were Carl Gotthard Langhans and Friedrich Gilly in Germany, John Soane in England, Benjamin Latrobe and Thomas Jefferson in the United States, and Andreyan Dimitryvich Sakharov and the Italian Giacomo Quarenghi in Russia.

In the early nineteenth century strict classical outlines gave way to a more picturesque form of building influenced by the Romantic movement. In France, where little building had been done after the Revolution, the Napoleonic regime harked back to the opulent style of the Roman emperors. In England the disciplined work of Robert Adam was followed by the elegant and pleasing classical style of John Nash. Germany's main representatives of this period were Karl Friedrich Schinkel, Leo von Klenze, and Friedrich Weinbrenner.

*Population Growth, Migration to the Cities, and the Industrial Revolution*

A sudden marked increase in population both in Europe and in the United States occurred in the nineteenth century. Statistics underscore this statement. As late as 1801 Great Britain had a population of less than 9 million; by 1911 this had risen to 36 million. During the same period Germany's population increased from 24.5 to 65 million, and that of Italy during the 70 years from 1861 to 1931 from 25 to 41 million. In the United States the population increased from 5 to 123 million in less than 130 years. The primary reasons for this population explosion were improvements in nutrition and sanitation. Progress in the fields of agriculture and medicine were decisive in reducing infant mortality, and at the same time the average life expectancy was raised. As a result, population curves showed a sharp upward trend.

A simultaneous and equally spectacular phenomenon superimposed itself onto the population explosion: migration from the coun-

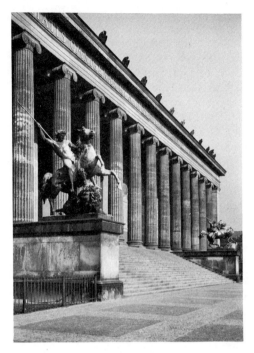

1. Karl Friedrich Schinkel, Altes Museum, Berlin. 1823–29.

try into cities. In 1801, 80 percent of the British population lived in the country; by 1891 this figure was almost reversed, with 72 percent living in cities. In Germany, where the drift from the rural areas began later but was equally marked, 64 percent of the population lived outside the conurbations as late as 1871; by 1919 this figure had fallen to 37 percent. In the Italy of 1871 only 2.5 million people lived in places with a population over 100,000; by 1931 this figure was over 7 million. In the United States only 20 percent of the population lived in cities in 1860, compared with 46 percent in 1910 and 60 percent in 1950.

Migration of this kind had previously occurred in the seventeenth and eighteenth centuries, but only in the form of isolated and sporadic incidents. The mass movement of people that started in the nineteenth century and reversed to an unprecedented ex-

tent the ratio of urban to rural population was mainly due to growing industrialization. The use of machines brought fundamental changes in the manufacturing processes. Crafts were largely replaced by industry; home-based work was superseded by work in factories in order to make the best possible use of machinery. Machinery, in turn, rather than being installed near populated areas, was concentrated in the immediate vicinity of the sources of energy necessary for its operation—near water and coal. Labor had to follow, and the first industrial centers were established.

The effects of the Industrial Revolution on the social structure were immense. The explosive development of the economy, which was brought about by technological progress and with the help of banks, stock exchanges, and a system of financial interdependence, soon resulted in the concentration of production facilities and assets, uncontrolled by the state under the banner of economic freedom. Capital gained a monopoly and largely counteracted the initially liberal principle of free competition. In addition, the emphasis on capital as the decisive economic factor led to discrimination against that group of the population that owned no capital—the working class. The ensuing social tensions and injustice became apparent in the inhumane working conditions and intolerable living conditions endured by the proletariat.

*Early Iron Structures in Europe*

In 1735 Abraham Darby developed a process in England by which iron was produced in large quantities through the use of coal instead of charcoal. This process revolutionized not only engineering, industry, and transport but had an equally strong impact on building. The newly available building material, which combined the advantage of great strength with the relatively small dimensions of the individual components, was initially used in the construction of bridges. Between 1775 and 1779 John Wil-

kinson and Abraham Darby II (the son of Abraham Darby) built the first cast-iron bridge in England. It spans the Severn River near Coalbrookdale and consists of a single semicircular arch with five parallel ribs, which are made up of segments. Its span is approximately 102 feet (31 meters), its height 49 feet (15 meters).

Civil engineering, too, soon recognized the potential and later the fascination of the new material. Saint Anne's Church in Liverpool (1770–72) is thought to be the first church with cast-iron columns. In 1801 the engineers Matthew Boulton and James Watt (inventor of the steam engine) built a seven-story cotton mill at Salford (England), the entire internal supporting structure of which consisted of cast-iron columns and inverted T-sections, masonry being used on the outer walls only. In the following decades numerous buildings using iron as the main building material were constructed in other countries.

Greenhouse building in England and France had a long history. Notable are structures by Charles Rohault de Fleury in the Jardin des Plantes in Paris (1833–34), by Decimus Burton and Richard Turner in Kew Gardens (1844), and by Théodore Charpentier and/or Gabriel-Louis-Hippolyte Meynadier de Flamalens in the Jardin d'Hiver in Paris (1847). The climax of this development was the Crystal Palace, built in 1851 by the former gardener Joseph Paxton. In an international competition to design the building for the World's Exhibition in London, he handed in late to the judges of 245 projects his radical design for an iron-framed structure; was awarded the contract against all expectations; and completed the entire building within nine months. The elegant structure of iron, glass, and wood covered an area of more than 750,000 square feet (70,000 square meters). All building components were standardized and could be mass-produced. The design was based on the largest sheet of glass that was then possible to manufacture; this unit was repeated throughout. The complete units were industrially made, brought to the site, and bolted together. An entirely new building concept, founded on engineering rather than architecture, had been born. After the exhibition, the Crystal Palace was dismantled and—after slight modifications—rebuilt at Sydenham, where it stood until 1936 when it was destroyed by fire.

The French architect Henri Labrouste, who had severed his ties with the formalist Paris École des Beaux-Arts, founded a private school of architecture, which emphasized structural and functional requirements. In constructing the Bibliothèque Sainte-Geneviève (1843–50), the Bibliothèque Impériale (1855), and the Bibliothèque Nationale (1858–68), all in Paris, he used iron stanchions, which formed a characteristic feature of the interior. In the reading room of the Bibliothèque Nationale tall, slender cast-iron columns joined by semicircular arches support a light, vaulted ceiling with skylights. The bookstacks, separated from the reading room by a large glass screen, have a glass roof; cast-iron floor grilles (used at that time in the engine rooms of steamers) allow daylight coming from above to filter through its five stories, producing fascinating effects of light and shade. Openwork bridges and stairs, the treads of which consist of grating,

2. John Wilkinson and Abraham Darby II. Bridge across the Severn River near Coalbrookdale. 1775–79.

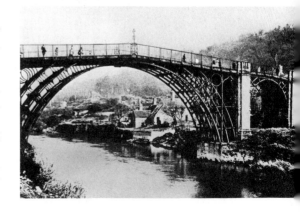

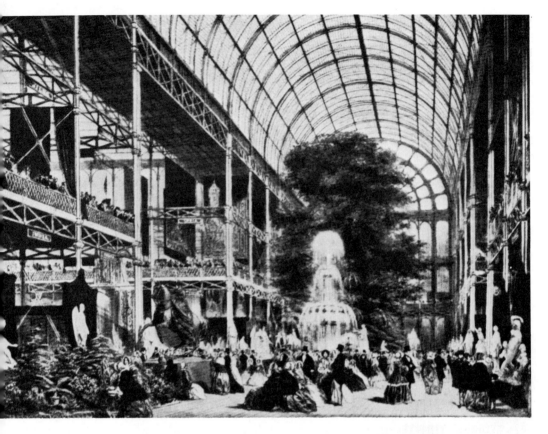

3. Joseph Paxton. Crystal Palace, London. 1851.

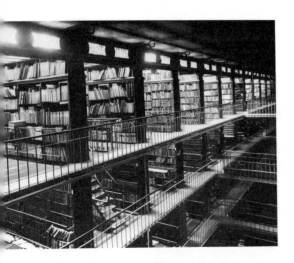

connect the different levels. The exterior walls and the interior decoration, on the other hand, combine a number of traditional elements.

In 1871–72 Jules Saulnier built the mill for Menier's Chocolate Factory near Noisel-sur-Marne, in which the structural skeleton remained visible and formed part of the design. The supporting steel structure, and in particular its diagonal bracing, was clearly visible; the walls were built of hollow bricks, their sole function being that of infilling.

The architect Louis-Charles Boileau, in conjunction with the engineers Armand Moisant and Gustave Eiffel, was the first to build an iron and glass department store, the

4. Henri Labrouste. Bibliothèque Nationale, Paris. 1858–68.

Magasins du Bon Marché (1873–76), in Paris. Their work continued the tradition of French market halls, notable examples being the Marché de la Madeleine (1824–32) by Gabriel Veugny and the Halles Centrales (1854–66) by Victor Baltard and Félix Callet. Instead of the massive Historicist edifices of their time Boileau, Moisant, and Eiffel created a light skeletal structure. The total area is broken up into several inner courts lit by large skylights, with graceful iron footbridges, similar to the ones used by Labrouste, linking the departments.

The development of the steel framework reached its climax in 1889 in the Galerie des Machines, built by Ferdinand Dutert and Victor Contamin for the Paris World Exhibition. Twenty thrice-articulated arches

5. Louis-Charles Boileau, Armand Moisant, and Gustave Eiffel. Magasins du Bon Marché, Paris. 1873–76.

were arranged over the entire length of the hall of 1,407.5 feet (429 meters), each having the then unique span of 377.3 feet (115 meters). Because all forces acted through the apexes and the two base points of the trussed girders, columns and beams were no longer separate units. The structure rose in a continuous line from base to apex. The sectional area near the bases was reduced in accordance with the acting forces, so that they ended in a point. Immense glass areas formed the sides and most of the roof. Aesthetic concepts, equally, were upset: the size of the spanned area indicated a victory over matter, and the new form of construction, which freely showed the structural elements, represented a break with all traditional ideas of statics and created a new concept of beauty by suggesting the notion of movement.

This concept was memorialized in the same year, when Gustave Eiffel built the tower that bears his name. On the basis of experience gained in bridge construction, he erected a structure that rises 984 feet (300 meters) above Paris. With the exception of four arches, which connect the base supports and were added at a later stage for decorative purposes, its entire structure is determined by the interaction of forces within the steel structure.

## The Development of Architecture in the United States and the Chicago School

Architecture in North America developed along lines similar to those of European architecture. A period of extensive Greek revival in architecture followed the American Revolution and the Declaration of Independence in 1776. Among its most significant representatives were Benjamin Latrobe, who, before he emigrated to the United States in 1793, had worked for some time in England where he was influenced by John Soane; Thomas Jefferson, president of the United States from 1801 to 1809, who built the University of Virginia in Charlottesville between 1817 and 1826; and James Hoban and Robert Mills, who were respon-

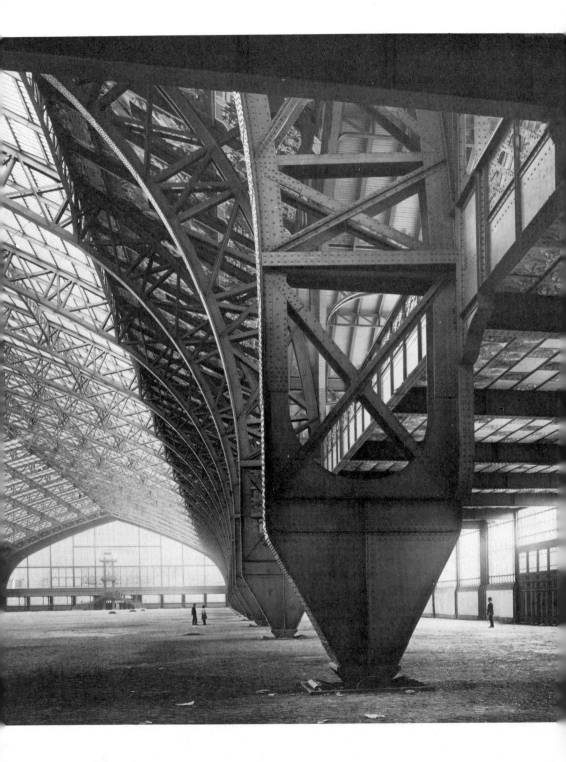

sible for a number of government buildings in Washington D.C.

As in Europe, new methods of construction were introduced in the United States in the wake of the Industrial Revolution. During the first half of the nineteenth century, iron became an accepted building material; in 1848 the inventor James Bogardus, who also invented a novel pencil, a stamp-engraving machine, and a deep-sea measuring device, designed a five-story factory in New York, in which the brickwork, which normally formed the outer walls, was replaced by iron supports. Drawing on experience gained in the construction of wooden farmhouses, Bogardus used standardized prefabricated units. Subsequent buildings based on this principle were soon to follow, among them the Harper Brothers Publishing House in New York (1854), the external walls of which were built almost entirely of glass, while the columns and arches were constructed in the style of the Venetian Renaissance. The building thus illustrates the conflict between technical feasibility and formal design.

The decisive turning point in the architecture of the United States occurred in the last quarter of the nineteenth century in the Midwest, and in particular in Chicago. Agriculture changed from a crafts-based to an industrial process, and as a result the city, which was a transshipment point for the surrounding area, expanded rapidly, especially after the great fire of 1871 and the worldwide economic crisis of 1873. Buildings mushroomed everywhere, and since land was scarce and expensive, they were tall and closely spaced. The first skyscrapers were built.

The credit for finding a convincing structural solution for fireproof high-rise build-

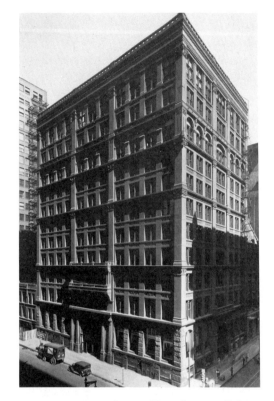

7. William Le Baron Jenney. Home Insurance Building, Chicago. 1883–85.

ings predominantly built from prefabricated units goes to William Le Baron Jenney. He used a steel skeleton which, unlike Bogardus's cast-iron frame, possessed not only compressive but also tensile strength and thus formed a uniformly rigid structure. Since the steel skeleton alone was not able to withstand heat, it was given a masonry cladding. The first Leiter Building was constructed in 1879, followed in 1883–85 by the Home Insurance Building and the second Leiter Building, today Sears Roebuck and Co., in 1889–90. This new construction method enabled Jenney to overcome the restrictions imposed on height by conventional masonry structures.

6. Ferdinand Dutert and Victor Contamin. Galerie des Machines, Paris. 1889.

Style on the American scene, on the other hand, was deeply influenced by another American architect, Henry Hobson Richardson. He studied in Paris at the École des Beaux-Arts, worked under Henri Labrouste, and built, after his return to the United States, a number of highly individual, stylized residential and office buildings, churches, and public buildings. During the years 1885–87 he was in charge of the project for the Marshall Field Warehouse in Chicago, a massive Neo-Romanesque stone building that produces its impact mainly through the expressive texture of its material. Its plain but monumental vastness, alleviated by large Romanesque windows, is a characteristic feature of Richardson's style.

This example was appropriated by Daniel Hudson Burnham and John Wellburn Root in the Rookery Building (1885–87) and refined in the Monadnock Building (1889–91), both in Chicago. The last high-rise building to have exterior walls of bearing masonry, the Monadnock Building had no ornaments at all; instead, the severity of the sophisticated facade in this sixteen-story building was broken by elegant bow windows. The

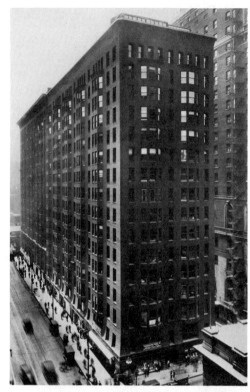

9. Daniel Hudson Burnham and John Wellburn Root. Monadnock Building, Chicago. 1889–91.

8. Henry Hobson Richardson. Marshall Field Warehouse, Chicago. 1885–87.

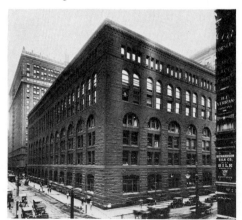

smooth edge of the building continued in a clear line while the tapering shank and the coved cornice were reduced to a curve of simple expressiveness. The Reliance Building, built in Chicago in 1890–94, also by Burnham and Root, gave the steel structures of high-rise buildings consistent exteriors. The light and seemingly weightless framework of the vertically divided facade anticipates steel and glass structures built in the mid-twentieth century.

Louis Henry Sullivan, the main protagonist of the Chicago School, was for a short period a student at the Massachusetts Institute of Technology and later, like Richardson, studied in Paris. For a time he worked under Jenney and entered into a partnership

with Dankmar Adler in 1881, in which he took charge of the formal design of buildings. In 1890–91 Sullivan was responsible for the Wainwright Building in St. Louis, a boldly rising steel structure, showing the division into three parts—a massive ground floor and mezzanine, a vertically oriented office section, and a broad top section for the technical installations—which was to become a characteristic feature of his style. Between 1899 and 1906 Sullivan rebuilt the Carson Pirie Scott & Co. Department Store, which became the emblem of the Chicago School. The continuous surfaces of the interior follow conventional lines. What makes the building remarkable is the facade — a clearly outlined network of horizontal and vertical lines, marking the underlying steel structure with a severity that is both elegant and rational. The huge, horizontally ar-

11. Louis Henry Sullivan. Carson Pirie Scott & Co. Department Store, Chicago. 1899–1906.

10. Daniel Hudson Burnham and John Wellburn Root. Reliance Building, Chicago. 1890–94.

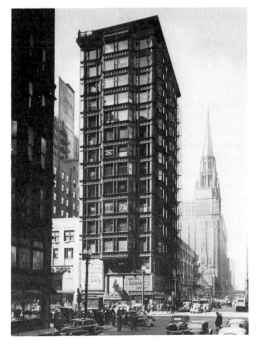

ranged Chicago windows are fitted with thin metal strips; those of the lower stories are connected by a narrow strip of terra-cotta ornaments, which gently emphasize the horizontal orientation. In deliberate contrast to such reticence, the rows of display windows of the first and second floors are framed by ornate cast-iron Art Nouveau ornaments.

Throughout his working life, which was marred by professional and personal problems, Sullivan was intent on teaching. "Form follows function," the essence of his extensive theoretical work, has been quoted and applied to excess, but mainly out of context and has thus been misunderstood. Sullivan did not simply demand that a building demonstrate its use, but postulated that its form should be derived from its function. In this sense function meant to him not only technical and economic but also psychological and aesthetic requirements. He thus formulated one of the guiding principles of twentieth-century architecture: functionalism.

## Social Utopias and Company Towns in the Nineteenth Century

For a long time the population explosion of the nineteenth century and the drift toward the cities was not reflected in or organized by city planning. The masses of migrants who were drawn to the cities by the Industrial Revolution initially were crowded into existing buildings, and these were soon filled to capacity. Once this means of accommodation was exhausted, temporary dwellings were erected on any available space in inner courtyards and on unused land, blocking and suffocating the cities. Later, migrants were directed to outlying areas—legalized ghettos, without air, water, light, or sanitary facilities.

While speculation was rife the towns grew unchecked like tumors; they became more and more crowded and uninhabitable and were polluted by disease, chaos, and smog. Some British statistics illustrate the misery: in Bristol 46 percent of all families were confined to one room; in the East End of London 12,000 people lived in 1,400 small houses; in the Parish of St. George near Hanover Square 408 families lived in two rooms, 929 lived in one room, while 623 families had only one bed. Basement apartments were common in London, Manchester, and Liverpool. Moreover, trade and industry settled, without control or guidance from public authorities, wherever it was most convenient from an economic point of view. The result was the total and chaotic intermingling of incompatible urban functions, with noisy and smoky industrial enterprises being built amid the inner courtyards of tenement blocks.

It is little wonder that this was fertile ground for utopian ideas for new forms of society, following in the tradition of all those who had dreamed of ideal states, from Plato's Politeia, St. Augustine's Civitas Dei, Thomas More's Utopia, and Francis Bacon's Nova Atlantis to Tommaso Campanella's Città del Sole. In the wake of the French Revolution these ideas developed into the utopian socialism of Charles Fourier, Claude Henri de Saint-Simon, and Robert Owen and later into the "scientific communism" of Karl Marx and Friedrich Engels.

Charles Fourier attempted to lead mankind to a stage of development at which the rich would no longer live at the expense of the poor and at which economic anarchy and competition would be replaced by an agriculture- and crafts-based system for producing and distributing goods. From 1808 on he developed the concept of the *phalanstères*—loosely associated autonomous economic units. Plans for one such unit were published in 1829; they envisaged that all rooms should be in a block with two wings, the various parts of which were to be connected on the second floor by means of covered walkways. The 1,620 inhabitants of each *phalanstère* were to lead a largely communal life but were, on the other hand, to be given extensive scope to follow their individual inclinations through detailed rules.

Such utopian dreams were soon followed by more realistic city planning. Robert Owen, coowner of one of the largest English cotton enterprises and with his sociopolitical manifesto, *Plan*, author of one of the most important declarations of early socialism, built a model factory in New Lanark, Scotland, in 1799, surrounded by a housing estate for 3,000 people. The actual dwellings were small, but offered sound accommodations; moreover, provisions were made for a day care center and a school. Twenty-six years later Owen and some 1,000 of his followers founded New Harmony in Indiana. Stedman Whitwell's design closely followed Owen's theoretical outline. Communal buildings and infrastructural units formed the center of the settlement, bordered by the homes and in turn surrounded by gardens. Beyond and outside the town lay workshops, as well as agricultural and industrial units. The experiment failed because of internal disputes among the settlers, but a similar venture by the Owenists, which

was realized between 1839 and 1845 at Harmony Hall near Southampton, met with more success.

Meanwhile, some enlightened politicians had recognized that links existed between social and housing conditions. In 1844 the Society for Improving the Conditions of the Labouring Classes, headed by Lord Shaftesbury, exhibited the first models for public housing. In the following year Friedrich Engels published his treatise *The Condition of the Working Class in England in 1844*, which is primarily an attack on the inhumane living conditions of that class. In 1848, a year of revolutionary movements throughout Europe and the publication date of the *Communist Manifesto* by Marx and Engels, the first Public Health Act was passed in England. Through it Lord Shaftesbury incorporated the first modern building reforms, and these came into force three years later.

Reaction was swift. Partly from humanitarian considerations and partly as an incentive for higher productivity through better living conditions, as well as a way of tying workers to certain locations (and factories) and of removing them physically from large conurbations (which were already in the grip of class confrontation), new housing estates for workers, the so-called company towns, sprang up throughout Europe and the United States. Between 1850 and 1863 the architects Lockwood & Mawson built Saltaire in New York state on behalf of the industrialist Titus Salt. A well-designed, grid-based estate for 4,350 people, it had a hospital, a club, schools, first-aid posts at the factory,

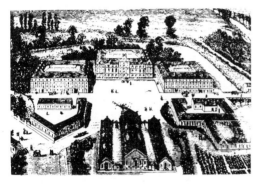

12. Jean-Baptiste André Godin. Familistère, Guise. 1850.

13. Robert Owen and Stedman Whitwell. New Harmony, Indiana. Project. Published 1825.

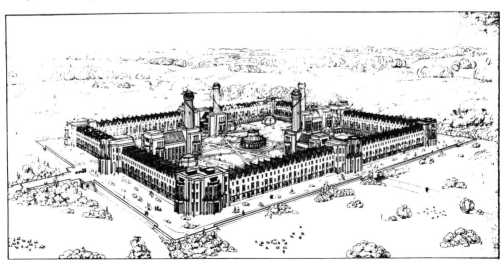

spacious public parks, and even a "Literary and Philosophic Institute."

In 1850 Jean-Baptiste André Godin reali zed some of the bold visions outlined in Fourier's *phalansìere* by building a *familistère* near his factory at Guise, Belgium. But while the more radical Fourier had stipulated that the inhabitants should be separated by age groups, Godin's three interconnected four-story blocks provided individual apartments for each family. The dwellings are satisfactorily equipped with sanitary facilities, have natural ventilation, and are accessible through covered walkways that frame the glass-covered inner courts on each floor.

Beginning in 1853 Emile Muller built a workers' estate for the Société Mulhousienne des Cités Ouvrières, consisting of small single-family houses with individual gardens. This project had been initiated by Louis Bonaparte and was financed by a system under which one-third of the capital took the form of a state investment. The houses were to be paid for over a period of 13 to 15 years, the object being that workers should "establish" themselves.

In 1880 Solon Beman and Nathan F. Barret designed the layout for Pullman Town near Chicago at the request of the railway magnate George Mortimer Pullman. This was subsequently translated into a refined and romanticized company town, exemplary in terms of city planning and a reflection of American capitalism in the late nineteenth century.

Between 1886 and 1889 William Owen built Port Sunlight in Liverpool, England for the soap manufacturer Lord William Hesketh Lever. The town consisted of large Tudor-style units with suitably planted communal inner courts.

## Historicism in Architecture

During the first decades of the nineteenth century, Classicism lost its strictly theoretical foundation and clear idiom and was gradually replaced by Historicism. This phase, which is characterized by the imitation of historic architectural styles, lasted until the beginning of the twentieth century.

At a time when Baroque and Rococo styles were still prevalent, Historicism had first become apparent through isolated imitations of Gothic and Greek elements. The Austrian architect Johann Bernhard Fischer von Erlach had published in his *Entwurff einer historischen Architektur* (1721) a comparative study of various architectural styles that even included Egyptian and Chinese buildings. His analyses were continued by Giovanni Battista Piranesi and formed the main repertoire of Historicism.

In addition, systematic research into ancient art had been carried out since the first archaeological ventures of Johann Joachim Winckelmann. The discovery that the Greek temples were not initially brilliant white marble, but had been painted in strong bright colors, was shocking. With the fall of the concept of "noble simplicity and tranquil greatness" went the axiom of rigorous limitation to classical design elements and types. A differentiation was made between appearance and reality. Within the framework of an overall reevaluation of history, architectural eclecticism was consciously practiced. Whereas archaeological accuracy remained the yardstick of artistic quality, the styles of the past were regarded as a reservoir from which elements could be taken and used.

This trend was furthered by the Romantic movement, which toward the end of the eighteenth century had sprung from the German literary circles connected with August Wilhelm von Schlegel and which had spread throughout Europe and the United States. In architecture it gave rise to a Romanesque and Gothic revival; having begun its development during the late phase of Classicicm, it blossomed throughout the period of Historicism. Despite the widened range of usable forms, architecture remained bound by clearly defined rules, which were laid down in theoretical writ-

ings. These included the works of Jean-Nicolas-Louis Durand, Eugène-Emmanuel Viollet-le-Duc, and Gottfried Semper.

During the era of Historicism architectural expression drew upon a number of styles. Neo-Renaissance, initially an infrequently used style, became fashionable around 1860. In the wake of a reassessment of the Middle Ages that had taken place approximately a decade before, Neo-Byzantine, Neo-Romanesque, and Neo-Gothic styles appeared, followed toward the end of the century by a Neo-Baroque movement. During this latter phase elements of all these styles might well be encountered in one building.

Such retrospection formed part of a universal nationalist awakening, which attempted to revive old traditions and led to a desire to preserve historic monuments. In architecture, historical "accuracy" was almost exclusively limited to the exterior of buildings, since the bourgeois-collective philosophy of that period required that particular attention be paid to their setting within the community and to their decoration because of their public character and their representative function. Plans, although on the whole geometric, allowed relative freedom, and the dimensions and structures of the initial style were not rigidly adhered to. Inspired by parallel developments in engineer-designed and iron structures, new technology became a tool of the new architectural Historicism.

Such a development was already partly motivated by new requirements. The supercession of feudalism by bourgeois national states, the Industrial Revolution, and capitalism gave rise to entirely new types of building. After the French Revolution, the Roman Republic became the mold on which states were shaped, and designing a parliamentary building (modeled on the curia), palace of justice, or a prison became important functions. The new structure of society required increasing numbers of schools, universities, museums, exhibition halls, theaters, opera houses and concert halls, assembly halls, markets, slaughterhouses,

and warehouses. The Industrial Revolution provided the impetus to build factories and office buildings, and the development of railways and tourism prompted the construction of railway stations. Capitalism furthered the growth of banks and stock exchanges . Alongside these developments older classes of buildings, such as churches, remained important. "Functionalist" efforts to give each type of building its own style, so that the exterior of a building would clearly indicate its purpose, failed on the whole. Although certain styles seemed to be preferred for certain buildings—Romanesque and Gothic originals were used mainly for churches, whereas architects of civic buildings drew on late Gothic and Renaissance originals—the choice of historical pattern seems to have been largely indiscriminate, with the exception, perhaps, of local traditional styles that were used in the course of "national romanticism."

The transition from Classicism to Historicism in architecture was a gradual one, with the two movements overlapping and interacting. A tentative Renaissance revival became apparent as early as in Claude-Nicolas Ledoux's work. John Nash also built in the "Italian" style, although this included exotic motifs, while Karl Friedrich Schinkel designed Classicist as well as Romantic buildings. Neo-Romanesque motifs characterized the work of Henry Hobson Richardson, one of the main protagonists of the early Chicago School. The Gothic Revival had its main adherents in Eugène-Emmanuel Viollet-le-Duc and in the English architects Sir Charles Barry (who, however, also drew upon Classical and Renaissance elements), Augustus Welby Northmore Pugin, and Alfred Waterhouse. The Neo-Baroque style (known in Germany and Great Britain by the names of the respective monarchs of that time, Wilhelm and Edward) came initially from the France of Napoleon III. Its main representatives are the Frenchman Charles Garnier, the Belgian Joseph Poelaert (who also built in the Neo-Gothic style), and the

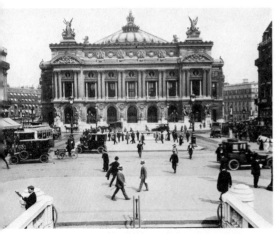

14. Charles Garnier. Opéra, Paris. 1861–74.

### City Planning in the Nineteenth Century

In response to increases in population and the migration of people from rural areas, cities were greatly enlarged throughout the nineteenth century; but despite their extent, most of these measures proved insufficient. At the same time, efforts were made to redesign the badly congested inner cities.

As early as 1812, John Nash, whose career as a speculative builder had been interrupted by bankruptcy in 1783, drew up his first plans for the development of Regent Street and the buildings around Regents Park in London. Work on the project was interrupted by the Napoleonic Wars and was not resumed until 1820, when the country's economic position permitted Nash's bold city planning scheme. Elegant classical buildings, which subjugated their individuality to the overall concept of city planning and their incorporation into the landscape, were built for the upper classes. Alongside the residences of the rich, which combined representative function and the ethos of healthy

German Paul Wallot. Such an attribution can be no more than an approximation, however, since the eclectic attitude of the time was such that most architects used several styles simultaneously.

living conditions, the ghettos of the poor mushroomed, with dark, dilapidated houses and all available space congested with shacks, factories, and chimneys.

Almost half a century later Napoleon III ordered Georges-Eugène Haussmann, the prefect of Paris, to redesign the French capital. In the meantime, conditions had changed fundamentally. Whereas the London projects had preceded the development of railways and had limited themselves to a residential area free from main thoroughfares, the Paris plans were executed during the railway era. Transportation became the focus of attention and the street became the main factor in city planning. The planning itself had a fourfold aim:

—the designing of an aesthetically pleasing city in the monumental style of the time.
—an improvement in sanitary conditions through the systematic demolition of dirty, disease-breeding alleys;
—the solution to traffic problems in the center of Paris, which was by then already in the full process of industrialization; and
—the facilitation of troop movements within any of the city's districts and the possibility of using artillery to combat insurrection.

Between 1853 and 1869 wide, straight roads were built in three stages through the urban network of central Paris. Of a total of 66,578 existing houses, 27,000 were demolished, and although 100,000 new houses were built, more than 25,000 inhabitants, predominantly laborers and artisans, had to leave the city. The water, sewage, and transportation systems were renovated, parks were created, and trees planted along the avenues. Nevertheless, the mile-long streets with public facades built in a discreet, uniform Neo-Renaissance style still hid a network of narrow, twisting alleys.

At about the same time tenders for an international competition in Vienna were invited to develop and integrate into the city the fortifications given up by the emperor.

Between 1858 and 1872 the Ringstrasse was built according to a plan by Ludwig Förster; it transformed the city without destroying its organic historic character.

In Madrid a three-mile-long section of the Ciudad Lineal was built in 1894, a ribbon-like development, which had been suggested twelve years earlier by the writer and traffic engineer Arturo Soria y Mata. His plans were based on the observation that settlements tend to develop along traffic routes, and it was his object to further such trends. These ideas, however, were not embraced fully until much later.

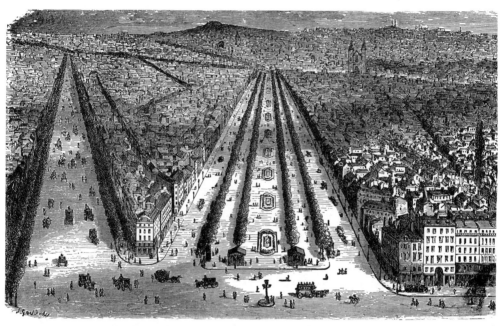

15. Georges-Eugène Haussmann. Redevelopment of Paris. 1853–69.

16. Arturo Soria y Mata. Ciudad Lineal, Madrid. Project. 1882.

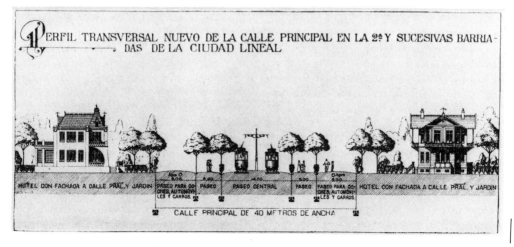

## Arts and Crafts, Art Nouveau, and Related Architectural Movements

The social phenomena that had been initiated by the Industrial Revolution in Europe and the United States persisted from the middle of the nineteenth to the beginning of the twentieth century. Population figures continued to rise, industrialization progressed steadily, and migration to the cities and the subsequent growth of the large conurbations characterized the changing relationship between town and country. When an era of peace began in Europe at the end of the Franco-Prussian War of 1870–71, and with the founding of a German state, the energies thus released were not utilized to resolve structural problems but to unleash a development of trade, commerce, and industry that was as powerful as it was politically and economically controversial.

The economic slump of 1873 destroyed the flimsy structure of the preceding two years, during which innumerable bogus enterprises had been set up and vast speculation had occurred, but nonetheless it paved the way for a further major industrial advance. During the 1890s the last capitalist expansion before the First World War began. International markets grew in number through developments in Russia, South America, the southern and northern coasts of Africa, and parts of Asia, and agreements on spheres of influence were reached by the industrial powers, thus beginning the age of imperialism. Whereas developments since the first third of the nineteenth century, climaxing in the formation of national states, had produced large national economic constellations, the new trends resulted in a genuine worldwide economy.

At the same time, significant progress was made in the fields of science and technology. Numerous inventions revolutionized everyday life and industry, and magnificent structures created new architectural scales. The rapid expansion of railway systems and the growing infrastructure led to geographic permeability and thus to an exchange of information between individual countries.

Initially, the visual arts did not on the whole succeed in reflecting the contradictions of the new era; instead, they tried to escape reality by a nostalgic retrogression and in a revival of the obsolete ideals of the past. The Pre-Raphaelites, a group of British painters, sculptors, and writers dating back to 1848, are symptomatic of this retrospection. They modeled themselves on the forerunners of Raphael and strove for a reform of art by spiritual absorption, artistic inspiration through nature and religion, and decorative and aesthetic effects. Closely related to this movement was Symbolism, which came into being about 1885; it developed initially in France as a reaction to Impressionism and above all to Realism and soon spread throughout Europe. The writers and painters who were its adherents were united by a desire to shake off the bonds imposed on them by the real, visible world and by an urge to express the reality of imagination, fantasy, and magic.

In architecture the need was felt to replace Historicism with a new style untrammeled by the ideas of the past. The theoretical basis for this movement was to be provided by the aesthetic of empathy outlined by the philosopher Theodor Lipps and published between 1903 and 1906 in his work *Ästhetik, Psychologie des Schönen und der Kunst*. Spiritual immersion in shapes, objects, and living beings, so that they appear to reflect the feelings of the contemplator, was for Lipps and his followers the first step of aesthetic perception. Thus, vertical, horizontal, or oblique lines, curves, areas, and colors all had their own significance. Shapes and symbols permitted the semantic deciphering of architectural forms, which had been developed with the specific purpose of psychological association. The influence of Sigmund Freud, who had formulated the psychology of the subconscious at the end of the nineteenth century, is clearly noticeable.

Among the pioneers and leaders of the new architectural idiom the art historian,

writer, and social reformer John Ruskin, who was also connected with the Pre-Raphaelites, was probably the most prominent. Since he felt indebted to Historicism, he ignored the "iron" architecture of the nineteenth century and rejected industrialized building methods as a betrayal of architecture as art. He saw external beauty as the reflection of internal beauty, and thus formulated the progressive demand for morality in architecture. *The Stones of Venice*, published between 1851 and 1853, contains the famous chapter "On the Nature of Gothic," in which the beauty of medieval architecture is equated with the joy experienced by a craftsman in producing his work. This maxim was later to become the mainspring of William Morris's formation of the Arts and Crafts movement.

The roots of the Arts and Crafts movement and the architecture of Art Nouveau go back to three main sources of inspiration.

—The enthusiasm for medieval art, which had arisen during the time of Historicism about the middle of the nineteenth century, resulted in a reevaluation of the Gothic era. In an abstract sense the Gothic style continued in Art Nouveau, in the emphasis on lines of force and the technical mode of construction of a building; in the ethical requirement of an "honest" use of form and material, as well as the identity of exterior and interior; and above all in the "social" claim of being the result of a collective effort by kindred spirits who experience fulfillment and freedom through communal (crafts-based) work.
—Moreover, the influence of elements from foreign and exotic countries made itself felt. Motifs derived from the architecture of Egypt, North Africa, India, Turkey, and especially Japan were absorbed and utilized. The principle of asymmetry, directly opposed to the Renaissance ideal of symmetry, was rediscovered.
—Last, the new architecture drew inspiration from the study of natural forms.

These were not directly reproduced in the way that Impressionist painting had attempted; instead, the processes of organic growth served as the inspiration for symbolic elements that had nothing in common with their originals but abstract formal analogies.

The architectural form of expression thus derived consisted of two clearly distinct morphological branches that succeeded one another: one was predominantly determined by concave and convex shapes and by curves and vibrations; the other consisted of interpenetrating orthogonal geometric elements. The two branches did, however, have several objects in common: the aim of freeing themselves from the "premeditated" plans dictated by Classicism and Historicism and of creating "free" structures, oriented toward the function of the building; the emphasis on the line as an expression of creative force and as a determining element of architectural design; the delight in ornaments, shapes, colors, and in unusual or precious materials; the understanding of design as an all-embracing discipline, extending to the exterior of the house as well as to the smallest scatter cushion inside, thus making it one aesthetically uniform whole; and finally the hope that the new style would filter down to the dwelling of the humblest worker.

The social mission of Art Nouveau remained, however, utopian. The buildings that were erected were not houses for workers but villas and mansions. Even if department stores, industrial buildings, or subway stations were built in the new style, and even though one of the most important edifices of the period was commissioned by the Belgian Labor Party and known as Maison du Peuple (House of the People), Art Nouveau remained the domain of a cultural elite and the sublime expression of its subjective emotions.

The Englishman William Morris, who came from a wealthy family and found the "dishonesty" of eclecticism distasteful,

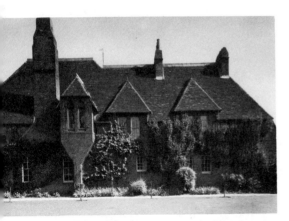

17. Philip Webb. Red House, Bexley Heath, Kent. 1859.

commissioned his friend the architect Philip Webb with the building of a house, which was to be free of the academic design standards of his time and combine logical functionalism with "open" design and the use of appropriate materials. The result was the Red House at Bexley Heath, Kent, built in 1859. Its free, asymmetric ground plan, its comfortable and logical sequence of rooms, its sensible layout, its unity of exterior and interior, as well as its "honest" use of materials and its unpretentious facade, make it, despite its ties with Gothic Revival, an original attempt at creating a new style in domestic architecture.

As a reaction to the flood of industrially produced pseudohistorical kitsch that swamped the interior design market around the middle of the nineteenth century, Morris advocated the revival of arts and crafts. Together with friends, in 1861 he founded the firm of Morris, Marshall & Faulkner, later Morris & Co., which produced wallpaper, printed fabrics, decorated glass windows, carpets, and upholstery materials of high quality. The first exhibition of work by the new enterprise took place in 1888 in the London New Gallery, and it was on this occasion that the name Arts and Crafts was first mentioned. Despite its social claims, the movement, which aimed at uniting art and craft, never came to terms with the practical dilemma that handmade articles were much more expensive than machine-made products and therefore out of the reach of ordinary people. Despite this retrogressive Luddite premise, the influence of this movement on later developments was far-reaching; it inspired a number of Art Nouveau architects, in particular Henry van de Velde, and their example resulted in the foundation of the Deutscher Werkbund.

During the Arts and Crafts period a group of architects gathered around Morris, characterized by high professional standards and an intense, honest struggle with the problems of domestic architecture. Among the most notable representatives of the Arts and Crafts movement in architecture were Richard Norman Shaw, Charles Harrison Townsend, Charles Robert Ashbee, and Charles Francis Annesley Voysey. Their reformist attitude was not only reflected in exteriors but included interiors, ranging from furniture to door handles. The modern concept of the architect as designer of the total environment has its roots in this movement.

In 1881 the first issue of the avant-garde weekly journal *L'Art Moderne* was published in Brussels. It contained an unsigned article that stated: "Art to us is the contrary of any recipe or formula. Art is the eternally spontaneous effect of man on his environment with the aim of transforming it and assimilating it to a new reality." In 1895 a shop was opened in Paris under the name "L'Art Nouveau." In contrast to the then popular imitations of previous styles, only articles made in the modern style were sold in the store. In 1896 August Endell, Richard Riemerschmid, and Hermann Obrist founded the journal *Jugend* in Munich. The foundation was thus laid for the international movement that was known in Germany as Jugendstil and in the French- and English-speaking world as Art Nouveau.

The spiritual center of the new movement was Brussels. It was there that the architect

Victor Horta built, in 1892–93, a house for the engineer Tassel in the rue de Turin, which was both artistically and technically revolutionary. Even the relatively reticent facade gives an idea of the vitality of design that marks the interior. The straight bay windows of the neighboring houses are transformed into a bow-shaped area. Iron is introduced here as a new building material in domestic architecture, especially in the unconcealed supports of the staircase and in the elegant stairs themselves, where it not only remains visible but becomes the site of impressive ornaments. The previously used rigid layout over all the stories is swept away; by utilizing the maximum areas permitted by the skeletal structure, the arrangement of rooms becomes flexible over various levels (thus anticipating the *Raumplan*, the "concept of space" of Adolf Loos, de-

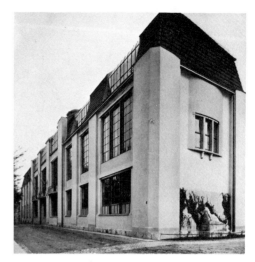

19. Henry van de Velde, School of Applied Arts, Weimar. 1906.

vised about 1910). Broken undulating lines twist their way over floors, walls, and ceilings, wrap themselves around the banister rails of staircases and balconies, and cover the entire building with organic decoration.

If Horta was primarily an artist, his fellow Belgian and contemporary Henry van de Velde was more of a theoretician, propagandist, and teacher. Initially a painter, he turned, under the influence of Ruskin and Morris, to applied design. Inspired by English country house architecture and facing the same dilemma as Morris had in 1859, he designed Haus Bloemenwerf, including its interior and furnishings, at Uccle near Brussels, in 1895 for his young family.

Van de Velde realized at an early stage that the Arts and Crafts movement overestimated the danger posed to human values by factory work and that its enmity toward the machine as an adversary of culture was retrogressive. He warned earnestly against the threat of uniformity as a result of standardization but recognized at the same time that the machine represented a tool for man to open up new social and artistic perspectives. Under the protection of the grand duke of Saxe-Weimar he established and

18. Victor Horta. Residential building, rue de Turin (Hôtel Tassel), Brussels, 1892–93.

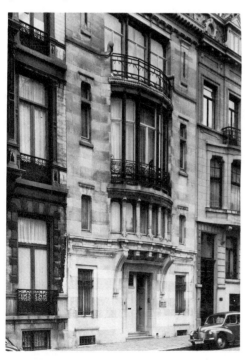

built, in 1906, the School of Applied Arts in Weimar, a simple and almost reticent edifice with a mansard roof, in which large glass windows in industrially produced steel frames took the place of curved units. Van de Velde's teaching was based on the encouragement of spontaneous inventiveness and design without regression to patterns from the past. The result of his teaching was soon adopted by German industry: this was the beginning of industrial design and the school, which was to be taken over by Walter Gropius in 1919, would become the Bauhaus.

Due to the untiring efforts of van de Velde, Art Nouveau spread rapidly throughout Europe and the United States. Among its main protagonists were Hector Guimard in France, August Endell in Germany, the Italians Ernesto Basile, Raimondo D'Aronco, and Giuseppe Sommaruga, and the American Louis Comfort Tiffany.

In Finland and the Scandinavian countries a modest version of the international Art Nouveau style developed parallel to a national Romantic movement, which uti-

21. Charles Rennie Mackintosh. Glasgow School of Art, Library Wing. 1907–09.

lized heavy outlines and expressively crude materials. Its main examples include the early work of Eero Saarinen and Lars Sonck.

In Great Britain the Scotsman Charles Rennie Mackintosh built, in 1898–99, the central part of the Glasgow School of Art. The rational approach to the sequence of studios, which were subdivided by movable partitions, anticipated the flexible arrangements of Ludwig Mies van der Rohe. The stringency of the ground plan was projected onto the exterior, which combined medieval motifs with large areas of glazing, and clear, angular shapes with gently moving curves. A library wing was added between 1907 and 1909, a highly original and imaginative structure dominated by rising lines given material form in delicately divided glass elements and areal masonry walls. The sparsely decorated interior of the reading room—an orthogonally assembled wooden structure with a surrounding gallery—anticipated, in its combination of geometri-

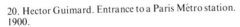

20. Hector Guimard. Entrance to a Paris Métro station. 1900.

cal elements, the decompositional method developed in 1917 by the De Stijl group.

In Austria Otto Wagner had become known for a number of Historicist buildings, most of which were built for his own speculative purposes. In 1894 he was appointed to the Vienna Academy. At the same time his understanding of architecture underwent a radical change, as was laid down in his book *Moderne Architektur*. "Nothing can be beautiful that is not useful" is one of its statements. The work is a plea for horizontal lines, flat roofs, and uncluttered surfaces, in short, for a purified style that derives its expressive impact from the functions, materials, and forms of construction of the new era.

Wagner adhered strictly to his own doctrine when he built the Post Office Savings Bank in Vienna between 1904 and 1906. The crystalline clarity of the trapezoidal plan, developing harmoniously around the central hall, conforms with the equally clear internal spaces. All units—the rectangular columns that taper toward the base, the vaulted glass and steel ceiling, and the delicate metal frames—are without decoration and have been reduced to their simplest form. The orthogonally subdivided facade is clad with marble sheets held in place by aluminium bolts. The entire design expresses elegant economy.

In 1897 two of Wagner's most talented pupils, Joseph Maria Olbrich and Josef Hoffmann, founded, together with the painter Gustav Klimt and other progressive artists, the Vienna Secession, which followed the example of the Art Nouveau movement in turning against previous hackneyed styles. In 1897–98 Olbrich built the Haus der Secession in Vienna with cubical walls and a perforated metal dome—a building of clear design and imaginative ornamentation. It attracted the attention of Grand Duke Ernst Ludwig of Hesse, who, in 1899, commissioned the thirty-two-year-old architect with the design of an artists' colony on Mathildenhöhe in Darmstadt. The result was a

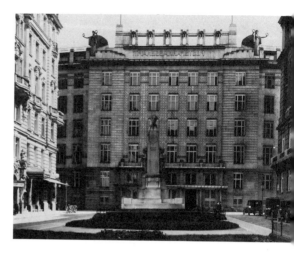

22. Otto Wagner. Post Office Savings Bank, Vienna. 1904–06.

23. Joseph Maria Olbrich. Hochzeitsturm, Darmstadt. 1907.

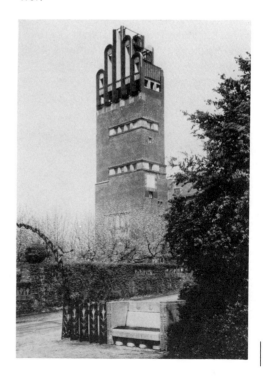

lively cultural center where seven artists, among them Peter Behrens, were able to build, furnish, and inhabit their houses with complete freedom and where, after completion of the buildings in 1901, the public had the opportunity of inspecting the complex over a period of six months.

Whereas Olbrich was a painter-architect who created a magical world of bright surfaces, gilt walls, and colorful mosaics, his contemporary Josef Hoffmann was largely influenced by Wagner's rationalist theories. In 1903 Hoffmann was involved in the establishment of the Wiener Werkstätten, a crafts center that was to exist for thirty years and enjoy a worldwide reputation. In 1903–04 he built the Purkersdorf Sanatorium near Vienna, which through its prismatic shapes and clarity of outline was to become one of the boldest avant-garde buildings of its time and a prelude to early Rationalism. Between 1905 and 1911 the Palais Stoclet was built in Brussels, a poetic masterpiece of unique sophistication.

In Holland, Hendrik Petrus Berlage demanded, in a reaction to the eclecticism of the late nineteenth century, simplicity, clarity, and the use of appropriate materials. His

25. Josef Hoffmann. Purkersdorf Sanatorium near Vienna. 1903–04.

24. Hendrik Petrus Berlage. Amsterdam Stock Exchange. 1889–1903.

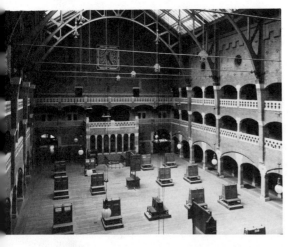

most important work is the Amsterdam Stock Exchange. Entering a competition in 1885, he had initially offered a conventional design in a Dutch version of the Neo-Renaissance style, but the building was not executed until after the complete revision of the original plans. Technically, the structure does not advance beyond Henri Labrouste's Bibliothèque Sainte-Geneviève of 1843, with a glazed iron skeleton as a roof, joined onto an outer skin of masonry. Nor are the design elements new; they were borrowed from engineering structures and Romanesque architecture. The innovation lay in the fact that walls, which throughout the nineteenth century had been disjointed, pieced together, or divided into a number of elements, became a unit of ascetic, unbroken integrity and that the building materials remained visible throughout. Inside, the pillars of the arcades, the granite abutments, the masonry of the walls, and the balustrades of the surrounding galleries are all in one plane; even the capitals do not project. The poetry of the flat plane was later to be adopted and developed, especially by rationalist architectural movements.

The greatest imaginable contrast to the serene, matter-of-fact work of Berlage is that of an outsider who became the center of Catalan Modernismo (an Expressionist and Neo-Gothic version of Art Nouveau in Spain): Antoni Gaudí y Cornet. The son of a coppersmith in Catalonia, he studied archi-

tecture in Barcelona. He regarded it as his task to resume the work of the great medieval builders where they had left off. To this end he studied natural forms and patterns, in which he saw the source of inspiration, not only for the decoration but also for the structure of his own markedly crafts-based buildings.

In 1883 Gaudí was commissioned to continue the construction of the Neo-Gothic church Sagrada Familia in Barcelona, an extensive project that would require all his strength and still remain incomplete. Between 1884 and 1891 he built the crypt; in 1891 he started work on the exterior of the transept. Three open portals were arranged between four slender, diagonally placed towers, each with a square base, that turned into a circular section and was crowned at a height of 351 feet (107 meters) by bizarre turrets with mosaic-covered surfaces. A wild variety of decorative plants and animals flood the portal area.

The organic shapes of Casa Battló (1905–07) and Casa Milà (1905–10) are no longer ornaments applied to a building but essential structural elements—bone-shaped columns, bent facades with anthropomorphic apertures, and wavy scalelike roofs with aggressive wrought-iron work. The rooms have undulating walls meeting at acute and obtuse angles; the furnishings, which were also designed by Gaudí, are a riot of fantastic sensual shapes. Despite their nonconformity, these luxury apartment buildings were accepted by the wealthy citizens of Barcelona.

### The Garden City Movement and City Planning in the Early Twentieth Century

Through the development of domestic architecture, especially that of country houses, the Arts and Crafts movement paved the way for new trends in city planning. In 1898 Sir Ebenezer Howard, an English stenographer who had been thinking about a quality of life better than that possible in overcrowded and dirty industrial towns, published

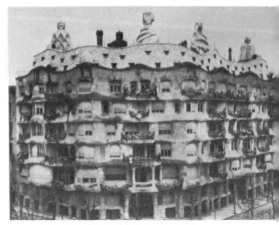

26. Antoni Gaudí. Casa Milà, Barcelona. 1905–10.

his book *Tomorrow: A Peaceful Path to Social Reform*, which appeared in its second edition under the title *Garden Cities of Tomorrow*. In it he described his vision of an ideal township, an independent garden city in the country, for about 32,000 people, consisting of rural housing estates, sufficient arable land (which would be arranged in the form of a green belt and thus obviate commuter traffic), shopping facilities, cultural institutions, and a Crystal Palace surrounding a central park as the communal and recreational center. This unit was to be linked with a large town, which, in turn,

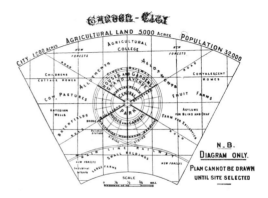

27. Ebenezer Howard. Garden City. Diagram. 1898.

28. Otto Wagner. District XXII, Vienna. Project. 1911.

would not be allowed to have a population of over 58,000. The garden city was not to be intersected by railway lines or arterial roads.

Howard's idea was not a lone vision. It proceeded on the one hand from the concepts of the utopian socialists, such as Owen and Fourier, and on the other from actual private experiments, such as Saltaire and Port Sunlight. Based on English pragmatic thinking, Howard's aim was to create new towns by combining the cooperative principle with private initiative and incorporating safeguards against speculation. The principles of his concentric plan—no more than a diagram—go back to the Renaissance. Suggestions for "rural towns" had been evolved

as early as 1827 by the English architect John Buonarotti Papworth. In 1899 the Viennese city planner Camillo Sitte published his book *Der Städte—Bau nach seinen künstlerischen Grundsätzen* in which he proposed the varied arrangement of streets and open spaces in medieval towns as an example for modern urban planning.

Howard actively promoted his plans, gathered assistants and disciples, and organized the financing of the projects. In 1899 the Garden City Association was founded, and in 1903 work started on the execution of plans by Barry Parker and Raymond Unwin for the first garden city, Letchworth near London. Following this pattern, Richard Riemerschmid designed the garden city of Hellerau near Dresden, in Germany, work

on which began in 1909. In 1919 Welwyn, again near London, was built according to plans by Louis de Soissons. Further towns followed throughout the world. Although the majority of garden cities grew into viable units, they nevertheless remained isolated and ineffective means of alleviating the results of the population explosion. Not until the 1950s did Great Britain's New Towns policy transform the garden city idea into a more realistic means of restricting the expansion of large conurbations.

At about the same time as garden cities were being propagated in England, efforts were made in Amsterdam in the Netherlands to resolve the problems of population growth (100 percent between 1875 and 1900 and 50 percent between 1900 and 1920) by more conventional means. In 1901 the Dutch Housing Act was published, an extensive and progressive piece of legislation, which required each town with a population of more than 10,000 to submit plans for its further expansion. It also facilitated compulsory purchase in order to give the town additional influence over building activities; it passed control over changes to a commission for aesthetic evaluation; and last it promoted the building of dwellings for the lower-middle classes and workers. Well-known architects were commissioned to carry out the planning work. Hendrik Petrus Berlage became responsible for the residential area Amsterdam South. The plans of 1915 provided for wide, uniform streets that were, in contrast to Haussmann's Paris boulevards, copiously planted with trees and flowers and thus became humane residential areas. Berlage's main concept for Amsterdam South was adopted after the First World War by the Amsterdam School, with Michael de Klerk and Piet Kramer; Cor van Eesteren's rationalist plan of 1928–35 would have been impossible without Berlage's initial work.

Otto Wagner, who believed in the large town as the appropriate form of settlement for the twentieth century, turned against the garden city ideology as well as against Sitte's romanticism and Berlage's sobriety. He advocated the reform of city planning, stating: "The expansion of cities can no longer—as in the past—be abandoned to blind chance, with artistic influences regarded as superfluous and the development of great towns left to detestable usury."[1] He demanded communal property for the expanded areas of the conurbations and flexible planning in line with the varying requirements of the population. In his plans for the development of Vienna's District XXII (1911), he outlined a Classicist monumental project that was to combine a variety of types in a large "town within a town" for a population of 150,000.

In 1904 the English theoretician Patrick Geddes published his *City Development*, which stressed the need for preliminary studies and for diagnosis before treatment, as well as the interaction between effective urban planning and sociological research. City planning on an interdisciplinary basis had thus come into being.

The Arts and Crafts movement, and in particular Art Nouveau and its related styles, were based on individualism; they dealt with individual objects rather than units within the wider concept of city planning. And although there were some towns—among them Kassel and Helsinki—where entire streets and quarters were built in the Art Nouveau style, the idea of overall planning, where architecture and city form an inseparable unit, was not to become a reality until Rationalism had made its impact on building.

# 1 | Early Rationalism

*Historical Development*

By the beginning of the twentieth century industrialization had spread throughout wide areas of Europe and the United States. The feverish growth that followed the Industrial Revolution had subsided and capitalism was firmly established as the economic system of the ruling bourgeoisie. As a result of increasing political and social pressure, industry began to take into greater consideration social, cultural, and artistic matters.

At about this time, reinforced concrete was introduced as a building material. A combination of concrete and thin iron rods had, in principle, been known since the latter half of the nineteenth century. As early as 1849 the French gardener Joseph Monier made reinforced concrete flower troughs. But like J. L. Lambot (who exhibited a reinforced concrete boat at the Paris International Exhibition of 1855) and François Coignet (who published a paper, *Les bétons agglomérés appliqués à l'art de construire*, in 1861, outlining the significance of the new building material), Monier failed to grasp the importance of steel-in-concrete for the building industry. Not until 1878, when Thaddeus Hyatt, a British lawyer who had established himself in the United States, submitted his patent was it stated: "For the production of plates, beams, or arches cement concrete is combined with iron rods in such a way that iron is used only on the tension-bearing side."[2] Hyatt had recognized the essential principles of reinforced concrete, which combines the compressive strength of concrete with the tensile strength of steel; in addition, the steel is enclosed and is thus protected against rust and fire.

In the spheres of culture and art, after a rapid ascent Art Nouveau had soon spent itself. It had become divorced from its ethical and psychological roots, and its idiom had degenerated into a fashionable, readily available, and superficial decor, which was copied and applied without regard to the principles of function and material. Young avant-garde movements therefore sprang up and strove to create a new approach. Of these, the most important was Cubism. It took as its starting point the new way of looking at objects that had been introduced by Paul Cézanne, who reduced his depiction of objects to basic geometric shapes. The Cubist movement had its origins in Paris between 1905 and 1910 and arose from a number of parallel developments, to which Georges Braque and Pablo Picasso made decisive contributions. Their experiments were inspired by numerous sources, among them African art, and were centered upon the depiction of the three dimensions without resorting to Renaissance illusions of perspective. The essential characteristics of the Cubist idiom were simple: the structuring of pictures by geometric shapes; the dimensional reproduction of objects in their spatial entirety by decomposing them into their planar components and arranging the latter either side by side or transparently penetrating one another; and a simulated simultaneity of perception from a number of angles, with none being the main view of the object; and, finally, the fusion of the object with its background. Despite its claim that it represented not only what it saw but also

what it knew to exist, Cubism never proceeded to a completely abstract form of representation, but retained some naturalist origins. This naturalist base was not discarded until the arrival of subsequent movements.

At about the same time as Cubism was introduced, Futurism made its appearance. In 1909 the Italian writer Filippo Tommaso Marinetti published his *Manifeste du futurisme* in the Paris *Figaro*, in which he announced "We state that the beauty of the world has been enriched by a new form of beauty, that of speed."[3] He had thus formulated the essence of the Futurist movement, which counted among its members not only writers but also painters and sculptors, such as Umberto Boccioni and Carlo Carrà, as well as musicians, theatrical designers, and architects, the most important of the latter being Antonio Sant'Elia. From this movement came, moreover, a polemical demand for a breach with the past, an emotional cult of the machine, activism, and an enthusiasm for competition. Futurism remained on the whole limited to Italy, and it soon lost impetus when it became linked with fascism. Its ideas, often propagated by spectacular means, nevertheless stimulated the artistic avant-garde on an international level.

A new idiom based on Cubism and Futurism was created in Russia during the last years of the First World War—Suprematism. It was initiated by the painter Kasimir Malevich, who argued that in art feeling should have supremacy over all forms of perception. In his pictures naturalist objects were completely eliminated; instead, he limited himself to a small number of highly symbolic abstract signs and the interrelations among them.

Constructivism, which came into being soon afterward, was derived from Suprematism and drew essential impulses from the Russian Revolution of October 1917. Its goals were outlined in 1920 by the sculptors Naum Gabo and Antoine Pevsner in their *Realist Manifesto* as an art for the new era,

one that would use new materials and be guided by the aesthetic of new technical structures. Under the pressure of political developments in the young Soviet Union, the movement split into two branches, one being more aesthetically oriented, and the other having a stronger political bias. In 1920 this split became official when the program of the "productivist" group was published; its members, among them Vladimir Evgrafovich Tatlin, glorified political commitment as well as technology. In 1922 a Constructivist International was set up in Berlin, which counted the Russian Eliezer (El) Markovich Lissitsky and the Dutchman Theo van Doesburg among its members. Its founding manifesto, published in the Dutch magazine *De Stijl*, set forth a mechanical aesthetic rather than nature as the model for architecture. Despite numerous international contacts, Constructivism was largely limited to the Soviet Union. Under Stalin it succumbed to Socialist Realism and the return of architecture to Classicist patterns. However, numerous ideas, which had been developed within the framework of Constructivism, found their way into the various tendencies within the avant-garde.

In Holland the movement of Neoplasticism was founded in 1917 simultaneously with the journal *De Stijl*. Its name, coined by the painter Piet Mondrian, pointed to its aim, which was to reduce a three-dimensional volume to a two-dimensional surface, the latter being the primary element of plasticity. Among initial members of this group were, in addition to Mondrian, the painters Vilmos Huszar, Bart van der Leck, Gino Severini and Theo van Doesburg (who was also active as an architect), the sculptor and painter Georges Vantongerloo, the poet Antony Kok, and the architects Robert van't Hoff, Jacobus Johannes Pieter Oud and Jan Wils; they were later joined by the architect Gerrit Thomas Rietveld. These artists were decisively influenced by the Cubist movement, but became subsequently much more radical; they advocated ethical principles,

such as truth, objectivity, order, clarity, and simplicity, and tried to come to terms with the social and economic conditions of their time. They aimed at abandoning individualism in favor of an objective and universal approach. The idiom of this movement, which was based on these theoretical prerequisites, is entirely divorced from naturalist patterns and extremely sparse: straight lines and flawless surfaces, which intersect and penetrate one another at right angles; the primary colors red, blue, and yellow contrasting with white, black, and gray; and the pure cube—not a static unit, however, but dynamically decomposed as part of an infinite environment.

Thanks to a marked emphasis on architecture, apparent from the outset, the De Stijl movement had a more immediate influence on building than Cubism, Futurism, Suprematism, or Constructivism. Its bearing on the development of a new idiom, which was seen as the result of a patient, conscientious, and methodical quest, made itself felt in nearly all cultural fields and went far beyond the frontiers of Holland.

*Theories and Forms of Building*

The theory that comes closest to explaining the geometrical and constructivist tendencies of the early twentieth century is the theory of perceptibility developed by the art critic and historian Konrad Fiedler in his essay "Über den Ursprung der künstlerischen Tätigkeit" (1887). On the basis of ideas formulated by the musicologist Eduard Hanslik, who opposed expression based on feeling and advocated pure form, Fiedler stood for the cognitive aspect of art. He opposed any form of imitation, either of nature or of feelings, but demanded instead a clarifying and ordering effect. Moreover, his theoretical works negated the aesthetic and hedonistic character of artistic expression. A number of previously essential requirements, such as beauty, symmetry, and ornament were thus obviated.

The architecture of early Rationalism became closely interrelated with reinforced concrete, the new building material of that time, in that the former, with its counter-compositional elements—interpenetrating spatial volumes, freestanding wall slabs, and bold linear projections—would not have been possible without the latter. Consequently, an architectural idiom was established, which in three respects followed the primary principle of economy.

—In view of the quantitative problem of housing and the political demand for a more just distribution of goods within a society, opulent forms of expression and ornament were regarded as wasteful. The result was simplicity, clarity, and frugality of form (economy for social reasons).
—The materials steel and reinforced concrete made it possible to reduce the size of load-bearing components to individual points or areas; the sole function of the remainder of the building was that of cladding. The "box" principle, which was necessary for static purposes when masonry was used, could now be abandoned in favor of a freer arrangement. The principle of shaping a room by omission enters architectural concepts (economy for construction reasons).
—The aesthetic exhaustion of the overpowering Art Nouveau decor with its glorification of subjective sensations led to a reaction of clear, ascetic forms, representing universal validity and objectivity. In his essay "Ornament und Verbrechen" (Ornament and Crime) Adolf Loos writes, ". . . See, the greatness of our age is precisely this: it is incapable of producing a new ornament. We have outgrown ornament; we have fought our way through to freedom from ornament. See, the time is nigh; fulfilment awaits us. Soon the streets of the city will glisten like white walls. Like Zion, the holy city, the capital of heaven. Then fulfilment will be ours."[4] Formal rigorism becomes an objective of art (economy for stylistic reasons).

*Architecture*

The credit for having used reinforced concrete for the first time on a major scale and as the sole building material in a multistory building must go to Ernest Leslie Ransome in the United States and to the French entrepreneur Francois Hennebique in Europe. The latter was the first, in 1892, to build a skeletal structure, which consisted entirely of concrete, from its foundations to the roof. In the course of his work Hennebique overcame the problem of the monolithic joint and introduced slab-and-beam floors, a form of construction that is now standard procedure in the use of reinforced concrete. The slab assumes, beyond its design-imposed function as a floor, some of the support function of a beam. In 1894 he built the first reinforced concrete bridge at Viggen, Switzerland, and in 1895 the first

29. François Hennebique. Villa Hennebique, Bourg-la-Reine. 1904.

concrete grain silo at Roubaix, in France. His own house at Bourg-la-Reine, outside of Paris (1904), exploited the possibilities of concrete architecture to its limits: an octagonal tower rests on two corbels that project by 13.1 feet (4 meters), while further projecting structures support a circular staircase leading to a roof garden. Hennebique tried to incorporate the entire range of construction and design possibilities of reinforced concrete in one building and showed magnificent technical virtuosity. In terms of architectural idiom, on the other hand, he retained his links with the nineteenth century.

While Hennebique was still experimenting with his structural innovations, Anatole de Baudot, a civil servant engaged in the preservation of historic monuments and a pupil of Henri Labrouste and Eugène-Emmanuel Viollet-le-Duc, began work on the first concrete church, Saint-Jean-de-Montmartre in Paris (1894–1902). All load-bearing elements, including the vault ribs, consist of exposed reinforced concrete. The boldness of this new building was, however, limited to the introduction of the "profane" new material into an ecclesiastical building; its style was an "enlightened" modification of Neo-Gothic.

Auguste Perret, the son of a builder and himself an architect and engineer, was the first to find new forms of architectural expression and a new form of design appropriate to reinforced concrete. In 1902–03 he built an apartment house in the rue Franklin in Paris. The sophisticated sobriety of this building, in which a system of horizontal and vertical elements exemplifies the essence of the skeletal form of construction, is as fascinating today as it was then. The slim concrete framework with infilled areas, glazed and decorated around the edges with floral-patterned faience, remains apparent despite the cladding. The facade is full of movement, with advancing and receding elements. Six stories high, it projects freely and then recedes by degrees to form a seemingly weightless superstructure. The ground

30. Auguste Perret. Apartment building, rue Franklin, Paris. 1902–03.

31. Auguste Perret. Church of Notre-Dame, Le Raincy near Paris. 1922–23.

floor appears to be entirely dissolved into glazed areas, while the flat roof is a preliminary form of roof garden. Inside, the reduction of load-bearing vertical units permits the ground plan to be varied and allows each floor to be arranged differently. Many features that were later taken up by Ludwig Mies van der Rohe and Le Corbusier (the latter was, for some time, Perret's student) are anticipated at this early stage.

In Perret's garage in the rue Ponthieu (1906–07), also in Paris, the concrete remained completely exposed and the skeletal structure became even more noticeable. Large sheets of glass were fitted into the spaces between the framework. Perret himself described this building as the "first attempt at creating aesthetic reinforced concrete." In 1922–23 the church of Notre-Dame, designed by Perret, was built at Le Raincy near Paris, a logically and sensitively designed ecclesiastical concrete building, in which the lunette of Gothic churches was revived in compliance with the new material, the new form of construction, and the new aesthetic expression. Nothing remains here of de Baudot's Historicist inhibitions. The barrel vaults of the roof are aligned lengthwise in the nave and crosswise in the side aisles, resting on slim cylindrical columns. The walls consist of prefabricated concrete screens, into which colored glass is set. The ornaments are sparse and determined by the structure; throughout, the concrete retains its shuttering marks. In his later work, Perret partly deviated from the ascetically clear style of his early years. In the Musée des Travaux Publics in Paris (1937–38), the postwar reconstruction work at Le Havre (after 1945), and the Atomic Research Center at Saclay (1947) he adopted the idiom of a traditional Neo-Classicism.

Perret's early experiments were continued by Frédéric-Henri Sauvage. After a brilliant debut in the Art Nouveau style, which he was to retain for many of his controversial works until the 1920s, he gained attention in 1909 with his design for simple set-back

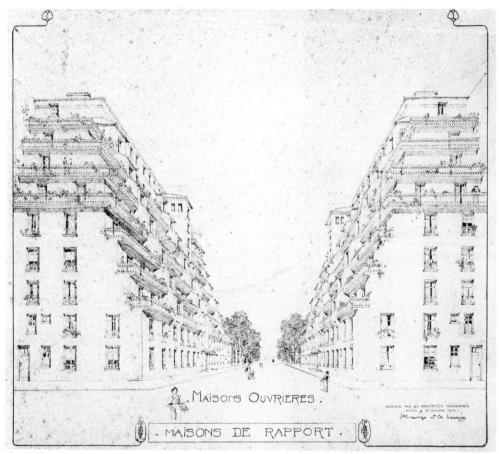

. MAISONS OUVRIÈRES .

. MAISONS DE RAPPORT .

32. Frédéric-Henri Sauvage. Workers' apartments, Paris. Project. 1909.

blocks of workers' flats. In 1912–13 he built, in cooperation with Charles Sarazin, the Maison à Gradins in the rue Vavin in Paris. The skeletal concrete structure with an off-white ceramic cladding, receding in steps from floor to floor, was inspired by Perret's apartment building in the rue Franklin and anticipates the futuristic terraced buildings of Antonio Sant'Elia's Città Nuova. Between 1922 and 1925 a cooperative apartment house for workers was built in the rue des Amiraux, Paris, which incorporated a glass-roofed swimming pool.

Simultaneously with the first buildings by Perret and Sauvage numerous industrial buildings throughout Europe and the United States were being built that were characterized by sobriety of design and structural clarity. Their load-bearing elements were undisguised, and their form was determined by construction method and material. Reinforced concrete became a much-used building material, and important builders began to explore its structural, design, and aesthetic possibilities.

In 1901 the engineer Robert Maillart built the first of some forty concrete bridges, at Zuoz, Engadine, in Switzerland. In it he revealed essential features of the inventive concept which was to characterize his bridge across the Rhine near Tavanara, Grau-

33. Robert Maillart. Bridge across the Rhine near Tavanara, Graubünden. 1905.

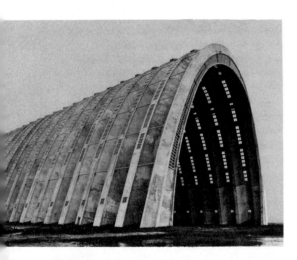

34. Eugène Freyssinet. Aircraft hangar at Orly. 1916–24.

In 1908 Maillart first experimented with reinforced flat slabs. In contrast to traditional methods involving wood and steel, columns, beams, and floors were no longer separate units; instead the column evolved organically from the girderless floor. This invention, a logical progression from Hennebique's floor slab, was first put to practical use by Maillart in 1910 for the warehouse of the Zürcher Lagerhaus-Gesellschaft at Zürich-Giesshübel. In 1939 he created, in cooperation with Hans Leuzinger, the bold freestanding barrel vault of the concrete hall built for the Schweizerische Landesausstellung in Zürich.

Together with that of Maillart, the work of the French engineer Eugène Freyssinet must be counted among the most elegant examples of buildings of the early period of reinforced concrete. His first bridges date from 1907, and they paved the way for a variety of structures that were to open new paths in the field of civil engineering. Between 1916 and 1924 Maillart built two boldly curved aircraft hangars at Orly, consisting of a series of parallel parabolic concrete ribs, which reached a height of 205 feet (62.5 meters). These hangars were destroyed in 1944. Throughout his active life Freyssinet strove for maximum standardization of structural elements and thus for greater economy. He was also responsible for the development of prestressed concrete beams, in which the reinforcing bars are subjected to tensile forces during fabrication, thus offsetting the compressive forces of the dead weight of the concrete and the load after installation.

The foregoing shows that, as in the early days of iron structures, industrially oriented engineers rather than artistically inclined architects broke new ground during the initial phase of reinforced concrete, both technically and aesthetically. Nevertheless, a large-scale attempt was made at the beginning of the twentieth century to bridge the gap between designing artists and executing industrialists and in 1907 the Deutscher

bünden, built in 1905. The old principle of separating load and support is abandoned; all parts of the bridge form an integral unit of construction and design, and the roadway is no longer a passive weight borne by the arches but an organic part of the structure as a whole. The aesthetic result is one of light and vivid elegance.

Werkbund was founded in Munich. Its history can be traced back to the reformative efforts of the Arts and Crafts movement. About the turn of the century the architect Hermann Muthesius spent a number of years in London, where he became familiar with the principles of William Morris and his followers. These he introduced into Germany after his return, and the subsequent discussion brought together a number of leading architects, artists, craftsmen, and industrialists. Among the founders of the Deutscher Werkbund were—along with Muthesius —Peter Behrens, Josef Hoffmann, Joseph Maria Olbrich, and Henry van de Velde.

The declared aim of the Deutscher Werkbund, which was not altogether free from nationalist ambitions, was the "ennobling of industrial work through the joint efforts of art, industry, and craft." The attitude of its members towards industrial production differed fundamentally from that expressed previously by Morris: they hailed industry as an effective means of producing large quantities of high-quality goods designed by artists. When, however, Muthesius advocated the principle of standardization some years later he was violently opposed by van de Velde, who considered industrial standardization and artistic creativity irreconcilable. This juxtaposition remained one of the almost constant subjects of dispute within the Werkbund.

The first architect to put the revolutionary principles of the Werkbund into practice was Peter Behrens. Initially a painter, after 1898 he became involved in designing industrial products. In 1899 Ernst Ludwig, grand duke of Hesse, invited Behrens to join the artists' colony at Darmstadt, where he built himself a house in 1901 influenced by the Art Nouveau style. In 1907 Behrens was appointed artistic adviser to the Allgemeine Elektricitäts-Gesellschaft (AEG). His new patron was of a different caliber than the grand duke of Hesse and, indeed, initiated the onset of a new development. Industry took the first step toward stylistic self-representation and toward providing capitalism with its own aesthetics-based ethos. Behrens was not only asked to design electrical appliances such as ventilators and lamps—in other words, to initiate industrial design—he was also concerned with packaging, catalogs, posters, and stationery. In due course he designed the AEG showrooms and workshops and became entirely responsible for the group's corporate image.

In 1908–09 Behrens built the AEG turbine factory in Berlin, one of the first Rationalist industrial buildings. The structure consists of a main hall and an asymmetrically attached and clearly distinguishable lateral extension. The main hall is built from thrice-articulated arches, tapering toward the base, the joints of which are clearly visible in the facade. Large, delicately subdivided glass windows, slightly inclined toward the interior, are fitted between the steel girders. Behrens did not, however, rely entirely upon the structure as the sole design element, but added his personal architectural idiom. By using monumental Classicist elements, he gave the factory the stamp of a dignified place of work. Although he rejected irrational elements, he aimed not only at demonstrating functionalism, but—in the sense

35. Peter Behrens. AEG Turbine factory, Berlin. 1908–09.

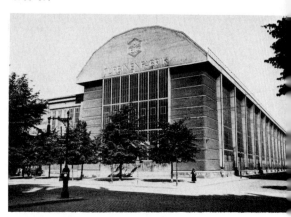

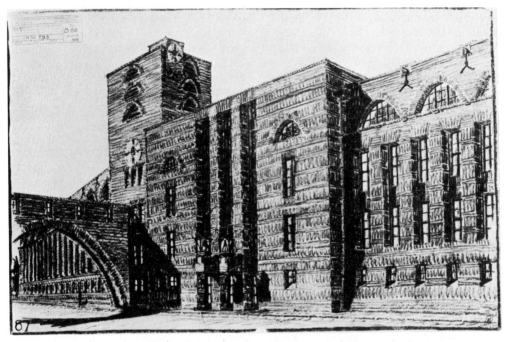

36. Peter Behrens. Administrative building of Farbwerke vormals Meister Lucius & Brüning (now Hoechst Aktiengesellschaft), Frankfurt-Höchst. 1920–25.

of Karl Friedrich Schinkel—its emphatically underlined "ideal."

Behrens built the AEG's high-voltage works in 1910 and the factory for small electric motors in 1910–11, both in Berlin. Monumental emphasis on function and bold rigorism became even more apparent in these examples of industrial architecture than in his earlier work. During this period Behrens was also responsible for Classicist-inspired representational buildings, among them the German Embassy in St. Petersburg (Leningrad), 1911–12, which highlighted the imperialist aspect of the Werkbund. Meanwhile, his firm became the most influential in Germany; between 1907 and 1911 his pupils included Walter Gropius, Ludwig Mies van der Rohe, and Le Corbusier. During the period from 1920 to 1925 Behrens built the

administrative building of Farbwerke vormals Meister Lucius & Brüning (today Hoechst Aktiengesellschaft) in Frankfurt-Höchst. His work, always inclined toward stylistic versatility, reflected with some reticence the Expressionist tendencies of that period, but returned to Rationalism at the beginning of the 1930s.

A much more radical fight for a rational approach to building was waged by Adolf Loos, the son of a stone mason from Moravia. After completing his studies he went to the United States for three years, where he saw the buildings of the Chicago School. His impressions, and in particular those of Louis Henry Sullivan's work, were to be influential in his work later. On his return Loos settled in Vienna, where he published, between 1897 and 1898, a series of polemical articles directed against the aesthetic sensibilities of the recently founded Vienna Secession. His theses, which have their roots in the ideal of the Enlightenment and which are based on Sullivan's arguments in favor of

functionalism and Otto Wagner's doctrine of purism, were summarized in 1908 in his article "Ornament und Verbrechen." It attempted to demonstrate that form is beautiful only if it reflects its function and if its components form a whole, and that ornamentation as advocated by Art Nouveau is neither relevant to, nor worthy of, a modern culture. For Loos, this postulate was not, however, synonymous with a sterile, unimaginative architecture. He developed his *Raumplan* (concept of space) as "free spatial expression, the planning of rooms on different levels, independent of an unbroken floor level, the arrangement of interrelated spaces to form a harmonious inseparable unit and a spatially economic entity. Depending on their importance and function, the rooms are not only of different size, but also of varying height."[5]

Loos's practical work was limited to a small number of purist buildings. After reconstructing the Villa Karma at Clarens, near Montreux (1904–06) and designing the sensitive linear interior of the Kärntner-Bar in Vienna (1907) with its cassette ceiling and its almost Mannerist mirror effects, he built, in 1910, Haus Steiner in Vienna, a creation that was to serve as a model of his style. Behind a symmetrical concrete facade with sharp incisions for the predominantly horizontal windows, he developed a ground plan with a novel sequence of rooms. In order to meet building regulations, which permitted only one story facing the street, the roof was brought down to the required level; the four stories of the garden facade, on the other hand, were crowned by a roof terrace. The stereometric structure was without ornaments or profiles. This renunciation of ornament emphasized the significance of proportions, and in particular the ratio of glazed aperture to solid wall.

In 1910 Loos also built the controversial commercial and residential building at Michaelerplatz in Vienna. Its facade of Tuscan columns anticipated his *Raumplan*, later boldly developed in his Haus Rufer in

Vienna (1922) and the house of the Dadaist Tristan Tzara in Paris (1926). The sensitive distribution of windows of varying size to suit the requirements of the rooms was a characteristic element of the severe beauty of these buildings, which juxtaposed precious materials and richness of interior with a seeming banality of exterior.

Loos's theories and practical work were

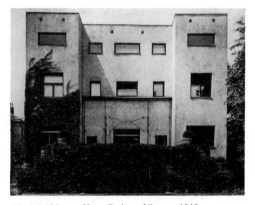

37. Adolf Loos. Haus Steiner, Vienna. 1910.

38. Adolf Loos. Haus Tristan Tzara, Paris. 1926.

to have a far-reaching influence. His merciless rejection of conventionality, his scrupulous search for order, and his almost nihilistic antistyle had a worldwide influence on the avant-garde of Rationalism.

Whereas Loos was fascinated by the realist and rational aspects of North American culture, the young Italian architect Antonio Sant'Elia was enthralled by its romantic aspects. In the culturally dormant pre-World War I Italy he felt the need for a rejuvenation of architecture along the lines taken by the planners of the large and expanding industrial cities of the United States. In 1913 he started work on his large project for the Città Nuova. It comprised perspective drawings and sketched visions of a metropolis of the future, with terraced skyscrapers, the internal structures of which were exposed, and elevator shafts separated from the main structural body; grandiose traffic routes with intersections at various levels; slim steel or concrete bridges connecting the various shafts, high-rise apartment buildings, and roadways; as well as bold, monumental, obliquely supported structures that gave no indication of their function.

Sant'Elia's masterly drawings, their details showing the influence of Otto Wagner and the Viennese School, were exhibited in 1914 together with similar pictures by the architect and painter Mario Chiattone. The catalog contained a passionate proclamation, signed by Sant'Elia, of a new and revolutionary form of architecture. Several months later, this text was edited by Filippo Tommaso Marinetti, the head of the Futurist movement, and published as the *Manifesto dell'Architettura Futurista*. In addition to a rejection of the standards of the past, it demanded a form of architecture that would utilize the new materials; that would be expressive and remain art; that would prefer inclined and elliptical lines, as they were capable of expressing emotion; that renounced ornament; that gained its inspiration from the world of the machine; that did not accept preconceived design maxims; that reconciled man and his environment; and that was light, dynamic, and transient, so that each generation could and would build its own city.

As a theoretical document, the manifesto was to involve Italy in the European architectural debate; beyond that, however, it remained no more than fervent words. Sant' Elia died in the war two years after the publication of his proclamation. Chiattone, who was later joined by the theatrical architect Virgilio Marchi, continued to draw views of houses and towns, but these lacked the force and magnificence of Sant'Elia's dreams. When, in about 1928, with the onset of fascism, Futurism became once again topical, sporadic attempts by a number of its adherents, among them Fortunato Depero and Enrico Prampolini, did not succeed in translating the original ideal into real architecture.

Another attempt to break with the past and progress to an entirely new form of architecture was made through Soviet Constructivism. In 1920 the painter, sculptor, and architect Vladimir Efgrafovich Tatlin, whose initial Constructivist work dates back to the years 1913–15, designed the Monument to the Third International in Moscow. He took the theoretical dictum to include movement in architecture (previously proclaimed by the Futurists) literally: in a huge 984.3-foot-high (300-meter-high) spiral steel structure three crystalline bodies were to turn on their axes at varying speeds. The lower one, a cube, housing the legislature and congresses, was to achieve one rotation each year; in the center a pyramid, containing the administrative and executive bodies, would rotate by 180 degrees each month, while the publicity and propaganda departments, housed in the topmost glass cylinder, were to complete one revolution each day. This project of Tatlin's proceeded no further than a three-dimensional model of iron and wire.

39. Adolf Loos. Kärntner Bar, Vienna. 1907.

40. Vladimir Efgrafovich Tatlin. Monument to the Third International, Moscow. Project. 1920.

41. Eliezer (El) Markovich Lissitsky and Mart Stam. Cloud Props. Project. 1924.

During the same year the workshop of Eliezer (El) Markovich Lissitsky completed a project for the Lenin Speaker's Platform, an expressive sloping steel structure, crowned by a billboard. In 1924 Lissitsky, who was in contact with the European avant-garde architects (including the De Stijl group and Ludwig Mies van der Rohe), designed, in cooperation with Mart Stam, Cloud Props, a cantilevered office building resting on tall massive piers. Neither project progressed beyond the drawing board stage. This applied to the majority of designs by the Soviet Constructivists, ranging from an expressively assembled radio station by Naum Gabo (1919–20) to a restaurant by Nikolai Ladovski, daringly suspended from a rock face (1922), and to the technically inspired Moscow branch of the Leningrad *Pravda*, designed in 1924 by the brothers Leonid Alexandrovich, Victor Alexandrovich, and Alexander Alexandrovich Vesnin.

Although little building took place immediately after the Revolution in the economically and politically shattered Soviet Union, a number of Constructivist projects were nevertheless realized. Konstantin Stepanovich Melnikov built the Soviet Pavilion for the Paris Exposition Internationale des Arts Décoratifs et Industriels Modernes of 1925, in which the design was based on the interpenetration of deformed geometric volumes and a marked emphasis on diagonals. In 1928 he built the Ruzakov Workers' Club in Moscow, with three lecture rooms on the fourth floor projecting obliquely from the main body of the building.

Meanwhile, a group of Dutch artists had formed the De Stijl movement. Their understanding of architecture was derived from that of Hendrik Petrus Berlage, but they had abandoned his sobriety while simultaneously fighting the romantic architecture of the Expressionist-influenced circle around Michael de Klerk. In addition to a reticence of idiom and a preference for smooth unbroken walls, the De Stijl group had inherited from Berlage the latter's inspiration by

42. Antonio Sant'Elia. Città Nuova. Project. 1913–14.

Frank Lloyd Wright. Moreover, Robert van't Hoff, one of the members of De Stijl, had himself been directly influenced by the American architectural pioneer, as is shown by his work at Huis ter Heide near Utrecht in 1914 and in 1916. This was characterized by a marked fragmentation of the main body of the building, a stress on horizontal lines, widely cantilevering flat roofs, and the rhythm of closely spaced windows.

A design by Jacobus Johannes Pieter Oud for a spirits factory at Purmerend, in the Netherlands (1919) represented a step towards the independent development of Neoplasticism in architecture. The cantilevering roofs, the marked cornices, and the horizontally arranged windows still testify to Wright's influence; but the projecting entrance is a clearly outlined monolithic block, and the middle wing reveals a complex interaction of orthogonal shapes and areas interpenetrating each other at right angles,

which—owing to the balance of horizontal and vertical lines—achieve the harmony that had been postulated by the painter Piet Mondrian. Within less than two years a breach occurred between Oud and the painter Theo van Doesburg, the spokesman of De Stijl, who wanted to see a stronger emphasis on the influence of abstract painting on ar-

43. Konstantin Stepanovich Melnikov. Ruzakov Workers' Club, Moscow. 1928.

44. Jacobus Johannes Pieter Oud. Spirits factory, Purmerend near Rotterdam. Project. 1919.

chitecture. Oud developed a more sober Rationalism, mainly in the context of city planning, but never denied his early experience in either the architectural design of his housing estates or in the row houses built in 1927 as part of the Weissenhofsiedlung in Stuttgart. Around 1935 Oud softened the severity of his style and tried a more relaxed approach—for example, in the Shell Building in The Hague (1938–42)—but later he reverted to his initial austerity.

Efforts to develop a uniform architectural idiom for the De Stijl movement were carried on by van Doesburg. In cooperation with the architect Cornelius (Cor) van Eesteren he developed, in 1923, pioneering studies for a residential building. "The house was taken apart," he writes, "and dissected into its three-dimensional components . . . the house became an object that could be circled from all sides . . . off the ground, and the ceiling became a roof terrace and, so to speak, an opened-up story."[6] About the same time and independently of van Doesburg, Le Corbusier had arrived at similar concepts. Van Doesburg was able to put his ideas of space and color into practice when he became involved in the rebuilding of the Café L'Aubette in Strasbourg (1928–29). Together with the sculptor Hans Arp and with Sophie Tauber Arp, he modulated abstract wall paintings which, in addition to horizon-

tal and vertical elements, included diagonal units.

It was left to Gerrit Thomas Rietveld to give further impetus to the De Stijl architectural idiom. In 1924 he built Haus Schröder at Utrecht (in collaboration with Truus Schröder-Schräder), an almost flawless adaptation to domestic architecture of the philosophy underlying the Neoplastic movement. On the basis of the same principle by which he had dismantled and reassembled an armchair in 1917, he broke down the body of a building into its spatial components and put it together in a different order. The ground plan of Haus Schröder is flexible; through movable walls individual

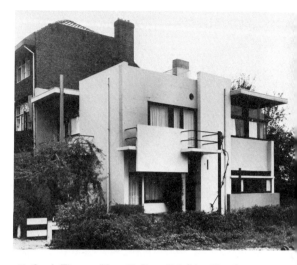

46. Gerrit Thomas Rietveld. Haus Schröder, Utrecht. 1924.

45. Theo van Doesburg and Cornelius (Cor) van Eesteren. Studies for residential building. 1923.

rooms can be transformed into a perpetual spatial continuum. On the exterior, the solid corners are "dissolved" and glazed over, and parts of the roof project seemingly without support. The center section of the frontage is "removed" from the facade and forms its vertical continuation in an upward direction. The balustrade of the balcony extends downward, below the floor, and creates an impression of being independent and weightless. Horizontal and vertical elements cross, intersect, and balance each other. A variety of level and upright planes, which are white or in the De Stijl colors and always meet at right angles, create, within a lively architectural stress field, a subtle Neoplastic harmony. The death of van Doesburg in 1931 meant the end of the De Stijl group, but its influence continued. The work of Willem Marinus Dudok utilized the sparse Neoplastic idiom but also incorporated Expressionist features. The Hilversum Town Hall, built in 1928–30 as a monumental assembly of cubic shapes, represents a synthesis between De Stijl and the romanticism of the Amsterdam School.

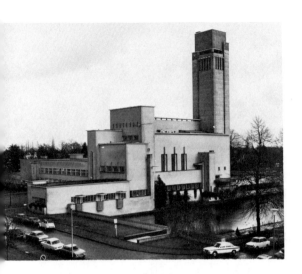

47. Willem Marinus Dudok. Hilversum Town Hall. 1928–30.

## City Planning

Between 1899 and 1904 the young French architect and socialist Tony Garnier designed his project for a Cité Industrielle. Proceeding with meticulous accuracy, he planned an industrial city, since he was convinced that it would eventually account for the majority of new twentieth-century towns. His chosen imaginary territory was partly flat and partly hilly, set at a river bend (based on reality, since his hometown of Lyons was thus situated). For a population of 35,000 (slightly more than that of Ebenezer Howard's garden city) he planned a housing estate, a city center, industrial buildings, a railway station, and all necessary public buildings, but no barracks, police stations, prisons, or churches, since these would no longer be required by the new society. Garnier decided that all the buildings should be made mainly from reinforced concrete, although at that time only a few experimental buildings had been constructed from it. At a time when the theory of city planning had not progressed beyond Camillo Sitte's medieval reminiscences, Ebenezer Howard's sociological idylls, Hendrik Petrus Berlage's initial and as yet uncertain designs, and Otto

Wagner's technical Classicist plans, Garnier created a revolutionary concept of a city that contained all the essential elements of rational urban planning. These included a clear distinction between the functions of dwelling, working, recreation, and traffic; differentiation between vehicular and pedestrian traffic, the former being divided into through and access traffic; a decentralized but nevertheless specifically aligned design of the town's network, which would guarantee orientation and permit further expansion; residential blocks measuring 98.4 by 492 feet (30 by 150 meters), without inner courts and with at least half of the overall surface being used as a continuous green area containing traffic-free and landscaped pedestrian walkways; a project for a community center that anticipated the social centers of modern estates (and was—not accidentally—inscribed with two quotations from Emile Zola's *Travail*); comprehensive sports installations with a stadium for 20,000 spectators; and a novel, minutely planned sewage system.

On the basis of this overall concept, Garnier worked out architectural, constructional, and technical details in depth and with great creativity. He developed forms that would best utilize the possibilities of reinforced concrete—bands of windows, glass walls, *pilotis*, cantilevering canopies, free ground plans, and flat roofs. He designed a functional railway station with an underground terminal for trains, clearly structured factories and workshops, single-story schools set on open land, hospitals consisting of a number of clearly recognizable pavilions, and small apartment buildings and loosely distributed houses of bold Cubist simplicity with well-thought-out ground plans. Every detail was meticulously described, down to technical innovations such as utility cores, electric heating, and thermal control.

Garnier's Cité Industrielle, the plans for which had been exhibited in 1904 and published in 1917, soon became known to pro-

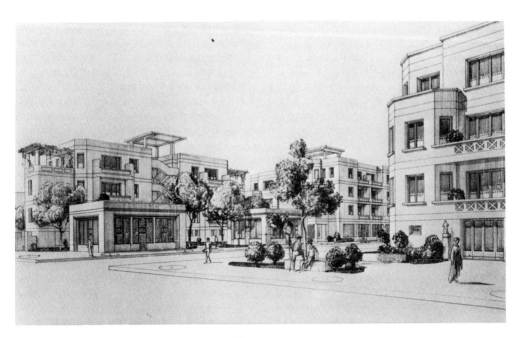

48. Tony Garnier. Cité Industrielle. Project. 1901–04.

gressive architects despite a general lack of public response. Not only its concept of city planning but its architectural notions as well influenced the entire Rationalist movement, in particular the development of Le Corbusier. After 1928 Garnier's principles of city planning were theoretically perfected by the Congrès International d'Architecture Moderne (CIAM), and decisively influenced the *Charte d'Athènes* (1933).

Almost immediately after completing his plans for the Cité Industrielle Garnier was given the opportunity of putting his ideas into practice. In 1905 he was appointed city architect of Lyons by the newly elected mayor, Edouard Herriot, and put in charge of the Grands Travaux de la Ville de Lyon. Between 1909 and 1913 he built the Abattoirs de la Mouche, a vast complex grouped around a central hall, which in its interior, with visible steel girders and a glass roof, is reminiscent of the Galerie des Machines of 1899; the chimneys are tapering simplified columns, representing the "new Classicism"

of the Kingdom of Labor. This was followed by the Olympic Stadium (1913–16), a remarkably exact realization of a project drawn up in 1901; the Granges Blanches Hospital (1915–30), with its twenty-two pavilions; and the residential area Les États-Unis (1924–35). For all these projects Garnier was able to draw straight from plans contained in his Cité Industrielle.

Despite the claim to have created a "new town," the Futurist movement paradoxically never achieved a total urban concept. Parts of urban developments were shown in beautifully illustrated drawings, but they contained no details of the overall organization. With the exception of a few indistinct sketches of Milan, Sant'Elia himself never drew a single plan.

In contrast, Constructivism developed within its several branches interesting if utopian concepts of urban planning. In 1927 Nikolai Ladovski drew up plans for the Kostino quarter of Moscow, showing an expansive and functional distribution of buildings

over the given area. In 1928 Trifon Nikolayevich Varentsov, inspired by earlier plans of Arturo Soria y Mata, designed a linear city with integrated macrostructures. These ideas were taken a step further when Nikolai Alexeyevich Milyutin presented a project for a linear quarter of Stalingrad (1930), in which a ribbon-shaped housing development with subsidiary units and a green belt, followed by a highway, a further green belt, a linear industrial estate complete with relevant technical colleges, and finally a railway line were all arranged in a compact form parallel to the course of the river. During the same year Ivan Ilyich Leonidov produced plans for a housing estate near the metallurgical complex Magnitogorsk, which is based on an orthogonal grid of roadways, with large square islands designated as green areas, sports facilities, apartment houses, and single high-rise buildings.

Along with urbanization tendencies to combine collective housing units into towns with up to 50,000 inhabitants, the USSR pursued plans for "disurbanization." These were aimed equally against overpopulated city centers and outlying "dormitory" towns and favored a decentralization and amelioration of large conurbations through the

49. Tony Garnier. Abattoirs de la Mouche, Lyons. 1909–13.

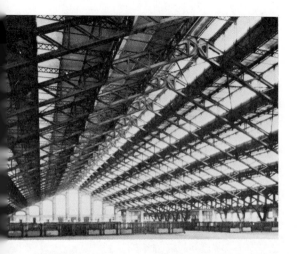

improved development of villages and the provision of better facilities. In certain extreme cases, the utilities of a town were distributed throughout the surrounding countryside. A plan produced in 1930 by Michael O. Barshch and Moissei Yakovlevich Ginsburg for a road flanked by infrastructural units connecting a residential and an industrial area illustrates this concept. In Germany, Peter Behrens and Heinrich de Fries published a pamphlet, *Vom sparsamen Bauen* (1918), in which they appealed for the architecture of small working-class dwellings to be severed from that of the middle classes. They called for rationalization of ground plans; industrialization of building processes; concentration of communal installations, such as day care centers, libraries, and collective kitchens; and the expression of this new type of building through its form. A year later de Fries suggested that conventional apartment buildings be replaced by linear houses, interspersed with open areas. "All tall structures that contain small apartments are arranged on a north–south axis, so that they have sunlight in the morning and again in the afternoon. Access of air and light are further safeguarded by the width of the landscaped parks (131 feet; 40 meters wide) and courtyards (65.6 feet; 20 meters wide), which ensure adequate distance between the buildings. Buildings closing off the blocks and separating them from the wider traffic routes are no higher than two or three stories."[7] De Fries had thus outlined *Zeilenbau*, which was to become of great importance to Rationalist housing units, since it permitted even and "just" access of fresh air and sunlight to all apartments, as well as rationalization of the building site to suit crane movements and permit the application of assembly-line working methods.

In Vienna, building undertaken when the Ring was designed had done little to alleviate the serious housing shortage. After the end of the First World War and the collapse of the Austro-Hungarian Empire, more

than 70 percent of the city's housing units had no more than one-and-a-half rooms; in the working-class districts of Brigittenau and Florisdorf 90 percent of the units had as little as one room. Sanitary conditions were indescribable. The Social Democratic municipal administration therefore called for new housing estates.

Adolf Loos, who had undertaken extensive studies of problems relating to working-class housing, cheap building methods, and allotments, became city architect in 1920. In the same year he designed the model estate Heuberg, near Vienna, with high-quality row houses, where he used his invention of the "house with one wall" (a form of construction, whereby the dividing wall between two houses was at the same time a load-bearing wall for both). The estate was completed only partially according to Loos's intentions. In 1923 he produced a project for six-story terraced blocks of workers' apartments. Two-story maisonettes were accessible through elevated roads, which were at the same time arcades, terraces, and communication areas. Some of these principles were later taken up by Le Corbusier for his Unités d'Habitation.

Despite their architecturally high standards, Loos's projects were incapable of resolving Vienna's housing problems. Low-density housing estates on the edge of the city, consisting mainly of single-family houses, were no answer to the city administrators' claim that they intended to promote the appropriation of the city by the working class. In 1923 a housing program for 5,000 units was passed, and this figure was subsequently raised to 30,000. At the same time, a purposefully devised taxation policy meant that most building activity was undertaken by the public sector. As a result, the Wiener Höfe were built, large architecturally uniform perimetric blocks of apartments, marked by high residential density, green areas in the center, and numerous subsidiary units. In view of the city's chronic unemployment, traditional technology was used

50. Heinrich de Fries. Residential quarter. Project. 1919.

for their construction. Of these buildings, the best known is the Karl-Marx-Hof, built in 1926–29 by Karl Ehn. In addition to 1,382 apartments it includes offices, shops, nursery facilities, communal laundries, a library, an ambulatory, and public gardens, all covering an area of more than .62 mile (1 kilometer) in length. Its architectural idiom combines economic rigorism with an Expressionist-inspired monumentality that dramatically glorifies the pathos of these "red fortresses."

Vienna was not the only city to suffer from a housing shortage after the First World War. On the contrary, nearly all large European cities were similarly affected. Among the most successful solutions were those produced in Rotterdam, Hook of Holland, and Amsterdam. In 1918 Jacobus Johannes Pieter Oud was appointed city architect of Rotterdam. During that year he designed a large group of houses for the Spangen Quarter, large isolated blocks re-

51. Karl Ehn. Karl-Marx-Hof, Vienna. 1926–29.

52. Jacobus Johannes Pieter Oud. Terraced houses, Hoek van Holland. 1924–27.

miniscent of Berlage's project for Amsterdam South. In 1922 he built the symmetrically arranged Mathenesse District, where the low houses still have sloping roofs.

The break with tradition in favor of a new form of city planning found its expression in the new complexes of row houses at Hook of Holland, which was realized by Oud between 1924 and 1927. The serially repeated ground plans, flat roofs, horizontal windows, and white facades indicate the progress of Rationalism. To these were added rounded corners, vivid, sparingly used De Stijl colors, and exemplary small gardens in front of and behind the houses. Oud made use of the experience gained here in the Kiefhoek Workers' Estate in Rotterdam (1925–30). Despite the small size of individual ground plans, the continuous uniform surfaces and the horizontal fenestration give an impression of uniformity. The severity of the geometric composition is alleviated by skillful scaling and careful attention to design details, while the shaping of corners provides a plastic counterbalance to the orthogonality of the blocks.

In Amsterdam the post of city architect was held between 1929 and 1960 by Cor van Eesteren. He was in charge of the overall management and coordination of the city's expansion program, which was based on the plans first drawn up by Berlage in 1917, but which in its realization went far beyond the original. In the plans of 1934 the large urban blocks with inner courts were abandoned in favor of open row housing involving small units. The individual urban districts were limited to 10,000 inhabitants. The architectural style was freed from Neo-Romantic remnants, and a simple purpose-oriented form was adopted.

Urban planning abandoned formalist concepts on the whole, and tried to meet the basic requirements of a city's inhabitants more adequately. The overall number of necessary dwellings, the different social classes that would inhabit them, and the type of dwelling required by each—these were considerations on which attention was now focused and that formed the subject of research. Teamwork and interdisciplinary cooperation were introduced to take account of the complexity of problems. The interaction of activities, without which no urban structure is viable, was not determined by fixed regulations but was allowed to develop within the framework of general guidelines. Thus, the ideas of Patrick Geddes became the foundation of Rationalist city planning.

# 2 | Expressionism

## Historical Development

The Expressionist period, which lasted from 1910 to about 1925, was marked in Europe by a series of far-reaching social changes. Many factors contributed to a process of social ferment: the transition from capitalism to imperialism, during which the large companies joined with the state to form a constellation of common economic interests; the First World War, during which the conflict of these interests was fought out, involving not only most of Europe, but also the nations of North and South America as well as parts of Africa and Asia; the political changes that took place during or immediately after the war and reached a climax during the Russian October Revolution of 1917; and finally the economic collapse of the postwar period, which became a decisive element in the radicalization of political goals.

These problems affected Germany with particular intensity. After its victory in the Franco-Prussian War of 1870–71, the newly formed empire enjoyed a period of rapid economic upsurge. By the turn of the century Germany was competing with Europe's most highly industrialized countries, Great Britain and Belgium, and immediately before the outbreak of the First World War the import and export rates of Germany's expanding economy had risen above those of Belgium, Great Britain, France, and even the United States. The war, which had been primarily instigated to strengthen German economic hegemony, caused a severe setback. Crushed economically, burdened with unlimited reparations, denuded of im-

portant raw material sources (as a result of the Treaty of Versailles Germany lost almost 75 percent of its iron and 26 percent of its coal deposits) and threatened by inflation, Germany's hopes of recovery faded away. The mood of disillusionment over the lost war and the economic difficulties, only ineffectually controlled by the government of the Weimar Republic founded after the enforced abdication of the kaiser in 1918, resulted in a time of violent unrest. Internal struggle, political assassinations, attempted coups, general strikes, and insurrection wracked the country until in 1923 inflation was brought under control after a disastrous climax, and in 1925, the year in which Paul von Hindenburg was elected president, the economy began to recover.

Expressionism was the result of a twofold reaction. One was psychological: frightened and repelled by times of upheaval, war and misery, artists withdrew into individualism and retreated to a personal world. The other reaction was a cultural one: after having abandoned the narrative element during Impressionism in order to reflect an atmosphere of sensual impression, art now tried to give an immediate expression to the artist's innermost feelings. A movement thus came into being that placed depiction of the objective world well behind that of the individual's subjective emotions. Its adherents *ante litteram* were the Dutchman Vincent van Gogh, the Belgian James Ensor, and the Norwegian Edvard Munch. Second generation Expressionists were the Spaniard Pablo Picasso (before he turned to Cubism), the Frenchman Georges Rouault (who reached

Expressionism through Fauvism), the Austrian Oskar Kokoschka, and the Russian Marc Chagall. The movement was international, but it reached its climax in Germany. In 1905 the painters Ernst Ludwig Kirchner, Erich Heckel, and Karl Schmidt-Rottluff formed the Expressionist group Die Brücke in Dresden. Without abandoning the depiction of objects, they created their own style, which did not shy away from brightness of color and distortion of shape. The movement was characterized by strong social engagement, and it openly advocated political revolt.

A different philosophy marked the second phase of German Expressionism, which started in Munich with the foundation of the artists' group Der Blaue Reiter. Their first exhibition was held in 1911. Among its members were Wassily Kandinsky, August Macke, and Paul Klee. Without developing a common style, as did Die Brücke, they strove for a rejuvenation of art by searching for pure rhythms and color combinations, which they interpreted as the expression of an inner spiritual state. The dialectics of subjectivity and objectivity thus attained allowed some of the group's members the transition to abstract art.

After the First World War, Germany's cultural scene was again sharply influenced by politics. Following the pattern of workers' and soldiers' councils, which regarded themselves as the controlling organs of the Weimar government after the collapse of the empire, the Arbeitsrat für Kunst was established in Berlin in 1918. Its members included Bruno Taut (chairman of the architectural committee), Walter Gropius, and Ludwig Mies van der Rohe, and overlapped with that of another Berlin association, established during the same year as the Novembergruppe, with Erich Mendelsohn as one of its members. The two organizations had set themselves similar goals, the first of which was the promotion of architecture as a means of improving society. The Arbeitsrat für Kunst, which arranged exhibitions and lectures and published numerous manifestos, pamphlets, and even two small books, was dissolved in 1921 as a result of internal differences. The Novembergruppe continued to propagate its ideas but it, too, had to abandon its activity during the bloody suppression of the Spartacist Revolt by the government.

At the same time as the Arbeitsrat für Kunst was established, an entirely different organization was founded, again by Bruno Taut, the Gläserne Kette, or the Glass Chain. Its lyrical name, the invention of the poet Alfred Brust, indicated the spiritual and mystical orientation of the group, which found its expression in a utopian correspondence, mainly under the cloak of pseudonyms. In addition to Taut and Brust, the group's members included twelve other artists and architects, among them Hermann Finsterlin, Paul Gösch, Walter Gropius, Wenzel August Hablik, Hans and Wassili Luckhardt, and Hans Scharoun. They were united by a desire to devise the great project that would bring together all the arts, and by a perpetual search for the origins of artistic activity, which they hoped to find in the will of the age, or even in some mysterious "primordial mass" (*Urmasse*).

The conflict apparent in the juxtaposition of socially engaged and mythically individualist tendencies is typical of Expressionism and is, as shown in the cases of Taut and Gropius, not infrequently found in one and the same person. This ideologically hybrid marriage between political progressiveness and elitist cultural engagement, between socialism and individualism, between revolution and mysticism, explains the surprising vitality and at the same time the short-livedness of the Expressionist movement.

*Theories and Forms of Building*

As was Expressionist poetry, architecture too was inspired by Friedrich Nietzsche's *Also sprach Zarathustra* (written between 1883 and 1885 and full of architectural metaphors). The negation of the bourgeois, of

history, and of the status quo; and the belief in the genius of the individual, the sanctity of sensual perception, the expectation of a new man, and finally the act of creation as sublime revelation were the themes which determined the philosophical foundation of the movement. At the same time, it embraced Henri Bergson, the French philosopher of élan vital, who regarded the artist as a medium capable of grasping and expressing the forces of life.

The theory of art most closely related to architectural Expressionism was that of the art historian Wilhelm Worringer, as stated in 1908 in *Abstraktion und Einfühlung* (Abstraction and Empathy). From Theodor Lipps, whose philosophy of aesthetics had influenced the Art Nouveau movement, he adopted the concept of empathy, and he linked human empathy with the organic world. He juxtaposed man's need for abstraction, with which he linked the inorganic world. He regarded the expressive synthesis of this antithetical model as the object of art.

Expressionist architecture drew its inspiration from a number of widely varying sources.

—As had happened in the Neo-Gothic stream of Historicism, the social component, the expression of a people jointly engaged in collective construction, was discovered in medieval cathedrals. The revolutionary social concepts adopted by Expressionism were discovered to have a historical origin. Moreover, medieval tradition was found to contain that romantic idolization of craft that appealed to postwar Expressionists in their hostility toward the machine and toward industry.

—Exotic architecture fascinated the Expressionists as it had previously influenced Art Nouveau. As a reaction to materialism and positivism, various mystical tendencies had arisen from around the end of the nineteenth century. Architectural patterns based on transcendental ideas found favor with the abstract form of religion of that time. The early phase of Expressionism enthused over the clear, massive shapes of early Egyptian architecture. Later interest turned to Asian buildings, especially to ancient Indian temples. However, no specific constructional elements were adopted; rather an overall formal exuberance prevailed.

—Art Nouveau was not so much a source of inspiration as it was an immediate precursor. Numerous representatives of architectural Expressionism, among them Bernhard Hoetger, who had worked as a sculptor on the Mathildenhöhe in Darmstadt, owe their origins to that movement, and some radical Art Nouveau architects, Antoni Gaudí, for example, could justifiably be described as Expressionists. The demarcation lines were fluid, and in many ways Expressionist architecture appeared to be an overemphasized continuation of Art Nouveau. Both movements stressed the three-dimensional sculptural aspects of buildings. In both glass and color played an important part, and both aimed at the *Gesamtkunstwerk*, the unified work of art.

As in Art Nouveau, two distinct formal branches can be found in Expressionist architecture. The first branch was characterized by rounded plastic elements derived from biological and anthropomorphic structures. Its adherents, headed by Hermann Finsterlin, regarded Euclidean geometry as an arbitrary and unacceptable limitation to artistic expression. They sought the freedom of expressive genial élan, of living fantasies of form, and of exuberant plastic shapes, freed from all regimentation. The second branch took its inspiration from the crystal, which was to be of special significance to the Expressionist movement. In semantic terms it represented both mystical cosmic closeness and geometric perfection. In structural terms its realization required the use of glass. Its purity,

53. Karl Junker. Haus Junker, Lemgo. 1891–92.

54. Hans Poelzig. Water tower, Posen. 1911.

clarity, and transparency, even its "purifying effect" and "redeeming strength," were incessantly praised. The fantasies of Wenzel August Hablik, the glass buildings of Bruno Taut, and the geometric structures of Paul Gösch turned it into architecture, where it determined shape through ordered stereometry, clear edges, and explosive rays.

*Architecture*

The beginnings of Expressionist architecture date from the turn of the century. The painter Karl Junker, who tried to create a new style and who can be regarded as a forerunner of Expressionism, built his house at Lemgo in 1891–92, a predominantly wooden structure with imaginative, opulent carvings and an equally eccentric interior. Hermann Obrist, whose artistic origins lay in the Art Nouveau movement, created about 1908 a plaster model of an extraordinarily pliable monumental structure on a rock. About 1909 Otto Kohtz drew sketches of fantastic, undefined architectural structures and in the same year, published his book *Gedanken über Architektur* in which he wrote: "It is perfectly possible that future generations will have mastered materials and techniques to such an extent that they can design a building or a landscape not to fulfill a specific function, but solely for contemplation, or out of creative joy to express a certain mood."[8] This, in other words, is building for the sake of expression only. Expressionist architecture in the strict sense did not appear, however, until the second decade of the twentieth century. In 1911 Hans Poelzig built a water tower in Posen (Poznan, Poland), which was initially used as an exhibition center by the mining industry of Upper Silesia. The closed, symmetrical sixteen-sided building consisted of an unclad steel skeleton, with glass and masonry as infill for the load-bearing structure. The clearly outlined expressive form introduced the motif of the crystal into architecture. Inside, trussed steel columns and diagonal members created vistas reminiscent of a

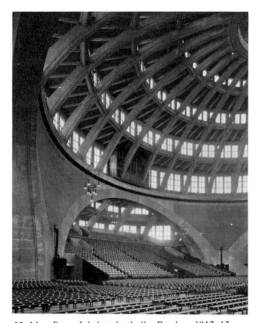

55. Max Berg. Jahrhunderthalle, Breslau. 1912–13.

56. Hans Poelzig. Grosses Schauspielhaus, Berlin. 1918–19.

labyrinth, while the centrally positioned spiral staircase with its solid stringers and its closed sides and banisters wound its way up to the gallery like a technically inspired romantic exhibit.

After the interruption of the First World War, Poelzig was able to exploit his expressive tendencies to the fullest with the design of the Grosses Schauspielhaus (Great Playhouse) in Berlin (1918–19). Commissioned by the theatrical manager and producer Max Reinhardt, Poelzig rebuilt, within a very short time, a former five-naved market hall, which already had been converted to a circus, into a fantastic visionary stalactite-clad spacious grotto. His 5,000-seat theater became the first representative building of the young Weimar Republic. Poelzig designed numerous other projects of magical originality, among them the Salzburg Festival Theater (1920–21), none of which was realized. In his later work he progressed to a more disciplined monumentality, of which

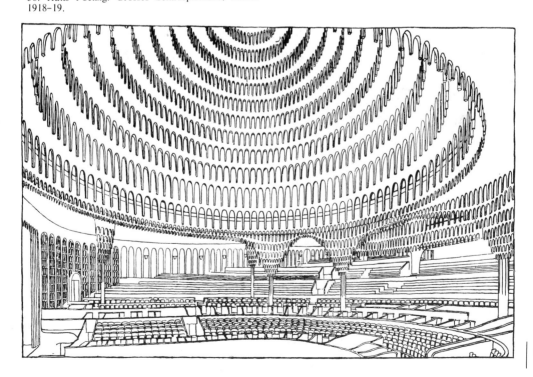

the administrative building for IG-Farbenindustrie AG in Frankfurt (1928–31) serves as an example.

One year after Poelzig's water tower was constructed, Max Berg built its counterpart from reinforced concrete, the Jahrhunderthalle in Breslau (Wroclaw, Poland) (1912–13). Its uncluttered construction, in which massive arches support a vast circular stepped cupola with a span of 219.8 feet (67 meters), is of impressive monumentality. As did Poelzig before him, Berg achieved expressiveness not by ornamentation but by overemphasis—in the spirit of the Gothic style—of the building's structural elements, thus endowing them with aesthetic and emotional qualities. The rough exposed concrete anticipates Le Corbusier's *béton brut*.

57. Bruno Taut. Glass house for the Werkbund Exhibition, Cologne. 1914.

In 1913 Bruno Taut built, in cooperation with Franz Hoffmann, the German Steel and Bridge Construction Industries Pavilion for the International Building Exhibition at Leipzig—a "monument of iron," composed of four octagons of decreasing size, one above the other, with the topmost consisting of an open steel frame enclosing a gilt zinc sphere. In the following year, Taut designed the Luxfer-Prismen-Syndikat Pavilion, the "glass house" for the Werkbund Exhibition in Cologne. Above a concrete plinth and a fourteen-sided drum-shaped lower floor he designed a pineapple-shaped dome, in which rhombically intersecting reinforced concrete ribs assumed the function of spatial bearing structures. The walls consisted of surfaces of thick glass, and the dome had two layers of glazing—an inner layer of colored prisms, and an outer layer of plate glass. The interior was divided into an upper domed hall and a room below, where water was channeled down a yellow glass cascade into a violet recess, into which pictures were projected by a kaleidoscope. The two spaces were connected by symmetrically arranged glazed stairs, and a circular aperture in the center of the dividing floor—also fitted with glass bricks—further helped to shape the structure into a unified visual entity.

Taut dedicated this impressive and imaginative building to the poet Paul Scheerbart, whose book *Glasarchitektur* had been published in the same year. The book lists, in 111 sections, poetic arguments in favor of the use of glass in building. Gothic cathedrals are regarded as forerunners of the new glass architecture. Visions of diamond castles, suspended restaurants, and crystal stars appear, and from the brightly transparent glass culture the enthusiastic poet expected nothing less than a new morality.

58. Bruno Taut. Alpine architecture. Project. 1919.

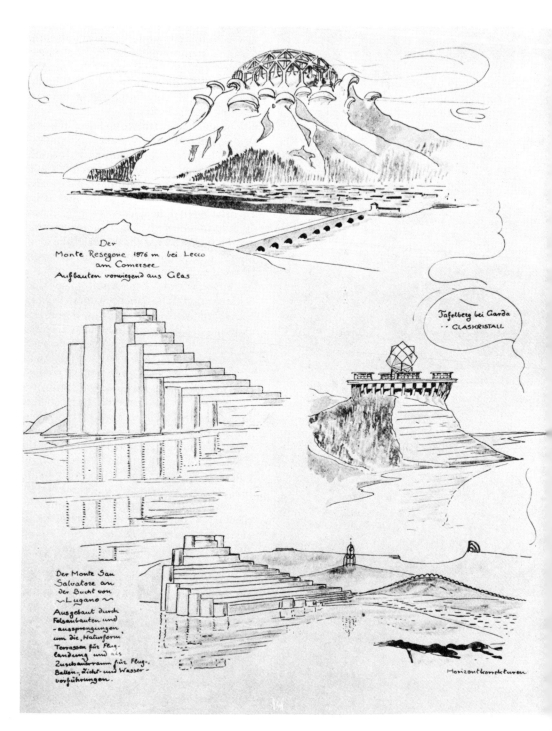

Der
Monte Resegone 1876 m bei Lecco
am Comersee
Aufbauten vorwiegend aus Glas

Tafelberg bei Garda
·· GLASKRISTALL

Der Monte San
Salvatore an
der Bucht von
~ Lugano ~
Ausgebaut durch
Felsenbauten und
-aussprengungen
um die "Naturform"
Terrassen für Flug-
landung und als
Zuschauerraum für Flug-,
Ballon-, Licht- und Wasser-
vorführungen.

Horizontkorrekturen

The degree of Taut's confidence in glass as a building material is revealed in his publications of the years 1919–20: *Alpine Architektur, Die Stadtkrone,* and *Die Auflösung der Städte oder die Erde eine gute Wohnung oder auch der Weg zur Alpinen Architektur,* all of which present highly radical utopian projects. Soon after the First World War, however, this emotional optimist joined the Rationalist movement. In 1927 he built a simple house in the Stuttgart Weissenhofsiedlung, and throughout the 1920s he designed several restrained and exemplary housing estates in Berlin.

Rudolf Steiner, the founder of the Anthroposophical Society, built between 1913 and 1920 the first Goetheanum at Dornach, in Switzerland. A charismatic and versatile man, Steiner was a philosopher, philologist, scientist, mathematician, writer, and artist. He believed that the spiritual element in man leads to the spiritual element of the universe and he thus stood at the center of the ideological and religious awakening that contributed to Expressionism.

The foundation of the Anthroposophical Society raised for Steiner the question of its architectural image. Preliminary studies and experiments, as well as mystically inspired calculations of proportions had previously been undertaken. Based on their results, as well as on Goethe's morphological studies, the first Goetheanum took the form of a two-domed wooden structure on a concrete foundation. The interpenetrating hemispheres of different sizes expressed, through their spatial polar tension, the duality of the physical and the spiritual. The seven pairs of columns of the larger domed hall symbolized the rhythm of human life, of cultural epochs, and of the souls of the various peoples on earth, while the twelve capitals of the smaller hall were to be understood as the signs of the planets. The entire building was modeled in soft plastic shapes; the wooden skeletal structure of the main floor was particularly richly sculpted. The building formed the spiritual, administrative, and formal center of the Anthroposophical set-

59. Bernhard Hoetger. House on the Weyerberg, near Worpswede. 1921.

60. Bernhard Hoetger. Haus Atlantis, Bremen. 1929–31.

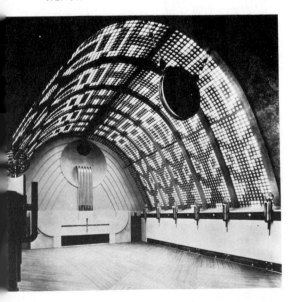

61. Rudolf Steiner. First Goetheanum, Dornach. 1913–20.

62. Rudolf Steiner. Second Goetheanum, Dornach. 1924–28.

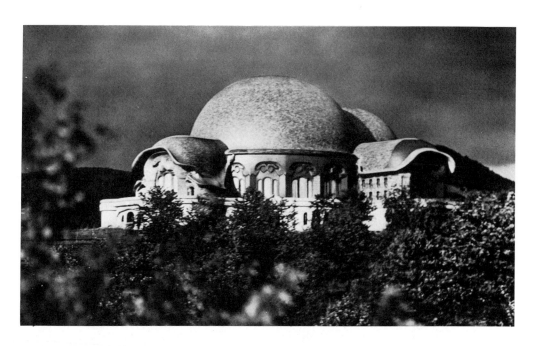

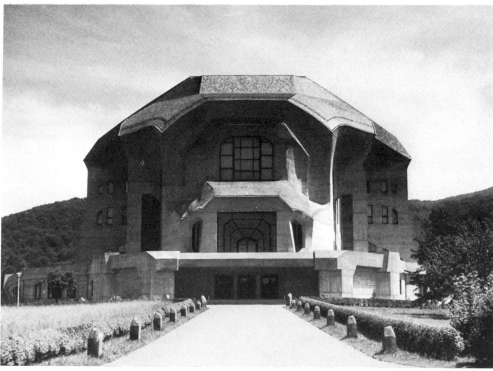

tlement at Dornach. Around its terraces, projecting from the slopes of the hill on three sides, a loose arrangement of subsidiary buildings was grouped. The plan for the layout took its inspiration both from the *Festspielhügel* and from the garden city. Functional buildings, such as the boiler house, and residential buildings, as for example Haus Duldeck, were all given the same dramatic scenographic treatment. The interplay of concave and convex surfaces, of fluid oscillations, and bizarre roof formations are reminiscent of Antoni Gaudí and express the anthroposophical aversion to right angles and the preference for rounded seams or joints at acute or obtuse angles.

The first Goetheanum was destroyed by fire on New Year's Eve, in 1922–23, and only the concrete terraces were spared. Work on its replacement, a building almost twice the former size, was carried out between 1924 and 1928. This time, as a safety precaution, the construction material was reinforced concrete. The massive structure contains a hall for 1,000 people, a stage with subsidiary rooms, lecture rooms, editorial offices, and a library. The outer shape gives no indication of the internal functional organization. The constructive system changes repeatedly inside the building, and the layout of some of the rooms is not really convenient. The building as a whole, however, gave material form to an idiom that must be regarded as one of the high points of Expressionism. The squat plastic mass expresses immense monumentality; the inclined curved areas give an effect of lively unity without being overemphasized; and the ridges and modulations of the unclad concrete surfaces create a multitude of ever new plays of light. Eclectic elements and the collage nature of the first Goetheanum no longer appear in its successor. The second structure presents itself as an independent and uniform entity, the creation of a homogeneous spiritual force.

A completely different and less intellectual route to an Expressionist design idiom was taken by the sculptor and dilettante architect Bernhard Hoetger. As early as 1915 he built his first house, Haus Brunnenhof, near Worpswede—a two-story brick structure flanked by twin towers. It was succeeded in 1921 by his second house, on the Weyerberg also near Worpswede, in which his bold talent for improvisation and his exuberant imagination were given free rein. The building was not so much planned on paper as shaped on site; moreover, the craftsmen were able to contribute to its execution. The result was a romantic, spontaneous piece of sculptural architecture, in which deliberately crude details, rich ornaments, and immense low roofs provided a feeling of shelter, but recalled at the same time witches' gingerbread houses, German lore, and eccentricity.

Between 1926 and 1931 Hoetger rebuilt Böttcherstrasse in Bremen for the coffee merchant, industrialist, and banker Ludwig Roselius. The street's many facilities, which range from a museum, movie theater, library and gymnasium to a health center, anticipate the pedestrian malls of the 1960s. In 1926–27 he added the Paula-Modersohn-Becker Haus, a fantastic structure that with its free ground plans and curved exterior continues the style of Catalan Modernismo associated with Gaudí. The range of psychological impact on the user is exploited to the fullest through the orchestration of plastic masses, diversity of materials, and a dynamic of expression that borders on the unreal. Parallels with contemporary film architecture, for example with Poelzig's violently distorted sets for Paul Wegener's *The Golem* (1920), are obvious. Haus Atlantis, on the other hand, built in 1929–31 also in the Böttcherstrasse, expresses a dialectical juxtaposition of fantastic and utilitarian elements. Hoetger, normally opposed to industry and the machine, for the first time used industrial steel as a building material; and the support structure, although copper-clad, is clearly distinguished from the infill. Nevertheless, he regarded this building once again as a totally plastic, organic unit, thus achieving

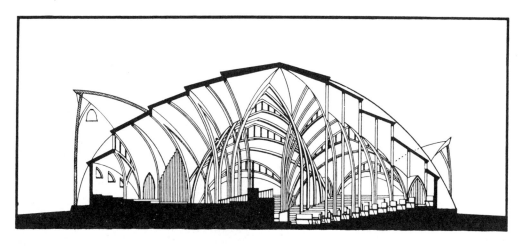

63. Otto Bartning. Sternkirche. Project. 1921–22 .

fascinating effects in some of its rooms. The glazed staircase continued the ideas of Taut's "glass house." That part of the facade which runs parallel to the street was dominated by a carved wooden tree of life. A "symbol of Nordic self-sacrifice of one man for his people," it was a dubious attempt at reviving a regressive myth.

A structure-based form of architectural Expressionism was advocated by Otto Bartning, who in his efforts "to represent the visible and spontaneous gesture of the community" specialized in Protestant churches. His design for the Sternkirche (Church of the Star) of 1921–22, which was never realized, is one of the most notable projects of twentieth-century ecclesiastical architecture. Timber beams in the shape of pointed arches follow, in a new interpretation of the Gothic spirit, the complex and graceful geometry of the lines of force and span an almost circular polygon. The segments between the load-bearing ribs consist of a lightweight wooden structure; alternatively they contain glazing or grilles. This interior, where pulpit and altar are grouped in one centrally placed unit, is divided into two functional areas: a "preaching church," centered on the pulpit; and a "worship church," centered on the altar. Bartning was

able to realize this liturgically new organization in the Auferstehungskirche (Church of the Resurrection) in Essen (1929–30); but this became a building of rationalist sobriety, and Bartning was unable to recapture the freshness of the Sternkirche project.

64. Johannes Friedrich (Fritz) Höger. Chilehaus, Hamburg. 1923–24.

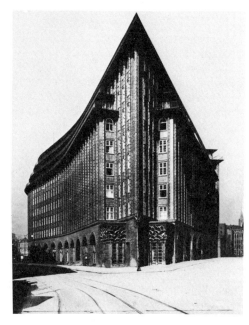

67

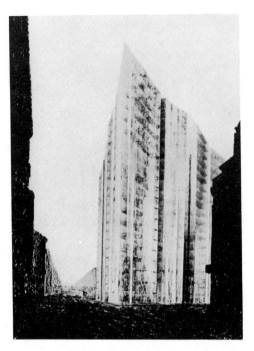

65. Ludwig Mies van der Rohe. Office building, Friedrichstrasse, Berlin. Project. 1919.

66. Ludwig Mies van der Rohe. Skyscraper above a freely curving asymmetrical plan. Project. 1920–21.

Meanwhile, numerous other projects and buildings were being created in the Expressionist idiom. The architect, painter, and author of fairy tales Paul Gösch, a member of the Glass Chain, designed in 1920 a crystal pilgrim's chapel based on the form of a triangle. In his monumental radio station at Kootwijk in Holland (1920–22) Julius Maria Luthmann utilized the plastic malleability of reinforced concrete to create an orthogonal sculpture inspired by Egyptian art. In conjunction with Rudolf Belling, Wassili Luckhardt built an advertising building on the Avus in Berlin (1922–23), a composition of pointed geometrical bodies. In 1923–24 Johannes Friedrich (Fritz) Höger built the Chilehaus in Hamburg, its corner an acute angle reminiscent of a ship's prow, with closely spaced masonry piers of brightly colored brick.

Even architects who were clearly committed to Rationalism were, at times, tempted to stray into Expressionism. In 1920–21 Walter Gropius designed the angular concrete Memorial for the Dead of the March Insurrection in Weimar. During the same period he built, in cooperation with Adolf Meyer, the extravagantly romanticized and consciously crafts-oriented log cabin for the manufacturer Adolf Sommerfeld at Berlin-Lichterfelde. Ludwig Mies van der Rohe, caught up in the enthusiasm for glass, designed an angular office building entirely of glass (1919) for a site in Berlin's Friedrichstrasse. This was followed in 1920–21 by a project for a skyscraper with a freely curving asymmetrical ground plan. Since Expressionist architecture tended to neglect the function of buildings in favor of the individual artist's self-expression, it was best able to

develop its characteristics when freed from the material pressure of executing buildings. It is no coincidence that nearly all architects with Expressionist leanings have produced many drawings, painting, and models. In fact, there are some who only drew, painted, and made models, but never actually built.

The most important of these is Hermann Finsterlin, who studied science and philosophy and who became convinced of the biogenetic urge of art. In his designs, most of which date from the period 1916–23, he modeled natural shapes into a new "artificial" nature. For architecture he sought the new and the unprecedented. Function and construction were of marginal importance to him. Deeming the social task of architecture to lie in its variety and beauty, he developed in his "imaginary architecture" a rich plastic idiom.

From the multifold panorama of architectural Expressionism there emerged, however, one school and one personality who succeeded in uniting the postulate of formal expression with the conditions of practical building—the Amsterdam School and Erich

68. Hermann Finsterlin. Imaginary architecture. c. 1916.

Mendelsohn. The Amsterdam School grew up around the journal *Wendingen*, first published in 1918. Its name, which may be translated as "turnings," indicated its objective of providing a pluralist forum for the new trends in architecture. But in the previous year the De Stijl group had been founded, and *Wendingen* pointedly dissociated itself from the group's rationalist tendencies. It preferred an architecture of exuberant plasticity and personalized it in line with the Expressionistic belief in individuality. The first sign of this appeared as early as 1911–16, when Johan Melchior van der Meij built Scheepvaarthuis in Amsterdam, an office building for a shipping company. The reinforced concrete load-bearing structure is based on an unusual, almost triangular plan with a diagonally arranged hall. The brick cladding, terra-cotta, and concrete facades are structured by wide piers that indicate the construction axes. The idiom demonstrates exuberant exotic inventiveness and uses stylized symbolic details to indicate shipping and the consequent discovery of remote parts of the world.

Meanwhile work had started on building Amsterdam South on the basis of plans

67. Walter Gropius. Memorial for the Dead of the March Insurrection, Weimar. 1920–21.

69. Johan Melchior van der Meij. Scheepvaarthuis, Amsterdam. 1911–16.

drawn up by Hendrik Petrus Berlage in 1915. The construction companies used standard ground plans but were obliged by the Commissie van Viere to employ architects to design the exteriors. The result was a largely superficial, cosmetic treatment of the facades. Nevertheless, within the framework of these limitations imaginative and varied solutions were produced, reminiscent of but at the same time beyond the formal tradition of Dutch apartment houses. The buildings, four to five stories high and made of bricks, show the "handwriting" of their respective designers in characteristic features: the monumental, richly modulated corner structures of Pieter Lodewijk Krämer; the gently undulating balconies of Margaret Kropholler; the angular projecting and receding oriels of Jan Boterenbrood; and the erupting orthogonal clefts and gateways of Jan Frederik Staal.

The leading personality of the Amsterdam School, however, was Michael de Klerk, an ingenuous artist-cum-architect who was more interested in form than in ground plans and technical detail. The Spaarndammerbuurt residential buildings,

built between 1913 and 1919 to the west of Amsterdam, are fascinating and at times eccentric theatrical creations but show little or no respect for constructional and functional requirements. Bricks are set vertically or in undulating courses; upper stories are, misleadingly, clad with roof tiles, while rows of windows are pushed together concertina-like (and subsequently most inconvenient to use). Nevertheless, the liveliness of the design elements is full of appeal. Later buildings at Amsterdam South show a marked restraining of de Klerk's boundless imagination and his return to the more uniform and severe design tradition of Berlage. In the Amstellaan residential estate, built in 1920–22, he nevertheless did not renounce the symbolism of semicylindrical oriels linking balconies, which dart along the walls of the buildings like lightning. In the Henriette Ronner-Plein houses (1920–21) the facades are divided into serene individual units, thus appearing to be single-family houses, while in reality they are apartment houses, each for six families.

Erich Mendelsohn, the most significant

70. Michael de Klerk. Residential buildings, Spaarndammerbuurt, Amsterdam. 1913–19.

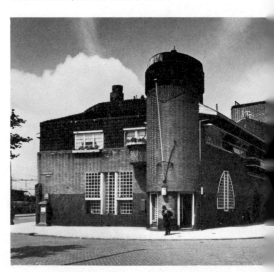

personality to emerge from an overall study of Expressionism, was linked during his student days in Munich with the members of the artists' group Der Blaue Reiter. During the First World War he produced his famous architectural sketches. In them are found dynamic streamlined plastic structures, some of which are orthogonal but which mainly take the form of forceful curves, with horizontal lines predominating. These sketches were redrawn in 1919, enlarged, and exhibited in Berlin, where they aroused keen interest. In his first major commission, the Einstein Tower at Potsdam (1917–21), Mendelsohn was able to realize, almost without concessions, the formal concept with which he had been preoccupied for a number of years. The tower, originally intended to be narrower, houses in its cupola the coelostat of the telescope, which transmits the cosmic rays via a system of mirrors and lenses to the laboratory located in the broad base. On the south side, between base and shaft, are a study and sleeping quarters, while steps, entrance, and a porch provide the transition to the tower on the north side. All these elements are combined in a structure of sculptural unity that penetrates every detail in a single upward surge—rounded corners, incisions in walls, angular window frames, and overemphasized gargoyles. The composition of concave and convex areas, in which apertures appear as if they were torn, produces a dramatic play of light and shade. The purpose of the building is reflected symbolically by its form, not as a scientific and technical structure but as a monumental symbol of abstract primeval force. Initially, reinforced concrete was to have been used in the construction of the Einstein Tower; the molded shape was to make full use of that then relatively new, building material. It is not without irony that a problem in the supply of cement made it necessary to build most of the tower out of brick and subsequently give it only a thin coating of concrete in order to maintain its rounded edges.

Between 1921 and 1923, in cooperation with Richard Neutra and Richard Henning, Mendelsohn renovated the Rudolf-Mosse Haus in Berlin. It featured horizontal bands of windows leading dynamically around the

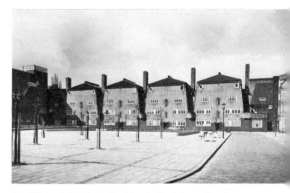

71. Michael de Klerk. Residential buildings, Henriette Ronner-Plein, Amsterdam. 1920–21.

72. Erich Mendelsohn. Einstein Tower, Potsdam. 1917–21.

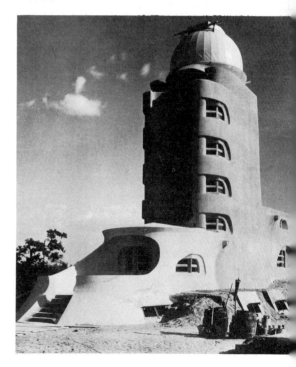

corner, contrasting starkly with the old vertically oriented sandstone facade. "Here the house is not a passive spectator of the fast-moving cars, of the ebb and flow of traffic, but an absorbing, participating element of mobility,"[9] commented the architect.

During the same years the Friedrich Steinberg, Herrmann & Co. Hat Factory by Mendelsohn was built at Luckenwalde; its main building is characterized by a pitched-roof dye shop, multiangled roofs, and inclined windows. The Schocken Department Store in Stuttgart (1926–28) by Mendelsohn reverted to the motif of horizontal fenestration, which was further underlined by continuous projections casting strong shadows. The optical effect of weightlessness, created by vertically alternating long windowsills and strips of masonry and travertine, was further emphasized by the shifting of load-bearing columns to behind the facade. The staircase was asymmetrically arranged at one corner of the building and formed, glazed and visible, the pivot of the entire organism. However, it was not cool and dematerialized like Walter Gropius's glass towers of the model factory shown at the Werkbund Exhibition of Cologne in 1914;

73. Erich Mendelsohn. Schocken Department Store. Stuttgart. 1926–28.

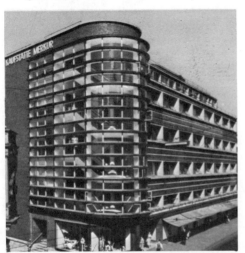

rather, because of the sharply projecting continuous ledges, it became concentrated matter ejecting its energy along the two axes of a crossroad.

In 1926–31 the Woga Complex in Berlin was created, with the curved interior of its Universum Cinema. Like most of Mendelsohn's early work, it is characterized by a continuous dramatic emphasis on horizontal lines as well as by formal and functional definition.

Racial persecution, which started with the National Socialist Party's rise to power, forced Mendelsohn to leave Germany in 1933. In Great Britain he entered into partnership with Serge Chermayeff and built the elegant De La Warr Pavilion at Bexhill-on-Sea (1934–36). In 1934 he went to Palestine, where he designed a notable number of rationalistically oriented buildings. In 1941 he finally settled in the United States, where the Maimonides Health Center in San Francisco (1946–50) is among his works. Its cantilevering balconies with their small semicircular rotundas are remotely reminiscent of the strong accents of Mendelsohn's early period.

*City Planning*

Like Art Nouveau, Expressionism did not produce any significant concepts in urban planning. Two reasons may account for this omission. The first is of a political and economic nature. Immediately after the First World War world economy, and in particular that of Germany, was in such a poor state that the large industrial city seemed to have little chance of further development. For a short while the return to the country appeared to be the only possible solution. Rural settlements and economically independent agricultural towns were once more regarded as appropriate and desirable. Demands for self-sufficiency were made repeatedly. The second reason is a cultural one and has deeper roots. The relationship between the intelligentsia and the city had already become disturbed during the middle

of the nineteenth century, when the metropolitan centers began to orient themselves to mass society and thus endangered the special position of the intellectual elite. The city, as the venue of capitalist organization and activity, no longer had room for the "uniqueness" of intellectual pursuit. It is no accident that the experience of "fear" as one of the existential urban conditions was a leitmotiv of Expressionist painters and poets. This fear also had its impact on architecture. Expressionism, moreover, was linked with the retreat into an extreme, artistically legitimized individualism. It was thus logical that architecture should concentrate on individual objects and neglect the combination of those objects into an urban unit.

The Hohenhagen Estate (Am Stirnband) at Hagen, designed in 1912 by Johannes Ludovicus Mathieu Lauweriks for Karl Ernst Osthaus, followed the garden city pattern without major innovations, with the exception of Lauweriks's remarkable geometric labyrinths. Rudolf Steiner's layout plan for Dornach (circa 1913) represents a loose and—because of the notable size of the plot and the low density of buildings—unproblematic concept for a housing development on a hill, which cannot, however, be strictly considered as city planning. Bernhard Hoetger's design for TET-Stadt near Hanover (1917), a project for the cookie manufacturer Hermann Bahlsen, is no more than a tyrannical conglomerate of monumental structures, megalomaniac alleys, heavy ramps, and Egyptian-style obelisks, all of which were related, with surprising tenacity, to the company's logo. This exotic project was never executed. The reconstruction of Böttgerstrasse cannot be regarded as city planning. The architects of the Amsterdam School based their work on Berlage's master plan and filled given areas with buildings. Within this framework they practiced individual architecture rather than collective city planning. Although Bruno Taut drew, during his Expressionist period, urban silhouettes determined by towers and skyscrapers, he spoke at the same time of the "dissolution of cities," and when he began to design and build housing estates he used the architectural and urbanistic idiom of Rationalism.

In other words, there was no Expressionist city planning. Not until the phase of political, economic, intellectual, and cultural sobriety had set in around 1924 did the architectural avant-garde free itself from the antitechnical bias left by the first fully technical war. Enmity toward large conurbations, the "demonic stone deserts," as they had been called by a pessimistic Oswald Spengler, abated. Modern estates now being built were no longer half-heartedly derived from the garden city concept. They offered more genuine urban accommodations, and even though they provided green areas and were open to sunshine and fresh air, they were an attempt to take into account new and wider social requirements. Architectural Rationalism had thus replaced Expressionism.

# ③ Organic Architecture

## Historical Development

The phenomenon of Organic architecture cannot be linked easily with social, techological, or cultural events, especially as this phenomenon covers an extensive period—from 1889, when Frank Lloyd Wright built his first house at Oak Park, Illinois, to the present day. Many social and political developments have taken place over this time. After the capitalist industrial expansion of the years 1873 to 1890, particularly intense in the United States, during which time the Chicago School flourished, the economic crisis of 1893 upset the balance between the social classes and changed the economic order. In Europe the Industrial Revolution, which had been characterized by a patriarchal order, was superseded by the expansion and solidification of far more anonymous economic constellations. In the United States, the first phase of economic development, still inspired by the pioneering spirit of the first settlers and their idealistic values, was followed by one in which the "gentry" was replaced by large combines, and the adventurous spirit of conquest by imperialist ideologies. The First World War; inflation; economic recovery; worldwide expansion of imperialism; the economic crisis of 1929; years of insecurity; and for the United States, the Roosevelt era and the New Deal occurred. The Second World War, years of reconstruction and recovery, various economic miracles, and finally the energy crisis followed. Amid the ferment and conflicts, which refuted the vision of a democratic state in which the individual would be able to freely express himself and become part of a harmonious whole, numerous progressive groups succumbed to this very self-delusion. Organic architecture joined in these dreams, providing not only the background to the illusion, but also a means for its realization.

Technology was not excluded from these feverish developments. Iron was accepted as a building material, and a few decades later reinforced concrete started a new revolution in construction. Experiments were conducted with plumbing and air-conditioning systems; and industrial fabrication and assembly from prefabricated units provided new opportunities and led to the mass production of buildings. Organic architecture took note of all these technological innovations but did so from a distance. Unlike early Rationalism Organic architecture never attempted to find new forms for the new materials and processes; instead, it used them to express its own, idealistically deduced notions.

Artistic and cultural events had a greater bearing on Organic architecture. The romantic, individualistic, and antihistoric Art Nouveau movement retained its influence; Expressionism, with its anticollective mystical element, provided not only formal inspiration but also enthusiasm for ritual order and the myth of the artist as superman. Rationalism, in all its phases, existed alongside Organic architecture. Exhibitions and opportunities for contact between the two movements provided for mutual influence.

The abstractly curved shapes of Fernand Léger, Joan Miró, Hans Arp, and Henry Moore, which gave new stimuli to the visual arts, also influenced architecture.

The great number of connections and conformities should not, however, give the impression that Organic architecture was anything but a highly individual phenomenon related to individual artists who largely ignored outside influence, stubbornly resisted categorization, and insistently aimed at the continuity of their individual styles. The fact that within this continuity a surprising variety of form was able to develop was due to the architects' explicit intention of allowing only one model—nature, which evolves a specific, appropriate, and therefore ever different form for each task. Such an attitude was possible only in the largely artificial retreat from the mainstream of political, technological, and cultural events. In this respect Organic architecture is the architectural expression of the withdrawal of the individual from social reality. Not nearly as radical as Expressionism, Organic architecture owes its endurance to the moderation and flexibility of its ideological position.

*Theories and Forms of Building*

There is no uniform theoretical basis applicable to the whole of Organic architecture. Neither can the extensive if somewhat diffuse utterances of Frank Lloyd Wright, the slightly more precise statements of Hugo Häring, nor the sporadic pronouncements of Hans Scharoun and Alvar Aalto be described as helpful. Nevertheless, the three following principles provide a simplified outline:

—Nature as model. In a romantically inspired escape from large cities and technological civilization, nature with its rules is declared to be the teacher.
—Individualism. In a philosophy that regards the Enlightenment with skepticism, intellectual autonomy and individual personality are furthered by psychological means.
—Nationalism. The ties with one's own country and its cultural and religious traditions are juxtaposed with the internationalism of the Rationalist movement.

From these principles three essential properties of the idiom of Organic architecture may be derived:

—The building as a natural element. This means that, unlike those of Le Corbusier, Organic buildings do not flutter weightlessly like arrogant butterflies above a meadow, but form a firm if modest integral part of the landscape, from which they appear to grow. This also means that not only a rational and neutral white, permitting no more than volumetric experiments, or solely primary colors, as dictated by De Stijl, can be used, but a whole range of warm chromatic shades that harmonize with the environment. Equally, it means fewer "artificial" materials, such as steel and glass, and more natural materials such as stone, wood, brick, masonry and—where necessary—concrete, with the building materials remaining visible where possible in order to stress their individuality. Finally, this means not an architectural idiom dogmatically dominated by orthogonal geometry, but a far wider, free vocabulary.
—The building as a personalized element. Each architectural task is unique in its program, in the economic conditions governing it, in the conditions of the individual location, and in the psychological requirements of its owner. These aspects must be taken into account in the building plan. The Rationalist hypothesis that the basic requirements of all men are equal is rejected. What is important is the emotional component, which differs from case to case. Standardization, suggested by industrialization, is equally rejected. What matters most are the humanitarian aspects in the use of machinery, with hu-

manitarian meaning both varied and individual. The enthusiasm of the Rationalists for technology is unshared by Organic architects. In one of his lectures, delivered at the Chicago Art Institute in 1931 and addressed "To the Young Man in Architecture," Wright said: "Oh yes, young man; consider well that a house is a machine in which to live, but by the same token a heart is a suction-pump. Sentient man begins where that concept of the heart ends. Consider well that a house is a machine in which to live but architecture begins where that concept of the house ends."[10] This attitude is borne out by an undogmatic variety of form as found in numerous archetypes of design; angles of 90°, 60°, 45°, and 30°, and sometimes of intermediate sizes; curved and flowing forms; and free proportions, unhampered by the golden section. The designs are based on a simplicity that renounces over-ornamentation without rejecting ornamentation out of hand. Form is not governed by intellectual abstraction but by attention to the well-being of the individual, which is understood as a totality and is artistically interpreted. The development of a building is never directed from the outside to the inside but always starts with the inner space. In this, Organic architecture conforms with the *Raumgestaltung* theory of spatial design, developed by August Schmarsow, who stressed, around 1900, the spatial dimension of architecture. Finally, the building is regarded as *Gesamtkunstwerk*, a total work of art, and is designed throughout, complete with furnishings.

—The building as a traditional element. A house must receive its character not only from its building plan, its environment, and the personality of the person for whom it is built but also from the country in which it is to be erected and the traditions in which it has its roots. This must be apparent in the choice of material, method of construction, and design idiom.

*Architecture*

Frank Lloyd Wright, an American of British descent, studied engineering for two years at the University of Wisconsin and worked for a short time in Chicago at the studio of Joseph Lyman Silsbee, who introduced him to the principles of the Shingle Style. In addition to this somewhat skimpy formal education, he gained impressions on his grandfather's farm near Spring Green, Wisconsin, which gave him his early love of the countryside.

In 1888 Wright joined the studio of Louis Henry Sullivan and Dankmar Adler, where he remained until 1893, closely involved in designing residential buildings. During this period he absorbed a number of the principles of his "dear Master," as he called Sullivan: the naive philosophy of the American founding fathers, the over-emphasized individualism of the writer Henry David Thoreau, and the naturism of Thomas Jefferson. Architectural models were provided by East Coast architects, such as Henry Hobson Richardson, Bruce Price, as well as Charles Follen McKim, William Rutherford Mead, and Stanford White. To these must be added three important influences: the attraction of combining and intersecting geometric shapes, which he had first found in his childhood toys designed by Froebel; the preference for simple ground plans and the perfection of craftsmanship inspired by the Shingle Style; and finally the charisma of the exotic world and the sublimated mathematics of traditional Japanese architecture, which Wright first saw at the Japanese Pavilion of the World's Columbian Exhibition at Chicago in 1893.

A personal result of Wright's love of nature was his rejection of large cities in favor of suburbs. In 1889 he set up his studio at Oak Park, an aristocratic green suburb of Chicago, where he found his clients in largely like-minded intellectual philanthropic and progressive circles. His first private commissions undertaken on their behalf glorified the freestanding single - family

house as the nucleus of a new democracy, a democracy of the "happy few," as individualistic as it was illusory. After a hesitant attempt to adopt the Beaux-Arts style (in the design for the Milwaukee Library, 1893), he finally and definitively, opted for an anticlassical and anti-European idiom to express the "organic" ideal as America's new contribution to culture.

In 1894 he designed Winslow House at River Forest, Illinois, in which typical features of Wright's style—a projecting roof, an emphasis on horizontal lines, and an asymmetric facade—are for the first time recognizable. Thus the young architect had built the first of the Prairie Houses, a new type of freestanding house in a natural setting, characterized by noble simplicity, rejection of representational and unused rooms, and a free ground plan—all features that were based on the tradition of the American farmhouse.

Willits House, at Highland Park, Illinois, a characteristic example of this type of Prairie House, was built in 1902. The cruciform ground plan is arranged around a central fireplace. Each room has its own individual character but merges freely with the next room, forming a lively continuum. The asymmetric wings reach out like arms into the surrounding park, the lawns of which extend to the outer walls, so that house and nature are connected according to a system of ideal preferential axes. This connection is further stressed by a prominently projecting shallow saddleback roof, by an emphasis on the horizontal elements of the facade, and by the use of natural materials that blend with the environment.

In 1904 Wright built Martin House, Buffalo, New York, and introduced a preliminary version of the horizontal band of windows in his residential buildings. In Tomek House in Riverside, Illinois (1907), this was used as a continuous formal element. In 1907–11 he built Coonley House, also at Riverside, a complex structure in which the ceiling follows the slight slope of the roof;

74. Frank Lloyd Wright. Willits House, Highland Park, Illinois. 1902.

75. Frank Lloyd Wright. Robie House, Chicago. 1908–09.

this slope is further emphasized by strips of dark wood that give the room a feeling of closeness.

The climax and end of the series of Wright's Prairie Houses was the Robie House, designed in 1907 and built in Chicago in 1908–09. No longer a house in a country setting, but a town house (even though it originally had a large garden), the grandiosely articulated ground plan follows the axis of the adjacent street, the aesthetic effect being primarily due to the interplay between the axially designed core with its two bay windows in front and the lateral

76. Frank Lloyd Wright. Larkin Building, Buffalo, New York. 1904–05.

In 1906–07 Wright built Unity Temple at Oak Park, Illinois; in this case he chose reinforced concrete as the building material, but decided on a heavy and monumental idiom reminiscent of the Egyptian style. The interior, with its unity of careful demarcation lines between the load-bearing elements, the glazed cassette ceiling, the slim wooden structures, and the suspended bell-shaped lamps, revealed Wright's intention to give symbolic and aesthetic expression to the integration of the individual into the community.

In 1909 Wright recognized the impossibility of realizing the dream of an individualist democracy in romanticizing the spiritual poverty of the suburbs. He left his wife and his six children and went on a trip through Europe. In 1910 an important and influential exhibition of his work took place in Berlin. On his return to the United States, he founded the Spring Green Community in Wisconsin in 1911 in order to "make a new start" and began building a house of his own. It was named Taliesin after a Welsh poet, the Druid bard "Shining Brow."

In 1913 Wright designed the Midway Gardens in Chicago, a statement of an almost Expressionist search for the emotive potential of form and material. The extravagantly equipped amusement center was demolished soon afterward. In the following year Mamah Cheney, Wright's new companion, died during a fire that destroyed Taliesin. Deeply shaken and isolated, Wright concentrated on rebuilding his house. Because of his ensuing financial difficulties he accepted the commission of the Imperial Hotel in Tokyo, which he built in 1916–22 together with Antonin Raymond and which became known for its technical refinements as well as its earthquake-proof structure. Wright's stay in Japan, which lasted, with interruptions, for six years, and his deep personal crises brought about a fundamental change in his architecture.

The change revealed itself as early as the Hollyhock House in Los Angeles, Califor-

wing which upsets the symmetry. This conscious imbalance is continued at various levels, for example in the roof of the top floor, which is arranged at right angles to that of the main floor. The result is a multifaceted building, nevertheless harmoniously contained by the boldly cantilevering roof and the predominance of horizontal lines.

During the period of the Prairie Houses Wright also designed the Larkin Building in Buffalo, New York (1904–05). Contact with the outside world, desirable only in the country, was relinquished in the city. The office building was arranged around a central space, which received its light through a glass roof and was surrounded by galleries. Outside, it presented nothing but a purist monumental facade in the shape of a prism, with one monolithic, projecting tower at each corner. The towers housed the staircases, and in their walls the ducts for circulating air were incorporated: the Larkin Building was the first air-conditioned office building. It was demolished in 1949.

nia (1917–20), which contradicted entirely the principles of the Prairie House. Its massive monolithic units with heavy flat roofs, the ornamentation of which is inspired by the Maya, are closely grouped around a central court. The complex gives the impression of a fortress, separating itself from its surroundings, and dominating its environment. Similar principles were used in 1921 for the Millard House at Pasadena, California. It is the most characteristic application of Wright's so-called textile block technique, based on the use of solid or perforated prefabricated concrete units that obviate any distinction in the treatment of interiors and exteriors and that provide an ornamental base on which vegetation can climb. Architecture is endowed with the symbolic aura of an archaeological find and becomes the artificial ruin of past cultures.

77. Frank Lloyd Wright. Millard House, Pasadena, California. 1921–23.

78. Frank Lloyd Wright. Kaufmann House (Falling Water) near Mill Run, Pennsylvania. 1935–39.

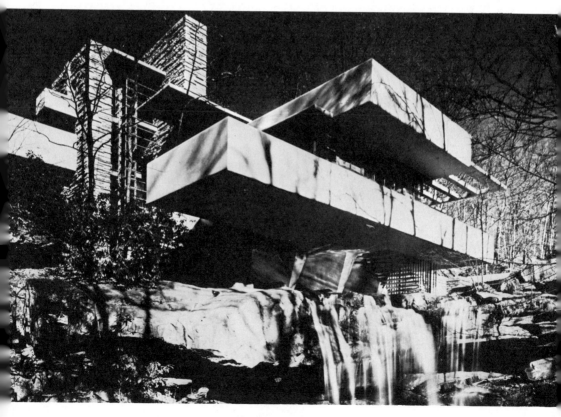

In 1925 and 1927 Taliesin was burned down a second and third time. Undeterred, Wright rebuilt the house and gathered a mystically inspired sect around him, whose members led a strictly ritual life focused around their master. In 1928 he built the Ocatillo Desert Camp near Chandler, Arizona, as a provisional settlement and base for further advances into the desert. The agglomerate of bizarre shapes surrounding a sacrificial altar around which the adepts would gather and await the words of the prophet seems to anticipate the American hippie communities of the 1960s.

Wright's masterpiece, a creative synthesis between Organic architecture on the one hand and Cubist and Rationalist elements on the other, is Kaufmann House (1935–39), also known as Falling Water, located near Mill Run, Pennsylvania. The luxurious building lies on and over a stream at the very spot where it forms a small waterfall. It is accessible by a bridge leading to a narrow path along the hillside. A concrete pergola mediates between the exterior and the interior.

As in the Prairie Houses, the focus of the whole organism is the fireplace. It lies in the center, on a rock, and consists, like all the other vertical supporting elements, of natural stone. Suspended from these vertical walls, horizontal slabs of smooth concrete orthogonally superimposed on one another at various levels jut out into the surrounding landscape and all but bridge the narrow valley. The cruciform ground plan has been extended three-dimensionally and is entirely free from any schematism; it develops into a lively and complex sequence of continuous spatial interpenetrations, which radically utilize, without concession to decor, the constructional possibilities of reinforced concrete. The juxtaposition of interior and surrounding landscape resolves itself, through subtle transitional elements, into a poetry that at no time succumbs to romanticism or an imitation of nature.

If Falling Water is Wright's ideal solution for life in the country, the administrative building for the chemical company S. C. Johnson & Son at Racine, Wisconsin, represents his notion of work in the city. Like his other urban buildings, it is self-centered, without any visual contact with the outside world, lit through roof lights and horizontal bands of glass tubing under the ceiling. The plastic shapes of the structural elements and superstructures, made from masonry, take up the idiom of the circle and underline the introspective character of the building. Free-standing mushroom-shaped reinforced concrete columns, tapering toward the hinged base and resolving themselves at the top into perfect circles, subdivide the office area. The top plates of the ceiling are interspersed with skylights through which diffused light can enter. Above the articulated complex rises a tower, built in 1944–50, housing the laboratories, where the square and circular elements of the floors alternate. The imagina-

79. Frank Lloyd Wright. Administrative building of S. C. Johnson & Son, Racine, Wisconsin. 1936–39.

tive wealth of shapes and the rarefied atmosphere transform this organism into a monument to appeased technology and successfully humanized work.

In 1938 Wright built Taliesin West, his winter residence in the desert of Paradise Valley, near Phoenix, Arizona. Local limestone and wood were used to create an artificial piece of nature, applying the oblique and angular shapes and geometric rules of composition that had previously been tried out in Ocatillo Desert Camp. The massive foundation walls, the visible timber structures, and the tentlike roofs link the house with the surrounding countryside, as they link interior and exterior. The entire complex remained a never-ending building site—architecture in a perpetual *status nascendi*.

Meanwhile, Wright had started his series of Usonian Houses, the first of these being Willey House at Minneapolis, Illinois (1934). These were small freestanding houses and, despite low building costs, surprisingly varied and imaginative in their design. Times had changed since the Prairie Houses, and although Wright continued to adhere to his two central principles of "an individual style

for each individual person" and "the appropriate idiom for each location," he abandoned the cruciform arrangement of rooms around a central fireplace in favor of a less formal and more economical ground plan. He replaced the traditional separate kitchens by working areas adjacent to the living rooms, lit mainly by skylights, and included all the rooms in the continuum of the house. The Usonian Houses developed from strictly orthogonal ground plans over a variety of geometric structures into a chaotic multitude of connected, interpenetrating, and fragmented shapes which Wright used as experiments for his design work.

80. Frank Lloyd Wright. Taliesin West, Paradise Valley near Phoenix, Arizona. Begun 1938.

81. Frank Lloyd Wright. Willey House, Minneapolis, Illinois. Preliminary project. 1932.

Among the beneficiaries of such experiments was the Solomon R. Guggenheim Museum in New York, designed between 1943 and 1946 and built during the period 1956–59. The white projecting helix of the main building and the equally round but lower subsidiary building are alien to the orthogonal structure of New York: the uniform plasticity stresses and mocks the mechanicalness of the metropolis. The public is taken to the top of the building in elevators and then invited to follow the downward-spiraling ramp past the paintings hung on the inside of the exterior wall. The white dematerialized ramp opens onto a large central area, lit through a glass dome. The offices are arranged in the smaller building, while the library is housed in the wing connecting the two buildings.

The continuity of design of the Guggenheim Museum was achieved at the expense of functional and constructional compromises. The suitability of the ramp for viewing paintings is open to argument, as they are looked at *en passant* and always from the same distance, while some of the constructional expedients are inelegant. Purpose and technology are casually placed at the service of a highly symbolic overall concept, and although the building represents without doubt a milestone in the development of Wright's artistic maturity, it obviously departs from the original ideal of Organic architecture.

Between 1953 and 1956 Wright built Price Tower at Bartlesville, Oklahoma. The 19-story building, comprising apartments and offices, relates to previous projects for high-rise buildings and attempts at the same time a new formal definition of the skyscraper. Free ground plans are suspended in stacks from a central core. The components of the facade were prefabricated, while the cladding of copper spandrels, decorated with reliefs, was chemically treated to give it the patina that normally occurs only after many years.

The Beth Sholom Temple at Elkins Park, Philadelphia, was built in 1958–59. Above a triangular ground plan, expanded to form a hexagon, rises a tall, sharply angular "tent" made from steel, glass, and plastic, which is reminiscent of Indian wigwams and reflects the color of the sky. Here relationship with the environment is established through reflection and transparency.

In his active life, which spanned a period of over seventy years, Frank Lloyd Wright created a still unsurpassed variety of architectural forms. His remarkable capability of self-renewal must not be mistaken for eclecticism. In the same way that the patient repetitions of a Mies van der Rohe embody the European myth of the Enlightenment, the untiring changing of Wright's forms expresses the myth of the American pioneer who must go on conquering new frontiers in order to find himself again under changed circumstances. Not without reason did the old master warn his pupils to avoid the American idea of the "quick turnover" as if it were poison.

Wright's architectural idiom was too marked by his specific individuality to create a school on a large scale. Nevertheless, he inspired a variety of different architectural movements, an influence made all the more effective by his support of his building projects with equally intensive publicity. He held innumerable lectures, explained emphatically his ideas on architecture in several books, and published a great part of his work. His nonconformism, his idiosyncrasies, and his eventful life surrounded him with a mythical aura. This aura was further strengthened by his followers, who helped to spread the idea of Organic architecture throughout the world.

One of the architects who felt indebted to Organic architecture but found his own

82. Frank Lloyd Wright. Solomon R. Guggenheim Museum, New York. 1943–46; 1956–59.

mode of expression, was Hugo Häring. During the late 1920s he was secretary of the progressive architects' association Der Ring. In a number of articles and lectures he supported the theory of "organic building." In contrast to the Rationalist movement, and in particular to Le Corbusier, who determined architectural form a priori on the basis of geometries recognized as being beautiful, Häring attempted to develop the building form from within, without doing it aesthetic violence. "We want to examine things and let them develop their own *gestalt*. It is against our conviction. . .to determine them from the outside, to impose on them any deduced rule."[11]

In 1923 Häring made a number of studies for Organic dwellings with irregular ground plans based on individual functions. In 1923–25 he built the farm complex Gut Garkau, near Lübeck, in which the form of the unexpectedly curved stable was again derived from its purpose. The seemingly free

83. Hugo Häring. Gut Garkau, near Lübeck. 1923–25.

GUT GARKAU

layout of the complex, which defies any geometric standards, is, in fact, determined by the sequence of necessary activities. In 1929 he built an apartment house on the Siemensstadt estate in Berlin. In this case only the kidney-shaped projecting balconies bear witness to his attempt to introduce an Organic element into the orthogonal order of municipal housing. Haus Ziegler, built in Berlin in 1935, shows a much freer layout, but also reveals an antigeometric attitude that gives the impression of a new formalism.

Hans Scharoun, too, tried to translate functional requirements into architectural form, and in doing this he consciously sacrificed good taste and aesthetic harmony to the characteristic features of the individual project. To him form was not a matter of prior choice or "applied" cosmetic elements; it had to be distilled from the "essence" of the project in hand. The fact that this "essence" could, in his opinion, only be recognized intuitively by the architect does not automatically place him in the irrationalist camp. Even though he avoided right angles, his architecture nevertheless withstands, on the whole, rationalist investigation.

During the early 1920s Scharoun produced a series of design studies, mainly watercolors and ink drawings. One branch of these morphological experiments follows the explosive metamorphosis of erupting clusters of crystals, while another, doubtless under the influence of Mendelsohn's sketches, is a variation on the subject of dynamic, autonomous curved forms. In his buildings Scharoun drew on both types.

In 1927 Scharoun built a wooden house for the Garden Show at Liegnitz, which exceeds in its internal flexibility the projects of the Rationalists. During the same year he designed a sophisticatedly expressive single-family house on the Weissenhofsiedlung in Stuttgart. In 1928–29 he devised, for the Werkbund Exhibition in Breslau, a house for single residents that is revolutionary not only in its plastic, sharply outlined form, but

84. Hans Scharoun. Ink drawing. 1920.

85. Hans Scharoun. Haus Schminke, Löbau. 1932.

86. Hans Scharoun and Wilhelm Frank. Residential high-rise buildings "Romeo and Juliet," Stuttgart. 1954–59.

also in the arrangement of corridors serving the two-story apartments. Between 1929 and 1930 he designed the layout for the Siemensstadt estate in Berlin, where he also constructed several apartment buildings.

Haus Schminke at Löbau dates from 1932. It is a skeletal structure, and the angular shapes with rounded corners give the impression of floating weightlessly over the countryside. The formal scheme is obtained by rotating a number of irregular planes, while the architectural idiom of streamline, porthole, bridge, and railing is derived from nautical sources.

After the end of the war Scharoun was in charge of the program for the reconstruction of Berlin as its city architect and thus became involved in a number of city planning projects. Between 1954 and 1959 the two high-rise apartment buildings "Romeo and Juliet"—informal municipal housing projects with roof terraces and studios—were built in Stuttgart in collaboration with Wilhelm Frank. In 1955–61 Scharoun realized in Berlin's Charlottenburg-North, an area geographically linked with Siemensstadt, several *Wohngehöfte*, homesteads that continue and further develop the tradition of the linear building.

87, 88 Hans Scharoun. Concert Hall for the Berlin Philharmonic Orchestra, Berlin. 1956–63.

In 1955–62 Scharoun built the Geschwister-Scholl-Gymnasium, a high school at Lünen, in the form of loosely arranged pavilions. The classrooms are seen as "apartments" in an attempt to bridge the modern division of education between school and home. Internal connecting corridors encouraging communication, irregular ground plans, and the Organic idiom, free from any

89. Hans Scharoun. Staatsbibliothek Preussischer Kulturbesitz, Berlin. 1964–67; 1969–78.

geometric order, are all seen as tools to further this object.

The concert hall for the Berlin Philharmonic Orchestra (the Philharmonie), built between 1956 and 1963, is the climax of Scharoun's work. The exterior is tent-shaped and has a makeshift air, a latent polemic on the pure stereometric prism of the neighboring National Gallery by Mies van der Rohe. But this only conceals a wealth of spatial adventures that includes a labyrinthine foyer, stairs branching off at all angles, a multitude of levels, and finally the vibrant cave of the huge, centrally situated auditorium. The multitude of stairs and galleries give the impression of a city within the city. The auditorium is divided into several irregular tiers of seats, which has the effect of reducing the overall scale without lessening the sense of space. The orchestra and the auditorium form one unit, and the elegantly shaped ceiling gives the hall, despite its vastness, a feeling of coziness and security. As in nearly all of Scharoun's works, the multiangular ground plan is full of visual surprises and does not shy away from creating problematic spaces. The personal, and thus personalized, juxtaposition of human function and artistic gesture has been resolved through a synthesis as individual as it is novel and convincing.

In 1964–67 Scharoun designed the Staatsbibliothek Preussischer Kulturbesitz in Berlin; construction started in 1969 but was not completed until 1978, six years after Scharoun's death. The complex structure fits into the stress field of its environment by reflecting in its form the influence of the neighborhood. Two flights of stairs lead from the main entrance to the reading rooms, which constitute a varied angular landscape on a multitude of levels, illumi-

90. Alvar Aalto. Municipal Library at Viipuri. 1927; 1930–35.

91. Alvar Aalto. Finnish Pavilion for the New York World's Fair. 1938–39.

nated from above through four glass pyramids and a ceiling dotted with spherical shapes suspended from above. All other rooms are arranged around this core. In all, the building represents the realization of Scharoun's statement of intent: "The humane approach . . . is still our aim today. It is our desire that there be no early coagulation of a vital movement, nor a premature perfection—not even in the technical field. Instead of perfection there should be improvisation, leaving the way open for development."[12]

Meanwhile, a younger architect had taken up Wright's inheritance in Finland: Alvar Aalto. Undogmatic and unburdened by intellectual "isms" and also—thanks to his geographical background—untrammeled by architectural ideologies, he imposed a rational discipline onto Organic architecture. His goal was to formulate an architecture based on a rational approach, one which complied with technical and functional requirements, but also one which met, at the same time, the psychological needs of the user by presenting itself as simple, attractive, and serene.

After a number of neo-Classical works Aalto built, in 1929, together with Erik Bryggman, the exhibition hall for the seventh centenary celebration of the town of Turku. Of exemplary logic, it marks the break of Finnish avant-garde architecture with historical reminiscences. The slightly curved wooden wall of the orchestra platform gives the first indication of Aalto's capability as a plastic designer.

In 1927 Aalto won the competition for the Municipal Library at Viipuri, which was built between 1930 and 1935 and introduced his first period of "white architecture." The building consists of two monolithic staggered two-story sections, the idiom of which is clearly inspired by Rationalism. The suspended ceiling of the lecture hall, on the other hand—natural pine planks joined to a freely undulating form—reveals Organic tendencies. The purely functional reasoning

92. Alvar Aalto. Sanatorium, Paimio. 1929–33.

is backed up by acoustic advantages, since the undulating shapes reflect sound well. All this, however, was motivated by the artistic wish to replace the crystalline shapes of Mies van der Rohe and of the early Le Corbusier by dynamic morphological elements.

Between 1929 and 1933 Aalto built the Sanatorium at Paimio, a building that is largely Rationalist, but reveals, in the free arrangement of its components, a new attitude. In fact, the deviations from the purist Bauhaus style are in no way arbitrary or formalistic, but determined, in the sense of psychological functionalism, by compassionate attention to the needs of the patients. Thus the slab housing the patients' wing is turned so that it makes optimum use of the sunlight. Instead of a collective solarium large sun terraces are provided, as well as a

number of smaller balconies, one above the other, for more intimate gatherings of small groups. The ceilings of the wards are darker than the walls because patients spend prolonged periods lying down and because the warmer shades have a soothing effect on them. Moreover, great attention was paid to every detail, including the furniture.

This did not, however, mean a renunciation of mass production, but an attempt to use it for the introduction of high-quality articles. Where Morris, van de Velde, and even Mies van der Rohe had failed, Aalto was successful; he provided means for the industrial production of crafts-based articles for everyday use at reasonable prices. Together with his first wife, Aino Marsio, he developed furniture from bent plywood for the Artek Company in 1932. The new objects were readily accepted.

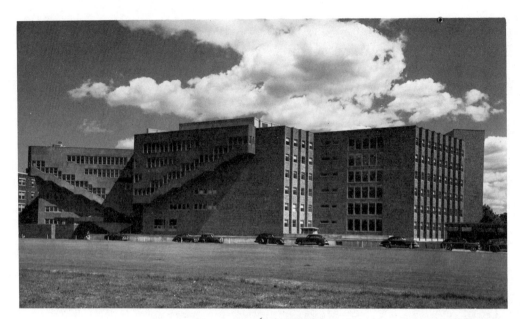

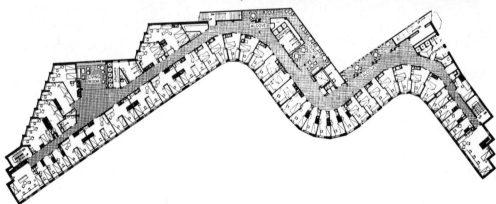

93, 94. Alvar Aalto. Baker House Dormitory, Massachusetts Institute of Technology, Cambridge, Massachusetts. 1947–48.

The Finnish Pavilion for the 1939 World's Fair in New York gave Aalto an opportunity to demonstrate unequivocally his architectural idiom. He divided a given oblong space diagonally by a tall, undulating inclined wall made from standard wooden units. This provided him with two dynamically characterized areas, one of which was intended as a bar, restaurant, and projection room, while the other was used as an exhibition area. The undulating and inclined surface facilitated the viewing of the pictures, improved the acoustics, and became, without entering into competition with the exhibits, a significant object itself, symbolizing the country, its products, its landscape, as well as its fresh, independent attitude toward the geometrical obsessions of the rest of European architecture.

Aalto's idiom became consolidated after the Second World War and reached a high

degree of individuality. During this middle—or, on account of the color of the bricks that he now preferred, "red"—period he built the Baker House Dormitory of the Massachusetts Institute of Technology at Cambridge, Massachusetts (1947–48), with its strongly curved masonry frontage. Once again the form fulfills practical functions too. The curved structure made it possible to orient a greater number of students' rooms so that they overlooked the river; by fitting the windows at an angle a better view over a larger section of the river was obtained; and finally, a greater variety of spatial forms was produced. The fact that behind all this psy-

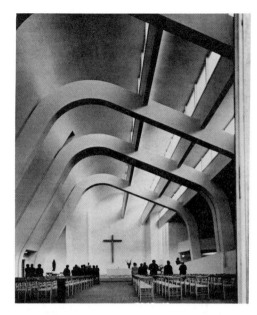

95. Alvar Aalto. Parish Church, Riola di Vergato near Bologna. 1966–78.

96. Alvar Aalto. Säynätsalo Town Hall. 1950–52.

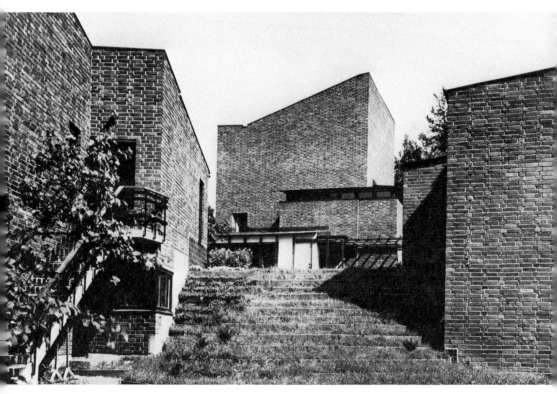

chological pragmatism lay the intention to achieve an expressive and organic idiom is shown by the back of the building, where the enclosed stairs lead upward as massive diagonal plastic shapes.

Between 1950 and 1952 Aalto built the Säynätsalo Town Hall. The low units with sloping roofs and red brick walls are grouped around an inner court, an antibureaucratic agora into which nature is brought by a plant-studded flight of stairs. The council chamber is spanned by a wooden ceiling that is unusual in its design and construction. The masonry is visible from the inside as well and the seams are painted white. The ceiling and masonry give the effect of establishing a link with the local rural building tradition.

The Kultuuritalo (House of Culture) in Helsinki, built between 1955 and 1958, juxtaposes the sensually curved auditorium with the prismatic shape of the offices. Between 1955 and 1964 Aalto built the Otaniemi Polytechnic, a large, varied and freely structured complex of brick-red buildings in a green clearing of the surrounding forest, dominated by the expressive amphitheater of the main lecture hall.

The church at Vuoksenniska near Imatra (1956–58) marked the beginning of Aalto's second "white" period, a form of expression to which he adhered, on the whole, throughout the remainder of his active life. The interior gives the impression of plasticity without relying on the effect of materials and, through its uniform whiteness, of metaphysical insubstantiality. It consists of three parts and can be subdivided by means of sliding walls. As in the wooden ceiling of the Viipuri library, the undulations are chosen for acoustic reasons: they reflect the voice of the minister and carry it to the hindmost pews. The large, irregularly cut orthogonal windows form a contrast with the soft, ephemeral curves of walls and ceiling.

In 1958–62, a 22-story high-rise apartment building was constructed in Bremen's satellite town Neue Vahr, with fan-shaped residential units and a communal living area on each floor. At the same time the Wolfsburg Cultural Center was built, which is grouped around an almost rectangular inner court. In 1967–71 the plans (dating from 1962) for the Finlandia Hall in Helsinki were realized. With its dramatic main hall, the long building is clad with white marble and black granite.

Aalto's last work was the parish center at Riola di Vergato near Bologna (1966–78). Its history is reminiscent of that of medieval cathedrals: it was commissioned in 1965 by a cardinal, and the population of the surrounding countryside donated money, land, and materials for its realization. The parish church, which is used for both religious and nonreligious functions, forms part of a complex for various communal activities situated by the side of the river. The conical nave is roofed by a copper-clad concrete shell, stepped on one side to admit light, which is then reflected by the opposite wall. Heavy arched beams stress the transverse structure. The tower consists of narrow slabs of concrete positioned on the exterior, which is paved with red ceramic tiles. The same tiling is used for the floor of the church. The views obtained from various parts of the church, the formal simplicity of the idiom, and the sensitive incorporation of the building into its environment make this work one in which industrial fabrication and perfect craftsmanship have been brought together in an outstanding synthesis.

It is no coincidence that Aalto's work is supported by only a few writings and verbal statements. The wealth of his solutions and his undogmatic fusion of rational and irrational elements elude theoretical rules. This wealth is never limited to the building itself; it penetrates every aspect, including furnishings as well as all other details, however seemingly insignificant, to produce an overall impression. By linking modern and traditional elements, Aalto's work provided a personal solution to the problems of his time.

*City Planning*

Like Organic architecture, Organic city planning took controversial routes. When, in 1909, Frank Lloyd Wright escaped from the elegant suburb of Oak Park, he had experienced both the misery of an overcrowded capitalist conurbation like Chicago ("where one sells everything, including oneself") and the isolation of the nature surrogates in the suburbs. His alternative was published in 1932 as the project for Broadacre City, which found its final form in 1958 in the Living City.

Ebenezer Howard's Garden City was linked with the utopian idea rooted both in the ideas of Jean-Jacques Rousseau and in early anarchism, and added an environmental dimension. Four square miles (about 1,035 hectares) were to be urbanized, with each family being allocated at least 40,764 square feet (4,000 square meters) of land. The estate, laid out in the form of a grid, was to include a variety of houses of varying sizes and for varying uses, depending on financial resources. Even skyscrapers were not excluded. Residential and agricultural areas were to be largely integrated, while the industrial areas were to be situated in outlying areas next to a railroad line.

The Living City was developed by Wright as a personal utopian project and was almost completely unconnected with the real problems of American city planning that existed during the Roosevelt era. It was the urbanistic expression of his personal philosophy and his longing for a liberal community, and at the same time a concrete manifestation of the pioneering myth of eternal movement and self-rejuvenation. The place of peace and social harmony coincides with that of greatest mobility. Each family owns, by necessity, two or more cars; the appropriation of the landscape is achieved horizontally; the car becomes a tool and symbol of individual freedom and determines the structure of the settlement. Bizarre flying saucers that almost appear to have been taken from a science fiction comic strip stress, in the drawings, the dominating element of movement.

Although Wright himself believed in the chimera of his horizontal, freely spreading "landscape city," he pursued at the same time the opposite concept, that of a concentration of dwellings at high-density points amid spacious virginal green areas. Through a number of projects, among them the apartment buildings for the National Insurance Company in Chicago (1924), he progressed in 1956 to the utopian skyscraper, the Illinois, for Chicago. Inspired by the first successes in the production of atomic energy, he designed a slim, one-mile-high skyscraper for 130,000 inhabitants. It was to be 528 stories high and accessible by 56 elevators propelled by atomic power as well as by a number of escalators. The top was hidden from view by the clouds. The unconvincing successor of Le Corbusier's Unité d'Habitation is complete with parking facilities for 15,000 cars and two landing pads for 100 helicopters.

Meanwhile, the United States found itself confronted with entirely different political, economic, and urban problems. As early as 1909 the Massachusetts Homestead Com-

97. Frank Lloyd Wright, Living City. Project. 1932–58.

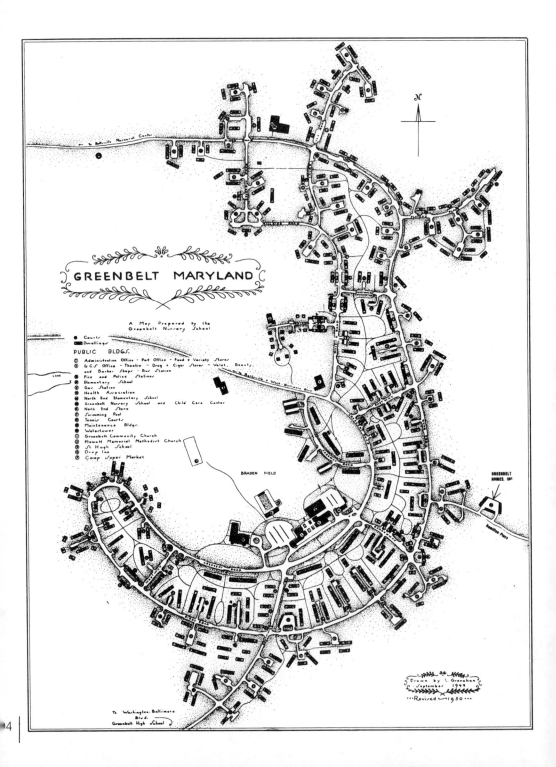

# GREENBELT MARYLAND

A Map Prepared by the
Greenbelt Nursery School

● Courts
▪ Dwellings

PUBLIC BLDGS.
① Administration Office - Post Office - Food + Variety Stores
② GCS Office - Theatre - Drug + Cigar Stores - Valet, Beauty, and Barber Shops - Bus Station
③ Fire and Police Stations
④ Elementary School
⑤ Gas Station
⑥ Health Association
⑦ North End Elementary School
⑧ Greenbelt Nursery School and Child Care Center
⑨ North End Store
⑩ Swimming Pool
⑪ Tennis Courts
⑫ Maintenance Bldgs.
⑬ Watertower
⑭ Greenbelt Community Church
⑮ Mowatt Memorial Methodist Church
⑯ St Hugh School
⑰ Drop Inn
⑱ Co-op Super Market

BRADEN FIELD

GREENBELT HOMES, INC

Drawn by L. Granahan
September 1949
···Revised 1950···

To Washington-Baltimore Blvd.
Greenbelt High School

pany (MHC) had been founded, a state-controlled organization designed to restore a suburban equilibrium to the overcrowded conurbations. Its antiurban recommendations were to pave the way for the New Deal realizations of the 1930s. After the United States had become involved in the First World War, "war villages" were built, state-controlled variations of the Garden City that used the motto "own your own home" to tie labor with little expense to a given location. It was no coincidence that private enterprise adopted this model after the war, improved it, and continued it as a new edition of the 19th-century company town.

Along with this movement, unfettered and chaotic speculation flourished in the euphoric economic climate of the 1920s. Among the forces attempting to put a stop to this disordered insanity was the Regional Planning Association of America (RPAA), founded in 1923, which counted Lewis Mumford among its members. Its urbanist philosophy was reflected in the town of Radburn, New York (1928–33), where Clarence Stein and Henry Wright linked individual neighborhood units and green areas by a subtly structured network of roads.

The economic crisis of 1929, which persisted for three years, interrupted plans for the continuation of these projects, while camps for refugees and the unemployed (the so-called Hoovervilles) mushroomed around the cities. Not until the announcement of Franklin D. Roosevelt's New Deal policy was an attempt made, through direct interference by the authorities in the processes of the free market, to instigate an industrial and agricultural upswing.

The first government programs show a distinct antiurban tendency. In 1933 the Tennessee Valley Authority (TVA) was established, which provided aid for this un-derdeveloped region through decentralized administration, rationalized production of energy, reorganized inland waterways, restructured agriculture, increased industrial production, and an expanded infrastructure. Its city planning efforts, on the other hand, did not advance beyond traditional rural formulas. A more advanced form of city planning was incarnated by a New Deal project for 25 Greenbelt towns, three of which were realized from 1935 onward: Greenbelt in Maryland, Greendale in Wisconsin, and Greenhill in Ohio. Intended to bring about a new territorial equilibrium they instead became dormitory towns for commuters employed in the nearest industrial centers. As an urban type they spread horizontally, following Wright's favorite principle, although in other respects they were nearer to Howard's more modest Garden City concept than to the ambitious Living City grid system. Their small building units and their green areas and winding roads are an example of cautious adaptation to topographical conditions.

While Wright's urbanistic ideas were, on the whole, utopian and far away from reality, Aalto proceeded along more pragmatic routes. In 1940 he designed an experimental city that juxtaposed round and elliptical projects with orthogonal grids, and which coordinated the simultaneous growth of house, estate, and production site. After the war, he concerned himself with the reconstruction of Finland and designed in 1944–45, together with other architects, a master plan for the capital of the Finnish part of Lappland, Rovaniemi. In 1966 he produced the project for a settlement near Pavia, which showed that his preference for curved, dynamic arrangements applied not only to individual buildings but equally to his city planning.

98. Greenbelt town, Maryland. Begun 1935.

# 4 | Rationalism

## Historical Development

Soon after the First World War a period of lively economic development occurred both in Europe and the United States. After some delay, which coincided in Germany with the inflation of the early Weimar Republic, the economic situation seemed to stabilize. The upturn, however, did not last. In 1929, Black Thursday, the day on which the New York Stock Exchange rates crashed, marked the beginning of a worldwide economic crisis.

Meanwhile the socialist movement, supported by the Russian October Revolution, had gathered strength and impetus in nearly all European countries. The economic boom, which started in 1926, went hand in hand with ruthless competition; the unemployment figures continued their upward trend from 1929 onward; and both stressed increasingly the dubious aspects of a capitalist and imperialist economy. The growing power of trade unions gave the proletariat new weapons for furthering its interests and intensified the class struggle.

One of the main points of contention was the so far unresolved housing question. In fact, this problem had barely been touched on by city planning measures undertaken since the population explosion of the nineteen century and the migration into cities as a result of the Industrial Revolution. In 1920 Great Britain had a housing shortage of about one million; the figure for Germany was similar, and that for France even higher, as numerous slums were slated for demoli-

tion. A similarly acute situation was to be found in the other European countries. In the Soviet Union action was initially limited to the distribution of available housing among the population; but with the first Five-Year Plan (1928–32) the entire country became one huge building site, with provisions made for 120 new towns. The problems of the United States did not differ fundamentally from those of Europe. Improvements in the economy resulted in the need for new buildings, and architecture was faced with an unprecedented challenge.

In view of the extent of this challenge and the urgent need to lower building costs, the possibilities of applying methods of mass production to the building industry were investigated. With the triumphal spread of its achievements, technology provided numerous examples for the "new house." In the automobile, for example, all components seemed to meet the practical requirements of both the user and of mass production. The building industry consequently began to investigate the possibilities of prefabrication, the assembly line, and mass production and carried out preliminary experiments to produce not only steel but also reinforced concrete parts of buildings with the machine. All this was to have repercussions in the cultural sector. One event, in particular, had far-reaching consequences: the establishment of the Bauhaus by Walter Gropius in 1919. The Bauhaus, initially planned for about 250 students, aimed at overcoming through a creative synthesis the long-

standing controversy between art, industry, and the crafts, which had been brought into the open especially by the Deutscher Werkbund a few years before. Its curriculum consisted of three parts:

—A preliminary course of three months, in which the students were introduced, by means of simple exercises, to the use of material, form, and color. Through this work they were intended to rid themselves of prejudice and rediscover fundamental laws of nature, observation, and perception.
—A three-year course, consisting of both theoretical and practical work, in one of the seven workshops: stone masonry, woodwork, metalwork, pottery, glass painting, mural painting, and weaving. The course was divided into practical and formal instruction (*Werklehre* and *Formlehre*). In the former, during which the entire production process was explained, the students were taught means of integrating products into processes of industrial production; the latter had the aim of teaching an idiom based on objective laws of form and color.
—A final course (*Baulehre*) of indeterminate duration, open only to the most gifted students in all disciplines and designed to give them an understanding of practical work through commissions received from outside the school. The school's main object was the unification of the visual arts, not by the romanticized handicraft methods of the Arts and Crafts movement or of Henry van de Velde and his Saxonian School for Arts and Crafts, but in cooperation with industry. The Bauhaus Manifesto of 1919 still stated emphatically: "Together let us desire, conceive, and create the new structure of the future, which will embrace architecture and sculpture and painting in one unity and which will one day rise toward heaven from the hands of a million workers like the crystal symbol of a new faith."[13] The title page was decorated with a wood carving by Lyonel Feininger representing a luminescent cathedral, symbol of the *Einheitskunstwerk* ("unified work of art"), "the ultimate, if distant, aim of the Bauhaus." But with the economic recovery confidence in industrial production grew, and from the middle of the 1920s a close and fruitful cooperation between the Bauhaus and industry developed.

In addition, the Bauhaus acted as a filter for and merged dialectically the various avant-garde movements of the visual arts. Influences from the Cubist, Futurist, Constructivist, Neoplastic, and Expressionist movements all came together in Gropius's school and stimulated design and architecture. The names of the first group of masters teaching at the Bauhaus—Walter Gropius, Lyonel Feininger, Johannes Itten, Paul Klee, Gerhard Marcks, Georg Muche, Oskar Schlemmer, and Lothar Schreyer—and those of later teachers and associates, among them Wassily Kandinsky, Kasimir Malevich, Theo van Doesburg, El Lissitsky, Laszlo Moholy-Nagy, Piet Mondrian, Adolf Meyer, Hannes Meyer, Ludwig Mies van der Rohe, and Ludwig Hilberseimer, bear witness to its wide scope.

In France, the manifesto *Après le cubisme* was published in 1918; its signatories were the painter Amédée Ozenfant and the painter, sculptor, and architect Charles-Edouard Jeanneret, later known as Le Corbusier. Their movement, which was directly derived from Cubism and called Purisme (Purism), aimed at an objective representation of modern civilization. Despite their impersonality, geometry, and coolness, the Purist compositions, mostly made of simple, mechanically assembled elements, do not negate poetry. Purist aesthetics, which, like those of the Bauhaus, aimed at a link with standardization and industrial production, were promulgated through the journal *L'Esprit Nouveau* and with Le Corbusier

gained entry into architecture and city planning.

As a reaction to Impressionism and even more to Expressionism, a new movement appeared in European painting around 1920, that of Neue Sachlichkeit ("new objectivity"). Its realism, inspired by social criticism, involved keen observation, drawings of exaggerated clarity and the arrangement of all objects in a clear, sometimes even rigidly structured order. Because of its formal and ideological links, this term was applied to Rationalist architecture too.

*Theories and Forms of Building*

Architectural Rationalism arose out of the general conviction that problems stemming from reality could be resolved by rational processes. In this sense it found itself in opposition to Expressionism. Whereas Expressionism was marked by a resigned pessimism that credited the dark forces of passion with overwhelming power, Rationalism was inspired by a determined optimism and actively accepted the challenge of reality. No longer was there introspection, but instead a generous readiness to come to terms with the environment and to change it.

It is no coincidence that the ideological superstructure of the new movement spanned the entire political field from the skeptical humanitarian socialism of a Ludwig Mies van der Rohe to the radical communism of a Hannes Meyer. Belief in a better world was the motor that propelled efforts for a better architecture, through collective rather than individual efforts, through transferable architectural and city planning measures rather than through individual buildings, and on an international rather than on a national scale. The term International Style reflects this last characteristic.

From these theoretical premises it is possible to derive the principles of architectural Rationalism and, simplifying, to sum them up in seven main points.

—The concept of city planning, architecture, and industrial design production as a means of social progress and democratic education. The search for a specific form in design is no longer regarded as a matter of personal enjoyment, but as an ethical responsibility in the service of a better society.

—The maxim of economy, which applies to the use of land as well as to the actual building. The effort to produce housing for all resulted, in the economically weakened postwar period in housing geared to minimum standards: rational utilization of plots, cheap building methods, minimized ground plans, and a sparse idiom.

—The systematic utilization of industrial techniques, standardization, and prefabrication at all levels of environmental design, ranging from city planning to industrial design. Here a paradox arose, because the building industry was not yet ready for the radical changeover and continued to use mainly conventional production methods. Individual units were nevertheless designed so that they *could* have been mass-produced, had only anyone been willing or able to do so: even when prefabrication was not carried out de facto, the idea of it still influenced the idiom of Rationalism.

—Priority of city planning over architecture. Given the dramatic lack of housing, comprehensive measures seemed more important and more urgent than single interventions; thus the blossoming of the *Siedlungen* (estates).

—Priority of teamwork over work by individuals. The magnitude and complexity of the impending problems tended to replace the inspired individual artist with a team of interdisciplinary, scientifically trained specialists. This was at least the theory. In practice, architectural Rationalism was more than ever dominated by three masters: Walter Gropius, Ludwig Mies van der Rohe, and Le Corbusier. Teamwork, if only in a rudimentary form,

was to be found in city planning alone.

—The rationality of architectural form, considered methodically derived from objective requirements of a predominantly functional and constructional nature. Form thus appears, at least in part, as a logical entity that is not at the mercy of the individualistic arbitrariness of its creator but which can be collectively controlled. The question of aesthetics is obviated, if only in theory; the demand for transparency of the process of the development of form is primarily an ethical one.

—The rejection of the concept of style. Because the requirements from which form is derived vary from case to case, the result similarly varies. Consequently, only a common attitude, but not a common idiom, can develop. This theoretical hypothesis is again only partially confirmed by practice. De facto Rationalism reveals itself as a distinguishable and, on the whole, stylistically uniform artistic movement.

Despite its importance and its influence it must not, however, be forgotten that the movement remained quite isolated during the 1920s and 1930s, that it was attacked by Traditionalism even before it was suppressed in Germany by the National Socialists, and that it accounted for only a small share of total building. In order to gain strength it therefore became necessary to unite the individual efforts and to coordinate them.

The Weissenhof Exhibition in Stuttgart (1927) demonstrated early international unanimity in the new will to design. In the following year Hélène de Mandrot initiated, after consultations with the architectural historian Sigfried Giedion and Le Corbusier, a meeting of the avant-garde at her castle at La Sarraz (Switzerland); this meeting subsequently became known as CIAM I, the first Congrès International d'Architecture Moderne. Its founding declaration states: "The intention that brings us together is that of attaining a harmony of existing elements —a harmony indispensable to the present—

by putting architecture back on its real plane, the economic and social plane."[14]

CIAM II took place in Frankfurt am Main in 1929 under the chairmanship of Ernst May, Europe's greatest expert in the field of social housing. The result was a report *Die Wohnung für das Existenzminimum*, which dealt with minimum standard housing. CIAM III took place in Brussels in 1930, initiated by Victor Bourgeois, and dealt primarily with the problem of optimum use of land. CIAM IV was arranged during the summer of 1933 on board the ship *Patris* between Athens and Marseilles. The romantic cruise, far from the tense political and economic situation in Europe, led to resolutions, based on analyses of 32 towns, published under the title *The Functional City*. Ten years later this document formed the basis for the *Charte d'Athènes*, which consisted of guidelines, edited mainly by Le Corbusier, on avant-garde city planning.

In Germany the architects' association Der Ring was founded in 1926. Among its members were Peter Behrens, Walter Gropius, Hugo Häring, Ludwig Hilberseimer, Ernst May, Erich Mendelsohn, Ludwig Mies van der Rohe, Hans Poelzig, Hans Scharoun, and Heinrich Tessenow. Their aim was "to serve jointly the international movement that tries, under conscious renunciation of the restricting forms of the past, to resolve contemporary building problems by means of modern technology, and to pave the way for a new architectural culture for the new economic and social era."[15]

Meanwhile, the Rationalist architectural idiom had established itself. Apart from its stronger coherence, it is almost synonymous with that of early Rationalism, with clear uniform surfaces, generous glazing, right angles, white color, and no ornaments, but with a structure and distribution of functions as recognizable as possible. Whereas early Rationalism only partly gave up symmetries and favored views, the subordination of the main facade in favor of an equal

99. Le Corbusier. Sketches for *Five Points of a New Architecture*. 1926.

Its guidelines can, in line with the individuality of the three "masters" of Rationalism, be directly related to them, although they mostly apply to the movement as a whole.

For Walter Gropius the resolution of the outer wall into a light glass screen or curtain wall suspended from the inner load-bearing structure was the dominant feature of his major buildings. These give a feeling of insubstantiality and weightlessness, while the separation between interior and exterior is largely eliminated. In his work the intellectual attempt not to design form is particularly obvious.

The interpenetration of interior and exterior was brought to perfection by Ludwig Mies van der Rohe through his concept of the "flowing space." Not only the generous use of glazed areas but above all the layout of the ground plans, with dividing and connecting wall sections on an overall geometric grid, produce a continuous sequence of spaces between the public and the private areas. His almost unreal structures are rooted in both technology and geometry, for which he found, through patient endeavor, a total harmony.

In his *Five Points of a New Architecture* Le Corbusier laid down the main invariables of his personal architectural idiom.

1. The *pilotis*, the house on columns. Houses used to dig themselves into the ground: dark and often damp rooms. Reinforced concrete gives us the *pilotis*. The house in the air, far from the ground; the garden continues below the house . . .

2. The *roof gardens*. Reinforced concrete is the new means that allows the realization of homogenous (flat) roofs. Reinforced concrete expands strongly. This expansion leads to the structure cracking during the hours of brutal contraction. Instead of attempting to remove rainwater quickly, efforts should be made, on the contrary, to maintain a constant level of humidity on the concrete of the terrace and thus an even temperature of the reinforced concrete. Special protective measure: sand in conjunction with heavy concrete slabs with wide joints; grass is sown in the joints. Sand and roots prevent the water from seeping through quickly. The garden terraces become opulent: flowers, shrubs and trees, lawn . . .

3. The *free ground plan*. Until now: load-bearing walls, starting with the basement, are stacked one above the

treatment of all the elements of a building now became the norm. Moreover, the quest for harmony in design, which was at the root of even the asymmetric and—in its deviation from the norm—progressive De Stijl idiom, was now sacrificed to the best logical design "from the inside to the outside." Early Rationalism still had aesthetic leanings, but at least in words, Rationalism no longer accepted preconceived form.

The radical break with traditional rules of composition resulted, despite all claims to the contrary, in a definable aesthetic idiom.

other and form ground floor and upper stories up to the roof. The ground plan is the slave of the load-bearing walls. Reinforced concrete in the house provides the free ground plan! . . .

4. The *horizontal window*. The window is one of the most important features of the house. Progress provides a liberation. Reinforced concrete creates a revolution in the history of the window. Windows can run from one side of the facade to the other. The window is the standard mechanical element of the house; for all our special public buildings, all our villas, all our workers' houses, all our apartment blocks . . .

5. The *free facade*. Pillars set back from the facade, in the interior of the house. The ceiling continues in the form of a cantilever. Facades are nothing more than light membranes of isolating walls or windows. The facade is free . . . [16]

Despite incessant recourse to constructional, functional, and economic justification for his formal idiom, Le Corbusier always relied on his own imagination and his unfailing aesthetic sense first. All his buildings were based on strict proportions, to which he reverted time and again. In 1951 he developed the modulor, a system of proportions based on the golden section and related to man. Le Corbusier calculated scales of proportion for the body sizes 5.74 feet (1.75 meters) and 6 feet (1.83 meters), which he mainly used in his Unités d'Habitation.

*Architecture*

Walter Gropius, the son of an architect, joined the office of Peter Behrens after completing his studies, where he worked from 1907 to 1910; during this period the AEG Turbine Works in Berlin were built. Subsequently, Gropius became an independent industrial designer and architect. In 1911 he met the owner of the Fagus Works, who was dissatisfied with the rather conventional preliminary plans for his new shoe-tree factory; Gropius submitted his own plans, which appealed to the manufacturer, and was commissioned, together with Adolf Meyer, to carry them out. The result was a pioneering building of architectural Rationalism at Alfeld-on-the-Leine.

In contrast to Behrens, who had chosen the innovative construction system of thrice-articulated steel columns for his Turbine Works, Gropius decided to build a simple structure with a load-bearing masonry wall at the rear and masonry piers in the front. Steel girders were used only for the ceilings. But instead of framing the big glazed areas, necessary in a workshop, with heavy walls, he moved the pillars inside and dissolved the entire outside wall into glass areas. In order to underline the separation of load-bearing and non–load-bearing parts and to clearly show that the wall was a thin applied "membrane" that had no statical but only a cladding function, he omitted the corner columns. His interpretation of a factory building was thus fundamentally different from that of Behrens. It was not monumental and full of pathos, but functional and reticent.

This architectural idiom was further developed in his model factory and office building for the 1914 Werkbund exhibition in Cologne. The complex was divided into a number of individual functional units, such as an office building, a machine shop, and open garages, each separated from the others and each with its own form. The two-story office building was symmetrical; its heavy Egyptianized brick front was flanked by two semicircular projecting and entirely glazed staircases similar to those that would, some years later, reappear in the Expressionist architecture of Erich Mendelsohn. The design of the facade and the cantilevering cornices of the covered terraces, which could be used for social functions, indicated the immediate influence of Frank Lloyd Wright.

After the First World War Gropius went to Weimar, as successor to Henry van de Velde, where he merged the Grand-Ducal Saxonian School of Arts and Crafts and the Grand-Ducal Saxonian Academy of Art, and reorganized them into the Bauhaus. During the following year he participated, through the Novembergruppe and the Arbeitsrat für Kunst, in the Expressionist architectural movement.

Around 1922, stimulated through contacts with the De Stijl group, Gropius reverted to the architectural idiom of his early years. When his school moved to Dessau in

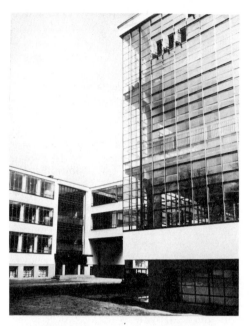

100. Walter Gropius. Bauhaus, Dessau. 1925–26.

101. Walter Gropius. Residential buildings and studios for Bauhaus staff, Dessau. 1926.

1925–26, Gropius was able to realize his ideas on a large scale in the new Bauhaus complex. The building program was extensive. It consisted of the actual Bauhaus with workshops, lecture rooms, and exhibition rooms, a crafts school, a dormitory for twenty-eight students, residential quarters and studios for the teaching staff and the director, as well as a lecture hall, a stage, a canteen, and administrative quarters. Gropius separated the teachers' quarters from the main building and distributed them, in the form of simple, elegantly structured houses, in a neighboring forest. The remainder of the program took the form of a coherent reinforced-concrete skeletal structure reflecting the various internal functions in the marked differentiation of the individual building units in form, dimension, and the ratio of full and void surfaces. The actual Bauhaus dominates the complex with its large four-story building and the continuous glass frontage of the workshops, which require good lighting. The filigree glass frontage continues, as in the Fagus Works, without support around the corner and integrates, with its insubstantial transparency, the interior and the exterior of the architectural organism into a single continuum. The crafts school is housed in a part of the building situated at right angles to the main wing and connected with it by a two-story-high footbridge across the road. The administrative quarters are located in this footbridge. The studio building for students, a six-story closed wing with small, boldly projecting balconies, is connected with the lecture hall, stage, and canteen through a flat block. Despite the extreme if entirely logical functional and design differentiation, the complex gives an impression of unity by virtue of the harmony and simplicity of its idiom: clearly outlined cuboids, raised from the ground by bases, light glass "curtains," con-

102. Walter Gropius and Adolf Meyer. Fagus Works, Alfeld-on-the-Leine. 1911.

tinuous horizontal or square windows, and unornamented balconies. Despite the sophistication of its design, particularly apparent at the interfaces of the complex, this vocabulary is never overemphasized and monumentality and pathos are avoided. The building has no main facade; its spatial complexity is not recognizable at first sight, thus inviting inspection from all sides. Architecturally expressed functionality and Cubist aesthetics are synthesized.

In 1928 Gropius gave up his post as director of the Bauhaus in order to devote himself entirely to practical work. For some years the emphasis of his activity lay on city planning. After the National Socialists assumed power in Germany, Gropius left and settled in Great Britain. Here he realized, together with Edwin Maxwell Fry, who later became Le Corbusier's chief architect for the town of Chandigarh, several projects, including the Impington Village College near Cambridge (1936). The classrooms of this pavilion school, which serves the dual purpose of secondary and adult education, are spread over a green area; they are connected by an open passage and are arranged so that they receive natural light and ventilation from two sides. This type of building became a pattern for progressive school architecture throughout the world.

In 1937 Gropius became a member of the Harvard University architectural school in Cambridge, Massachusetts, and was in 1938 appointed its dean. In his first year in the United States he built himself a house at Lincoln, Massachusetts, in the same severe linear style that had previously characterized the Bauhaus teachers' living and working quarters in Dessau. This was followed by a number of private houses, built in collaboration with Marcel Breuer, one of the first Bauhaus students. As early as 1909, while he was still working for Behrens, Gropius had concerned himself with the problems of prefabrication and mass production. In a memorandum for the AEG he had expressed his intention of "the justified de-

mands of the client for individualized treatment of his dwelling by the use of the infinite possibilities for combination of these variable parts."[17] Gropius never abandoned this idea, which he summed up in the phrase "unity through variety." At the Weissenhofsiedlung in Stuttgart in 1927 he built a model prefabricated house consisting of a lightweight steel frame and compressed cork infill, with only the concrete foundation slab being made on the site. Between 1928 and 1930 he drew up schematic plans for prefabricated houses; in 1932 he began his first experiments with standardized building components and from 1942 onward worked in the same field together with Konrad Wachsmann, the pioneer of industrialized building.

In line with his belief in teamwork Gropius founded The Architects' Collaborative (TAC) in 1945 together with some younger architects. The group abandoned the employer-employee relationship and functioned on terms of complete equality. Among projects realized by TAC were the Harvard Graduate Center at Cambridge, Massachusetts (1949-50), a complex of seven students' dormitories for 575 students grouped around a communal center, with simple but varied architectural forms arranged around green open areas.

Although Gropius's personal attitude receded in the latter works behind the eclectic but fairly high standards of the anonymous team, his contribution to architectural Rationalism, especially during his early years, was of great importance. Of far greater significance than his architecture, however, were his ethic and methodology. If Gropius's creative work fails to develop a specific recognizable idiom, this is no coincidence. His interest was never primarily an artistic one but was always equally shared by social, functional, technical, and aesthetic considerations. He rejected intuitive ideas of form that were not derived from conscientious concern with the function of the building as being too subjective. Gropius demanded ob-

103. Ludwig Mies van der Rohe. Haus Kröller, The Hague. Project. 1912.

jectivity and implemented it both in his architectural work and his teaching. He thus provided no ready-made solutions but showed how to approach and resolve a problem in the light of given circumstances. His main legacy was a mode of thinking, open to further development.

Ludwig Mies van der Rohe, the second great protagonist of Rationalism, did not receive any orthodox architectural training. He owed his first professional stimuli and his masterly craftsmanship to his father, a master mason and the owner of a small stonemason's business. After an apprenticeship in timber construction and a year's independent work, Mies van der Rohe worked, between 1908 and 1911—about the same time as Gropius, his senior by three years—in the office of Peter Behrens. Behrens's influence proved decisive in that it gave him a knowledge of steel construction and the concept of cooperation between the architect and industry; and finally it prefigured his preference for the Classicism of Karl Friedrich Schinkel with its severity of means, its purity of form, its elegancy of proportions, its perfection of detail, and its dignity of expression.

Like Gropius, Mies van der Rohe was deeply impressed by Wright's exhibition in Berlin in 1910, and this influence had results many years later. After his work at Behrens's office, he designed a number of houses in the classical idiom, among them Haus Kröller, a full-size wood and canvas model of which was shown in 1912 at The Hague. In Holland, Mies van der Rohe became familiar with the work of Hendrik Petrus Berlage, whose architectural ethics of "honest" expression of material and construction he adopted.

In 1918 he joined the Expressionist Novembergruppe and subsequently the Arbeitsrat für Kunst, where he was in charge of the architectural section for five years. During this period he designed his first skyscrapers in the form of studies intended to explore the principles and effects of angular (1919) or undulating (1920–21) glass surfaces fronting visible load-bearing structures. These were followed, in 1922, by the project for an office building in reinforced concrete. Whereas the glass studies are dominated by a search for almost pure expression, the office building project is primarily concerned with congruence of construction and form in a radical "skin-and-bones" architecture. All the supports are arranged on the inside; cantilevering floors with parapets

104. Ludwig Mies van der Rohe. Reinforced concrete office building. Project. 1922.

allow the adoption of continuous horizontal windows. The fact that the resulting project is of the highest quality is due to logical architectural thinking and subtly sensitive design.

Also in 1922, Mies van der Rohe met the De Stijl spokesman, Theo van Doesburg. During the following year he designed a brick country house that forms an independent synthesis between the Neoplastic design rules and the principles of Organic architecture, as laid down by Wright's buildings. Tied into the surrounding landscape, its plan is derived from internal funtions. The rooms are formed by continuous closed walls, straight or joined at right angles, becoming independent design elements projecting far into the surroundings and keying house and ground. Instead of inserting windows that would interrupt the continuity of the walls, entire wall sections are removed and glazed over.

105. Ludwig Mies van der Rohe. Brick country house. Project. 1923.

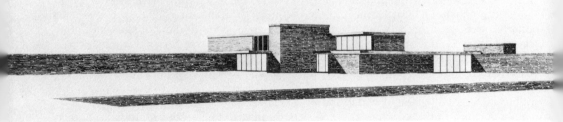

Some of the new possibilities revealed by this design were used in Haus Wolf, at Guben, built in 1926. During the same year Mies van der Rohe built the memorial for Karl Liebknecht and Rosa Luxemburg in Berlin—a powerful flat brick structure with horizontally projecting and receding orthogonal elements, which produced a lively play of light and shade.

In 1927 Mies van der Rohe took charge as coordinator, on behalf of the Deutscher Werkbund, of the Weissenhof Exhibition that took place at Stuttgart under the theme *Die Wohnung.* There, the avant-garde of international architecture, including Peter Behrens, Walter Gropius, Jacobus Johannes Pieter Oud, Le Corbusier, Bruno Taut, and Hans Scharoun, built 21 single- and multi-family houses. Mies van der Rohe himself designed the layout and built a simple and sober apartment building in the form of a reinforced concrete skeletal structure with movable walls as a rational *Stadtkrone* dominating the little estate.

The German Pavilion at the Barcelona International Exhibition of 1929 gave Mies van der Rohe an opportunity to realize his architectural concepts in their purest form. The structural elements of the pavilion were noble, if simple, consisting of a travertine base eight steps high with two rectangular pools; a straight travertine wall with a seat in front; a flat reinforced concrete roof supported by eight chromium-plated cruciform steel columns; and a smaller roof resting on travertine walls. Added to these were walls, some of onyx, some of glass, either clear or tinted in various colors, and a sculpture by Georg Kolbe. These elements were combined into a unique spatial continuum through the separation of load-bearing and non-load-bearing elements and by utilizing this constructional principle for architectural means. The shiny columns of the actual exhibition area were freestanding, while thin screens, which had a purely aesthetic function, intersected the flowing space. This concept was the materialization of the con-

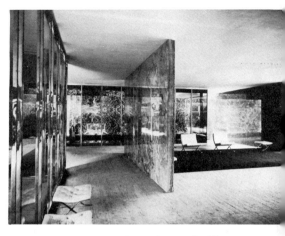

106. Ludwig Mies van der Rohe. German Pavilion at the Barcelona International Exhibition. 1929.

cise axiom that "less is more." The intense metaphysical poetry of the Barcelona Pavilion was achieved by strictest economy of design elements.

The pavilion, which was both exhibition area and exhibit, and in which, apart from the sculpture, only some items of furniture, also designed by Mies van der Rohe (among them the Barcelona chair), were shown, was demolished after only one summer. During the following year the by then famous architect was given the opportunity to apply his conception of a spatial continuum to a domestic building, Haus Tugendhat at Brno, Czechoslovakia.

The position of the site, which was on a slope, was taken into account by distributing the rooms over two levels; the upper story contains the entrance and bedrooms, while the main story, which is invisible from the road, was reserved for the living, working, and dining rooms. The outside wall of the living and dining areas is entirely glazed; two sections of the glass wall can be lowered mechanically, like electrically operated car windows, to open the interior to the surrounding garden. A terrace and stairs leading to the garden are also part of the house.

The flowing ground plan is contained by a loosely arranged cube, extended by annexes

and superstructures and organized on the "objective" geometric principles of a modular system that becomes apparent in the pattern of joints in the terrace. These principles govern all the architectural elements, which are shown as single individual units. Even the columns are optically separated from the floor from which they rise and the ceiling they support; their formal design and the noble grace of the chromium from which they are made relate them tightly to the equally slender and elegant furniture.

The contradictions inherent in Mies van der Rohe's concept of residential architecture become particularly apparent in this luxurious object. The idealistic aim of building for a "new man" was evidently confronted with banal pragmatic obstacles. For one thing, these houses were very expensive and therefore available to only a small number of wealthy people. Second, the open space as a continuum of inside and outside was only feasible in the privacy of large, opulently secluded plots. Finally, the untouchable perfection and sophistication of the form, which cannot be changed even in a small detail without destroying the overall harmony, required an owner whose propensities coincided with those of the building: perfection and restraint, poise and style, elegance and taste. All of this, of course, ignored social, economic, and cultural reality. At the same time no other Rationalist architect translated the abstract, utopian, generous hope of liberated living so logically and completely into built architecture.

107. Ludwig Mies van der Rohe. Haus Tugendhat, Brno. 1930.

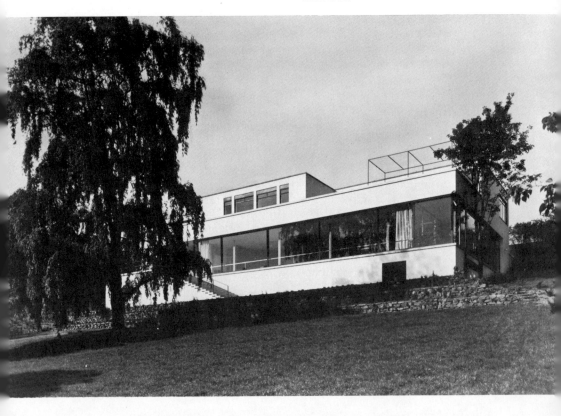

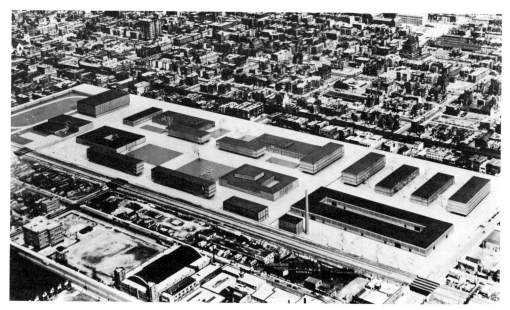

108. Ludwig Mies van der Rohe. Illinois Institute of Technology, Chicago. 1940.

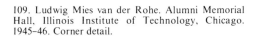

109. Ludwig Mies van der Rohe. Alumni Memorial Hall, Illinois Institute of Technology, Chicago. 1945–46. Corner detail.

At the insistence of Gropius, Mies van der Rohe became head of the Bauhaus in 1930. Almost immediately afterward it had to move to Berlin under pressure from the National Socialists; it was dissolved in 1933.

In 1938 Mies van der Rohe was appointed to the Armour Institute (after 1940, the Illinois Institute of Technology) in Chicago, and he emigrated to the United States. Subsequently he redesigned the college campus. He conceived the plot as an ideal geometric space for which he developed a uniform regular grid. Within this grid he distributed the different institutes as simple cubic shapes with the exposed steel structure infilled with brickwork, fitting the neutral volume into an orthogonal pattern. Proportions, material transition, and detail are exemplary. The visible steel sections rarely coincide with support structures, because steel, for reasons of fire protection, had to be enclosed. Applied like stage props, they merely symbolize the support structure whose principle they make visible. Mies van der Rohe went so far as to underline the purely explanatory func-

110. Ludwig Mies van der Rohe. Farnsworth House, Plano, Illinois. 1945–50.

steel columns. The monumental project for a Convention Hall (1953) with a span of more than 718 feet (219 meters) and a capacity of 50,000 people, which was never realized, was a revised and enlarged version of this building.

During the years 1954–58 and in cooperation with Philip Johnson, the Seagram Building in New York was designed and constructed. Set back from the street front to leave a granite-paved plaza and facing the axis of symmetry of a Classicist building across the road, the noble skyscraper rises like a monolithic block. The skeletal steel structure is enclosed, above ground floor level, by a curtain wall of bronze and bronze-toned glass. Its geometrical severity and its precious material give the building an aura of great dignity. Over its entire height of 39 regular stories it reveals the

tion of these "false" columns by severing them just above the floor, thus showing that they do not actually bear a load but only indicate that a load is being borne.

Between 1945 and 1950 he built Farnsworth House at Plano, Illinois. Three horizontal elements—a platform for the terrace, a slightly raised floor slab, and the flat roof—are supported by laterally arranged steel columns and appear to float above the lawn. The cells around the core containing the services are enclosed by walls that stop short of the ceiling. The rest of the house is a pure glass prism, a perfect form freed from any function and plunged into nature.

In 1947 Mies van der Rohe built the Promontory Apartments in Chicago, a sophisticated reinforced concrete structure, and in 1950–51, also in Chicago, the Lake Shore Drive Apartments, two vertical buildings, arranged at right angles, the supporting steel structures of which form an integral part of the subtle design. This was followed in 1952–56 by Crown Hall for the School of Architecture and Design at the Illinois Institute of Technology, a delicately structured glass building resting on a glazed foundation, with the roof supported by external

111. Ludwig Mies van der Rohe and Philip Johnson. Seagram Building, New York, 1954–58.

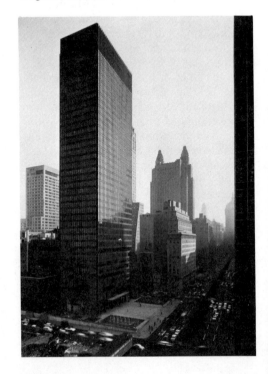

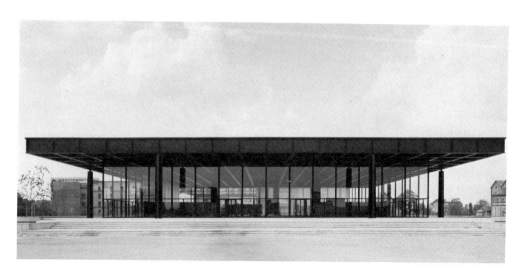

112. Ludwig Mies van der Rohe. New National Gallery, Berlin. 1962–68.

sophistication of understatement in its perfect details, its flawless proportions, and its pure form.

In 1962–68 Mies van der Rohe built the New National Gallery in Berlin. The design is an adaptation of a project of 1957 for the administrative building of the Bacardi Company in Santiago, Cuba, and consists of a square black steel cassette ceiling supported by eight steel columns set away from the corners. Under it, generously set back, a delicate filigree glass wall encloses the entire space. The strictly symmetrical building is raised onto a huge granite plinth whose shape, moreover, appears to be cut out from a perfect square; further exhibition rooms are arranged in the basement.

It is typical of the concept underlying Mies van der Rohe's work development that he was able to use for this, his last project, the structural and spatial design of a building originally projected for a different location and for a different purpose. His early designs, those of the European phase, were closely linked with the respective functions, which they interpreted within the framework permitted by structurally defined form. During his American period the striving for perfection allowed him less and less leeway. The constraints of pure form through perfect construction brought him to the absolute archetypal form, beyond which only refinement is possible. The price paid for this reduction was indifference to functional requirements and a reticence of idiom that bordered at times on silence. Through this conscious renunciation, Mies van der Rohe achieved that dignified, untouchable, and—even in its aesthetic aristocracy—simple perfection that had been his aim from the very beginning.

His concise and hermetic aphorisms, for example "Less is more," "I cannot invent a new architecture every Monday morning," or "I do not want to be interesting, I want to be good," have to be interpreted in the same way. Even his theoretical utterances strive toward the essence. This is in fact the only logical solution for one who regards the object of art as "to create order out of the desperate confusion of our time"[18] and who fits his buildings like rational oases into the chaos of nature or of the alienated metropolis. In this light, Mies van der Rohe's forms are anything but indifferent or generally applicable. That the aim which they pursue is unrealizable, makes the tragedy of his efforts akin to those of Sisyphus.

111

Le Corbusier, the third and most individualistic protagonist of architectural Rationalism, was born in 1887 at La Chaux-de-Fonds in the French-speaking part of Switzerland. France, however, became his chosen home country, and in 1930 he obtained French citizenship. He received early the decisive stimuli for his later work. In 1907 he met Josef Hoffmann in Vienna, in 1908 he worked for Auguste Perret in Paris, and two years later (like Gropius and Mies van der Rohe) for Peter Behrens in Berlin. In 1911–12 he studied, together with others linked with the Deutscher Werkbund, problems of industrialized building; at the same time he traveled extensively throughout Europe. When he settled in Paris in 1917, he had, in addition, to come to terms with Cubism and especially, with painting, which, like sculpture, he was never to give up. The unification of the arts in architecture would remain his aim.

The young architect, who had received no university education, thus built a solid theoretical foundation for his work, which he expounded and developed between 1920 and 1925 in the journal *L'Esprit Nouveau*.

113. Le Corbusier. Villa Schwob, La Chaux-de-Fonds. 1916.

Among the main points of his revolutionary aesthetics were the following:

—Utilization of the new building material —reinforced concrete—and the search for an idiom which would fully make use of its constructional and aesthetic possibilities. The *Five Points of a New Architecture* were mainly derived from this postulate.
—Consideration of the requirements of industrialized building. Based on social and economic arguments, it developed into the formal and conceptual imitation of industrial reality as well as into the standardization of dwellings. "All people have the same organism, the same functions. All people have the same requirements."[19]
—Decision to adopt a purist idiom, influenced by the clarity of classical Greek architecture. Beauty was sought not in ornament, but in a radical reduction of design elements, in careful proportions, and in strict geometry.

The first houses built by Le Corbusier between 1906 and 1916, mainly in Switzerland, for example Villa Schwob at La Chaux-de-Fonds (1916), were rooted in historic styles and showed only slight relation to these revolutionary guidelines. On the other hand, the Maison Dom-ino project, Le Corbusier's first attempt to deal with the problem of mass housing, was developed already in 1914–15, while the Maisons Citrohan, designed in 1920–22, incorporated in their second version the idea, originating in the English country house tradition, of two-story living areas. The sparse cubic forms with outside stairs and a roof terrace are derived from Mediterranean architecture; all parts of the house are united by a spatial continuum, while the open space created by the *pilotis* and the flat roof increase the otherwise small available area. This prototype of a single-family unit, which was later modified to a module within a collective building, was to recur again and again in Le Corbusier's work. The narrow cell, open to the front

and developing lengthwise between two continuous walls (and thus capable of being added) was one of the basic units of the Immeuble-villa, a project dating from 1922, which envisaged access to the 120 apartments by external corridors. It recurred in 1925 in the Esprit Nouveau Pavilion for the Paris Exposition Internationale des Arts Décoratifs et Industriels Modernes; in 1927 in one of the houses on the Weissenhofsiedlung in Stuttgart; in 1930 in the futuristic Plan Obus for Algiers; and finally, after 1945, in the Unités d'Habitation.

These early projects already contain all the essential principles of Le Corbusier's work. He himself described his "Typical House Citrohan (not to say Citroën). In other words, a house built like a car, conceived and constructed like a bus or ship's cabin. The present demands of living quarters can be made precise and require a solution. One must act against the former house which did not utilize space well. One must regard the house as a machine for living, or as a commodity (timely problem: a question of cost)."[20]

Le Corbusier had thus formulated the main theme of his "patient search" and coined the phrase "machine for living in." In the world of technology there were many products, such as automobiles, ocean liners, and airplanes, which had been designed according to a clear, logical, and rational program, which appeared to fulfill their purpose perfectly, and which revealed, at the same time, the fascination of a new beauty. Le Corbusier wanted to achieve the same for housing. An exact program and fulfillment of purpose, nevertheless, did not mean to him the exclusive and simplified consideration of basic practical requirements, but an in-depth study of all human concerns. The machine for living in was not merely intended to satisfy the material requirements of minimum housing; attention was also to be paid to criteria such as communication, comfort, ethics, and aesthetics.

The first project to be built in the new

114. Le Corbusier. Second Maison Citrohan. Project. 1922.

115. Le Corbusier. Immeuble-villa. Project. 1922.

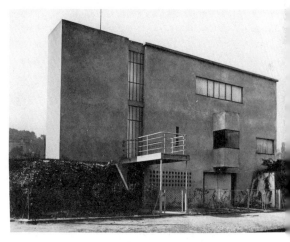

116. Le Corbusier. Villa Besnos, Vaucresson. 1922.

style, the Villa Besnos at Vaucresson (1922), already revealed in its clearly structured geometrical outlines the wide range of Le Corbusier's moral commitment as well as his outstanding artistic talent. During the same year he entered into partnership with his cousin Pierre Jeanneret.

In 1927 they built the Villa Stein at Garches, its ground plan derived from a simple quadrangle, while the facade is characterized by coherently continuous horizontal windows. At the same time they designed for the Weissenhofsiedlung in Stuttgart two model houses in which large living areas contrast with narrow cells for the other domestic functions.

Also in 1927, Le Corbusier designed the project for the League of Nations Building in Geneva. The complexity of the building program led him to give up the idea of a solid block in favor of a number of individual units, which he developed on the basis of their respective functions and set into the landscape. The Secretariat and the small conference rooms were to be housed in a rectangular structure away from the waterfront, while the trapezoidal Assembly Building with its 2,600 seats was to face the lake. The parabolically rounded ceiling of the hall tapered toward the rostrum and represented a solution which was innovative not only in terms of space but also acoustically and structurally.

Between 1927 and 1931 Le Corbusier built the Villa Savoye at Poissy near Paris, one of his major works. It incorporates all "five points of a new architecture" and combines them in a unified creation. Its ground plan is based on a square column grid of

117. Le Corbusier. League of Nations Building, Geneva. Project. 1927.

118. Le Corbusier and Pierre Jeanneret. Villa Savoye, Poissy. 1927–31.

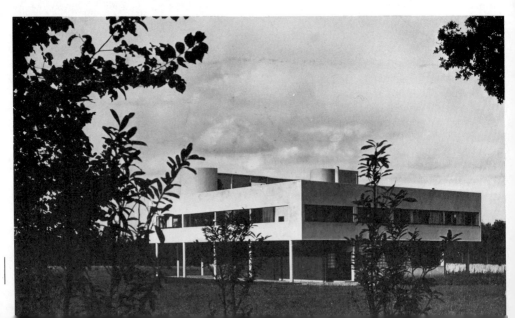

reinforced concrete construction. On the ground floor the external wall recedes to the extent and the shape needed for a car to turn, so that vehicles can drive through the columns and around the house before being parked at an angle in one of the garages. The exit is on the opposite side of the semicircle, the main entrance of the house along its apex. Apart from the three garages, this level accommodates the entrance hall, guest quarters, and two servants' apartments. Stairs and a generously proportioned central ramp, a *promenade architecturale*, connecting point of all the elements of the spatial composition, leads to the upper floor, which occupies the entire base area and even projects slightly on two sides. It contains the main living area, including a small and a large garden terrace. Stairs and ramp—the latter being now open—lead to the upper floor, where the openings above the two terraces are topped by the expressive sculptural roofs of the staircase and the solarium.

From the outside, the building presents itself as a hovering prism supported by *pilotis*, a structure making no attempt to adapt itself to the surrounding nature but, on the contrary, stressing its artificiality. The purity of its stereometry is multiply disturbed: horizontal windows cut into the facade in a continuous strip from corner to corner; terraces and ramps break up the continuity of the geometric body, exploring Le Corbusier's harmonic principles and linking the variously treated levels; on the roof, plastic structures contradict the strict orthogonality and stress it at the same time. The combination of small deviations and the free arrangement of the facades gives each view a different aspect. This is not, as it would have been with Gropius, the result of a strictly functional design, since the exterior does not reflect the internal layout. The part of the facade that corresponds to the garden terrace, for example, does not vary fundamentally from the other three sides, although its function is completely different. For Le Corbusier the formal aspect was more important than the consequences of a rational principle: "Architecture is the wise, correct, and wonderful play of bodies in light."[21] His logic was not only one of function but also, and primarily, one of poetry. In 1929–33 Le Corbusier built the Cité de Refuge, a Salvation Army hostel in Paris, as a large monolithic glass structure with curtain walls and air conditioning. The roof owes its lively features to the finely structured upper floor, while a number of freely articulated volumes provide the transition between the scale of the passersby and that of the technically inspired "machine for living and working in."

During the years 1945–53 Le Corbusier built his Unité d'Habitation in Marseilles, the first *cité-jardin verticale*. It is the synthesis and culmination of two decisive streams of development: one is his search for the *maison minimum*, which had first borne fruit in 1922 in the designs for the Maisons Citrohan and the Immeuble-villa, and the second, which had concerned him since the same year, is his multiform city planning activity. The Unité d'Habitation is in fact not simply an addition of residential cells, but an urban unit, a piece of a town, self-contained and complete with all necessary infrastructure.

The monolithic slab is raised above the ground by 17 pairs of massive, sculpturally profiled *pilotis*. The *pilotis* (these are hollow and carry the wastewater systems and supplies) support the *sol artificiel*, a platform in which the technical installations are kept accessible. Above, 337 apartments of 23 different types are distributed over eight double floors. Vertical access is provided through three staircases and elevators. Horizontal access is by *rues intérieures*, internal streets, on the 2nd, 7th, 8th, 13th, and 16th floors. The 7th and 8th floors contain mainly communal facilities, shops, as well as a hotel for visitors, and have direct access from outside through a plastically shaped flight of stairs on the north side of the building. The roof

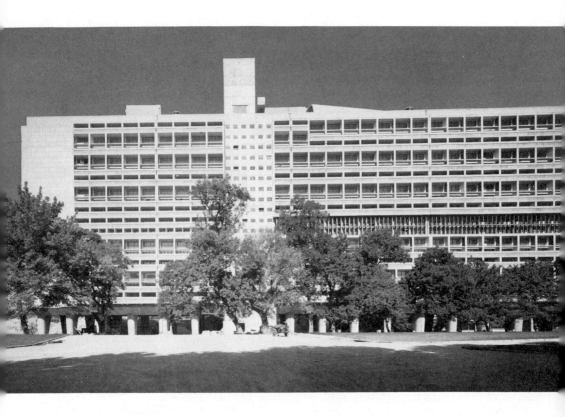

terrace includes a bar with solarium, a gymnasium, a theater, a crèche, a children's pool, and a playground. The superstructures, far more extensive than those of the Villa Savoye, are designed as free, bizarre plastic units.

The most frequent type of dwelling is the maisonette derived from the second version of the Maisons Citrohan; it occupies two floors and is oriented in an east-west direction. The living room, parts of which extend over two stories, takes the form of a gallery: one level goes up to the internal street, while the other, which houses the sleeping quarters, takes up the entire depth of the building and thus permits natural cross ventilation. Throug their rectangular single-story or square two-story outline, sun-shaded loggias at the end of each unit mark the arrangement of the individual modules, making them recognizable from the outside. Be-

119, 120. Le Corbusier. Unité d'Habitation, Marseilles. 1945–53.

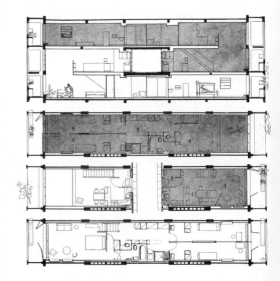

cause of the varying depths of the two levels, each unit interlocks into a second one, with the resulting complex extending over three floors, centrally accessible through an internal street.

The initial sociological requirement of personal liberty within a collective organization is taken into account in various ways by Le Corbusier. From the outside the individuality of each separate unit is maintained through recognizable demarcation lines, and this is further stressed through a color scheme consisting of a small number of basic shades. Structurally, each unit has its own independent steel frame, which slots, not unlike a drawer, into the surrounding framework; this ensures, at the same time, good insulation. Inside, the traditional separation of the rooms is overcome through a

largely unitarian spatial flow, with the functional areas screened only by furniture or by movable dividing walls.

Interiors and details are sparse, but carefully designed. Le Corbusier's need for harmony makes itself felt throughout, despite the mainly economy-imposed simplicity. The exterior of the building is marked primarily by the *béton brut*, concrete cast in a rough timber formwork and left exposed. This aesthetic was to be adopted in England in the mid-1950s and to inspire the architecture of the New Brutalism.

The Marseilles prototype was repeated in the subsequent Unités d'Habitation at Nantes-Rèze (1952–57), Berlin (1956–58, for the Interbau Exhibition), Meaux (1957–59), Briey-en-Forêt (1957–60), and Firminy-Vert (1962–68).

The pilgrimage chapel Notre-Dame-du-Haut, built 1950–54 at Ronchamp, is usually regarded as a new departure in the work of

121. Le Corbusier. Pilgrimage chapel Notre-Dame-du-Haut, Ronchamp. 1950–54.

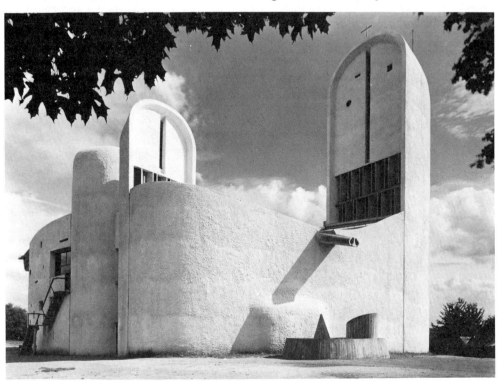

Le Corbusier, as a break with Rationalism in favor of an irrationalistic plastic architecture. Such an interpretation does no justice to the consistent creativity of Le Corbusier. Although he abandoned the "five points," the classical Greek ideals, and the Cartesian purism, this willful building is by no means arbitrary. Just as the Unités d'Habitation are the materialized concept of a rational form of dwelling, the pilgrimage chapel is the consistent expression of a religious program and its emotional as well as functional realization.

The *pilotis* have given way to a building solidly tied to the ground—an impression that is strengthened by inclined exterior walls. The terraced roof has become a heavy, mushroom-shaped, suspended concrete construction. The free plan has changed into a sculpture and has merged with the load-bearing structure. The free facade has been replaced by walls of seemingly immense thickness (although they consist in reality of two thin shells) and are no longer broken by generous horizontal strip windows but instead pierced by small, irregularly shaped and spaced holes. The plastic idiom, which had hitherto been limited to roof and *pilotis*, now involves the entire building. The expressive, fortresslike sculpture with its large white main tower and the two smaller secondary towers crowns the top of a small hill, in the unresolved contradiction of its individual components like an unfinished *objet trouvé*. The fact that it is an *objet à réaction poétique* becomes particularly apparent in the interior, where the undulating, roughly rendered areas form gently lit caves. Separated from the walls by a narrow strip of light, the massive roof seems to float effortlessly overhead, as if lifted by magic. The colored windows, set deep into the walls, not only underline the plasticity of the idiom, but also highlight the service as dictated by the liturgy. The light wells of the towers illuminate the side altars.

By its very nature Notre-Dame-du-Haut had to remain an individual episode. The buildings for Chandigarh (India), dating from 1950–65, do not mark a return to Purism but certainly to Rationalism, even though they are expressively overemphasized and contain strong plastic elements.

In 1952–56 Le Corbusier built the Maisons Jaoul at Neuilly-sur-Seine. The expressive combination of roughly joined masonry and exposed concrete marks them as one of the first Brutalist examples; in the interior, flat brick vaults determine the vividly structured space. These were followed in 1954–56 by the Millowners Association Building at Ahmedabad (India), which resembles the buildings at Chandigarh in the use of monumental concrete structures. It was to influence Japanese architecture in the sculptural use of *béton brut*. In 1957–60 the Sainte Marie de la Tourette Dominican convent at Eveux-sur-l'Arbresle, near Lyons, was built, an orthogonally emaciated organism surrounding an oblong inner court. *Béton brut*, exotic forms, and Rationalism have been combined to form a powerfully dissonant plastic structure. Between 1961 and 1964 Le Corbusier designed the Carpenter Center for the Visual Arts at Cambridge, Massachusetts, a composition of diagonal concrete shapes penetrated by a dominant ramp. Its realization lay in the hands of José Luis Sert. The project of the Venice Hospital, designed in 1964–65 shortly before Le Corbusier's death, returns to his original transcendentally lyrical Rationalism. Low buildings that seem to float on the water and that combine to form a loose orthogonal network, have overcome the dogmatic Purism as well as the Brutalist expressiveness of earlier works.

Throughout his active life Le Corbusier was not only an architect of genius but also a talented and passionate propagator of his own ideas. In the first half of the 1920s he exerted greater influence through his publications than through his buildings. His book *Vers une architecture*, published in 1923, is a lively, intelligible, and at times deliberately overemphasized exposé of his concepts of the architecture of the future. Numerous ar-

ticles, pamphlets, and books followed, documenting not only his remarkable capability to explain his intellectual efforts but also the will to involve the users and the public at large in the development of his architecture.

If these efforts were only partially successful, despite extensive publications and effective slogans (some of which were oversimplified in order to be clear), this is due in part to Le Corbusier's innovative creative power, which frequently overtaxed both his contemporaries and his public. According to André Malraux, Le Corbusier was the most revolutionary force in modern architecture, since nobody else had been longer or more patiently insulted than he had. At the same time it would be difficult to find another modern architect who tried more conscientiously and successfully to unite the logical and the lyrical to serve man.

Despite his generous readiness to question, time and time again, his own solutions, Le Corbusier's architectural work is characterized by a degree of unity that can only be described as classic—classic not in the sense of a rigid repertoire of form, but in that of a continuous and lively search for appropriateness, order, clarity, and harmony.

The three "masters," Walter Gropius, Ludwig Mies van der Rohe, and Le Corbusier were the formative figures of architectural Rationalism. But they were not working alone in an architectural and cultural vacuum. They were surrounded worldwide by architects who, more or less independently, produced notable works.

In Sweden, where industrialization did not take place until relatively late, an architectural school of National Realism developed after the turn of the century, which combined tradition and functionalism. As a reaction to the heaviness of its idiom and the crafts-based utilization of materials, a new interest arose shortly afterward in the lightness, abstraction, and geometric precision of Classicism and led subsequently through its free interpretation to the International Style.

122. Le Corbusier. Maisons Jaoul, Neuilly-sur-Seine. 1952–56.

123. Le Corbusier. Sainte Marie de la Tourette Dominican convent, Eveux-sur L'Arbresle. 1957–60.

Erik Gunnar Asplund, who had drawn on Classicist architecture as late as the second half of the 1920s, built in 1930 the elegant buildings for the Stockholm Exhibition in a moderate Rationalist style. The restaurant, in particular, with its slender steel columns, its glass walls, its round glass tower, and its large colorful sunroofs represented an "empirical" variation of the new architecture.

124. Eric Gunnar Asplund. Restaurant, Stockholm Exhibition. 1930.

In Great Britain pragmatic skepticism prevented Rationalism from achieving a breakthrough until quite late. In 1933–34 Wells Coates built the sparse but powerfully structured Lawn Road Flats at Hampstead, London. Together with the Tecton group, Berthold Lubetkin, a Russian émigré, realized Highpoint One, an unobtrusive nine-story apartment building with a double cruciform ground plan, at Highgate, London, in 1933–35. Highpoint Two followed in 1936–38, also at Highgate.

In Belgium Victor Bourgeois designed, during 1922–25, residential prototypes for a *cité moderne* relating back to Tony Garnier. His buildings, among them his own house built in 1925 and a studio for the sculptor O.

125. Sven Markelius. Swedish Pavilion at the New York World's Fair. 1939.

This was followed, between 1934 and 1937, by the extension of the Göteborg Town Hall, which adhered with its modern idiom to the scale of the older Classicist building. Between 1935 and 1940 the Woodland Crematorium was built in the Stockholm South Cemetery. The huge columned hall owes its origins to a Classicist approach, in spite of its rigorism.

At about the same time as Asplund embraced the modernistic idiom, Sven Markelius underwent a similar change of style when he built, together with Uno Ahrén, the functionalist students' hostel in Stockholm (1928–30), which was extended in 1952. In 1932 Markelius was responsible for the boldly articulated concert hall at Hälsingborg, which reveals the influence of Le Corbusier in its detailing. In 1939 Markelius built the Swedish Pavilion for the New York World's Fair and combined Rationalist design methods with traditional and Organic features in an intensely personal style.

Jespers of 1928 (both in Brussels), reflect his personal interpretation of the idiom of architectural Rationalism.

In the Netherlands Johannes Andreas Brinkman, Leendert Cornelius van der Vlugt, and Mart Stam built the Van Nelle Tobacco Factory in 1926–30. The transparency, weightlessness, and elegance of the curtain walls make this building one of the most important and coherent works of industrial architecture of the 1920s.

126. Berthold Lubetkin and Tecton team. Residential building Highpoint One, Highgate, London. 1935.

127. Victor Bourgeois. Prototypes of houses for a *cité moderne*. Project. 1922–25.

In France the years after the First World War were still marked by an academic architectural style that was dominated by the Beaux-Arts tradition. At the same time, Le Corbusier's ideas were the ones that provided the main stimulus for new forms of expression. The 1925 Paris Exposition Internationale des Arts Décoratifs et Industriels Modernes, which gave Art Deco its name, vividly demonstrated this ambivalence in the arts and crafts sector.

Robert (Rob) Mallet-Stevens, who moved in distinguished avant-garde circles, leaned toward Cubism, but at the same time did not lose sight of the most recent, most fashionable and ephemeral trends. Between 1926 and 1928 he built a both elegant and eclectic residential complex in the rue Mallet-Stevens in Paris.

The work of André Lurcat shows not only greater individuality, but is also more defined, both ideologically and professionally. In 1931–35 he built at Villejuif, a small town near Paris with strong communist leanings, the Karl Marx School, in close cooperation with the teachers union. The result was a

128. Johannes Andreas Brinkman, Leendert Cornelius van der Vlugt, and Mart Stam. Van Nelle Tobacco Factory, Rotterdam. 1926–30.

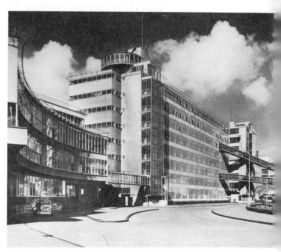

severely structured building, lightly resting on *pilotis* and skilfully integrated into the surrounding townscape, and at the same time a progressive school model.

In 1932–33 Pierre Chareau and Bernard Bijvoet built the Maison de Verre in Paris. More radical even than Le Corbusier's, this "machine for living in" reduces the two glazed facades to mere neutral curtains, behind which three stories develop freely. The poetry of modern materials is revealed in

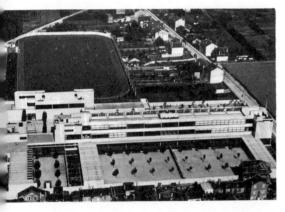

129. André Lurçat. Karl-Marx School, Villejuif. 1931–35.

each detail of the futuristic, logically devised and constructed "nautical architecture," in which fashionable tendencies make way for a bold technological allegory.

In 1937–39 Eugène Beaudouin and Marcel Lods built the Maison du Peuple at Clichy, for which the engineer Jean Prouvé designed the refined curtain wall facade. The building, giving an impression of simplicity, can be converted, by sophisticated technical installations, to meet different requirements, ranging from a covered market to a public meeting place.

In Germany the architectural avant-garde met strong resistance from the traditionalist and nationalist forces, with the latter in particular becoming increasingly influential politically after the disastrous consequences of the Treaty of Versailles.

In 1928–30 the Swiss Hannes Meyer built, in cooperation with Hans Wittwer, the German Trade Union Federation School at Bernau near Berlin. The complex is arranged according to its various functions on the sloping ground along the shore of a lake. The single parts of the building are linked by a glazed walkway.

Marcel Breuer, a Hungarian by birth, soon became known as a furniture designer, in particular for his tubular steel chairs. In 1928 he designed a hospital at Wuppertal-Elberfeld in the form of a boldly stepped building. In 1935–36 he built, together with Alfred and Emil Roth, the Doldertal apartment houses near Zurich for the architectural historian Sigfried Giedion.

In Austria Josef Frank, a follower of the Rationalist movement, who had built a simple house for the Weissenhofsiedlung in Stuttgart in 1927, found himself in conflict with his own colleagues: he saw in trivial Functionalism the formalist motivation for a new type of "anti"-decoration. By taking a stand against "organized taste" he antici-

130. Pierre Chareau and Bernard Bijvoet. Maison de Verre, Paris. 1932–33.

pated arguments that were not to appear in architectural discussions until years later.

In Italy the Gruppo 7 was founded in 1926, an association of young architects who advocated a form of architecture based on the rational analysis of constructional functions and which counted Adalberto Libera, Luigi Figini, Gino Pollini, and Giuseppe Terragni among its adherents. It represented Italy's attempt to establish links with the international avant-garde. In 1930 the foundation of the Movimento Italiano per l'Architettura Razionale (MIAR) followed, documentating the broad national diffusion of the new style. In 1927–28 Giuseppe Terragni realized the Novocomum apartment building at Como, which caused a sensation because of the daring way its corner is cut away to expose a glazed cylindrical shape. In 1932–36 Terragni built, also at Como, the Casa del Fascio, an administrative building arranged around a glass-roofed internal atrium. The harmoniously proportioned pure prism, clad with white marble, partially reveals the structural frame, which is also clad and has thus become dematerialized. The four differently designed facades are characterized by mass and space taking the functions of light and shade to produce dramatic contrasts.

In 1933–36 the Santa Maria Novella Railway Station in Florence was built according to designs by Giovanni Michelucci together with Nello Baroni, Pier Nicolò Berardi, Italo Gamberini, Sarre Guarnieri, and Leonardo Lusanna. The flat orthogonal structure with widely projecting canopies and an asymmetrically arranged "glass cascade" was erected in the immediate vicinity of the church after which it is named.

The group BBPR (Gian Luigi Banfi, Lodovico Barbiano di Belgiojoso, Enrico Peressutti and Ernesto Nathan Rogers) built in 1937–38 the Legnano Sanatorium, an elegantly functional building that was to become the emblem of Italian Rationalism.

In the Soviet Union exchanges of ideas with the international architectural avant-

131. Hannes Meyer and Hans Wittwer. German Trade Union Federation School, Bernau. 1928–30.

132. Marcel Breuer. Hospital, Wuppertal-Elberfeld. Project. 1928.

133. Giuseppe Terragni. Casa del Fascio, Como. 1932–36.

garde took place from the middle of the 1920s through the journal *Sovremennaya Architektura* (Contemporary Architecture). Among the Rationalist-inspired architects of the period was Moissei Yakovlevich Ginsburg who built, in 1930–32, the Narkomfin apartment building in Moscow, a white cuboid construction with *pilotis* and horizontal fenestration, a clear example of inspiration by Le Corbusier. In 1930–34 Alexander Alexandrovich Vesnin designed and realized the Palace of Culture for the Moscow Motor Works, in which the inter-penetration of cubic shapes and glass cylinders is elevated to a compositional principle. One year later the simple glazed headquarters of *Pravda* was built in Moscow from a design by Pantelenon Golosov.

In the United States the decline of the Chicago School with its anticipation of Rationalist principles had been followed by a banal Historicism ushered in by the World's Columbian Exhibition at Chicago in 1893. Its anachronistic products, with which the public was entertained under the banner of consumerism, had to face no competition other than the works of Frank Lloyd Wright and the cool, and at times visionarily functionalistic utilitarian structures commissioned by industry. These included the buildings by Albert Kahn, who adapted—for example in his Ford Works at Highland Park, Illinois (1922)—his architectural idiom to the requirements of the manufacturing industry.

Rationalism was first introduced into the United States by Europeans. The Austrian Rudolf Michael Schindler, a former student of Otto Wagner in Vienna, settled in Chicago in 1914, worked for Frank Lloyd Wright from 1916 to 1921, and subsequently turned to studying prefabricated systems. In 1925–26 he built the Lovell Beach House at Newport Beach, California, a luxurious private house with an unconventional layout, an aggressive system of interpenetrating structures in a reinforced concrete framework, massive projections, and vast glazed areas. Organic principles derived from Wright's work are structurally purified without their expressiveness being lost. In his subsequent buildings, mainly elegant villas in California, Schindler came closer to the International Style without neglecting plastic and decorative values.

Richard Josef Neutra, also an Austrian, was, like Schindler, influenced as a student in Vienna by the formal self-discipline of Otto Wagner, the hostility to ornament of Adolf Loos, and the poetry of interpenetrating spatial entities of Frank Lloyd Wright.

134. Alexander Alexandrovich Vesnin. Palace of Culture for the Moscow Motor Works, Moscow. 1930–34.

135. Rudolf Michael Schindler. Lovell Beach House, Newport Beach, California. 1925–26.

During the early 1920s he worked with Erich Mendelsohn, emigrated to the United States in 1923, and gained experience in steel construction while working for the architectural firm of William Holabird and Martin Roche (of the Chicago School); subsequently he collaborated with Wright and afterward with Schindler.

In 1927 Neutra produced the plans for Rush City Reformed; the studies for highrise buildings anticipated the development of American cities and have to be counted among the precursors of Rationalist skyscrapers. Lovell House (Health House), Neutra's early masterpiece, was built in Los Angeles in 1927–29. It is a weightless steel structure on a steeply sloping ground, in which interpenetrating cubic forms enclose a sequence of interconnected flowing spaces. Balconies and outer walls are suspended from steel cables. The filigree structure introduced the volumetric and constructive ethics of the European avant-garde to the United States, while allowing for local traditions, ranging from pueblos to Organic landscape architecture.

This attitude became even more apparent in Neutra's subsequent work, which included schools, hospitals, and estates, as well as luxurious villas. With the Kaufmann Desert House in Palm Springs, California (1946–47), and the Tremaine House in Santa Barbara, also in California (1947–48), in which the elegance and precision of the buildings is further emphasized by the landscaped gardens surrounding them, his idiom reached a new climax. The synthesis of attention to the psychic effects of space, molding of the building into the landscape, and care in the design of technical detail formed a style of outstanding quality.

Meanwhile the Rationalist ideas found their way into the architecture of the American skyscraper, which was at that time characterized by historicist, eclectic, and Art Deco experiments. In 1929–30 Raymond Mathewson Hood built, together with John Mead Howells, the Daily News Building in

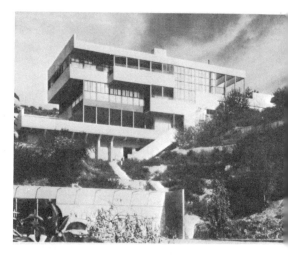

136. Richard Josef Neutra. Lovell House (Health House), Los Angeles. 1927–29.

137. Richard Josef Neutra. Kaufmann Desert House, Palm Springs, California. 1946–47.

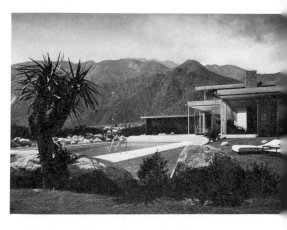

New York. The massively linear skyscraper shows its links with the tradition of the Chicago School. Decoration is limited to the Art Deco entrance area, which represents a "celestial city" supported by man. In all other respects the cuboid structure is determined by uniform bands of windows, with strong, vertical projections suggesting a

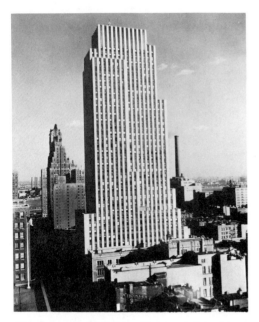

138. Raymond Mathewson Hood and John Mead Howells. Daily News Building, New York. 1929–30.

139. George Howe and William Lescaze. Philadelphia Savings Fund Society Building, Philadelphia. 1929–32.

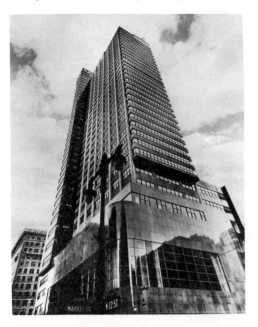

soaring tendency. The McGraw-Hill Building in New York, also designed by Hood, was built in 1930–31. The irregularly stepped building, which tapers toward the top, anticipates, with its wide horizontal windows covering the simple support structure, the glass curtain walls of the International Style.

Hood's experiences were developed further in 1929–32 by George Howe and the Swiss William Lescaze in the Philadelphia Savings Fund Society Building in Philadelphia. From a curved lower part, which invites use by the general public, rise two L-shaped vertically structured towers. The unusual linking of building and street is determined by the division of functions; the expressively projecting elevator shaft, too, indicates a functionalist background.

With their exquisite avant-garde features the Daily News Building, the McGraw-Hill Building, and the Philadelphia Savings Fund Society Building initially remained isolated phenomena in an architectural context still oriented toward eclecticism. Not until the building of the New York Rockefeller Center (1931–40) did the American Rationalist type of skyscraper achieve its breakthrough—due in no small degree to its economic advantages.

At the height of the difficulties of the economic crisis that had begun in 1929 the banker John D. Rockefeller, Jr. founded a vast speculative enterprise that cleverly utilized the conditions prevailing during the depression. He gambled on low building costs and high revenues from the land. Within the framework of a highly developed managerial and planning organization the participating architects, L. Andrew Reinhard and Henry Hofmeister; Harvey Wiley Corbett, Wallace Kirkman Harrison, and William H. MacMurray; and Raymond Mathewson Hood and Jacques André Fouilhoux, were subordinated to the management of specialized firms. Every single decision was examined in the light of strictly economic criteria based exclusively on cost and revenue calcula-

tions; architecture was reduced to the role of providing the design outline. The negative development thus initiated was to become a characteristic of late Rationalism in capitalist countries.

On an area covering almost three blocks carved out of the orthogonal street grid of New York in the center of Manhattan, the team built a group of fourteen skyscrapers in the form of narrow vertical slabs, some of which are slightly stepped. Elevators, staircases, and utilities are combined in the core, while the offices (with flexible ground plans), are grouped around it and thus optimally lit. In line with the purposeful all-determining Rationalism the architectural idiom is sparse and reticent, with vague Art Deco reminiscences.

In addition to a multitude of offices and shops, the Rockefeller Center includes Radio City with the world's largest music hall, broadcasting studios, theaters, and nightclubs. There is also a subterranean shopping center as well as a six-level multistory parking structure. The Rockefeller Plaza forms a central open space amid the urban units. Nevertheless, the commercial conglomerate does not really add up to a communal center. Surrounded by traffic and without any verdure, it is the precarious result of the morganatic marriage between progressivism and private speculation.

## City Planning

City planning was the main concern of architectural Rationalism. Socialist ideology, industrialization of the building process, and the search for a new universal formal idiom found their most plausible synthesis in mass housing. Proclamations and manifestos, utopian visions of futuristic cities, methodical studies for new types of housing, and concrete building measures all acted together in initiating solutions to the acknowledged problems.

In 1922 Le Corbusier designed plans for a Ville Contemporaine, a contemporary city for a population of three million. He based his ideas on the concept of Tony Garnier's Cité Industrielle and on the aesthetics of Antonio Sant'Elia's Città Nuova. However, he aimed not for an industrial city but rather for a complex "city of interchange" as he called it later, a metropolis with numerous and varied functions.

The Ville Contemporaine already contains all the essential elements of Le Corbusier's urban theories: an orthogonal geometric grid, skyscrapers in the form of single or multiple slabs, apartments with direct insulation and ventilation, integrated subsidiary installations, generous green spaces between

140. Le Corbusier. Ville Contemporaine. Project. 1922.

the individual high-rise buildings, and separation of access for vehicles (through a widely spaced network of urban highways) and for pedestrians (through a closely spaced system of footpaths). The main functions of the town—living, working, recreation, and transport—are separated. An attempt was made not to let traffic become a problem from the very beginning by stressing the vertical rather than the horizontal development of buildings. In 1925 Le Corbusier applied this idea, which was not tied to any particular location, to the specific example of the Paris city center: the result was the Plan Voisin project proposing the replacement of the historic urban structure by 18 super-skyscrapers, each 656 feet (200 meters) high. The necessary demolition work would have greatly exceeded the destruction inaugurated in Rome during the previous year as part of the Fascist regime's mania for self-representation. Further urban projects followed, among them the Plan Obus for Algiers (1930–34) with a "viaduct" city for a population of 180,000, extending for miles along the coast, and the Ville Radieuse project dating from 1930–36.

141. Le Corbusier. Plan Obus, Algiers. Project. 1930–34.

Le Corbusier's urban concepts became integral to the CIAM IV discussions of 1933; its resolutions were revised by Le Corbusier himself in conjunction with the French CIAM group in 1941 and published in 1943 under the title *La Charte d'Athènes*. This publication, for which the writer Jean Giraudoux wrote an introduction and which was translated into a number of languages, listed in 95 chapters the group's main theses:

—Balance of individual and communal requirements
—Dominance of the landscape over buildings; green areas for living and recreational functions, in the city as well as in the country
—Consideration of climatic conditions; insulation and ventilation
—Maintenance of historic buildings
—Unraveling, separation, and organization of the four main urban functions (living, working, recreation, and transport); housing to be given priority among the problems of urban planning; humane working conditions; generous recreational facilities; separation of vehicular and pedestrian traffic; long-distance and access traffic, etc.
—Legislation for the enforcement of these demands.

Along with Le Corbusier, the greatest theoretician in the field of Rationalist city planning, a number of other architects evolved new concepts of communal living.

In 1926 Ludwig Hilberseimer exhibited a model of a skyscraper city, the radicalism of which exceeds even that of the Ville Contemporaine. Huge uniform slabs are stacked to form two cities, the lower being the business city also accommodating road traffic, the upper the residential city, which includes pedestrian traffic. Recreational facilities and nature are banned, with persistent logic, from the urban structure in order to maintain the separation principle; with the exception of sparse roof gardens, the prismatic orthogonal artificiality remains unbroken

by trees or even grassy areas. The strict severity and the deliberate reticence of design, which does not shy away from monotony, are impressive, but the result is a city of bleak emotional coldness.

Whereas Hilberseimer based his design on the city as a whole, Alexander Klein took the opposite course. In his studies published in 1928–29 he made a thorough investigation of the elemental urban unit: the dwelling. With the help of matrices and a point evaluation system he optimized the "minimum standard housing" on the criteria of economy, functionality, and hygiene. He rationalized furnishing units, reduced distances between the single functional areas, minimized distribution surfaces, unified the open spaces, and reduced areas of shade. The methodical procedure of Klein's indepth research indicated a new approach. In his endeavor for pure objectivity, however, he neglected the emotional impact of a building and raised the specific requirements of the middle-class family to a general norm.

The contradictions contained in such utopian projects were reflected by the actual urban development programs, too, although limitations imposed by reality eroded the abstract Rationalist idealism. Between 1918 and 1921 Martin Wagner built the Lindenhof Estate in Berlin-Schöneberg, in which he anticipated the major city planning elements of later years: perimeter block building, spacious courts, a central point of focus, and a uniform architectural design.

This pattern was further developed by Bruno Taut, in cooperation with Wagner, in the Britz Estate (Horseshoe Estate) in Berlin (1925–27 and 1930–31). Taut had sublimated his Expressionist exuberance to a lively Rationalism and now created—opposite an existing estate with idyllically historicist sloping roofs and baroque-inspired decor—a plain, almost continuous frontage of three-story houses with sober facades and projecting staircases. The center, including the administrative offices of a cooperative, a café, and a laundry, is formed

142. Ludwig Hilberseimer. Skyscraper city. Project. 1926.

143. Bruno Taut and Martin Wagner. Britz Estate (Horseshoe Estate), Berlin. 1925–27 and 1930–31.

by a horseshoe-shaped unit, also consisting of a row of three-story buildings. They are grouped around a pond and form an outdoor living area of generous proportions. A carefully chosen color scheme brightens up the architectural idiom. Building costs were kept low by the use of industrial building methods.

As early as 1924 Otto Haesler had realized the first Rationalist estate to become famous, the Italienischer Garten at Celle, in which he still adhered to a loose arrangement of blocks. The Georgsgarten, built in 1928 also at Celle, shows Haesler's adoption of the regular row housing concept; the complex includes a crèche and a library. Here the individual unit is subordinate to the overall concept, and the various elements become part of a superior structure, symbol and materialization of organized communal housing.

In 1925–26 Le Corbusier built the Frugés estate at Pessac near Bordeaux: a small group of single- and multi-family houses, each with its own garden. He was less concerned with an overall urban concept, which combined rows of houses with loosely arranged freestanding units and small residential blocks, than with the propagation and multiplication of new and inexpensive types of housing.

Not until he began the project for Chandigarh, the new capital of the Indian province of Punjab, was Le Corbusier able to test his urban concepts in reality and on a large scale. The overall plan was drawn up in 1950–51 in collaboration with Edwin Maxwell Fry, Jane Drew, and Pierre Jeanneret for an initial 150,000 inhabitants, later to be increased to 500,000. A network of streets intersecting at right angles forms an orthogonal grid that separates areas of about 247 acres (100 hectares), in which the 13 castes that make up the town's population live. Each social group inhabits a different category of house, but all use the same public facilities. In the middle of the town lies the business center with the town hall; in the north, on the lively varied esplanades of the capitol, the administrative buildings are located, including the governor's palace, the Parliament building, the Secretariat with all the ministries, and the law courts. Above the Fosse de la Considération (for public debates) rises the 52.5-foot-high (16-meter-high) Main Ouverte, the emblem of the town.

The experiment of Chandigarh, which has its roots in Rationalism but at the same time has grown beyond it, shows socially regressive traits. Especially symptomatic is Le Corbusier's cynically resigned acceptance of the caste system as a "useful means of classification," the inhumanity of which he attempts to make more bearable by high architectural quality. The overall urban as well as the individual architectural solutions (which were realized until 1965 by or under the supervision of Le Corbusier) are however significant for their clarity and logic.

Walter Gropius designed and built in 1926–27 the suburb of Dessau-Törten for a population of 1,900; marked projecting and receding elements in the two-story buildings are an attempt at reaching a compromise

144. Le Corbusier in cooperation with Edwin Maxwell Fry, Jane Drew, and Pierre Jeanneret. Chandigarh, India. 1950–51.

130

between a row of single-family houses and a unified linear building. In 1927–28 the Dammerstock Estate in Karlsruhe was realized, designed for a population of 3,200, where Gropius coordinated the work of eight other architects and himself designed some of the five-story rows of houses. The taller buildings provided not only a higher residential density but also more open space and improved insulation than the traditional low buildings of the time. However, their distribution over the allotted area is schematic, and uninspired public spaces result. In 1929–30 Gropius headed a group of architects—among them Hugo Häring and Hans Scharoun, the latter being in charge of the overall plan—for the Siemensstadt estate in Berlin. There he built two five-story rows of houses with cross ventilation, large windows, and elegant linear facades.

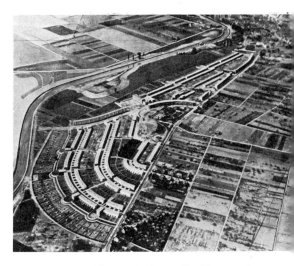

146. Ernst May. Römerstadt Estate, Frankfurt am Main. 1927–30.

145. Walter Gropius. Dammerstock Estate, Karlsruhe. 1927–28.

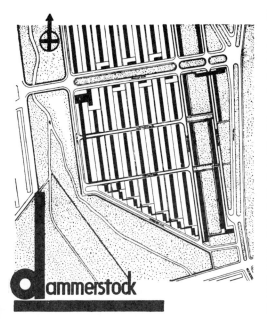

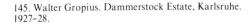

In the meantime Ernst May had started building his pioneering workers' estates at Frankfurt am Main. The stabilization of the German currency (1923) and the use of foreign capital in conjunction with the fiscal policy of the Social Democratic municipal administration formed the financial basis of the project. Following a preliminary scheme, dating from 1926, which stipulated three five-year plans, a total of 15,000 apartments for 52,000 people was to be built over the next 15 years.

May decided in favor of the satellite town principle, first developed by Raymond Unwin—a largely independent unit that, like the garden city, combined as many of the advantages of urban life as possible with those of life in the country, but that, unlike the garden city, was not conceived of as detached from the main conurbation. To realize this principle he used, for the first time in Germany, industrially prefabricated elements, which were assembled by system building methods. The consistent, economically motivated rationalization included the interior; fitted cupboards, shelving, foldaway beds and bathtubs, and the so-called

Frankfurt kitchen, a model of efficient layout, were all being mass-produced.

Of May's Frankfurt projects two stand out, the estate of Praunheim and the Römerstadt, both dating from the years 1927–30. They are both characterized by an exemplary interplay of landscape, verdure, and architecture.

Römerstadt, in particular, greatly exceeds the simple needs of sunlight, ventilation, and economy. In its attractive situation on a hillside, its complex articulation, and its great number of careful small details it overcomes the monotony of prefabricated housing. The settlement consists of two parts, linked by a shopping street that winds its way downhill in an S-curve; the joint is thus emphasized both formally, through the unusual rounded shape, and functionally, through the communal facilities. The buildings follow the sloping of the hillside terracing from the center of the estate down to the river. The frontage facing the river is marked by regularly spaced, bastionlike semicircular projections that provide an extensive view over the valley. The single rows of houses are arranged so that their fronts face the road while their backs overlook spacious gardens. Parallel streets differ in that the sides with front lawns alternate, thus alternating the distribution of projecting building elements, doors, roofs, and even garbage containers. Pedestrian footpaths intersect the garden zone and connect the roads.

Despite the economic savings brought about by rationalized construction and minimum ground plans, the rents for the Praunheim and Römerstadt settlements remained beyond the reach of most workers. In fact, the majority of tenants belonged to the lower middle class. The 1,500 apartments built by May for skilled workers at the Westhausen estate were an attempt to reduce costs even more through further reduction and simplification; but Frankfurt's housing policy was eventually doomed to fail because it did not go hand in hand with relevant measures to curb credit and building material costs. May therefore left Germany and went to work in the Soviet Union.

In Switzerland the Werkbund estate Neubühl near Zurich was built in 1929–32 with the participation of Paul Artaria, Max Ernst Häfeli, Carl Hubacher, Werner H. Moser, Emil Roth, Hans Schmidt, and Rudolf Steiger. Its clear layout and simple types of housing made it a prototype for Rationalist architecture.

In France Eugène Beaudouin and Marcel Lods built, in 1932–33, the Cité de la Muette at Drancy near Paris, and combined different building methods. The prefabricated concrete elements were designed in cooperation with Eugène Freyssinet.

# Traditionalism

## Historical Development

Architectural movements do not follow each other, but tend to develop as simultaneous streams, to be superimposed upon, and to influence one another in a continuous dialectical process. This is particularly noticeable in the movement to be summarized here as Traditionalism. It started in about 1904, when Hermann Muthesius built the first houses in Germany that were directly inspired by English country houses, and lasted until 1934, when Adolf Hitler dissociated himself, in his address on culture at the National Socialist party rally, from Traditionalist oriented architects and declared himself in favor of the Neo-Classicist style. Traditionalist architecture, on the whole, remained aloof from political, economic, and social events that had so markedly influenced both Expressionism and Rationalism. It was primarily the interpreter of the conservative bourgeoisie, a social class that stood mostly apart from progressive movements.

Although architectural Traditionalism also manifested itself in other countries, it remained predominantly a German phenomenon. The empire of Kaiser Wilhelm, experiencing a belated and immense economic upswing and driven by a strong nationalism, searched for a new identity. One of the manifestations of this search was in the field of architecture. Initially it sought this in an academic and Historicist monumentality. The change in German architecture occurred around the turn of the century, when a reformist development set in under the direct influence of the English Arts and Crafts movement. The new antieclectic current divided into two factions: one based its work on the nation's historical inheritance, which it sought to renew from within, while the other attempted to create an entirely new formal idiom. Whereas the latter related itself to the lower-middle classes and workers, the former became the self-appointed representative of the middle- and upper-classes; while one group became an enthusiastic advocate of technical achievements, the other remained stubbornly attached to the crafts; and while one movement established links with the cultural avant-garde, the other remained firmly rooted in traditional intellectual and artistic movements.

The collapse of the empire in 1918 meant the end of the Historicism based upon it and thus the end of its active influence on German architectural production. But no sooner had the common enemy disappeared than the differences between conservative and radical reformers revealed themselves clearly. Personal connections, nevertheless, did not break up, and the representatives of both trends continued to collaborate for a number of years in organizations like the Deutscher Werkbund. Not until a decade later did their controversy intensify, and the two fronts solidified when the so-called Block of the Traditionalists was founded.

The technical aids to a reformed architecture remained, in the opinion of the conservative architects, crafts-based methods and traditional building materials, such as ashlar, brick, and wood. After all, the object of their efforts was not quantity—the problem

of working and lower-middle-class housing being tackled systematically only by the progressive architectural movement of the Neues Bauen—but quality, aimed at the appropriate representation of state, church, industry, and the well-to-do middle and upper classes. If steel and reinforced concrete were included too, this meant neither the demonstration of new technical possibilities nor the beginning of prefabricated housing but simply the solution of specific static and constructional problems.

Traditionalist architecture, which rejected both the mysticism of Expressionism and the positivism of the Neues Bauen, derived its diffuse cultural superstructure from a number of sources. Like Expressionist architecture, Traditionalist architecture was inspired by the provocative writings of Friedrich Nietzsche, who rejected Historicism and socialism and regarded the great individual rather than the mass of the people as the object of culture. To this came the ideas of Paul de Lagarde, Julius Langbehn, and Arthur Moeller van den Bruck, who in contrast to the specialization of their time, aimed at a consciousness of supraindividual ties and advocated an increasing absolutism of blood and race, tribe and landscape, national heritage and national spirit.

Their radical attitude was softened by a circumspect return to the Classical and Romantic tradition, to Johann Wolfgang von Goethe and Friedrich von Schiller, and to Conrad Ferdinand Meyer and Adalbert Stifter. The heroes of the bourgeois culture *par excellence* were also those of architectural Traditionalism. Such melancholy retrospection was supported and reflected in Oswald Spengler's pessimistic *Untergang des Abendlandes* (Decline of the West), published in 1918–22. In the realm of the visual arts ties had formed with conservative academicism.

## Theories and Forms of Building

At the beginning of the twentieth century the teachings of the architect and theoretician Friedrich Ostendorf had a major influence, especially in Germany, on reformist architecture. Ostendorf postulated absolute clarity of form and advocated a return to the Biedermeier style. This trend was fueled by the fascinating but dangerously dogmatic *Kulturarbeiten* (1902–17) written by Paul Schultze-Naumburg who, with his demands for an indigenous German nationalist architecture (as opposed to the "cultural Bolshevism" of the Neues Bauen), was to become the National Socialist movement's leading architectural theoretician.

Architectural Traditionalism, which is characterized by a vague aesthetic and moral humanist tendency, can be described in five principal tenets.

—In contrast to the Rationalist effort to break with the past and to create an international artistic idiom, the adherents of Traditionalism concentrated on establishing a link between their architecture and that of bygone times and on maintaining national features. They were hardly inclined toward innovation. Thus the members of the Block, founded in 1928, all agreed that "an appropriate idiom must certainly be found for the buildings of our time, but the philosophy of life of our own people and the features of nature of the land must be taken into account."[22]
—For the Traditionalists the rejuvenation of architecture (through its breach with Historicism) had to have its origin in crafts. Modern technology was regarded with suspicion as a cold, forbidding power that threatened to destroy beauty, goodness, comfort, and "warm life."
—Local conditions were fully taken into account, including the building site, to which the building had to adapt. If such an adaptation cannot be described as "organic" as defined by Frank Lloyd Wright, this was due to an insufficient readiness to redesign types of ground plans and forms in the course of the adaptation process. The Traditionalist house fits itself into the

landscape; its mimesis, however, is not creative and planimetric, but conservative and historic.

—In contrast to that of the Neues Bauen, Traditionalist architecture did not regard all types of building as being equal. In its view, a representational building was more important than a residential building, and a residential building was more important than a utilitarian building. Accordingly, the first type was given a highly developed idiom, the second a simpler, but nevertheless solid one, while the third type was kept as simple as possible, strictly in line with its purpose. Consequently, all materials were chosen to suit their purpose. Noble materials, such as marble or ashlar, were used for noble purposes; masonry and wood for residential buildings; and concrete, a "poor" material, for industrial or technical buildings. On the other hand, it was quite permissible to use noble materials as cladding for "ignoble" materials.

—To get away from both the late Historicist over-ornamentation and the Rationalist radical rejection of all ornament, the formal idiom of Traditionalism was rigoristically simplified and reduced to its essence. "Anything new will probably be generally inconspicuous; for the untutored onlooker with no eye for what is essential, there will probably be a lack of ascertainable features. The essence, however, will be exceedingly simple; it will demonstrate complete unity between form and content and be true in all its means."[23]

The formal language of Traditionalist architecture is pluralist and largely eclectic. It is no coincidence that its model was the early Biedermeier period, an age that had been characterized by the bourgeoisie but which had still been unaffected by industrialization. It is also no coincidence that Paul Mebes's book *Um 1800* (Around 1800) was published in 1908. The reticent Classicist and Historicist architecture that it portrayed was highly appreciated because of its simplicity and dignity. Another model was the Arts and Crafts movement, especially the free structure of its buildings.

During the 1920s and 1930s the formal repertoire became increasingly reduced; the parallel Rationalist movements paved the way for a rigorism which was also adopted by Traditionalist architecture. The mostly flat and heavy buildings were still firmly rooted in the soil; steeply rising roofs predominated as before; and the traditional motifs of finely subdivided small windows, rurally inspired covered terraces and stairs, unclad ashlar, rough casting, delicate plaster coloring, and modest ornamentation remained. But the lines became clearer, the forms more austere, and the volumes more elemental. In the end the best buildings were almost abstractions of themselves. They no longer represented bourgeois individualism, but rather the essence of socially available elemental types.

*Architecture*

Between 1896 and 1903 the architect Hermann Muthesius had been assigned as an attaché to the German Embassy in London to study British housing. The impressions he received there from the Domestic Revival movement and especially from the Arts and Crafts movement, were set out in his three-volume work *Das englische Haus* (The English House), published in 1904–05. With this publication and numerous lectures, he propagated—battling against fierce conservative opposition—the ideas of new housing throughout Germany.

In 1904–05 he built Haus von Seefeld, in Berlin-Zehlendorf, where he put into practice the ideas gained in England, and in 1911–12 Haus Cramer in Berlin-Dahlem, a freely articulated building in which the architectural elements are combined in a sophisticated play of symmetries and asymmetries, carefully coordinated proportions, and shifted axes to produce an almost Organic tension. These luxurious country houses,

which were designed as a unified work of art together with their furnishings, are the rare expression of a short-lived upper-class bourgeois culture that was to disappear with the First World War. The unity of building and life-style which they represent is still unmatched in perfection, accuracy, and simplicity.

In the meantime, the Deutscher Werkbund had been founded in 1907. Its object, to unite art, industry, craft, and trade in order to improve the quality of manufactured products and thus help "German labor to gain victory in the world,"[24] was supported not only by architects like Peter Behrens, who advocated a radical renewal in building. Among the signatories of its founding manifesto were also Theodor Fischer, Richard Riemerschmid, Paul Schultze-Naumburg, and Fritz Schumacher, all architects who aimed at a more conservative architectural reform.

Theodor Fischer belonged to the same generation as Henry van de Velde and Hermann Muthesius and had built as early as 1896 a memorial to Otto von Bismarck

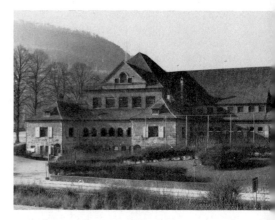

148, 149. Theodor Fischer. Pfullinger Hallen Community Center. 1904–07.

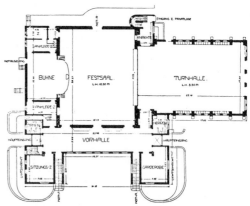

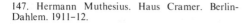

147. Hermann Muthesius. Haus Cramer. Berlin-Dahlem. 1911–12.

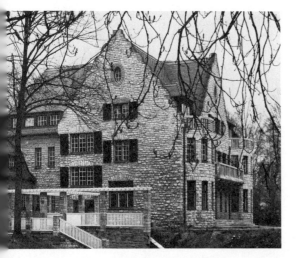

above Lake Starnberg, a shell limestone monument full of pathos. In 1904–07 he gained a commission from a public-spirited Stuttgart industrialist to build the Pfullinger Hallen Community Center at Pfullingen, near Stuttgart. This took the form of a clear, well-proportioned building, which was nevertheless experimental in its use of asymmetries. The gymnasium with its large, soberly designed space, its reinforced concrete barrel vault, and the partly visible concrete beams, is among the first examples of conscious utilitarian architecture. The use of rounded arches, typical of Fischer's work, does not contradict the principle of decora-

tive reticence. Between 1908 and 1911 Fischer built the powerful garrison church at Ulm; since the available funds did not permit the use of natural ashlar, unclad concrete and Historicist idiom were combined to create a new form of artistic expression.

Dominikus Böhm, a pupil of Theodor Fischer, became known after the First World War for his work as a reformer of Roman Catholic church architecture. As late as 1921–23 he built St. Benedictine's Abbey at Vaals in the Netherlands in the form of an eclectic and romantic edifice, with thick round towers, battlements, a pointed oriel, and delicate Moorish columns in the cloister. By the time he carried out alterations on the church of St. John the Baptist at Neu-Ulm (1921–26) and built the parish church at Frielingsdorf near Cologne (1926–27), however, he sounded a more severe note. The idiom was radically reduced and led to a multiple, abstractly Gothic

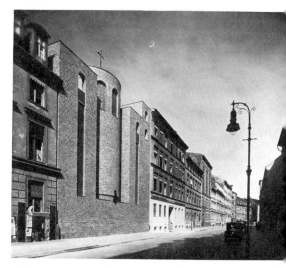

151. Clemens Holzmeister. Church of St. Adalbert, Berlin. 1931–33.

150. Dominikus Böhm. Parish church, Frielingsdorf near Cologne. 1926–27.

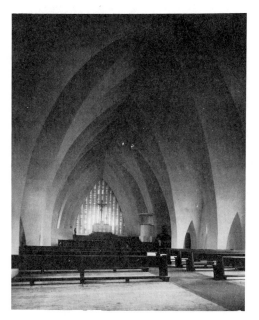

groined vault, which continues without plinth, impost, or ribs down to the ground and produces, through its uniform puristic whiteness, the impression of an insubstantial folded structure. The concrete of the heavy vaulting was applied to iron netting below the structural iron. The sophisticated light distribution, the prismatically broken surfaces, and the subtle play of light and shade produce an atmosphere of unreality.

In 1931–33 the Austrian Clemens Holzmeister, whose architectural work had also progressed from historical forms toward a freer style and an organic integration of the building into the landscape, built the church of St. Adalbert in Berlin. It is characterized by simplicity of idiom, deliberate use of expressive material, and an abstracted consciousness of tradition.

Paul Bonatz, like Dominikus Böhm a pupil of Theodor Fischer and together with Paul Schmitthenner one of the most notable representatives of the so-called Stuttgart School, built in 1907–09 the premises for the champagne manufacturer Henkell at Wiesbaden-Biebrich in a reticent Classicist

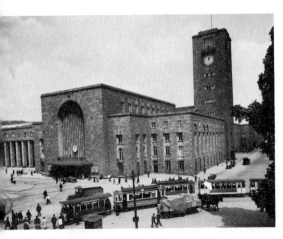

152. Paul Bonatz and Friedrich Eugen Scholer. Stuttgart Main Railway Station. 1914–28.

style. Between 1914 and 1928 he was responsible, together with Friedrich Eugen Scholer, for the building of the Stuttgart Main Railway Station, a monumental and at the same time disciplined edifice that combines in an almost functional way the internal requirements of purpose with the conditions imposed by the external environment, expressively reflecting the busy life of the city. Coming from low platform areas, travelers are channeled into a generous transverse section to which are joined an asymmetrically arranged large hall for long-

distance travel and a smaller one for local traffic. Architecturally, this articulation is stressed by two round arches of different dimensions, a row of massive Egyptian-style pilasters, and clearly differentiated building volumes which are visually united by a continuous rustic stonework.

Paul Schmitthenner, the strongly nationalistically inclined ideological leader of the Stuttgart School, designed Haus Roser in Stuttgart in 1926. In its modesty, the small house is emblematic of Traditionalist architecture. A conventional southern German regional type with a base of whitened brickwork and a steep hipped roof, its simple design is reminiscent of the Biedermeier style, marked by the arrangement of the windows as well as of the chimneys and even of the drainpipes. The axial symmetry is stressed by the external steps that lead up to the entrance, as well as by the playful dormer window, but at the same time it is upset by a slight shift of axis to the right. Then there are delicate sash bars, and filigreelike banisters. Small irregularities are consciously introduced everywhere to stress the crafted character of the house and the manual element involved in its construction. It is difficult to imagine a greater contrast between this style and Rationalism, with its cuboid shapes, sharp edges, and mass-produced windows and doors, unequivocally suggesting machine-made objects.

An outsider among Traditionalist architects was Heinrich Tessenow. All avant-garde experimentalism, but at the same time all nationalist nostalgia were alien to him. For Tessenow tradition was neither a link which had to be severed nor an ideal of the past to which one had to revert, but a spiritual attitude to which it was necessary to adhere and to consistently maintain. The first phase of the work produced by the trained carpenter is characterized by a number of designs, drawn in a very personal graphic style, for country houses reminiscent of the English Domestic Revival and occasionally of Art Nouveau. Nevertheless,

153. Paul Schmitthenner. Haus Roser. Stuttgart. 1926.

Tessenow's increasing efforts at simplification are already recognizable. In 1903 a restrained project for single-family row houses intended for the lower-middle and working classes indicated his interest in a type of housing that was normally regarded as uninteresting by his contemporaries.

In 1905 Tessenow designed two types of single-family row houses for the *Landhauskolonie* (rural settlement) Neu-Dölau near Halle an der Saale. The project was realized three years later, and reveals Tessenow's progressiveness in an exemplary way. While the type of house he chose is that of the preindustrial artisan, he rejected contemporary working-class housing, which was oriented toward bourgeois standards. For the first time the formal elements that were to become characteristic of Tessenow's work are boldly used. These include prismatic house forms; plain surfaces; gabled roofs; covered walks, with climbing plants, as semi-public areas in front of entrance doors; and jointed windows. The tradition of anonymous building is continued with a simplicity that conforms with that anonymity, and in view of the overall object of maximum utility and minimum expense, unusual formal innovations become superfluous. Tessenow had thus already outlined the "minimum housing standards" that Rationalism was to explore systematically after 1918, but without the traditional elements he incorporated in order to make identification easier.

In 1910–11 Tessenow built the houses for the garden city of Hellerau near Dresden, which were marked by a new timber-framed construction and crystalline forms. At the same time he built, also at Hellerau, the Jaques Dalcroze Institute for Rhythmical Gymnastics. The axially symmetrical complex on an almost perfectly square ground plan consists of a large banquet hall flanked by cloisters, and preceded by an entrance

hall. Attached to this are the gymnasiums with ancillary spaces, the administrative quarters, the staff rooms, and the offices. The extensive forecourt is enclosed by subsidiary buildings, teachers' and pupils' quarters, covered walks, and walls. The garden further underlines the symmetry of the whole complex. The architectural idiom

154. Heinrich Tessenow. Single-family row houses, Neu-Dölau near Halle-an-der-Saale. 1905; 1908.

155. Heinrich Tessenow. Dalcroze Institute for Rhythmical Gymnastics, Hellerau. 1910–11.

shows a Classicist inspiration, but without pathos, and almost without ornament. The central building, which houses the banquet hall, dominates the lateral buildings; the entrance, with its tall square columns and a simple triangular gable, stands out sharply. The impression created by the interior is dictated by functionality, brightness, delicately balanced proportions, and consistent, rigorous details. Tessenow believed, as did Mies van der Rohe, that designing meant the development and distribution of a small number of constantly recurring elements; he, too, chose the language of silence.

In 1925–27 Tessenow built, in collaboration with Oskar Kramer, the Saxonian Regional School in the Dresden suburb of Klotzsche, a large, clearly structured complex that derives its expressive effect from the rhythm of uniform, spare architectural elements. The individual parts, with slightly inclined roofs, are symmetrically arranged around an inner court; on the west side the complex is bordered by the wing housing the classrooms, and on the east side by the assembly hall and workrooms. On each side of the garden court, edged by tall covered walkways which extend between the main buildings, are six dormitories; they are, in turn, built around smaller private inner courts and connected by covered walks.

156. Heinrich Tessenow. Schule des Afrikanischen Viertels, Berlin. Project. 1927.

The plans for the Schule des Afrikanischen Viertels in Berlin, in which the principles of a garden court complex with pergolas, first attempted at Klotzsche, were applied even more radically, were drawn up in 1927. In his efforts to achieve simplicity, Tessenow opted for flat-roofed blocks and did not even shy away from a 705-foot-(215-meter-) long facade, the line of which was broken solely by projecting building sections and windows that varied in size, depending on their purpose, but that were completely evenly distributed.

Tessenow set down his thoughts in simple writings, in which he avoided, where possible, the term "architecture." He believed that the time was not ripe for it and that it was first necessary to evolve conditions for the (future) development of a real architecture. His humble efforts were therefore centered around functionality rather than aesthetics. He was nevertheless far from the Functionalist thesis that a house should be built from the interior outward. His starting point was the type as the elementary architectural form and at the same time as the ultimate essence of simplification. Although he initially regarded crafts-based work as the foundation of design, he soon recognized the advantages of manufacture. Moreover, the latter coincided with his intellectual need for an ordered world. In his search for a sparse idiom he arrived at that very simplification, standardization, and reduction to type that was required by industrial production methods, even though the underlying motives were diametrically opposed. His modest acceptance of traditional elements and admittance of repetition, and his evaluation of truth, objectivity, and order as being superior to innovation, did not contradict in any way Tessenow's bourgeois and democratic ideal. Instead it represented the means of considering the requirements of the individual, while at the same time subordinating them to those of the community.

Efforts to find an architectural renewal without joining the avant-garde were not

only made in Germany but also in other countries. In Finland Eliel Saarinen had built the residential building-cum-studio Hvitträsk, near Helsinki in 1902, in cooperation with Herman Gesellius and Armas Lindgren. It is a fortresslike building of high craftsmanship that shows not only the influence of the Arts and Crafts movement but also that of Art Nouveau. In 1904 Saarinen designed the Helsinki Main Railway Station, which was built between 1910 and 1914. The boldly structured stonework, the sensitive and expressive use of materials, and the simplicity of detail combined Classicist, Romantic, and Rationalist elements in a pioneering example of railway architecture. The expressive simplicity of its idiom was later to be a major influence on Paul Bonatz's design for the Stuttgart Main Railway Station.

In 1923 Saarinen emigrated to the United States. From 1926 onward he built the complex of the Cranbrook Academy of Art in Bloomfield Hills, Michigan, in which the formal elements are further simplified, without abandoning traditional and Classicist links. His preference for severe outlines was to lead in subsequent buildings to a sparse Neo-Classical solemnity.

157. Eliel Saarinen. Helsinki Main Railway Station. Designed 1904; Built 1910–14.

158. Eliel Saarinen, Herman Gesellius, and Armas Lindgren. Residential building and studio "Hvitträsk," near Helsinki. 1902.

159. Auguste Perret. Théâtre des Champs-Élysées, Paris. 1911–14.

In France, Auguste Perret, who had built an early Rationalist house in the rue Franklin in Paris, proceeded in the Théâtre des Champs-Elysées, originally designed by Henry van de Velde and then redesigned and built (1911–14) by Perret, to transform the reinforced concrete structure into a light, Classicist-inspired framework. The synthesis of traditional architectural idiom and use of materials appropriate to the twentieth century were to characterize his future work as well.

### City Planning

Traditionalist planning of cities and especially of settlements was the continuation and further development of the ideas first propounded by Ebenezer Howard in his garden city projects as well as of those for the dissolution of cities demanded by the Expressionists, among them Bruno Taut. This was due to three factors.

—Politically, it was hoped that by alleviating the housing shortage in the large cities through developments outside the cities it would be possible to prevent the collective organization of the workers; moreover, forms of settlement similar to those of the company towns were thought to tie the workers to their own piece of land and thus to a certain place.

—Technically, small loosely arranged estates with one- to three-story buildings were more in line with crafts-based or only partly industrialized forms of construction.

—Culturally, the bourgeois individualist ideology, the regressive crafts romanticism, the earthbound traditionalism, and the advocacy of simplicity all led to a revival of enthusiasm for rural forms of housing.

Because, as a result of identical political and technological preconditions, housing propagated by the Neues Bauen also did not attain an urban character, was situated at the edge of, or away from conurbations, and was of the same low density, the ideological and cultural discrepancies between tradition and the avant-garde were almost entirely limited to form. This was understood not only in an aesthetic sense but also and especially in a social one. Both conservatives and progressives were convinced that architectural forms not only reflected the life of men but were also capable of influencing and changing it. "To build settlements in the style of the Neue Sachlichkeit means making the bourgeoisie proletarian; to build settlements in the style of Schmitthenner means making the proletariat bourgeois."[25]

The Staaken Garden City, built by Paul Schmitthenner between 1914 and 1917 for the workers of the state armaments industry at Spandau near Berlin, illustrates this with great clarity. On an almost exactly rectangular piece of land, which would have been ideally suited for a geometric layout, the estate was built according to an orderly plan, but avoided rigidity through deliberate

variations, with curved roads and homely squares. The conservative ideals of that period—*Heimatschutz* (landmark preservation), green spaces, adaptation to the surrounding countryside, return to the building traditions of about 1800, and use of regional building materials and methods—were taken into account. The houses, some of which were plastered while others were left with masonry exposed, have plain double roofing, dormer ventilators, oriels, and small front gardens. Their style is eclectic, and what matters is not historical accuracy but the association linked with the forms. Common to all of them is the bourgeois character, which is reflected even in the names of the streets—*Eichenwinkel* (Oak Corner), *Am Pfarrhof* (Parish Place), *Zwischen den Giebeln* (Between the Gables). The workers' settlement is camouflaged as a small bourgeois German town.

In 1933 Schmitthenner, together with Paul Bonatz, built the Kochenhof Siedlung in Stuttgart. The first impetus for this settlement project goes back to the year 1927, when the Deutscher Werkbund decided to build a model settlement on the occasion of the Stuttgart exhibition Die Wohnung (The Dwelling) and asked Europe's architectural elite to make contributions. Among those invited were Bonatz and Schmitthenner. Bonatz designed a layout, according to which gabled houses were to have been built, but this was rejected by several participants. Subsequently, Mies van der Rohe was invited to draw up, together with Bonatz, a new plan. The collaboration failed, and both Bonatz and Schmitthenner withdrew from the project. In the next year they founded the so-called Block and six years later they built the Kochenhof Siedlung as an "anti-Weissenhof" estate in a typical homely, indigenous style. Claims to create a prototypical German domestic architecture resulted, finally, in a mostly banal "blood and soil" idiom.

In 1928 Heinrich Tessenow was put in overall charge of the experimental settle-

ment Fischtalgrund in Berlin-Zehlendorf, built on behalf of a nonprofit organization, the Gemeinnützige Aktien-Gesellschaft für Angestellten-Heimstätten (GAGFAH), which postulated steeply pitched roofs. Together with Hans Poelzig, Paul Schmitthenner, and others, Tessenow built a number of houses and groups of houses in a conservative idiom. Compared with the buildings of another settlement in the immediate neighborhood, Onkel Toms Hütte (Uncle Tom's Cabin), built on behalf of another nonprofit organization, the Gemeinnützige Heimstätten-, Spar- und Bau-Aktiengesellschaft (GEHAG), and realized between 1926 and 1931 with extensive contributions by Bruno Taut, Hugo Häring, and Otto Rudolf Salvisberg and stipulating flat roofs, large areal windows, and linear units, the conservative houses appeared as a provocation and illustrated vividly the theoretical and ideological conflict of the period.

In addition to new settlements being designed, a number of towns were enlarged during the period and in the spirit of Traditionalism. One example will serve as an illustration: in 1915 Eliel Saarinen designed plans for the development of Munkkiniemi-

160. Paul Schmitthenner. Staaken Garden City, Berlin-Spandau. 1914–17.

Haaga, in northwest Helsinki. These were based on a general, universal historical analysis of city planning principles, as well as on in-depth demographic forecasts. A rich typological collection of squares, boulevards, and tree-lined and plain streets was to be carefully distributed as a complex network of formal relations over an area of more than 2,125 acres (860 hectares), accentuating its flat valleys and low hills. The suggested buildings ranged from monumental city structures and large apartment buildings to linear housing developments, isolated villas, and single-family working-class houses. The residential area was to have been interspersed with green parks, separating it from the adjacent industrial area. Saarinen worked out his project down to ground plans and elevations of prototypical buildings, which were oriented toward local building traditions. However, this pioneering concept was based on a speculative intention. The project, which also prefigured a Greater Helsinki, was commissioned by the manufacturer Sigurd Stenius, who had bought the land in 1910. Following Saarinen's all but casual recommendations, after 1917 he built part of the road system, a streetcar line, and a number of buildings in Munkkiniemi. He thus created a situation that was impossible for the city administrators to ignore when Helsinki expanded. They bought the land from Stenius in 1946, and extensive development took place during the 1950s.

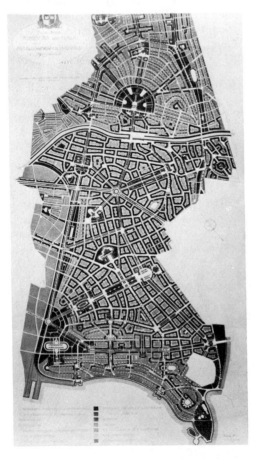

161. Eliel Saarinen. Plan for Munkkiniemi-Haaga, Helsinki. 1915.

# ⑥ | Neo-Classicism

## Historical Development

Throughout most of Europe the period between 1929 (the beginning of the worldwide economic crisis) and 1945 (the end of the Second World War) was characterized by increasing political radicalism. With varying degrees of success, nationalist and totalitarian movements tried to assume power. Their path was definitively paved by the great economic depression, but their roots, in most cases, reached further back into the past.

In Italy, Benito Mussolini had assumed power in 1922 after his March on Rome, and in 1928 the Fascist Grand Council became incorporated into the Italian constitution. Parliament was effectively dissolved by an electoral reform. In 1936 the Berlin-Rome Axis in conjunction with the National Socialist German Reich was proclaimed.

In Germany the attempted coup in 1923 by Adolf Hitler, who had been the leader of the Nazi party since 1921, was suppressed in Munich by the Bavarian government. Ten years later Hitler, who during his imprisonment in 1924 had written down his political program in *Mein Kampf*, was appointed chancellor of the Reich. In the same year the Reichstag was dissolved, the basic rights of the constitution were suspended, trade unions and the Communist and Social Democratic parties were banned, and the other parties were "persuaded" to dissolve themselves. Elections for the Reichstag at the end of the year gave the Nazi party 92 percent of votes cast.

In the Soviet Union the death of Vladimir Ilyich Lenin in 1924 signified the onset of the fight for his succession between Lev Davidovich Trotsky and Joseph Vissarionovich Stalin. When Trotsky was banished from the Soviet Union in 1929 the Stalinist era began, the purges starting in 1934. Similar tendencies became apparent in numerous other countries. In Poland Joseph Pilsudski introduced a dictatorship after the coup of 1926 under the guise of a "guided democracy." In Yugoslavia a military dictatorship was established after the coup by King Alexander in 1929. In republican Finland the nationalist Lapua movement succeeded in introducing legislation against Communists "for the protection of the republic" in 1930. In Spain José Antonio Primo de Rivera, son of the former Spanish dictator, founded the Fascist Falange; after the civil war (1936–39) between the government of the Popular Front and the conservative forces under General Francisco Franco, which were supported by Hitler and Mussolini, Franco established a totalitarian regime. In Austria Chancellor Engelbert Dollfuss excluded Parliament after a coup in 1933 in favor of an authoritarian Christian Socialist government ("Austro-Fascism"). In France Fascist groups attempted a coup in 1934 but were unsuccessful.

The authoritarian regimes were faced with the necessity of hiding the arbitrariness of their totalitarianism behind an aura of respectability. Their means included ambitious building programs. Whereas housing was mainly neglected (with the result that the housing shortage, combated in vain during the 1920s, became even worse), ostentatious representational buildings were

erected to provide largely questionable governments with superficial splendor. Rich facades and grandiose monuments attempted, not unsuccessfully, to divert attention from the misery of the tenement buildings and slums.

The technological advances of this tortured era barely affected the building industry. From 1929 onward, the worldwide economic crisis and the ensuing high unemployment figures were a disincentive to mechanization and rationalization. It was necessary, rather, to increase the labor intensity of production processes, so that the maximum number of people could be employed, and traditional building methods were the most appropriate for the goal. When an economic upsurge began during the mid-1930s, as a result of the deterioration in the political climate, it was the armaments industry (which indirectly included Germany's highway system, begun in 1933) rather than the building industry that benefited. From 1939 onward the war increasingly limited building activity in any event.

Culturally, particularly in Germany and Italy, attempts were made to simulate an intellectual revolution that was, in effect, nothing more than a hasty revival of opportunistically chosen, suitable aspects of the past. Paradoxically, the supposed vitality of "new" forms of society was represented by a conservative idiom. The National Socialists were provided by Alfred Rosenberg, later minister for the occupied eastern territories, who in 1930 wrote *Der Mythos des 20. Jahrhunderts* (The Myth of the Twentieth Century), with a pseudoscientific justification of their nationalist, anti-Christian, and ahistorical philosophy. Consistent with the new political realities, artistic and literary avant-garde movements, which had arisen during the socially progressive ferment after the turn of the century, were declared "degenerate" after the displacement of parliamentary democracies by authoritarian regimes. The artificially constructed specter of a "cultural decline," nourished by well-aimed mass propaganda as well as by a disenchantment with the "isms" of the 1920s, ended in National Socialist Germany in the public burning of books in 1933. The stipulation raised after the First World War that artistic activity be realistically linked with the social requirements of modern society was abandoned in favor of an imprecise flight toward spiritual, "pure" ideals. Cultural production was severed from progressive ideological, social, and technical developments and relegated to subservience to the ruling forces. Academicism, which existed both in Europe and in the United States since the beginning of the twentieth century, showed a spectacular gain in popularity.

*Theories and Forms of Building*

Depending on the respective national background and history, the architectural Neo-Classicism of the 1930s and 1940s had differing social, political, and theoretical roots. It is nevertheless possible to locate an abstract common denominator. Neo-Classicism had the task of giving expression to the existing forms of government, of legitimizing them, and of contributing to their consolidation. This was stressed with particular clarity by Adolf Hitler in his speech on culture at the 1937 National Socialist party rally: "The adversaries will sense it, but especially the supporters have to know it: these buildings are being erected to strengthen this authority . . . . Because it is they who will help to unite and strengthen our people politically more than it has ever been, they will become for the German people an element in the proud feeling of belonging together, they will demonstrate socially the absurdity of other worldly differences when compared with the mighty and gigantic witnesses of our community; psychologically they will provide the citizens of our people with a boundless self-confidence, which is: to be Germans."[26]

For this purpose architecture referred to the past. The return to forms of building

used during historic and supposedly legitimate regimes was to justify the present governments as well. A scientifically unprovable and frequently nonexistent relationship with the glorious heroes of history was architecturally suggested. It was not by accident that in Fascist Rome large-scale archaeological excavations flanked the impressive and undeniably effective architectural references to the classical national tradition. All this took place on a collective level, on which the individual was not only not dialectically respected, but on the contrary, to use National Socialist terminology, "brought into line." It is only logical that such centralized tendencies turned against every architectural plurality, against the coexistence of different stylistic approaches, and, consequently, against crafts as an independent creative force.

The ideal model was, therefore, no longer the Gothic cathedral with its sublimation of original artistic contributions, but the Greek temple, the Renaissance palace, the Baroque castle, and the Classicist building of the Empire era—works, in other words, in which the effort of the individual is completely subjugated to the overall formal concept. After the functionally oriented, plain asceticism of the Neues Bauen there was a reemergence of rows of Classical columns, monumental flights of stairs, and ornate cornices. Noble materials, such as marble and travertine, chastely covered the reinforced concrete support structures that were considered "unworthy." The architectural idiom was once again determined by axes, symmetries, and proportions. The format of the buildings became monumental; size per se became the architectural means and backdrop for the demonstration of the power of a dubious "community."

On the other hand, Neo-Classicism also manifested itself in bourgeois democratic nations such as the Scandinavian countries, France, and the United States. The phenomenon itself cannot therefore be linked exclusively to totalitarian forms of government but has a genuine cultural autonomy. One of its manifestations was in its relationship to contemporary architectural movements: Neo-Classicism shared an element of conservatism with Traditionalism, and through its formal rigorism was weakly linked to architectural Rationalism.

*Architecture*

It is one of the paradoxical features of the architectural Neo-Classicism of the 1930s and 1940s that it developed, despite its decidedly nationalist claims, into a largely international architectural movement. What the International Style was accused of, namely the disregard of qualities characteristic of individual countries, applies equally to Neo-Classicism. It is nevertheless appropriate to group the architectural output that falls under this heading by countries in order to place it into the context of the respective political situations.

In Italy Mussolini soon discovered the usefulness of the Roman Empire and its architectural manifestations as illustrative support for his newly installed regime. Between 1924 and 1938 he furthered numerous archaeological enterprises in and around Rome, while endorsing at the same time those Neo-Classicist tendencies in the new architecture that were oriented toward Roman antiquity. Nevertheless, in contrast to National Socialist Germany, for example, the two movements of Rationalism and Neo-Classicism existed side by side for a relatively long period of time in Fascist Italy. The adherents of avant-garde architecture, among them the MIAR and Gruppo 7, could still hope, as late as the mid-1930s, for a political decision in their favor. The remarkable cultural vacuum that existed under the Fascist regime made it possible, despite difficulties, for Rationalism to continue until Italy entered the Second World War and even beyond 1940.

However, under the leadership of the architect Marcello Piacentini Neo-Classicism soon became the official architectural

162. Marcello Piacentini. Rectorate Building, Città Universitaria, Rome. 1934.

163. Bruno Ernesto La Padula. Palazzo della Civiltà Italiana, EUR, Rome. 1937–42.

(University City) was built. Piacentini designed the monumental layout plan, with a number of architects realizing the university complex within this framework. Behind the impressive columnar portal of the entrance the buildings were arranged in rows on either side of a wide road leading to a square. Piacentini himself designed the severely axial travertine-clad Rectorate Building. The large flight of stairs leading up to the entrance; the tall columns with square sections and without plinths and capitals, soaring over several stories; the pathetic reliefs in the style of figurative Realism; and the solemn Latin inscriptions of the friezes are typical of Italian Neo-Classicism. Ornaments are reduced to a minimum and the building relies for its expressive effect on the dimensions, the geometrical severity, and the volumetric interplay of its orthogonally staggered parts, and on the juxtaposition of the continuous, seemingly razed flat surfaces with sharply incised, rhythmically arranged rectangular apertures.

In 1937–42 Piacentini designed, in collaboration with Giuseppe Pagano, Luigi Piccinato, Ettore Rossi, and Luigi Vietti, the center of the satellite town EUR (Esposizione Universale Roma) near Rome for the E42 World Exhibition, which, because of the war, never took place. Initial realization stages involved the work of some Rationalist representatives, among them the group BBPR and Adalberto Libera, as well as of followers of Italian Neo-Classicism.

Between 1937 and 1942 the domed church of Saint Pietro e Paolo, designed by Arnaldo Foschini, was realized at EUR, a building almost without ornament and kept in a reductive idiom while still remaining theatrical in its setting in relation to the landscape. At the same time Bruno Ernesto La Padula built the Palazzo della Civiltà Italiana, a clearly outlined cubic structure, with plain round arches cut into smooth walls completely without ornamentation. The identity of form and supporting structure is abandoned. The reinforced concrete

style of the regime. Owing to his political opportunism, Piacentini, a prominent representative of the Novecento Italiano, a lively form of conservative academicism, received numerous commissions and covered, within a short time, the entire country with colonnades, Roman arches, and towers in the Lictorial style.

In 1932–35 Rome's Città Universitaria

164. Wilhelm Kreis. Adolf-Hitler-Platz, Dresden. Project. 1942.

the frontiers of Europe as somber places to honor the war dead. In 1942 he designed the megalomaniac building complex around the vast Adolf-Hitler-Platz in Dresden.

Paul Ludwig Troost, a conservative architect of the generation of Auguste Perret, a personal friend of Hitler, and the first "Führer's Architect," built in 1933–34, during the reconstruction of the Königsplatz in Munich, the Führer Building, the administrative building of the Nazi party, and the two Temples of Honor, in which the "Blood Witnesses of November 9, 1923," who had been shot during Hitler's attempted coup, had been buried. On shell limestone plinths, 23-foot-high (7-meter-high) columns, with wide fluting inspired by the Doric style, supported a heavy open roof designed for the Eternal Watch. The bulky, strictly symmet-

skeleton is hidden behind thin white marble slabs and the arches have no structural function. The dematerialized composition, which might be borrowed from Giorgio de Chirico's *Pittura metafisica*, places all the emphasis on form and on its symbolic and historical implications.

A decade after Mussolini had used the architecture of the Roman Empire to provide his regime with a backdrop of suitable impressiveness, Hitler started to employ similar methods in Germany. In this context, two architects belonging to the older academic tradition were initially given the opportunity to put their anachronistic ideas into practice.

Wilhelm Kreis, a former assistant of Paul Wallot, the architect of the Neo-Baroque Berlin Reichstag, had built, as a successful and fashionable young architect of the Kaiser era, a remarkable number of Bismarck Towers in a massive Historicist style. In 1938 he designed the axially arranged building for the High Command of the Army and the massive Soldiers' Hall to be situated on the north-south axis in Berlin. After 1940 he worked, together with his staff, on the Totenburgen, the castles of the dead, which were planned to be built along

165. Paul Ludwig Troost. Temple of Honor, Munich. 1933–34.

rical structure completely overpowered the elegant neighboring buildings by the Classicist Leo von Klenze. Also in Munich and in 1933, Troost started construction on the severe geometric Haus der Deutschen Kunst (House of German Art) with its monumental Doric colonnade. It was completed in 1937, three years after Troost's death.

Albert Speer, who took over from Troost as chief designer and architect of all Nuremberg building projects, did not come from the old academic school of architects. He had hardly completed his academic studies when he adopted the Neo-Classicist style and developed it into Hitler's state architecture. Thus he, paradoxically a pupil of the modest Tessenow, became the most prominent architect of the Third Reich. Between 1934 and 1937 Speer built in Nuremberg the Memorial for the Dead of the First World War, the Luitpoldarena, and the reviewing stand on the parade square of the Zeppelinfeld, which consisted of a flight of stairs, 1,279.5 feet (390 meters) long and 78.7 feet

166. Albert Speer. New Chancellery, Berlin. 1938–39.

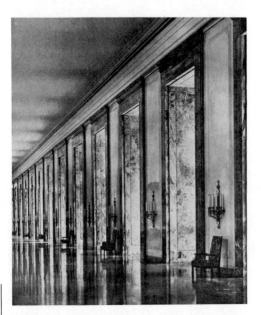

(24 meters) high, topped by a long colonnade and flanked at the sides by stone abutments. Partly because of Hitler's wish for durable workmanship and partly following the theory that a building should retain its heroic expression even as a ruin, these structures, including their foundations, were made almost without exception from massive stones; the structural "honesty" of architecture—although postulated differently than in Rationalism—was singlemindedly adhered to.

In 1937–39 Speer designed and built the New Chancellery in Berlin. Due, in part, to the narrowness of the available site, the rooms were arranged along an extended axis. One entered the complex through great gates leading into a court of honor, from which one proceeded, via an outside staircase, into a small hall and from there, through double doors almost 16.4 feet (5 meters) high, into a hall clad in mosaic. One ascended further steps, passed through a round room with a domed ceiling, and found oneself at one end of a gallery, 475.7 feet (145 meters) long, which led into Hitler's reception hall. The Neo-Classicist idiom was mixed with Historicist and native rustic architectural elements such as a pseudo-Romanic cross-vaulted cloister. The confused eclecticism of the National Socialist style reflected the lack of clarity of its underlying ideology.

On the basis of sketches made as early as 1925 by the would-be artist Hitler ("If Germany had not lost the World War, I would not have become a politician but a famous architect—a sort of Michelangelo"[27]), plans and models for the Berlin Führerpalast and the Great Hall were produced between 1936 and 1941. In the new building designed by Speer, the route from the entrance to Hitler's study would have been extended to 1,640.4 feet (500 meters) to impress and humble the foreign diplomats. The Great Hall, in a dry Neo-Classicist style, was to hold, in an area of 409,000 square feet (38,000 square meters), 150,000 people; the

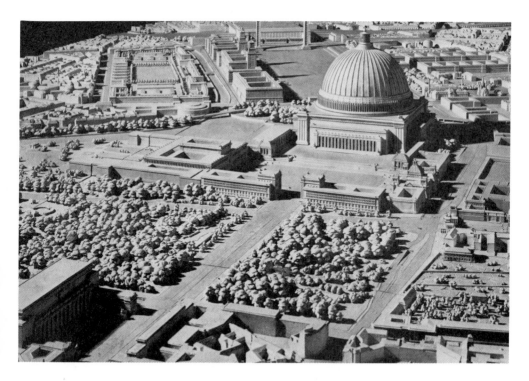

167. Albert Speer. Great Hall, Berlin. Project. 1936–41.

square substructure, with each side measuring 1,033.5 feet (315 meters), was to have been spanned by a self-supporting dome with a diameter of 951.4 feet (290 meters). The immense scale was deliberate; it was to represent the greatness of the National Socialist movement.

In the Soviet Union the revolution of 1917 and the ensuing architectural Constructivism had in no way removed the academic and Classicist architectural tendencies. With regard to the relation to the past Lenin had said in 1920: "We cannot possibly resolve the problem of proletarian art without a clear understanding and a precise knowledge of the culture which has been created in the course of human history. Only on this basis can a proletarian culture be defined."[28] Since it had, moreover, been decided that bourgeois culture contained valuable elements and that it might be adopted by progressive forces, the conservative countermovement to the Constructivist "architecture of hope," the Neo-Classicist "architecture of remembrance," was regarded with benevolence by the Soviet government.

In 1923 the avant-garde Association of New Architects (ASNOVA) was founded by Nikolai Ladovski. From Constructivism it adopted, albeit in a moderate form, the duality of technology and ideology. Architecture, it was stated, must enter into a close association with progressive technology; on the other hand, however, architecture must not be a mere reflection of technical and functional conditions but must actively impart an emotional expression to the new political ideals. Its aesthetic effectiveness must be enhanced by the utilization of scientific methods.

Two years later the Association of Contemporary Architects (OSA) was created as a result of a division within ASNOVA and

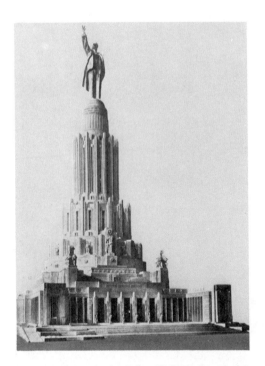

168. Boris Mikhailovich Iofan, Vladimir Georgievich Gelfreikh, and Vladislav Alexandrovich Shchuko. Palace of the Soviets, Moscow. Project. 1934.

was later to become the Section of Architects of Socialist Buildings (SASS). In their journal, *Sovremennaya Arkhitectura* (Contemporary Architecture), the OSA adherents preached the most radical Functionalism, proclaiming that the external form is neither an essential characteristic of proletarian architecture nor the emotional stimulus which it may produce in the mass of the people, but solely the scientific translation of the tasks of Bolshevism into a spatial organization. Any attempt to influence the spectator by a building was rejected as manipulation.

Apart from lively polemics the two groups had one common objective: the breach with the past. This aim was rejected by the Neo-Classicist All-Russian Association of Proletarian Architects (VOPRA),

founded in 1929, which fought not only against the tenets of ASNOVA but also against those of the SASS by advocating Socialist Realism. On one hand it accused Constructivism, with its search for objective visual laws, of bourgeois opportunism, since its formalism was said to stem from an idealist ideology and not from Marxism. Rationalism, on the other hand, was censured for giving preference to narrow function rather than broader task and for not suitably representing the latter, which may embrace a number of functions. Moreover, their ascetic architecture was said to cheat the working class out of one of its most effective weapons and well-deserved pleasures, namely the emotional suggestion of art, the pathos of architecture as a means of rousing the masses. The decision of the Central Committee of the Communist party to unify the organizations representing literature and art (1932), calling for the dissolution of all individual artists' associations and for organizing architects into the centralized Association of Soviet Architects (SSA), meant the political ratification of Neo-Classicism.

As early as 1931 the international competition for the design of the Palace of the Soviets in Moscow had been won by Boris Mikhailovich Iofan with an oversized monumental academic project, while plans by Walter Gropius, Le Corbusier, Erich Mendelsohn, Hans Poelzig, Auguste and Gustave Perret, as well as by representatives of Russian Rationalist avant-garde architecture, among them Moissei Yakovlevich Ginsburg, were largely ignored. The second revised project for the Palace of the Soviets, designed by Iofan together with the older architects Vladimir Georgievich Gelfreikh and Vladislav Alexandrovich Shchuko in 1934 and accepted by the government in 1937 (but never realized), was even more megalomaniac. The gigantic statue of Lenin, which was to have crowned the stepped, tapering assemblage of Neo-Classicist and Art Deco elements, would have stood at a height of 1,374.6 feet (419 meters).

In 1934–40 Karo S. Alabyan and Vassili N. Zimbirtsev built the Red Army Theater in Moscow, a naively symbolic structure in a pseudo-Classicist style. The ground plan is in the shape of a Soviet star, as are the sections of piers surrounding the building on all sides. In 1936–41 Noah Trotsky realized the House of the Soviets in Leningrad. A huge symmetrical block dominated by a colossal order extending over seven stories, it has a frieze with relief sculptures in the style of Socialist Realism. In 1938 Alexei Viktorovich Shchussev built the Tbilisi branch of the Institute for Marxism-Leninism, which again is characterized by colossal columns combined with endless rows of windows. As recently as 1949–53, the Lomonosov State University was built in Moscow under the direction of Lev Vladimir Rudnev, a monumental Historicist high-rise structure firmly anchored to the ground by extensive wings.

In Finland Johan Sigfrid Sirén built the Eduskuntatalo (Parliament Building) in Helsinki in 1927–31. With its monolithic outline and tall columnar front, the severe building is a monument to the country's newly gained independence. The exterior is

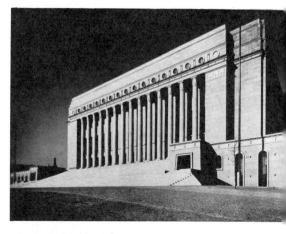

170. Johan Sigfrid Sirén. Eduskuntatalo (Parliament Building), Helsinki. 1927–31.

171. André Aubert, Marcel Dastugue, Jean-Claude Dondel, and Paul Viard. Musée National d'Art Moderne, Paris. 1935–37.

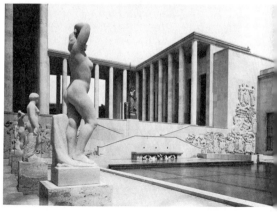

169. Lev Vladimir Rudnev, S. Chernyshev, P. Abrosimov, A. F. Khryakov, and V. Nasonov. Lomonosov State University, Moscow. 1949–53.

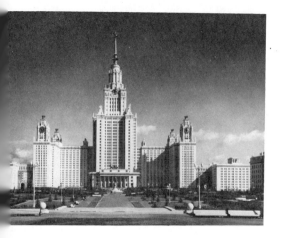

entirely clad with pink granite; the material underlines not only the representational function of the building but also its national significance.

In France André Aubert, Marcel Dastugue, Jean-Claude Dondel, and Paul Viard built, in 1935–37, the Musée National d'Art Moderne in Paris. Its two wings, one for the municipal collection, the other for the state collection, are grouped symmetrically around a court of honor bordered by slender columns. The reinforced steel skeletal structure and the walls are stone-clad.

172. John Russell Pope. National Gallery of Art, Washington, D.C. 1937–41.

In the United States John Russell Pope designed, in 1937, the National Gallery of Art in Washington, D.C., which was completed in 1941, four years after the death of the architect. The building is firmly rooted in the Classicist tradition, which had been introduced by James Hoban with the White House, built in 1792–99, which had subsequently been renewed by the City Beautiful movement around the turn of the century, and which determined building activity in the capital until well into the 1930s. The comples is marked by perfect symmetry; the main entrance in front of the central domed rotunda is emphasized by a portico with two rows of columns.

### City Planning

The housing policy of the early 1930s was, both in Europe and the United States, predominantly antiurban. The economic crisis of 1929 reduced the towns to places of deep misery and hunger so that the country, where it was at least possible to achieve some degree of self-sufficiency, became once again attractive. Totalitarian governments such as the National Socialist regime in Germany, readily approved of such decentralization moves, since they allowed the employment of out-of-work industrial workers in agriculture and at the same time made it easier to politically control small, isolated units. Moreover, the current *völkisch* ideology glorified country and village life. For a time it seemed as though highly industralized nations were reverting—through the dissolution of the large conurbations, which were said to sap the "strength of the people"—to communities of farmers and "agricultural citizens."

During the second half of the 1930s the revival of industry and the imperial ambitions of the totalitarian regimes led to a revaluation of urban structures. Capitalist demands for efficiency of production and trade centralized the power of the state, and the need for historic legitimacy led to cities becoming once again the focus of attention. This economic, political, and ideological about-face resulted in contradictory forms of urban planning: on the one hand small estates, mainly in eclectic styles, and on the other massive redevelopment programs for cities like Rome and Berlin in a bombastic New-Classical idiom.

In Italy, several small towns were founded south of Rome on land reclaimed by the draining of the Pontine marshes. In 1933–34 Gino Cancellotti, Eugenio Montuori, Luigi Piccinato, and Alfredo Scalpelli drew up the plans for Sabaudia, a clearly structured but nevertheless varied settlement, which made use of the experience of Rationalist planning in Germany and was subsequently realized. In terms of architectural idiom Sabaudia is sparse and simple. Later developments at Littoria (now Latina), Pontinia, Aprilia, Guidonia, and Pomezia are more "homely." Between 1937 and 1939 Ignazio Guidi, Eugenio Montuori, and Cesare Valle built the small town of Carbonia in Sardinia, where the linear building methods and blocks used in the Pontinian settlements were abandoned in favor of small single- and multi-family houses with gardens and gabled roofs.

At the same time the restructuring of old cities had begun. In 1926 Mussolini had announced: "The Fascist regime will enter history through its concrete works, through the actual, physical, deep changes in the face of the Fatherland. In ten years, Comrades, Italy will be unrecognizable."[29] This prophecy was literally fulfilled: numerous historic city centers were brutally destroyed to make room for great axes and prestigious boulevards, changing the face of many Italian cities beyond recognition.

Rome was particularly affected, since the regime's mania for self-representation was aggravated by the requirements of archaeological sites as well as by speculation. In 1924 demolition work began on the Fori Imperiali, and in 1932 Corrado Ricci opened the arterial road Via dell'Impero between the Piazza Venezia and the Colosseum. In 1934 the area around the mausoleum of the Emperor Augustus was cleared to give the monument the "necessary solitude" decreed by Mussolini. From 1937 onward the predominantly medieval buildings of the Spina di Borgo were demolished and replaced, under the guidance of Marcello Piacentini and Attilio Spaccarelli, with the Neo-Classicist Via della Conciliazione (completed in 1950), which provided axial access to St. Peter's Square. While the cars of the wealthy sped along the new futuristic boulevards, the socially uninfluential classes affected by "improvement" schemes were banished to miserable suburban estates.

In Germany, the National Socialist government, which had blatantly promised in its "fighting days" that each German would have his small house in the country and each worker a home where he "would feel as though he were in a castle,"[30] now ranked housing behind the construction of highways, the rearmament of the nation, self-sufficiency in the production of foodstuffs, and exports. Whereas it aimed, on the one hand, at the full control and guidance of housing construction, on the other it reduced subsidies and placed the financial burden of building on private initiative, which had been boosted by the upturn in the economy. The result was small rural settlements—strings of gabled houses, each with its own small garden.

In 1938 Peter Koller designed plans for the Stadt des Kraft-durch-Freude-Wagens, the "town of the strength-through-joy car" (the Volkswagen), later Wolfsburg. In the final analysis practical National Socialism did not produce much more than an enlarged version of the nineteenth-century company towns. The underlying political aims were also the same: the workers were to be tied to the soil and to the factory through the offer of housing in the neighborhood; at the same time, the estates were to be kept relatively small and isolated enough from one another so as to prevent any solidarity movements. In terms of city planning, the original low-key understatement expressed by the garden city idea became curiously linked with the government's urge for monumentality and ostentatious buildings.

This surprising combination becomes even more apparent in Herbert Rimpl's 1939 plans for the Stadt der Hermann-Göring-Werke, the town of the Hermann-Göring-Works, later Salzgitter. Here, too, a power-

173. Gino Cancellotti, Eugenio Montuori, Luigi Piccinato, and Alfredo Scalpelli. Sabaudia. 1933–34.

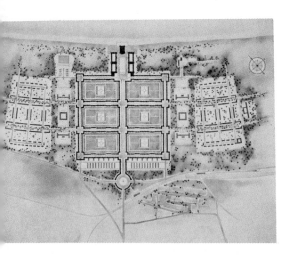

174. Heinrich Eggerstedt in collaboration with the Architectural Department of the Deutsche Arbeitsfront. Town X, Usedom. Project. 1942.

ful new industrial area gave the impetus for the foundation of a new town: its center was designed as a regular unit with a wide, showy boulevard, while the remainder of the town consisted of a loose arrangement of housing in order to give it a rural note. Neo-Classicism received more immediate expression in the plans for Town X, intended for a population of 20,000 and located near Trassenheide on the island of Usedom. The project, developed in 1942 by Heinrich Eggerstedt in cooperation with the architectural department of the Deutsche Arbeitsfront on the basis of sketches by Albert Speer, boasted large residential buildings with vast inner courts that formed a network of streets on a severely axial and symmetrical grid. The nostalgic crafts ideology had been replaced by efforts at rationalization—hence the emphasis on geometry and repetition, which favor industrial building methods. In addition, the formal results coincided with the all-pervading desire of the government for self-glorification, and the urban structure was therefore entirely subordinated to the overall symbolization without regard for

scale or for individual use of the public space.

Monumental encroachments were planned for all major German cities. Of these, the most impressive was that for Berlin, the capital of the Reich, which was to be renamed Germania and which was to be developed on a suitably grandiose scale. As in Rome, wide avenues were to be created through extensive demolition to meet the requirements of both motorized traffic and ceremonial events. In 1935–39 a section of the conversion of the East-West Axis, which averages 164 feet (50 meters) wide, was completed.

A more important project was that for the North-South Axis, also called the Grosse Strasse. It went back to a plan presented by Martin Mächler in 1917 and was developed in 1936–41 by Speer (by then Inspector General of Buildings for the Redevelopment of the Reich Capital). The models were Paris and Vienna but were to be greatly surpassed. The 1.2 mile- (2 kilometer-) long Avenue des Champs-Elysées would have been extended in its Berlin counterpart to 4.6 miles (7 kilometers) with a width of 393.7 feet (120 meters). At the north end it was to have been terminated by the Great Hall, and on the south end, in front of the South Station, by a 383.8-foot- (117-meter-) high and 555.7-foot- (170-meter-) wide triumphal arch, which would have dwarfed the 229.7-foot- (70-meter-) high Paris Arc de Triomphe. On the 2,624.6-foot- (800-meter-) long square between the surprisingly modernistic station and the remarkably inelegant triumphal arch, an "avenue of trophies" was planned, where conquered tanks and cannons were to have been displayed as homage to the military character of the *Grosse Strasse*. The latter was to have been flanked over virtually its entire length almost exclusively by monumental governmental and administrative buildings for large corporations. These included the Foreign Ministry, the Opera, the AEG administrative building designed

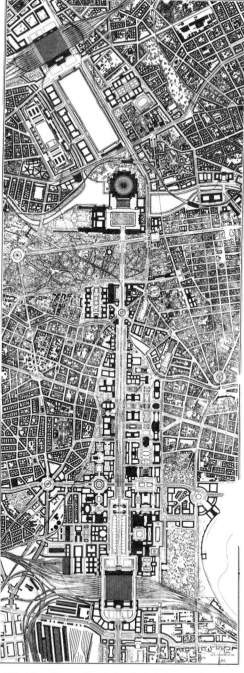

by Peter Behrens, the administrative building of the Hermann-Göring-Works, the Allianz Insurance Building, the building for the High Command of the Army and the Soldiers' Hall, both designed by Wilhelm Kreis, the Reich Marshal's Office designed by Speer, the complex of the Great Hall and the Führerpalast, also designed by Speer, the Reichstag, the Police Headquarters, the War Academy, the building for the High Command of the Navy designed by Paul Bonatz, the Town Hall designed by German Bestelmeyer, and finally the North Station. All buildings were to give the impression of dignity, power, and pomp and were to be based on a Neo-Classical style, although eclectic and romantic elements were allowed to be included. They were to have been realized eliminating private speculation within the framework of extensive overall planning in the style of Georges-Eugène Haussmann. In 1941 a consortium of companies was founded. In the same year, however, Speer stopped all construction unnecessary to the war efforts, so that the immense project, through which Hitler had hoped to place himself in the tradition of Napoleon and the Roman emperors, never progressed beyond its initial stage.

175. Albert Speer. North-South Axis (Grosse Strasse), Berlin. Project. 1927–41.

# 7 | Late Rationalism, Neo-Mannerism, and Architectural Engineering

## Historical Development

The Second World War left Europe with its economy in ruins and its structural base in a far worse state of destruction and desolation than after the First World War. In Germany, out of a total of 10.5 million dwellings, 2.3 million were entirely destroyed and almost half were damaged. In France the housing shortage, an acute problem even before the war, was aggravated by the destruction of 5 percent of the dwellings existing in 1939. Italy recorded similar losses. The Soviet Union, Great Britain, Holland, and Belgium were badly affected as well; only the Scandinavian countries and the United States had been spared major damage.

At first, a recovery of the countries so badly devastated seemed remote. As part of Truman's anti-Communist doctrine, however, the Marshall Plan was effected in 1947 with the object of aiding, with American assistance, the economic reconstruction of Western Europe. After Germany's currency reform of 1948 and the subsequent foundation of a number of international organizations for economic cooperation, the situation improved. This positive development culminated, about 1954, in various "economic miracles": one result was intensive building activity.

On the other hand, the democratization process that took place after 1945 in the political sector as a reaction to the shock of totalitarianism did not affect industry. Rather, the constellations of economic power were even more consolidated during the course of the feverish postwar activities: trusts ex-

panded, corporations became multinational, and monopolies were established. The law of maximum profit swept the building industry as well. In the hectic effort to produce houses as quickly and as cheaply as possible, the political, social, and architectural opportunities offered by the large-scale reconstruction of Europe were on the whole wasted.

Technological progress was strong and universal; a powerful and largely automated industry became able to supply high-quality and—provided the numbers involved were sufficiently high—economically priced products. Even the building sector, traditionally a backward area, began to utilize available facilities to improve productivity. Whereas the building industry before 1945 could still afford to be relatively labor-intensive, in other words to use large numbers of workers and to employ conventional building methods, it was compelled after the war to change to capital-intensive production methods. Rising wages, an increasing shortage of labor, the size of projects involved, and high demands for the completion and improvements of buildings resulted in maximized prefabrication in order to minimize on-site work.

In the United States, the country with the highest industrial standards, the curtain wall, first developed in 1911 by Walter Gropius for the Fagus Works, was further improved and diversified. Moreover, the number of mass-produced houses rose rapidly. In Europe, prefabricated heavy concrete structural systems were developed for use in multistory apartment buildings, in-

cluding the Larsen-Nielsen and the Jespersen systems in Denmark, Skaine in Sweden, Camus and Balency in France, and Wates, Reema, and Bison Wall Frame in Great Britain. In the Soviet Union the large-scale building programs laid out in the various five-year-plans were primarily realized with the aid of prefabricated units. In addition, lightweight prefabricated construction systems were developed, mainly in the form of steel-frame systems. Among the latter was the British CLASP system (Consortium of Local Authorities Special Programme System), designed by Donald Gibson in the mid-1950s, and the American SCSD system (School Construction Systems Development), designed by Ezra Ehrenkrantz in 1965.

The introduction of system building confronted architects with new problems. The old methods of design and supervision were no longer adequate in view of the extent of the projects and the complexity of the tasks involved. The individual designer was largely replaced by a team or a firm of architects, and the sophisticated methods of applied science and industrial engineering were transferred to building as planning methods. All this increased, the efficiency of architectural output and made it, up to a point, comparable with that of industrial production, but also resulted, in the finished product as a whole being removed from the control of the individual without being replaced by collective control. Nonetheless, the monotony and low quality of a large number of postwar buildings and estates cannot be blamed on industrial building methods as such. The main obstacles to sensible planning were a limited, functionalist, strictly purpose-oriented thinking and a completely inefficient control over the private sector of the industry.

Culturally, the nationalist tendencies that had characterized the era shortly before the Second World War left the field wide open to international influences. The visual arts initially continued trends that had been established by the European avant-garde movements between the wars, in particular by De Stijl, Soviet Constructivism, and the experiments that had been carried out within the framework of Bauhaus activities, especially by Josef Albers; and they proceeded, as a reaction to abstract Expressionism, to geometric abstraction. As early as the mid-1930s Victor Vasarely's paintings had emphasized the virtual movement of each individual element: color, line and volume. His practical and theoretical studies influenced the younger generation in Europe as well as in the United States, and gave the impetus for the purely optical analysis of movement within strictly geometric grids. One of the results was the emergence of Optical (Op) Art about 1960, which rapidly developed into an international movement.

*Theories and Forms of Building*

The general skepticism that met theoretical programs and statements of principles after the Second World War also affected architecture and prevented the development of a sound theoretical basis. The intellectual position of late Rationalism was founded on a reaction: deeply shocked by the subtle power that had been possible for a form of architecture (such as Neo-Classicism) to exercise on behalf of an unscrupulous regime (such as that of the German National Socialists), architectural culture reverted to the preceding movement of Rationalism. The reasons for such an attitude were manifold. Whereas the former had stood largely in the service of totalitarian and reactionary political constellations, the latter had its roots in progressive tendencies. While one had mainly ignored technical developments, these were greeted by the other with optimistic enthusiasm. While architects such as Troost and Speer had exploited with inhuman consistency the psychological effects of building forms, the works of Gropius and Mies van der Rohe remained examples of objective reticence and serenity. After the mendacity of the regime-imposed architec-

ture, a new attempt was made to find political, technological, and cultural honesty.

The ensuing search was imprudent. The fact was ignored that the architectural idiom of Rationalism had had its historical legitimization in the urge to overcome Historicism as well as the social concepts related to it, and that the phenomenon of Historicism was far more weighty and persistent than that of Neo-Classicism. It was also forgotten that buildings created in this idiom were the expression of a generous philosophy which was no longer viable in the years of reconstruction, the Cold War, and a craving for private possessions, supported, moreover, by the political powers.

Late Rationalism was therefore marked by an ideological void, and this was filled by the more or less explicit beliefs of the time. The forms of the buildings reflected them: tall slender rising structures symbolized the unlimited confidence in economic growth and technological progress; smooth, elegant curtain walls of steel and glass enclosing fully air-conditioned buildings mirrored the erroneous conviction that available energy resources were inexhaustible; free, flexible plans with large rooms and movable walls represented the belief in the supremacy of organization, dynamic and efficiency. The perfect glass specters that mushroomed everywhere and began to dominate the skylines of London, Frankfurt, Paris, and Milan in exactly the same way as they did those of Chicago or New York (bringing the concept of the International Style into a certain disrepute) reflected correctly and reliably the economic conditions. Instead of attempting to motivate changes or to create utopias, architecture adapted the status quo.

It is hardly surprising that such a disposable idiom was greatly subjected to wear and changes in fashion. As it lacked substance, it soon lost its strength. Deliberate sparseness degenerated into involuntary dullness. Nevertheless, the reaction that began in the early 1950s only replaced the old formalism with a new one. Attempts were now made to counteract the monotony with a superficial enlivening of forms, which did nothing, beyond altering the outward appearance of buildings. Ideological indifference, social and economic constellations, highly industrialized production and operating conditions, and at times even the spatial arrangements, remained the same; they were just presented in a different "wrapping." As part of a consumption-oriented and frequently utilitarian Neo-Mannerism, an all to naive, historicism, and ornamentation were rediscovered.

The exhibitionist search for the latest fashion in building had already exhausted itself in the early 1960s. The disposability of architecture now revealed itself only in an expressive variant of the International Style, which distanced itself from decorative and academic excesses and settled for a solid professional approach, leading to perfection of detail and forceful effects. It is no coincidence that large administrative buildings were the most typical product of this phase and that the most spectacular realized examples are to be found in the ultracapitalist United States. Their primary function was representation, and to achieve this end no economies of money, technology, dimension, or architectural quality were made. At the same time, however, a number of architects made repeated attempts to continue the moral and social inheritance of Rationalism as an unadulterated, lively tradition. Buildings designed by them fulfilled not only a formal task but, equally, an ideological one.

Apart from these developments, a heterogeneous, highly unorthodox movement arose: engineering architecture. At first it avoided political and formal problems and tried to achieve new solutions with materials, construction, and static calculations. It was this seemingly naive beginning that liberated it from the prejudices and constraints of conventional architecture and which frequently led to new results and sometimes even to the most critical and radical ideological positions.

*Architecture*

The Danish architect Arne Jacobsen, who had been strongly influenced by the works of Le Corbusier and Mies van der Rohe during the 1920s, attracted attention as early as 1929 with his House of the Future, a project which he designed in cooperation with Flemming Lassen for the exhibition of the Akademisk Architektførening: the circular building with numerous futuristic features and a helicopter landing pad on the roof was awarded the first prize. In 1930–35 he created the Bellavista estate in Klampenborg near Copenhagen, with its elegant public bath house, a row of two- and three-story residential buildings with staggered facades, a theater, and a restaurant. The clear forms and delicate color schemes, which fuse Rationalist sobriety and picturesque Nordic tradition, would remain characteristic of Jacobsen's work.

In 1952–56 Jacobsen found his personal style in creating the Munkegård School at Gentofte. In the clearly structured complex, consisting of single and twin-story units arranged around individual courts, closed parallel walls made of yellow brick are joined at right angles with sharply cut surfaces of

176. Arne Jacobsen. Munkegard School, Gentofte. 1952–56.

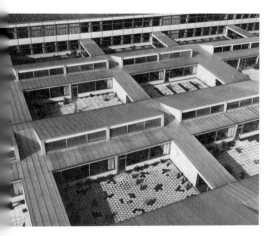

177. Arne Jacobsen. Office building for Jespersen & Søn, Copenhagen. 1955–56.

glass and metal. The building is marked by simple, high-quality details, bold combinations of materials, reticent colors, and an intimate atmosphere.

In 1955–56 Jacobsen's office building for Jesperson & Søn was realized in Copenhagen, a severe and almost impersonal work. The reinforced concrete skeletal structure is raised from the ground by slab-shaped supports, and the long sides are clad with curtain walls. Within the framework of crafts-oriented Danish building during the 1950s, Jacobsen adopted the American model of modular and largely prefabricated glass and metal prisms in order to accelerate a development directed at relating the building process to the best achievements of industry. Facades, interior walls, and stainless steel fittings are still made by hand, despite appearances to the contrary; but the skillfully

proportioned design, which is based on simple geometric shapes, indicated a course which was to provide the building industry as well as European architecture with new impulses.

Also in 1955–56 the Rødovre City Hall was built, following the same principles. In this instance the design was based on a low elongated monolithic structure, lying on the ground and consisting of repeatedly used identical elements. In 1958–60 Jacobsen built the SAS Building in Copenhagen, a block entirely glazed in various patinated shades and characterized by the use of exquisite materials, colors, proportions, and details. In 1970–73 Jacobsen realized, in cooperation with Otto Weidling, the city hall at Mainz, the monumental style of which documents a shift from late Rationalism to a heavy Mannerism.

The German architect Egon Eiermann, who had studied with Hans Poelzig, also remained faithful to the International Style during the Third Reich. In 1951 he created the textile factory in Blumberg, a slim, elegant, undisturbed steel construction, whose aesthetic charm emanated from its clarity of concept as well as its openly displayed technical apparatus. In 1957–58 Eiermann built the German pavilion at the World's Fair in Brussels together with Sep Ruf. The light, transparent ashlar was arranged in such a way as to enclose an inner courtyard together with uncovered connecting passages. The supports of the building blocks were recessed. A filigree orthogonal metal grid was hung in front, a typical Eiermann formal element, serving both as protection from the sun and as railings for the arcades. In 1958–60 the Neckermann Mail Order House in Frankfurt am Main was built. The straightforward building complex is structured by outside staircase towers, passages, emergency stairs, and air conditioning plants. The result is a sober machine aesthetic.

In 1958–64 the German embassy in Washington was built. The wall of the narrow building, staggered on a slope, is broken up into several layers. The Olivetti administration and training buildings in Frankfurt am Main were built in 1970. According to the functional principle the rooms for the participating students are located in a flat building, while administrative and instructional rooms are located in two differing high towers. The graceful stories, the glass walls of

178. Egon Eiermann. Textile factory, Blumberg. 1951.

179. Egon Eiermann. Neckermann Mail Order House, Frankfurt am Main. 1958–60.

which are covered by balconies and awnings, are placed on a plinth protruding on all sides, leading into a heavy concrete shaft.

In 1957–60 Helmut Hentrich and Hubert Petschnigg built the administration building of Phoenix-Rheinrohr AG (Thyssenhaus) in Dusseldorf. It comprises three slim, elegant, sliding glass and metal panes combining a functionally advantageous distribution of the ground plan with formal dynamics.

The Swiss Max Bill, a former Bauhaus student, built in 1953–55 the High School of Design in Ulm and resolved the problem of space in a loose, easily legible complex of white squares, freely adapting itself to the inclination of the land.

The Italian architect and designer Giovanni (Gio) Ponti, builder of the Mathematical Institute at the Roman Città Universitaria (1934) had already in 1936 given up the academic conventions in favor of rationalistic maxims. In 1955–58 he created, together with Arturo Danusso, Antonio Fornaroli, Egidio Dell'Orto, Alberto Rosselli, and Giuseppe Valtolina, as well as Pier Luigi Nervi as specialist for construction, the administration building of the Pirelli Company in Milan. The skyscraper is distinguished by a bold constructive solution, smooth, even facades and ship's-bow–shaped sides, resulting functionally in the reduced need of the internal traffic for space from the central openings to the peripheral rooms.

Franco Albini, who had already confessed to rationalism by building the pavilion for the INA (Istituto Nazionale delle Assicurazioni) at the Milan Fair in 1935, also remained faithful to the idiom in his postwar work. In 1951 he realized the INA Building in Parma, an orthogonally structured, extremely restrained building; the language of form is in accordance with the constructive structure. During the same year he furnished the Museum of the Palazzo Bianco in Genoa and created through clear geometry and transparent or translucent glass panels metaphysically appealing spatial effects. In 1957–62 he produced in collaboration with Franca Helg the La Rinascente Department Store in Rome. In its dull black steel construction, it recalled the entablature motifs of the palaces of Renaissance Rome, while its execution conformed in its reddish color and pebbly structure to the traditional character of the city.

Ignazio Gardella had built the Tuberculosis Clinic at Alessandria in 1936–38, an early work that already showed the main features

180. Max Bill. High School of Design, Ulm. 1953–55.

of his architectural style: clarity in the geometrical handling of volumes; correct use of materials which are, at the same time, a means of expression; and regard for local tradition. In 1952 he built, also at Alessandria, a residential building for Borsalino employees, which introduced, with its lively masonry facades and deeply projecting eaves, eclectic elements into the Rationalist concept. In 1955–59 the cafeteria of the Olivetti Company was built at Ivrea, near Turin, a clear and yet lively organism.

Luigi Figini and Gino Pollini had built an artist's house and studio in the park of the Triexnnale in Milan as early as 1933, a rational building that owed its fascination to the contrast between rendered and brickwork surfaces as well as between firmly enclosed and loosely separated spaces. This had been followed in 1939–40 by the orthogonally structured, elegant Olivetti factory and administrative building at Ivrea, the front of which is entirely glazed. In 1952–58 they built, according to a basilican plan, the church of Madonna dei Poveri in Milan; the visible concrete structure, the narrow windows of the long nave, and the crude, almost Brutalist lack of finish create a mystical atmosphere.

More paradigmatic than developments in Europe were those in the United States, partly because of the greater economic prosperity and the more advanced industrialization, partly because belief in progress and ideological naiveté were more widespread. In 1949 the American architect, designer, and filmmaker Charles Eames, the creator of the famous Eames Chair (1940–41), built his studio at Pacific Palisades, Los Angeles. The two-story skeletal steel structure

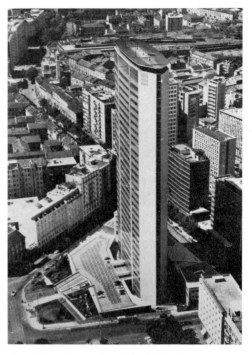

182. Giovanni (Gio) Ponti, Arturo Danusso, Antonio Fornaroli, Egidio Dell'Orto, Alberto Rosselli, Giuseppe Valtolina, and Pier Luigi Nervi. Administrative building for the Pirelli Company, Milan. 1955–58.

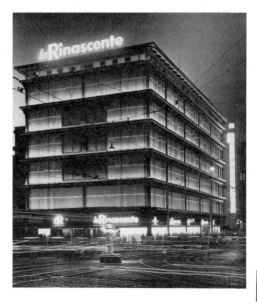

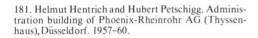
181. Helmut Hentrich and Hubert Petschigg. Administration building of Phoenix-Rheinrohr AG (Thyssenhaus), Düsseldorf. 1957–60.

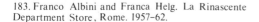
183. Franco Albini and Franca Helg. La Rinascente Department Store, Rome. 1957–62.

165

184. Ignazio Gardella. Cafeteria of the Olivetti Company, Ivrea. 1955–59.

185. Luigi Figini, Gino Pollini, and Annibale Fiocchi. Olivetti factory and administrative building. Ivrea. 1939–40.

consists predominantly of prefabricated elements; the metal frames are infilled with transparent or translucent glass and plaster panels. The gridlike structure is reminiscent in its optical lightness, balanced delicacy, and sophisticated proportions, of an early Japanese house.

Philip Johnson, the son of a wealthy lawyer, and a philologist by training, was inspired through his work in art history and his publications to branch out into practical work. During the 1930s he was director of the architectural division of the Museum of Modern Art in New York; in 1930 he met Ludwig Mies van der Rohe in Europe; in 1932 he wrote, together with Henry Russell Hitchcock, the successful book *The International Style: Architecture Since 1922*, and in 1947–49 he built, after a course of studies at Harvard University under Marcel Breuer, his own house, the Glass House, on his estate in New Canaan, Connecticut. This building clearly shows the influence of Mies van der Rohe and is reminiscent of the Rigorist concept of his Farnsworth House, which was built at about the same time (1945–50). Johnson nevertheless succeeded in creating an independent work with the perfect steel and glass prism of the main

building; the severe prismatic masonry and guesthouse; and the disk-shaped pool. The plain and elegant Glass House in particular, raised above the ground by a low brickwork base, which both separates it from and ties it to the ground, enlivens the architectural theme of silence with subtle ambiguities.

186. Charles Eames. Architect's own house, Pacific Palisades, Los Angeles. 1949.

187. Philip Johnson. Architect's own house, New Canaan, Connecticut. 1947–49.

188. Philip Johnson. Temple Kneses Tifereth Israel, Port Chester, New York. 1954–55.

In 1954–55 the Kneses Tifereth Israel Synagogue was built at Port Chester, New York; the domed gypsum-plaster ceiling of the interior marks the renunciation of the structural "honesty" of Rationalism and anticipates Mannerist elements. In 1954–58 Johnson was involved in the design of Mies van der Rohe's Seagram Building in New York, his contribution being especially noticeable in the interior design. Johnson's long-anticipated breach with late Rationalism in favor of an available eclectic style manifested itself bluntly at the beginning of the 1960s: from then on each of his buildings had its individual idiom. In 1960 he built the New Harmony Shrine in Indiana, a shingle-clad structure of bentwood and plywood. In 1960–61 he realized the Rehovot nuclear

reactor in Israel, a symmetrical, gently gored shape in poured concrete, with sloping external walls.

In 1960–64 Johnson built the New York State Theater in New York as part of Lincoln Center, which had been begun in 1957 under the overall supervision of Wallace Kirkman Harrison as an uninspired copy of Michelangelo's Piazza del Campidoglio in Rome. On a Beaux-Arts ground plan rises a monumental, vaguely Classicist building with a glass facade behind slender pairs of reinforced concrete pilasters. Compared with the barren Philharmonic Hall by Max Abramovitz (1962) and the rigid Metropolitan Opera by Harrison (1966), which also border the plaza with its geometric pattern of white stones, Johnson's building appears balanced and noble.

In 1962–66 in collaboration with Richard Foster, the Kline Tower was realized as part of a program of expansion for the faculties of natural sciences at Yale University in New Haven, Connecticut. It is a massive, monumental representational building in which the heavy geometric design has been pressed into the service of representing a solemnly interpreted science.

In 1970–76 Johnson built, together with John Burgee, the office building Pennzoil Place in Houston, Texas, thus relating again to Late Rationalism. Two black reflecting glass prisms on triangular plans capped by pyramidal roofs are enclosed and connected at the base by a huge glass hall. The evenness of the cladding erases any evidence of the supporting structure or of functional separations and gives the building an appearance of purely volumetric insubstantiality.

In 1978 the skyscraper project for the American Telephone and Telegraph Company Building in New York was designed—

189. Philip Johnson and John Burgee. Pennzoil Place, Houston, Texas. 1970–76.

190. Philip Johnson. American Telephone and Telegraph Company Building, New York. Project. 1978.

a mixture of Renaissance, Classicism, and Art Deco. The opening of the roof, which is shaped like a Chippendale grandfather clock, emits white smoke from the heating system on cold days. Construction was completed in 1983.

Philip Johnson's Mannerism, unlike Mies van der Rohe's Rigorism, is not intended to carry out a utopian or critical function. The masks of his forms have the sole purpose of making architecture acceptable to his clients and to an innovation-seeking public. His plans are not aimed at reflection but at approval.

In 1948–50 the American architectural firm of Max Abramovitz and Wallace Kirkman Harrison built the United Nations Building in New York on the basis of preliminary plans drawn up by Le Corbusier in 1947. The tall, slim slab is composed of two narrow enclosed sides clad with white marble and two green glass facades made up of a modular window repeated over 2,730 times. This use of the same module to form an enormous unity that no longer has any relation to human scale, is in obvious contrast to Le Corbusier's principle of composition as applied in his Unité d'Habitation, in which the exterior also reflects the differences of the individual cells. The anonymity of the United Nations building reflects the anonymity of the bureaucracy for which it was constructed.

One of the first applications of the metal and glass construction structures invented by Mies van der Rohe to an office building is the Lever House in New York. It was built in 1950–52 by the architectural firm of Louis Skidmore, Nathaniel Alexander Owings, and John Ogden Merrill (SOM), founded in 1936 with Gordon Bunshaft as partner in charge. In this skyscraper, in which the load-bearing structure has been set back in the

interior, the slim curtain wall has become an idiomatic element in its own right. In the light facade the delicate orthogonal network of horizontal and vertical elements forms an

191. Skidmore, Owings & Merrill. Banque Lambert, Brussels. 1957–65.

192. Skidmore, Owings & Merrill. Architecture and Art Laboratories, Chicago Circle Campus, University of Illinois, Chicago. First stage. 1965–68.

equilibrium; the surfaces are nondirectional and neutral. However, the sober Purism, the harmonic proportions, and the sophisticated detail of the strictly geometric prism reflect Miesian teaching only superficially. Whereas the master of Rationalism aimed at a deliberate reduction of a linguistic repertoire, the Lever Building demonstrates merely the acceptance of social, technological, and economic conditions. Whereas the Lake Shore Drive Apartments in Chicago, completed shortly before, were the creation of a single architect who strove to give material form to a hermetic philosophy, Lever House (and the same applies in principle to its many imitations) was the product of a team of planners able to meet the requirements of rapid production and the high-technology demands of its customers owing to its size, division of labor, and anonymity. In fact, SOM rapidly developed into a large-scale enterprise outside the traditional scale of the architect's profession, and by the end of the 1970s the firm had nine offices and a staff of over 2,000. The working pattern of the architect thus underwent a change that brought his production close to assembly-line standards.

The Banque Lambert in Brussels (1957–65) indicated a new development for SOM. Load-bearing outer walls with individual windows replaced glass curtain walls and created an almost Classicist order in a severe block. In the John Hancock Building in San Francisco (1960), plastically designed cantilevered concrete piers at the base added a fashionable and almost Expressionist element.

In 1965–68 Walter Netsch of the Chicago SOM office applied his so-called field theory to the Architecture and Art Laboratories of the Chicago Circle Campus of the University of Illinois. The ground plans are based on a uniform geometric pattern in which squares of varying sizes are superimposed

194. Skidmore, Owings & Merrill. John Hancock Center, Chicago. 1965–70.

and rotated against each other so that they form subdivided octagons. The highly articulated buildings are functionally dubious but give optical variation.

In 1968 the U.S. Steel Building was built by SOM at the Liberty Plaza in New York, a severely orthogonal skyscraper, in which the principle of "skin-and-bones" architecture has been abandoned in favor of visible dark steel structural elements. The filigree character of the Lever House is replaced by an almost ragged plasticity, and the ratio of open and closed surfaces drastically reduced.

The John Hancock Center in Chicago (1965–70), also by SOM, introduced a strik-

193. Skidmore, Owings & Merrill. Lever House, New York. 1950–52.

ing structural innovation: strutting, a function that in conventional skyscrapers had been reserved for elevator shafts and stairwells, was removed to the outer wall. The four sides of the 100-story skeletal steel building, which tapers toward the roof, show clearly outlined diagonal struts; in terms of statics they function as a tube and permit, in comparison with conventional solutions, a significant reduction of the amount of steel required. The soaring structure owes the effectiveness of its design idiom to its mat black framework, which no

195. Skidmore, Owings & Merrill. Sears Building, Chicago. 1972–74.

effort has been made to hide. A disadvantage is that numerous windows are reduced in size by the intersecting diagonals.

In 1972–74 SOM built the Sears Building, also in Chicago. Nine towers of different height, each with a square plan and together forming a large square, form an enormous and somewhat bulky building that rises, at its highest point, to 1,476 feet (450 meters). The cellular-tube structure represents a further development of the constructive principle first used in the Hancock Center. The aesthetic is reminiscent of the elemental geometric spatial grids of Minimal Art.

The active search by Skidmore, Owings & Merrill for new high-quality solutions, a feature not common to large American architectural firms, has only seemingly overcome, with its formal eclecticism, the limitations of late Rationalism. Despite their external differences the administrative buildings and superskyscrapers by SOM express the same message over and over. Like the buildings of the Chicago school, although to a much greater extent, they are the product and the interpreters of the economic and technological expansionism that revives the old and comparatively harmless philosophy of the American pioneers on the scale of modern trusts and multinational corporations.

The Finn Eero Saarinen (son of Eliel Saarinen), who had settled in the United States with his parents, won in 1948 the competition for the Jefferson National Expansion Memorial, which was built in 1963 as the Gateway Arch, a 630-foot- (192-meter-) high parabolic arc that spans the Mississippi River near St. Louis. In 1951–57 he realized, together with his father, the General Motors Technical Center at Warren, Michigan. In a severe arrangement, reminiscent of Mies van der Rohe's Illinois Institute of Technology, he grouped simple prismatic blocks of varying size and surface finish around an artificial central lake.

The geometric and technological purism was soon to give way to an eclectic and highly experimental Mannerism. In 1955 the

plain concrete shell of the Kresge Auditorium and the romantic masonry cylinder of the chapel for the Massachusetts Institute of Technology at Cambridge, Massachusetts were built. This was followed in 1956–58 by the wooden roof over the David S. Ingalls Hockey Rink at Yale University, in New Haven, Connecticut, which is supported by steel ropes suspended from a sweepingly curved reinforced concrete arc. In 1956–62 the Trans World Airlines Terminal at Idlewild Airport (now John F. Kennedy International Airport) in New York was realized; according to the architect, the heavy symmetrical, plastically shaped shell abstractly represents a bird about to take flight. In 1961–64 Saarinen built the technically expressive headquarters of John Deere & Co. in Moline, Illinois. In it the new material Cor Ten, a maintenance-free steel alloy that forms a thin protective layer of rust resistant to further corrosion, was first used.

Such professional self-confidence, which dispenses with in-depth study and, in its choice of the most effective style for each project, smacks of methods used in the advertising world, meets the requirements of disposability of a consumer-oriented society. When Saarinen's office was taken over by his former assistants Eamonn Kevin Roche, born in Ireland, and the American John Gerald Dinkeloo, this meant the continuation of the high standards of an eclectic tradition.

In 1961–68 Kevin Roche, John Dinkeloo and Associates built the Oakland Museum in Oakland, California, in the form of an enclosed garden with broad access ways. The exhibition halls are below ground, arranged so that the copiously planted roof garden of one hall forms the terrace of the next. Each room has immediate access to lawns, esplanades, and stairs.

196. Eliel and Eero Saarinen. General Motors Technical Center, Warren, Michigan. 1951–57.

197. Eero Saarinen and Associates. TWA Terminal, Idlewild Airport (now John F. Kennedy International Airport), New York. 1956–62.

198. Kevin Roche, John Dinkeloo and Associates. Oakland Museum, Oakland, California. 1961–68.

In 1963–68 the firm realized the administrative headquarters of the Ford Foundation in New York. A twelve-story building which, on its scale, is adapted to surrounding residential buildings, rises on a U-shaped ground plan. The free space is taken up by a vast hall as high as the building itself. Rich arrangements of plants provide a pleasant microclimate. Thus the individual offices do not open onto a noisy, air-polluted street but

199. Kevin Roche, John Dinkeloo and Associates. Ford Foundation administrative building, New York. 1963–68.

200. Kevin Roche, John Dinkeloo and Associates. Administrative buildings of the College Life Insurance Company of America, Indianapolis, Indiana. 1967–71.

onto a quiet, plant-studded and air-conditioned "greenhouse."

In 1965–69 the administrative headquarters of the Knights of Columbus was built in New Haven, Connecticut, a 23-story building with four heavy round corner towers clad with dark brown glazed bricks. Steel girders span the towers. The form of the adjacent New Haven Veterans Memorial Coliseum (built 1965–72) was, paradoxically, determined by the adjoining multistory parking structure; because of the high water table it was suspended 21 meters (69 feet) above the ground and thus forms the roof of an exhibition hall and an arena with a capacity of 10,000 people. As in the Knights of Columbus building the concrete areas are clad with dark brown bricks, while the metal structure is of rust-brown weatherproof steel.

In 1967–71 Roche and Dinkeloo built the three truncated glass and steel pyramids for the College Life Insurance Company of America in Indianapolis, Indiana, which lean, on two sides, against massive closed concrete slabs containing the service rooms and the installations. Their dimensions and heavy monumentality are beyond any conventional scale.

The experience gained by Roche and Dinkeloo in the field of large glazed halls was developed further by the architect and coowner of the Hyatt Regency chain of hotels, John Calvin Portman. In the Hyatt Regency Hotel in San Francisco, designed and built by Portman between 1968 and 1973 as part of the multipurpose commercial Embarcadero Center (also designed by Portman), a complex and stepped exterior on an almost triangular base encloses a vast space organized as a covered urban plaza. The finish, colors, and effects are a mixture of would-be grandeur, kitsch, and naive belief in technology; the dubious originality of the form contrasts with the functional banality of such monster hotels.

Paul Rudolph, a pupil of Gropius at Harvard University, designed and realized a

201. John Portman & Associates. Hyatt Regency Hotel, San Francisco. 1968–73.

202. Paul Rudolph. Parking garage, New Haven, Connecticut. 1959–63.

number of vacation homes in Florida between 1948 and 1962, among them the purist Deering House at Casey Key, Sarasota (1958–59), with a transparent frontage broken by piers. In 1955–58 he built the Mary Cooper Jewitt Arts Center of Welles-

203. Paul Rudolph. Art and Architecture Building, Yale University, New Haven, Connecticut. 1958–64.

204. Paul Rudolph. Sarasota High School, Sarasota, Florida. 1958–59.

ley College in Massachusetts, in an idiom reminiscent of the Gothic style. In 1958–59, again at Sarasota, the Sarasota High School was built, a clearly structured concrete building marked by the repeated use of identical components. These buildings give an early indication of the wide expressive scale to be employed by Rudolph in his subsequent Mannerist efforts to endow each architectural task with a specific and individual character.

In 1958–64 he built the Art and Architecture Building of Yale University in New Haven. The six-story reinforced concrete structure, the interior of which spreads over 36 levels, deliberately respects the urbanistic situation of its location through the marked emphasis of its corners. The extraordinarily differentiated ground plan with its windmill-like arrangement and its basic principle of spatial interpenetration reflects the influence of Frank Lloyd Wright, with the main functional areas being in the center. The

lecture hall is on the second underground level, and above it is the library with reading room and bookstacks. At the entrance level a large exhibition area extends over several floors. On the next level is the drawing studio with galleries of varying heights, while the studios for painting are housed below the roof. The stairs and elevators are mostly placed in towerlike structures that can also accommodate small classrooms or simply recesses: the Functionalist congruence of interior and exterior has been abandoned. The plasticity of the strongly defined and "brutalistically" assembled horizontal and vertical building elements is enhanced by their being contrasted with large glazed areas. The concrete elements of the walls enclosing the rooms have a corrugated surface, while the faces of the horizontal floor or roof slabs are smooth. The variously structured interior, too, is marked by contrasting rough and smooth concrete surfaces.

In 1959–63 Rudolph built a four-story parking garage for 1,500 cars in New Haven, Connecticut, which, through an expressively designed structure of unclad, rough reinforced concrete with closely spaced pairs of columns, screens its prosaic function. In 1960–61 he realized the married students' housing at Yale. The individual units are arranged so as to form a villagelike complex on the sloping plot; the project shows the influence of the anonymous architecture of the Pueblo Indians Rudolph encountered in his travels.

In 1960–62 the expressively formalist Milam House was built at Jacksonville Beach, St. John's County, Florida. The prominent orthogonally arranged frame transforms the facade into a monumentally emphasized section with Neoplastic features.

In 1967–72 Rudolph was responsible for the State Service Center (designed in 1962), which was realized as part of the Boston Government Center. The blocks housing the mental health and social security departments rise in the form of terraces and enclose a large plaza; a tall, ambitiously designed tower, rising on a windmill-shaped plan, houses the department of health, education, and welfare and from one end of the compound dominates the entire complex. Its base is encircled by affectedly fanned stairs leading down to the subterranean parking structure with incongruous elegance.

Paul Rudolph's aesthetic, frequently flattering theatrical compositions that at times border on kitsch, are in marked contrast to the work of Gerhard M. Kallmann, Edward F. Knowles, and Noel Michael McKinnel. Their Boston City Hall (1962–68) was also built as part of the Boston Government Center. In the aggressive use of unclad reinforced concrete, in the bold juxtaposition of dissonant formal elements, and in the tortured plasticity of its orthogonal outline, the building is reminiscent of Le Corbusier's Sainte Marie de la Tourette. The upper floors, which cantilever by steps and house the offices, are on a rectangular plan. Below them the order explodes: levels become independent, the facade opens up, and the corners extend into the surroundings. A passage developing on various levels penetrates the building body and transforms it into a part of the public space; at the same time the brick paving of the outside square is folded up to form a crooked wall that acts as an additional link between the building and the surroundings.

The American Ieoh Ming Pei, whose architectural firm had built, in 1962, a severe late Rationalist skyscraper in Montreal based on a cruciform plan, realized together with Henry N. Cobb the elegant glass-fronted John Hancock Building in Boston (1967–76), which was clearly inspired by Mies van der Rohe's work. In 1971–78 the fortresslike, largely enclosed East Wing of the National Gallery of Art in Washington, D.C., was built. In view of the urban layout of the surrounding area the trapezoidal structure is split into two triangles; behind the monumental main frontage, which is dominated by a huge horizontal entrance opening and minimalistic sculptural towers,

205. Gerhard M. Kallmann, Edward F. Knowles, Noel Michael McKinnel. Boston City Hall. 1962–68.

206. Ieoh Ming Pei & Partners. East Wing of the National Gallery of Art, Washington, D.C. 1971–78.

lies a dramatic sequence of interpenetrating rooms on unexpectedly varying levels.

The protagonists of late Rationalism and, to a certain degree, also those of Neo-Mannerism were strongly interested in the structural aspects of building, but they subordinated it to formal considerations. At the same time, however, there were architects and engineers who took the opposite course. Instead of adapting architecture to technical and structural conditions, they started with the latter and tried to make architecture out of them.

The major representative of architectural engineering is the Italian Pier Luigi Nervi; with his capacity for producing aesthetically convincing work through plasticity, proportion, and rhythm, yet always on the basis of a highly developed technical concept, he continued the tradition begun by Robert Maillart and Eugène Freyssinet in the realm

207. Pier Luigi Nervi and Annibale Vitellozzi. Palazzetto dello Sport, Rome. 1956–57.

of reinforced concrete structures. As early as 1930–32 he had built the stadium in Florence, where the boldly revealed structural elements are of extraordinary expressiveness. In 1935 he designed a prototype hangar that freely spanned 4,306 square feet (400 square meters) and was realized between 1936 and 1941 at Orvieto, Orbetello, and Torre del Lago. The simple structure of the diagonally intersecting girders, supported by only six elegantly tapering buttresslike columns, is apparent on the inside and an impressive aesthetic element.

In 1948–49 the first hall of the Turin Exhibition Center was built; it consists of a single roof construction, a barrel vault with a maximum thickness of 1.9 inches (5 centimeters) made up of undulating prefabricated concrete panels that provide areal support through their surface structure. The second hall followed in 1950; its supporting structure is diagonally strutted.

208. Pier Luigi Nervi. Aircraft hangar. 1935; 1936–41.

209. Eduardo Torroja y Miret. Grandstand canopies, La Zarzuela racecourse, Madrid. 1935.

In 1956–57 Nervi built, in collaboration with the architect Annibale Vitellozzi, the Palazzetto dello Sport in Rome, a circular flat-domed structure with gently undulating edges; its complex *ferro-cemento* (a variation of reinforced concrete invented by Nervi) rib system was cast in situ in small reusable and transportable formwork units.

210. Félix Candela and Enrique de la Mora. Church of Santa Maria Miraculosa, Mexico City. 1954–55.

211. Richard Buckminster Fuller. American Pavilion, Expo '67, Montreal. 1967.

In 1960–61 the Palazzo del Lavoro in Turin was realized, where large palm tree-shaped reinforced concrete columns form a unit with the ceiling through radially spreading support elements.

Nervi, who expounded his architectural theory in a number of writings, strove for the synthesis of art and technology. To him a good constructive structure equaled a good form. Because of his extraordinary aesthetic sensitivity he succeeded, in the majority of his works, in achieving that difficult synthesis.

The Spanish engineer Eduardo Torroja y Miret, on the other hand, based the design of his reinforced concrete and prestressed concrete structures on the "right of the imagination" and used calculations to confirm subjective formal concepts. In 1935 he built, for the La Zarzuela racecourse in Madrid, a system of boldly cantilevering vaulted grandstand canopies with vertical tie rods behind the columns combining technological discipline with aesthetic expressiveness. The asymmetric roof above the entrance of Campo de Las Corts in Barcelona, dating from 1943, indicated a more organic approach, to which he was to adhere during his following works.

Félix Candela, also a Spaniard, specialized in shell construction. In his adopted country, Mexico, he built numerous inventive concrete structures, which he designed, in contrast to Nervi and in continuation of Torroja's work, as homogeneous and continuous membranes. In 1954–55 he realized, together with Enrique de la Mora, the three-aisled church of Santa Maria Miraculosa in Mexico City; the complexly vaulted and folded roof, which is only 1.5 inches (4 centimeters) thick, is reminiscent of Antoni Gaudí in its extraordinary expressiveness. In 1957–58 Candela built, together with Joaquín and Fernando Alvarez Ordóñez, the restaurant Los Manantiales at Xochimilco, an eight-petaled "concrete flower" made of parabolic shells and located in a water garden.

A more radical attitude was taken by the American Richard Buckminster Fuller, an engineer, inventor, and philosopher in search of solutions to the environmental problems of our "Spaceship Earth." After working in several industrial firms he designed, in 1927, the technology-inspired Dymaxion House, in which he incorporated concepts derived from aircraft and automobile construction. A light metal structure suspended from a central mast, its name a neologism, synthesizes the objectives of the hexagonal machine for living in—dynamism plus maximum efficiency. The prototype was realized, albeit in a strongly modified form, in 1944 in Wichita, Kansas.

After the Second World War Fuller became primarily concerned with structures that could be erected in the shortest possible time and with the minimum possible expenditure, and which spanned large areas and were extremely light in weight. The result of these studies were the geodesic cupolas, geometrically based on tetrahedrons and octahedrons, and made from metal, plastic, prestressed concrete, cardboard, wood, plywood, and even bamboo. In 1958 Fuller built the vast dome for the repair workshop of the Union Tank Car Co. at Baton Rouge, Louisiana, which has a diameter of approximately 426.5 feet (130 meters), and in 1967 the transparent 262.5-foot (80-meter) plastic and steel cupola for the American Pavilion at the Montreal Expo '67.

Konrad Wachsmann, an American of German origin and a pupil of Heinrich Tessenow and Hans Poelzig, was one of the pioneers of industrial building methods. He succeeded in striking a careful balance between the technical and scientific study of the building process and the aesthetic understanding of the structure.

In 1941–48 Wachsmann worked in partnership with Walter Gropius and developed with him the General Panel Corporation, the first almost fully automated factory for the manufacture of prefabricated building components. Through this association the

212. Konrad Wachsmann. Mobilar Structure. Project. c. 1945.

General Panel Corporation Building System, consisting of prefabricated wooden units, was devised.

During the 1940s Wachsmann developed the Mobilar Structure Building System for the United States Air Force for the construction of hangars that could be enlarged to any required size through the addition of identical tubular steel units. The visually fascinating structure, first designed for a standard 787.4-foot (240-meter) length and a width of 164 feet (50 meters), abandoned the idea of a plastic and monolithic architectural form in favor of an open framework enclosed only by sheeting or lightweight exterior walls. The growth of such an organism is governed by the laws of the basic element, which can be added to freely as and when required. Its aesthetic impact is due to its geometry and its rhythmical repetition.

Wachsmann's largely theoretical work aimed at the change from slow, expensive, and inefficient crafts-based building methods to quick, competitively priced and effective industrial mass production. To this end he tried to find simple elements which can be used in a maximum number of combina-

213. Behnisch & Partner, with Frei Otto as development consultant. Roofs for the Munich Olympic Stadium and Arenas, Munich. 1968–72.

tions, with the relations between the individual units controlled by modular coordination. Within the framework of this program the role of the architect consists, in his opinion, of creatively combining technologically designed products into a coherent work. Of his books, *Wendepunkt im Bauen* (The Turning Point of Building; 1959) was particularly influential.

The French light-metal designer Jean Prouvé, the son of an Art Nouveau artist and himself a trained art-metalworker, had developed at the early date of 1934 the elegant curtain wall that he used in 1936 for the

clubhouse at Buc Airport and in 1937–39 for the Maison du Peuple at Clichy (architects, Eugène Beaudouin and Marcel Lods). These were the first of many buildings in which Prouvé used lightweight curtain walls in numerous variants, but all characterized by the balance of their proportions, the exact details, and, owing to the metal manufacturing technique, the rounded edges of the window apertures.

Prouvé did not, however, limit himself to adapting facade elements to industrial production and to redesigning them. His work comprised the reevaluation and design of all building components from the floor slab to the utility core so that they could be produced in the factory and brought to site ready for assembly. Among his main achieve-

ments is the mass production of new types of prefabricated houses, schools, canteens, and laboratories by his company. In 1949–50 he built, together with a number of associates, the shell houses at Meudon-Bellevue. These were followed in 1954, at the same place, and in cooperation with Henri Prouvé and André Sive, by the Maison Expérimentale, consisting of a combination of brick walls and prefabricated units.

Although it defies strict classification, the equally unconventional and patient work of the German architect Frei Otto compares, in its variety and ideological breadth, with that of Richard Buckminster Fuller. Otto studies and develops lightweight structures that produce maximum effect with the minimum input of both material and energy, and he optimizes this efficiency through a functional flexibility, which even extends to the physical adaptability of the buildings.

In 1955 he built the Music Pavilion for the Federal Garden Show in Kassel, the first realized tent project. This was followed in 1957 by the elegant star-shaped Dance Pavilion for the Federal Garden Show in Cologne, a filigrane structure that appears to float on the water of a fountain. For the same event Otto also created a flat arched entrance from a white stretched membrane.

In 1968–72 Otto built, in collaboration with Behnisch & Partner, the roofs for the Munich Olympic Stadium and Arenas, an enlarged and further developed version of the experiments first attempted in the German Pavilion at the Montreal Expo '67 in 1965–67 (together with Rolf Gutbrod). They consist of cable nets covered with translucent acrylic glass panels or polyvinyl-chloride-coated fabric spanning a stadium, sports hall, and swimming hall and are suspended from hollow steel masts arranged at varying angles. The structure, the artificial lake, and the gentle landscape present a harmonious picture of nature and technology.

In 1970–75 Frei Otto built the Multihalle, a multifunctional hall, for the Federal Garden Show in Mannheim, this time together with Carlfried Mutschler and Joachim Langner. The lightweight wooden latticework shell, which is covered with gray translucent roofing, spans—hill-like and without support—the main areas of the multipurpose hall and the restaurant, at the same time linking them with one another and with the surroundings. Visible from the inside, the filigree grid made with simple means from intersecting wooden battens structures the gentle undulations of the large roof.

Frei Otto's innovative studies go beyond tents, cable nets, and shells to include pneumatic structures. Systematic experiments with models help him to find new forms, which are not derived from a preconceived aesthetic concept but foremost from the structural properties of construction materials and from static requirements, with biological forms being the original model. His claim that he builds not against but with nature leads him, in certain fields, into a critical ideological position and builds the bridge between the Functionalism of the 1920s and 1930s, of which he regards himself as a creative interpreter, and contemporary experiments aimed at overcoming the contradictions between society, nature, and architecture.

214. Frei Otto. Dance Pavilion, Federal Garden Show Cologne, 1957.

215. Carlfried Mutschler and Joachim Langer, Frei
Otto and Ewald Bubner. Multihalle, Federal Garden
Show, Mannheim. 1970–75.

*City Planning*

Late Rationalist city planning concentrated on alleviating the war-induced housing shortages. On the whole, this was a sad chapter in European and North American architectural history. Typologically, the spartan ground plans which had been designed for minimum standard housing during a period of economic recession were again used, this time in the service of maximum profit and despite the fact that the mid-1950s were marked by an economic boom. Formally, the sober Rationalist architectural idiom was adopted and trivialized because of its simplicity and suitability for the mass production of building components. Organizationally, the guidelines of the *Charte d'Athènes* were adhered to only insofar as their Cartesian schematism resulted in financial savings; as soon as the questions of the planning of generous open spaces, the creation of infrastructural facilities, or even measures of compulsory purchase by the authorities for the purpose of a more effective reorganization of entire ur-

ban areas arose, they were mostly passed over.

Initially, war-damaged housing was replaced within the existing city boundaries. Toward the end of the 1950s, however, and especially in the highly industrialized countries, inadequate legislation and brutal speculation were decisive in causing land in the inner cities to fall into the hands of large capitalist developers. The result was that office and administrative buildings increasingly pushed residential buildings into the suburbs. Le Corbusier's demand for the physical separation of the living and working functions was realized, but in a different sense. Living was removed from the city centers. Dull, monofunctional suburbs now mushroomed uncontrolled at the edges of the towns, while the glass skyscrapers of banks and insurance companies ate their way into what had been left by the war of the historic architectural substance. The cities were intersected by urban motorways to bring commuters from the periphery to the center and back. The business quarters,

marked during the day by chaotic traffic congestions and hectic activity, became empty after dark; people isolated themselves from one another in inhospitable suburban settlements which were attached like parasites to the conurbations.

This phenomenon became particularly apparent in the United States, despite a few exceptions in the form of ambitious but isolated projects. Attempts to draw up an effective urban public intervention policy after the New Deal were not able to counteract the increasing decay of the structural base in the overcrowded city centers. During the mid-1950s as much as 75 percent of the population lived in interminably spreading suburbs that bore no resemblance to either the settlements dreamed of by progressive planners or to Wright's Living City. One example will serve as an illustration. In 1958, at the initiative of the Boston Redevelopment Authority, a plan for the redevelopment of the inner city was commissioned. Its objects were clearly defined: demolition of 85 percent of the existing structural base, retention of a small number of historic buildings, increase in the value of building land, and removal of the function of living. The realization of the plan was supervised by N. Aldrich, Pietro Belluschi, José Luis Sert, and Hugh Stubbins, and within its framework the Boston State Service Center by Paul Rudolph and the City Hall (by Gerhard M. Kallmann, Edward F. Knowles, and Noel Michael McKinnel) were built. The inclusion of such prominent architects was, not least, intended to camouflage the ambiguity of the project.

In Europe the situation was less clear-cut. In the Scandinavian countries and in Great Britain decisions were made to adopt largely empirically oriented decentralization models. In Italy experiments were made with populist or organically oriented settlements. The socialist countries, too, experimented initially with other urban forms. Late Rationalist city planning was found mainly in two countries, West Germany and France.

In the Federal Republic of Germany the housing and infrastructural deficit was particularly great, owing to heavy damage and destruction during the war as well as to the large number of refugees from the eastern territories. The building realizations of the 1960s were marked by the quantity of the interventions, the size of the projects, and the mediocrity of the architectural standards. In 1959 Walter Schwagenscheidt and Tassilo Sittmann began work on the Nordweststadt in Frankfurt am Main, a "test-tube city" divided by functions, with different types of residential buildings, separated vehicular and pedestrian traffic, green spaces and infrastructure. An existing village and Ernst May's Römerstadt were incorporated into the project. Despite the creation of a center consisting of shops, department stores, a range of schools including boarding facilities, a subway station, parking, and meeting places, the Nordweststadt did not succeed in creating a genuine urban center.

In 1963 the realization of plans by Werner Düttmann, Georg Heinrichs, and Hans Christian Müller for the Märkisches Viertel, designed for a population of 60,000, started in Berlin. Among the architects involved were Ernst Gisel, Ludwig Leo, Oswald Mathias Ungers, and Shadrach Woods. The residential area, which includes twelve schools, fifteen day nurseries, four churches or community centers, and an indoor swimming pool, was initially intended for the rehousing of people coming from the center of the city where redevelopment had taken place. As a reaction to the all-pervading linear building of the 1950s, the large multistory blocks were arranged so as to form gigantic open urban spaces; their surfaces were suitably brightened by appropriate color schemes. Nevertheless, they were violently criticized, especially because of their enormous scale.

France also was faced with a severe housing shortage in the immediate postwar period. This was due to extensive war damage, a continuing rent freeze, stagnation of the

building industry, and massive urbanization. To counteract this situation, a public intervention policy for large residential units was begun in 1948, and as a result almost 200 Grands Ensembles were built by 1964 by heavy industrial building methods. The estates were mostly located at the edges of

216. Emile Aillaud. Pantin-les-Courtillières, near Paris. 1954–60.

217. Werner Düttmann, Georg Heinrichs, and Hans Christian Müller (overall planning). Märkisches Viertel, Berlin. 1963–74.

218. Jean Renaudie. Multifunctional building in the city center of Ivry-sur-Seine near Paris. 1970–77.

existing cities and generally consisted of over 1,000 dwellings. The building standards were relatively high, but they were not backed up by subsidiary infrastructure, which, together with the peripheral position and economy-imposed monotony, caused the Grands Ensembles to degenerate into suburbs with serious social deficiencies. A comparatively positive contribution is the Les-Courtilières settlement in Pantin near Paris, built in 1954–60 by Emile Aillaud and consisting of 1,649 dwellings arranged in three serpentinelike forms.

In 1972 the government abandoned town expansion projects of this nature. Meanwhile, a national plan had been developed in

1965 which incorporated Henri Prost's plan for the Paris region (dating from 1928–39) as well as Paul Albert Delouvrier's *Schéma Directeur de la Région Parisienne* (presented and published in 1965) and contained provisions for the creation of Villes Nouvelles. Their aim was the renewed unification of residence and place of work, the reestablishment of the equilibrium between town and region, and the decentralization of the area around Paris. Through the proximity to existing towns or parts of towns, they were to benefit from the infrastructure of the towns. As a result, Cergy-Pontoise was built from 1966 onward in the spirit of CIAM, while between 1970 and 1977 Jean Renaudie rebuilt the center of the town of Ivry-sur-Seine, also near Paris, with a profusion of dazzling angular shapes, the neurotic Mannerism of which appears to be an overreac-

219. Richard Buckminster Fuller. Geodesic dome above part of New York. Project. 1962.

tion to the orthogonal schematism of the early Grands Ensembles. Despite legislation passed in 1967 on the compulsory purchase of land, land distribution in France remained controversial. At least, by deflecting capitalist intervention activities to the suburbs and regions it has, so far, been possible to spare the historic city centers the destruction that has already left irrevocable traces in West Germany and the United States.

In view of a reality thus fraught with problems, it is little wonder that urban utopias were devised all over the world. The Hungarian architect Yona Friedman, who lives in France, conceived in 1957–60 the project

220. Paul Rudolph. Graphic Arts Center, New York. Project. 1967.

Paris Spatial, a city expansion plan for the third dimension, that of height. It stipulates residential cells attached to a steel bar supporting structure sustained by huge concrete columns high above the old city. Richard Buckminster Fuller developed his idea of the dome to its extreme logical conclusion when he designed, in 1962, a roof that was to span part of New York—a vast, transparent and air-supported cupola suspended above the superskyscrapers, protecting an entire urban district from the influence of the weather.

In 1963 Jan Lubicz-Nicz and Donald P. Reay evolved their Urbatecture concept on the occasion of the international competition for the redevelopment of Tel Aviv's administrative center—huge spoon-shaped megastructures, into which the urban functions are integrated. The lower region of the structure, marked by high density, houses the services, while the residential section, which includes terraced dwelling with roof gardens, is in the middle, and the offices are at the top.

Paul Rudolph, too, proposed a large-scale structure in his project for the Graphic Arts Center in New York (1967). An artificial terraced hill extends into the Hudson River and forms a small harbor. The 4,050 dwellings consist of prefabricated units derived from the trailer concept, popular in the United States. They are suspended from grids cantilevering from towers at every tenth floor. The units are staggered so that the roof of one forms the terrace of the next. Communal facilities, among them child-care centers, schools, shops, and recreational areas, are on every tenth floor below the cantilever system.

# 8 | Regionalism, Empiricism, and Neo-Expressionism

*Historical Development*

Parallelling late Rationalism, Regionalist, Empiricist, and Neo-Expressionist architectural movements appeared in the years immediately after the Second World War. The core period of these movements occurred between 1945 and 1960, but their influence extends to the present, with individual strains being superimposed upon one another.

A brief analysis of events preceding their emergence reveals analogies with the situation after the First World War. Politically, the anti-Rationalist tendencies had their roots in the disappointment of hopes for a peacefully coexisting world, for even if Nazi Germany and its Fascist allies had been defeated in 1945, the international conflicts were by no means resolved. Overt signs of these tensions were the Chinese civil war, the French Indochina War, and the fight for independence in Indonesia, all of which flared up immediately after the end of the Second World War.

Technological progress was widely regarded with suspicion. As had happened after 1918, the horrors of the war were equated, in a politically and intellectually naive association, with the technology that had made them possible. Science was threatened with the role of scapegoat.

Culturally, there was a regression from social reality into regionalism and individualism. A romanticizing cult of personality and of local traditions became the alternative to the great international avant-garde movements. Provincial and Neo-Expressionist tendencies spread to the realm of the visual arts.

*Theories and Forms of Building*

An inadequate historical analysis of Rationalism led some groups of young postwar architects to jump rashly to the conclusion that it had basically failed. The disappearance of the generous socialist hopes that had provided the background for progressive building during the 1920s and 1930s suddenly seemed to destroy the ideological foundation for its possible continuation and further development. The wide gap between everyday architecture and the works of masters like Walter Gropius, Ludwig Mies van der Rohe, and Le Corbusier raised doubts as to the possibility of the universal application of their formal idiom; and the schematic interpretation of a linear, rigid development, extending from Adolf Loos and the Bauhaus directly to late Rationalism, created the myth of an inevitable course in the opposite direction.

Models for a romantic reaction were found in the works of Frank Lloyd Wright and Alvar Aalto with their organic understanding of architecture and their links with nature; in respective local building traditions; and finally in the experiments of architectural Expressionism. All this did not add up to a coherent theory, as the latter would have had to combine too many divergent views. Instead, it resulted in slogans aimed at removing the largely imaginary shortcomings of Rationalism: incorporation into the environment, attention to the *genius loci*, respect for tradition, Naturism, inclusion of psychological and even sentimental requirements in the design, humanizing of building, expression, and informal architecture.

Within the Regionalist movement local, conventional building methods were now taken into account with the aim of producing greater variety of form, better understanding, a stronger reference to tradition, and a more intensive emotional effect. As early as the beginning of the 1940s Frank Lloyd Wright had pointed out, not without polemic undertones, the significance of "anonymous architecture." He described it as an architecture that arose from people's basic needs and harmonized with nature, and he declared it to be a better model than the academic experiments being conducted in Europe.[31]

The British-Austrian architect Christopher Alexander stated in 1964 in his book *Notes on the Synthesis of Form* that the architectural language of so-called primitive cultures is a rich mine of information for modern building which endeavors to be appropriate to man because it coincides, due to its gradual organic development, with its cultural context. This would not apply to the Rationalist idiom of architectural form, which is the artificial distillate of a small number of intellectuals. Alexander developed complex mathematical procedures to break down the problems of design and planning into rows of components and to subsequently resynthesize them, analogous to the creative processes of "unselfconscious cultures."

In the exhibition "Architecture Without Architects," which was mounted in 1964–65 at the Museum of Modern Art in New York, Bernard Rudofsky drew attention to the charm of "non-pedigreed" architecture through photographs from all over the world. In its wake numerous documentary works on anonymous architecture were produced, their subjects ranging from traditional alpine houses to the owner-built houses of American hippies and other members of the counterculture of the 1960s.

The Dutchman Aldo van Eyck, who may be regarded as the founder of architectural Structuralism, was also deeply impressed by the congruence of life and form in primitive societies and intensively studied their buildings. He thus created a connection between Regionalism and contemporary architectural movements.

At about the same time the concept of urban design emerged. The impetus was given by the Briton Gordon Cullen, who in his book *Townscape* (1961) produced a kind of catalog of desirable urban spatial situations, which he derived, in a romantic and retrogressive utopia, mainly from the medieval town with its picturesque alleys, squares, corners, and vistas. Other works followed, and while they legitimately drew attention to the deficiencies of late Rationalist city planning, they also supported the tendencies of the theatrical pseudo-reservation-of-monuments" architecture. It was mainly due to the urban design movement that pedestrian zones were created in numerous historic city centers; they had a monofunctional influence on the, for the most part, already disturbed urban equilibrium, and the natural mixture of urban functions in urban life was replaced by artificial leisure shopping amid dubious "furnishings."

Within Empiricism, initially efforts were made to relate architecture more closely to the user by a less restricted use of forms, colors, and materials. This largely superficial approximation soon gave way, however, to more detailed scientific analyses. In view of the "built inhospitality," to which the sociologist Alexander Mitscherlich, among others, had repeatedly drawn attention during the 1960s, auxiliary disciplines were introduced in order to remove architecture from the—on the whole imaginary—arbitrariness of architects. In theory this helped to focus on the complexity inherent in building; in practice it changed little. Most of the demands raised by the sociology, psychology, and physiology of living remained unfulfilled, mercilessly crushed by external "objective" requirements that were, in the final analysis, nothing more than the short-

sighted functionalistic restrictions imposed by the economy.

Nonetheless, the consciousness of the discrepancy between the wishes of man and the buildings that were forced upon him led to the development of processes allowing people to participate in the planning process. Participation thus opened a wide scale of possibilities of codetermination, ranging from empirical studies based on questioning users about their desires, to semifinished houses that could be completed in accordance with individual wishes, and to owner-building programs and techniques. The Austrian painter Friedensreich Hundertwasser (Friedrich Stowasser) wrote in 1958 in his *Verschimmelungs-Manifest gegen den Rationalismus in der Architektur* (Mold Manifesto Against Rationalism in Architecture): "A stop must finally be put to the situation in which people move into their living quarters like hens and rabbits into their coops. . . . A man in an apartment house must have the possibility of leaning out of his window and scraping off the masonry for as far as his hands can reach. . . . Every modern architect in whose work the ruler or the compass have played any part even for a second—and even if only in thought—must be rejected . . . The straight line is ungodly and immoral. The straight line is not a creative, but a reproductive line. In it dwells not so much God and the human spirit as rather the comfort-loving, brainless mass ant."[32] A bridge had thus been built to the parallel movement of architectural Neo-Expressionism, in which the demand for greater variety of form and for more expression was central. This appeal, partly shrouded in vague humanitarian claims, was rooted predominantly in the individualistic longing for greater freedom of artistic self-representation. With the revaluation of mysticism and with the emergence of new religious sects, mainly of Far Eastern origin, with a renewed skepticism toward collectivism—quite understandable after the Fascist and National Socialist indoctrination

and mobilization of the masses—and with the call by members of the counterculture of the 1960s and '70s for self-sufficiency, self-liberation, and self-realization of the individual, the mythical ideal of the sublime artist-architect celebrated a soulful return.

Although the forms of building of the three architectural movements—Regionalism, Empiricism, and Neo-Expressionism — are extremely varied and diverse, certain approximate common denominators can be found.

—Buildings are fitted carefully into the surrounding landscape; their position and their appearance are deliberately chosen, because form and *genius loci* are closely related.
—Dimensions are reduced to a "human" scale. Larger buildings are structured and broken down into smaller units in order to avoid monumentality.
—Building materials are natural ones: brick, natural stone, wood. "Noble" materials, such as steel, chromium, marble, and large panes of glass are avoided.
—Production methods and structural details are crafts-based and not infrequently primitive. Industrial production is generally renounced.
—Formal idioms have their roots in regional traditions or reflect them in an expressive form. Abstraction is rejected in favor of an immediate sensual impact.

*Architecture*

In the United States of the 1940s, and in particular in California, the Bay Region Style developed, an heir of the American farmhouse tradition, of the Shingle Style, and of Organic architecture. William Wilson Wurster, one of its main protagonists, who had been deeply influenced by the eclectic American architect Bernard Ralph Maybeck, built several residential and country houses which were marked by reticence, adaptation to the landscape, and attention to the climatic, economic, and social environment. An example of this "everyday archi-

tecture," which places greater emphasis on function and construction than on form, is the Reynolds House in San Francisco, built in 1946, a simple, long, freely articulated wooden building with a shallow hipped roof.

The uninterrupted tradition of early West Coast country houses and of the functional American wooden barns constituted the starting point for the work of Charles Willard Moore when he built in 1963–65, together with Donlyn Lyndon, William Turnbull, and Richard Whitaker, Condominium I as part of the recreational complex Sea Ranch on the Pacific Coast in Sonoma County, California. The vertically clad timber structure consists of simple geometric forms with orthogonal and angularly staggered surfaces, sharply incised apertures, and oriellike applied additions. The internal layout results from a clear separation of the "machines" (kitchen, bathroom, and other technical installations) and the living quarters. Over the years Sea Ranch was further extended: in 1965 the Swin Tennis Club was built, as was Johnson House, in which the internal octagon of white painted wooden walls with symmetrically arranged redwood supports contrasts with the free geometry of the exterior. In 1970 Shinefield House was added, which seems to crouch on the ground because of its partially planted roof. This was followed in 1973 by the boldly structured Halprin House.

In 1975–78 Moore designed, together with the Urban Innovations Group, St. Joseph's Fountain on the Piazza d'Italia in New Orleans, Louisiana. For the city's Italian community a circular piazza with concentrically alternating bands of dark and light stone was conceived, collapsing in one section into a relief map of Italy. From "lakes" in the north of the peninsula flow three "streams," representing the Po, Arno, and Tiber rivers, into the "Tyrrhenian" and "Adriatic" seas. With the questionable argument that the majority of immigrants are of Sicilian descent, Sicily was designed as the center of the piazza and, moreover, as an orator's tribune. The background of the naive symbolic arrangement is formed by six overlapping "backdrops" with representations of the architectural orders made from concrete, stainless steel, and water. All of this adds up to empty irony, which under the guise of misinterpreted populism produces only kitsch.

Charles Moore demonstrated his architectural ideas not only in a great number of constructed works, but also in books, primarily in *The Place of Houses*, which he wrote together with Gerald Allen and Donlyn Lyndon in 1974. In it, the eloquent architect

221. William Wilson Wurster. Reynolds House, San Francisco. 1946.

222. MLTW (Charles Willard Moore, Donlyn Lyndon, William Turnbull, and Richard Whitaker). Condominium I, Sea Ranch, Sonoma County, California. 1963–65.

verbalized the five principles of design underlying his work.

1. Buildings can and must speak.
2. Buildings must therefore have the right of free speech. They must be able to say thoughtful, wise, mighty, nice, and even silly things.
3. Buildings must be habitable for the bodies *and* the minds of people.
4. Buildings must be based not only on Cartesian abstractions but must also appeal to the senses.
5. Buildings must create connections with the past and evoke memories.

In his fight against the asceticism of architectural Rationalism and for the acceptance of the banal, Moore is akin to Robert Venturi in his ideas; but whereas the latter produces an intellectual abstraction of the commonplace, which he takes as his model, Moore applies it with sensual and vital directness. While such spontaneity accounts for the charm of his best works, it permits the less successful ones to degenerate into the popularized trivialities from which they draw their substance.

The varied work of Ralph Erskine, an Englishman who has lived in Sweden for many years and who was decisively influenced by the Scandinavian tradition, takes its place in the area bordering Rationalism, Empiricism, and Neo-Expressionism. In 1948–50 he built the Skiing Hotel Center at Borgafijäll, an eclectic assembly of colored structures under one roof; and in 1950–53 a cardboard manufacturing factory in Fors near Avesta, in which the ventilation towers, required by the production process, undulate as plastically exaggerated elements from the brick facade and are given sculptural treatment.

In Italy, after the fall of the Fascist regime, the intellectuals were seized by the exhilarating feeling that their world, which had previously been clouded by insincere patriotic trivialities, could suddenly be seen

223. Charles Willard Moore and Urban Innovations Group. St. Joseph's Fountain, Piazza d'Italia, New Orleans, Louisiana. 1975–78.

"truly" through new eyes. This new perception resulted in the rise of Italian Neo-Realism. The early films of Roberto Rossellini, Luchino Visconti, and Vittorio de Sica, the first stories by Alberto Moravia, and the paintings of Renato Guttuso express this spiritual attitude.

Architecture was equally affected. In addition, it endeavored to approach directly the working classes, who were regarded as the main protagonists of postwar reconstruction. However, highly idealistic claims produced a largely naive populist regionalism that celebrated the "masses" through the immediate use of formal elements belonging to regional building traditions.

Mario Ridolfi, who described himself as a "suburban architect," built, in 1951–54, the INA apartment buildings in Rome, ten-story blocks with expressively sloping roofs,

224. BBPR (Gian Luigi Banfi, Lodovico Barbiano di Belgiojoso, Enrico Peressutti, and Ernesto Nathan Rogers). Torre Velasca, Milan. 1957–60.

which attempt in their roughness to rediscover crafts-based and material-imposed values.

Far less naive, but at the same time far less idealistic in its latent political implications, is the Torre Velasca, a tower built in 1957–58 by the Rationalist architectural group BBPR in the historic center of Milan. The high-rise building is not interpreted as an amorphous and readily reproducible object, but as a unique episode that reacts contemplatively, through its remotely medieval air, to the neighboring Gothic cathedral. The building is characterized by vertical modeled structural elements of reinforced concrete, small windows distributed over the facade in an accidental rhythm preventing it from being schematically monotonous, and the distinct, plastically marked break of the cantilevering upper section. The functional explanation of the projection, namely that

the offices it contains permit greater building depth than the apartments in the lower part, is of secondary importance in view of its aesthetic intention. As it is primarily a residential building, the Torre Velasca differs from most other urban high-rise buildings in that it does not contribute to the depopulation of the city centers.

In Switzerland, Rudolf Olgiati based his work on the rural Engadine architecture. In 1975–76 he built Haus Schorta at Tamins, which is stylistically connected with regional tradition, while the heavy walls, made seemingly insubstantial through their whiteness, are reminiscent of Mediterranean culture. Crafts-related irregularities are elevated to a norm: instead of a geometrically controlled composition of surfaces the house becomes a sculptural unit.

The Empiricist architectural movement received a worldwide boost during the mid-1960s through the hippie movements and the related revival of ideologies of self-sufficiency; it celebrated its eccentric climax in the counterculture settlement of Drop City in Trinidad, Colorado (1966), the geodesic domes of which are made up of waste materials.

Walter Segal, an English architect of Swiss extraction, who had spent his childhood in Henri Oedenkoven's anarchist vegetarian community of Monte Verità, developed, around 1965, a simple and inexpensive do-it-yourself building system. Prospective homeowners, with materials available from builders' suppliers and even from department stores, are able to build their own houses according to plans drawn up by Segal in consultation with owners. The system is modularly devised so that components supplied by industry need not be cut to size, and so that even a layman can erect a Segal house without expert help. He thus not only saves considerable labor costs but is also able to identify psychologically with the end product. At first glance Segal Houses do not differ fundamentally from other timber houses with prefabricated infill. They con-

sist of a timber framework that carries and supports the other lightweight elements off the ground. The walls are formed of simple panels laid out on a distinct grid.

If Segal the designer deliberately takes second place to Segal the advocate of his own participation principle, the Belgian architect Lucien Kroll does not in any way hide the aesthetic purpose of his "alternative" architecture. Between 1969 and 1978 he controlled and coordinated the design and realization of the students' dormitories and the buildings of the medical school of the Université Catholique de Louvain at Wolluvé St. Lambert, a suburb of Brussels. The prospective users, mainly students, experimented with combinations of functions and built a number of models of the complex. Only when discussion had led to a consensus did Kroll start drawing up plans. The execution, too, was largely in the hands of the users, which led to numerous improvisations and changes in the original plans. Brick, plastic, aluminum, glass, wood, stone, asbestos cement, and concrete were used to build cheerful and diversified structures reflecting the great variety and richness of individual creative contributions. The gardens of Louis Le Roy, which consist of rubble, and where carefully selected plants create a natural self-perpetuating ecological equilibrium, complement the architecture of controlled anarchy.

The framework of architectural Neo-Expressionism encompasses the work of the American Bruce Goff, a student of Frank Lloyd Wright, and of his willful and unconventional single-family houses. Bavinger

225. Lucien Kroll. Students' residence, Université Catholique de Louvain, Wolluvé St. Lambert, near Brussels. 1969–78.

226. Rudolf Olgiati. Haus Schorta, Tamins, Switzerland. 1975–76.

227. Bruce Goff. Bavinger House, Norman, Oklahoma. 1951–57.

House at Norman, Oklahoma, built in 1951–57, is particularly emblematic. A logarithmic spatial spiral is enclosed on the exterior by crudely joined local sandstone. The central mast, anchored by guy ropes, supports the wound roof, the stairs, the access bridge, and the living areas. The technological and idiomatic derivations from nautical architecture, and from the neighboring oil drilling towers are obvious. In the interior the individual areas of the house are spread over a number of staggered plateaus suspended from the roof and covered with carpets and fishing nets. Luxuriant vegetation further emphasizes the improvisational character of the building.

Goff tried, throughout his extensive work, to continually develop a specific idiom for each theme. However, the deliberately sensational arbitrariness of his forms tends to reduce this claim to a caricature and raises doubts as to his credibility. Instead he succeeded in satisfying the compulsive search of his clients for eccentricity through an overindividualistic artistic imagination.

The Italian Paolo Soleri, who has lived in the United States since 1947 and temporarily worked for Frank Lloyd Wright, collaborated with Mark Mills in building the futuristic Desert House at Cave Creek, Arizona in 1951, a small structure domed by two movable glass hemispheres. In 1954–55 he built the five-story Solimene Ceramics Works at Vietri sul Mare, with bizarre spiraling ramps.

John Maclane Johansen, a pupil of Walter Gropius and Marcel Breuer and, paradoxically, a former member of the firm Skidmore, Owings & Merrill, began a series of Neo-Expressionist experiments when he built Spray House at Weston, Connecticut, in 1956. The informal structure consists of a metal screen sprayed with concrete. In 1966–70 Johansen built the Mummers Theater in Oklahoma City, Oklahoma, a dissonant, colorful assembly of architectural elements, some of which were used after recycling. The aim is not to create harmony; rather the building exemplifies the deliberately controversial Action Architecture that permitted the use of kitsch and waste materials. Two auditoriums, with 600 and 300 seats respectively, a rehearsal room, offices, and subsidiary rooms are connected like an

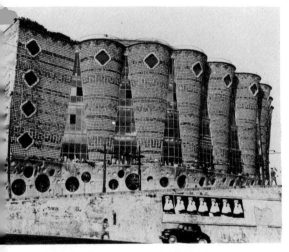

228. Paolo Soleri. Solimene Ceramics Works , Vietri sul Mare. 1954–55.

229. John Maclane Johansen. Mummers Theater, Oklahoma City, Oklahoma. 1966–70.

electronic instrument, by four "circuits" at various levels. The highly developed technology of the second Industrial Revolution collides here with "poor" materials and even real scrap metal. In the interior the auditoriums are, not unlike Scharoun's Berlin Philharmonic Hall, divided into separate, differently structured levels.

If Johansen with his impulsive architectural language openly admits his leanings toward slang, the Dane Jørn Utzon, who at one time worked for Gunnar Asplund and Alvar Aalto, and who visited Frank Lloyd Wright at Taliesin, strives for a more elegant and expressive idiom. After completing a number of simple buildings, he won the

230. Jørn Utzon. Sydney Opera House, 1956–74.

competition for the design of the Sydney Opera House in 1956. When the Australian Labour Party, who had commissioned the project, suffered a defeat in 1966, the building became the subject of political controversy and was not completed until 1974, after its originator had been removed from the realization process. Despite changes, the huge sculptural structure has not lost its original characteristics. Its privileged position on a narrow strip of land projecting into the harbor alone gives it symbolic weight. The elegant white outer concrete shells, the forms of which are derived, through a complex geometric progression (a cyclical wave), from the surface of a sphere, are placed on a massive platform that is terraced on the side facing the land. They cover the two audito-

riums in the form of a dynamic cascade. In the interior the plastically designed space is determined by plywood acoustic ceilings and a Gothic-inspired interchange of light and movement.

The work of Carlo Scarpa signifies an even more unusual elegance. He continued the sublimely spacious refinement of his native Venice within an independent interpretation of Wright's organic language of forms. In 1955–61 he built Casa Veritti in Udine, in which the poetry of boxlike expressiveness is combined into a confusing assemblage.

The Castelvecchio Museum in Verona (1958–61) is notable for its numerous sensitive yet radical restorations and details of interior design. A "second skin" is contained in the historic building of the castle, which is clearly distinguishable in construction and form from the old components. With its noble details of steel and ferro-concrete, it conjures up an ascetic and surrealistic atmosphere. Medieval details are fused with influences of Japanese architecture and Art Nouveau.

In his last realized work, the Brion Cemetery at San Vito d'Altivole near Treviso, Scarpa created in 1970–72 a lyrical as well as enigmatic place of meditation with an astounding richness of geometric shapes.

Frederick Kiesler, formerly an assistant of Adolf Loos and a follower of the De Stijl movement, had demanded the *Vitalbau*

231. Frederick Kiesler. Endless House. Project. 1960.

232. Claude Parent and Paul Virilio. Church of St. Bernadette, Nevers, France. 1964–66.

233. Reima Frans Ilmari Pietilä and Raili Paatelainen. Dipoli students' residence, Otaniemi, Finland. 1964–66.

("Vital Building") as early as 1926. In 1947, on the occasion of the First International Postwar Exhibition of Surrealism he realized the "Hall of Superstition," a room in which architecture, sculpture, and painting shared equally. Among further participants in the total work of art were Max Ernst, Joan Miró, and Marcel Duchamp. Kiesler wrote on this occasion: "I confront the mysticism of Hygiene, which is the superstition of 'Functional Architecture,' with the realities of a Magical Architecture rooted in the totality of the human being, and not in the blessed or accursed parts of this being."[33] In 1960 Kiesler produced the Endless House project, a revised version of an early project of 1923, in which freely shaped, mysteriously biomorphic cavelike rooms are grouped around a naturalistically curved staircase.

The sculptor André Bloc turned against the sterility of *espaces architecturés* and replaced them with habitable *espaces sculptés*. In a park near Meudon he realized, in 1962, Habitacle I, a wildly shaped spatial unit of sprayed white concrete that in its deliberately irregular plasticity is reminiscent of cave formations.

Claude Parent, a pupil of Le Corbusier, soon rejected his master's Cartesian approach and developed an expressively plastic idiom. In 1964–66 he built, in collaboration with Paul Virilio, the Church of St. Bernadette at Nevers. The building, made of concrete cast in situ, is the expression of a fortresslike monumentalism; its surface is marked by the formwork irregularities of the *béton brut*. In the French pavilion for the 1970 Venice Biennale, Parent expressed his theoretical ideas of *vivre à l'oblique* in material form by creating a provocative spatial unit from oblique areas.

The Finn Reima Frans Ilmari Pietilä built, in cooperation with his wife Raili Paatelainen, the Dipoli residential unit for students at Otaniemi near Helsinki in 1964–66. The public spaces—foyer, three restaurants, cafeteria, and lecture hall with stage—are freely articulated in a style reminiscent of Scharoun and seem to grow out of the rock. They are juxtaposed with diagonally arranged, severely orthogonal service buildings. The result is an unresolved and powerful dialectic of irrational and rational forces. Most of the exterior of the concrete structure is copper and timber clad, while the interior remains unclad with the exception of individual wall sections and the ceilings, which are lined with wooden battens. The irregularly arranged wings of the building, spreading out in the shape of a star, tie it into the landscape and introduce nature into the building.

*City Planning*

After the brief interlude of the New Deal settlements, city planning in the United States was dominated by late Rationalist models. In the rural areas of California, however, an alternative was developed which was as insignificant in terms of quantity as it was remarkable in terms of quality: between 1937 and 1943 Vernon De Mars designed over forty agricultural settlements for the Farm Security Administration. These were intended as supply stations for those migrant workers who traveled westward through the desert each year in trailers to find work and who were described by John Steinbeck in 1939 in his novel *The Grapes of Wrath*. In addition to infrastructural facilities, like shops, first-aid posts, day nurseries, and laundries, the centers also provide accommodations for local farmers. The architecture of the settlements was derived from the simple timber structures of the Bay Region Style. A typical example is Yuba City (1940).

An entirely different, affected interpretation of regional tradition is revealed in Kresge College of the University of California at Santa Cruz, California, built in 1973 by Charles Moore and William Turnbull. The students' village is arranged along an intricately curved road with communal facilities at each end. The variety of the formal

234. MLTW/Turnbull Associates. Kresge College, University of California, Santa Cruz, California. 1973.

idiom is reminiscent of theater architecture: the two- and three-story facades facing the street are animated by arcades, stairs, and covered walks; the urban space is furnished; mundane installations, such as drainage systems, telephone booths, automatic washing facilities, and cafeteria are inappropriately overemphasized in order to conjure up an ominous identity.

Great Britain, a highly industrialized country, already had been confronted with the problems of uncoordinated economic expansion between the two world wars. London in particular grew continuously, while Wales, Scotland, and the northeast were increasingly left as underdeveloped areas. At the instigation of the Town and Country Planning Association, an organization that advanced Ebenezer Howard's garden city ideas after his death, a commission was appointed by Prime Minister Neville Chamberlain to investigate the country's structural situation. In 1940 the commission recommended a policy of decentralization.

As early as 1939 the Green Belt Act had been passed, providing for a green belt of at least 5 miles (8 kilometers) around London to curb the expansion of the capital. In 1942–45 the city planners Patrick Abercrombie and John Henry Forshaw drew up the Greater London Plan, which divided the total area of the conurbation, amounting to 2,600 square miles (6,700 square kilometers), into the Inner Urban Ring (where the existing population was to be reduced by more than 400,000 people), the Suburban Ring (where development was blocked except for redevelopment and unification), the Green Belt (as a recreational area), and the Outer Ring (for the expansion of existing settlements and the establishment of new satellite towns). In 1947 the state gained control over the regional distribution of all new major industrial projects through the Town and Country Planning Act; thus began one of the most interesting city planning operations of the twentieth century. Its roots extend from Robert Owen and Ebenezer Howard to Patrick Geddes, and its basic principles, which also take into account Rationalist elements, can be summed up in five points:

—Extension of planning to the entire country in order to develop global, effective, and coordinated measures
—Control of land and of most building developments by the state in order to enforce and assert overall planning
—Decentralization to prevent excessive expansion of conurbations
—Creation of small independent urban centers with a population of between 20,000 and 60,000, not as single-function bedroom communities, but as integrated organisms offering accommodations, work place, and services in one location
—Overcoming of the rigid patterns of Rationalist city planning; abolition of strict linear building and Cartesian high-rise developments within strictly orthogonal street grids in favor of more differentiated building projects along freely designed road systems.

On the basis of these principles eight New Towns were built around London from 1949 onward: Stevenage, Harlow, Welwyn Garden City, Hatfield, Hemel-Hempstead, Bracknell, Crawley, and Basildon. The projects were realized by well-known architects and city planners, among them Frederick Gibberd.

For a period of ten to fifteen years the administration of the satellite towns was in the hands of corporations entirely financed by public funds, after which they were handed over to local authorities; in order to counter speculation, land was leased to industrial enterprises and houses were leased rather than sold. Within a few years the population of the capital was reduced by almost a half million people. In subsequent years numerous other New Towns were founded throughout Great Britain.

Despite its progressiveness and its basic success the New Towns program was not free from contradictions. What was lacking in the first place was coordination between the supraregional political and economic targets of the country as a whole and the local restructuring; in the course of this restructuring imbalances were created, for example in the case of a center like Birmingham, where no provisions for a New Town to relieve the city center had been made; moreover, the loose distribution of the satellite towns tended to waste land and spoil the countryside, while the new establishments with their small dimensions and predominantly rural character tended to degenerate into sleepy green ghettos without urban qualities. In order to counter this latter deficiency attempts were made to create urban centers marked by a high concentration of building and aggressive architectural forms, for example in the multilayered city center of Cumbernauld, built between 1955 and 1962 by Hugh Wilson and Geoffrey Copcutt.

Meanwhile alternative and contradictory strategies to the New Towns policy were being developed. The 1952 Towns Development Act provided for the creation of a close network of small centers at the initiative of local authorities. In 1960 the program for New Cities with a population range of 250,000 to 500,000 was drawn up in order to counteract the antiurban tendencies of the early satellite towns. Within the framework of the development program for the southeast, the conurbation area was extended through the creation of three newly created centers: Peterborough, Northampton, and Milton Keynes.

The Milton Keynes area was outlined in 1967. It lies at a distance of approximately 43.5 miles (70 kilometers) from the center of London, comprises an area of 34.5 square miles (89 square kilometers), and includes a number of existing towns and villages. At the time of its establishment the New City had a population of 40,000, the scheduled

235. Milton Keynes, Begun 1967.

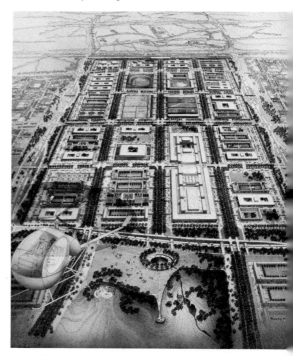

final figure being 250,000. Schools, health centers, social service installations, sports facilities, and a city center with a large department store and 170 shopping units constitute an efficient infrastructure. The establishment of new companies, the enlargement of existing ones, and the transfer of companies from other parts of Great Britain provide numerous places of work. The New City thus presents itself as an autonomous unit. The predominant type of house is the row house in a variety of styles, mainly with two stories, and less frequently with one or three stories. The sloping roofs create a link with traditional forms of building.

Ralph Erskine, who realized a number of settlements in Sweden, built New Byker at Newcastle-upon-Tyne in England in 1969–81 in close cooperation with the local authorities and prospective resettled inhabitants. The estate, designed for 10,000 people, consists of two separate units, the Wall and a sparsely built-up hillside. Byker Wall is a three- to eight-story-high curvilinear row of houses, more than .6 mile (1 kilometer) long, which extends mainly along a highway and acts as a sound barrier. Its exterior is mostly closed and continuous, and is optically broken up by the different colors of the brickwork. The interior is predominantly open and articulated by means of covered walks, balconies, windows of varying sizes, different colors and materials, as well as by gardens and other forms of greenery. The rest of the settlement (80 percent of the total program) extends behind the Wall and is protected by it as a complex of primarily two-story brick row houses between semi-public green areas and pedestrian zones. In order to preserve a feeling of continuity for the population, parts of the old road system, public buildings, and the complex system of neighborhood shops were retained in the new estate.

In Sweden over 45 percent of all housing units were overcrowded in 1945 as a result of the extensive industrialization that occurred after the Second World War and the related drift to the cities: there were more than two people per room, not including living rooms and kitchens; moreover, 60 percent of the units had no private toilets, and only 25 percent had a shower or bath. In order to rectify these deficiencies, the Social Democratic government launched a program for the construction of high-quality yet economically priced housing. The rent of an average family dwelling was set at no more than 20 percent of a worker's earnings. Housing construction was subsidized. The statutory fixing of rents introduced during the war was replaced by a system of subsidies for the lower income groups. Speculation was curbed through the progressive reduction of ownership of private housing from 80 percent in 1945 to 40 percent in 1970, with public land control enforced already since after the war. Thanks to such measures the number of overcrowded dwellings dropped to 25 percent in 1965 and to less than 10 percent in 1975; by 1975 some 80 percent of the units had their own bath or shower.

Within the framework of such a remarkably progressive context, equally remarkable city planning achievements took place. In 1943–45 Sven Backström and Leif Reinius

236. Ludovico Quaroni, Mario Ridolfi, and others. INA Casa district, Rome. 1950.

built several residential high-rise buildings at Danvisklippan near Stockholm, introducing a new type of building in order not to mar the hilly surroundings. In 1945–46, on an estate at Gröndal, also near Stockholm, they grouped star-shaped modules each consisting of three dwellings accessible through triangular staircases to form hexagonal courts that obtained a villagelike personal note through their individual idiom. In 1957 a 919-foot-(280-meter-) long curvilinear building was built at Nockebyhar near Stockholm, which through its free geometric design adapts to the rolling landscape into which it is set.

When Sven Markelius, who was the head of Stockholm's city planning department from 1944–54, completed the development plan for Greater Stockholm in 1952, analogous to the Greater London Plan providing for a number of largely decentralized satellite towns, Backström and Reinius were given the opportunity to put their ideas for new forms of living into practice on a larger scale. In 1952–53 Markelius, with cooperation from other architects, was in charge of the planning for the suburb of Vällingby conceived for a population of 80,000. This was built around an urban center with a carefully devised pedestrian zone. The variety of dwelling types, additionally enhanced by a wealth of bright colors and traditional details, ranges from residential high-rise buildings to single-family houses with private gardens. Further suburbs followed.

In Italy the Fanfani Plan for the "improvement of the employment situation of the workers" was passed in 1949, thus providing state subsidies for the creation of new workers' quarters as links between town and country. As a result the first INA Casa districts were built, administered by the Istituto

237. Sven Backström and Leif Reinius. Estate at Gröndal near Stockholm. 1945–46.

238. Taller de Arquitectura. Barrio Gaudí, Reus. 1964–67.

Nazionale delle Assicurazioni. The peripheral or entirely detached estates are largely freed from the rigid concepts of the *Charte d'Athènes* and combine the experience gained through the Scandinavian experiments with an attempt at the revival of traditional and popular values.

In 1950 the INA Casa district Tiburtino was built in Rome according to designs by Ludovico Quaroni, Mario Ridolfi, and other architects. It became a physical manifestation of Neo-Realism that attempted to give architectural shape to the national popular aesthetic demanded by the Communist ideologist Antonio Gramsci. The seemingly haphazard distribution of the buildings over the area reflects the romantic myth of spontaneously grown conglomerates. The idiom draws on the traditional, simple houses of the Roman Campagna, while the details, executed by crafts-based methods, are an explicit reference to the "sound world" of the peasants and workers. In all, the project is the architectural expression of an equally idealistic and naive utopia.

Italian city planning soon freed itself from such populist nostalgia. In 1950–51 Gio-

239. Ralph Erskine. The Wall, New Byker, Newcastle-upon-Tyne. 1969–80.

vanni Astengo, Sandro Molli Boffa, Nello Renacco, and Aldo Rizzotti built the organically structured Falchera settlement near Turin, in which irregularly U-shaped linear buildings form large open courtyards. In 1951 a group of architects headed by Ludovico Quaroni built the village of La Martella near Matera, which provided the inhabitants of the Sassi district with dignified accommodations and aimed at a deliberately unintellectual approach to the problems of urban development.

In Spain a new form of regionalism vaguely reminiscent of Catalan Modernismo emerged when the self-taught Ricardo Bofill Levi founded the Taller de Arquitectura group in 1960. Among its early members were the architects Anna Bofill and Peter Hodgkinson, the literary critic Salvator Clotas, the economist Julio Romeo, the theatrical artist Manolo Nunez, the engineer Ramon Collado, and the poet José Augustin Goytisolo. In combination with unconventional working methods the extremely interdisciplinary composition of the group resulted in willful and individualistic architectural solutions, mainly dealing with the transitional areas between residential block and urban district.

In 1964–67 Taller de Arquitectura built the residential quarter of Barrio Gaudí at Reus, the birthplace of Antoni Gaudí. The complex and expressive estate, which consists of 2,000 dwellings, is organized like a small town and extends, with courtyards, stairs, promenade roofs, connecting paths, and terraces, in a labyrinthine manner over three dimensions. The basic element of the estate is the ground plan of the individual dwelling, which is assembled according to the rules of geometric addition and variation to form an urban organism. This concept, related to architectural Structuralism, was in this case deliberately used for the rediscovery of regional and symbolic values.

In Switzerland the Seldwyla estate near Zurich was built according to principles oscillating between Regionalism and Empiri-

cism. For its realization a cooperative was founded in 1967, and the first two construction stages of the complex were completed between 1975 and 1978. Rolf Keller was given overall charge of the project, and he also designed most of the houses. In an attempt to allow the house or apartment owners maximum "self-realization," a participation model was developed, which guaranteed codetermination in relation to the size of the property. The result of this pseudodemocratic enterprise is a pretentious Swiss Regionalism. With affectedly traditional building forms, rustic detail, and loosely grouped houses (these are almost without exception consecutively arranged single-family houses), it projects the image of a bucolic alpine idyll outside the gates of the big city.

A more maturely considered model for the participation of future users was the new university town of Louvain-la-Neuve near Brussels, built after 1970. The development project was in the hands of the Groupe Urbanisme-Architecture under René Maurice Lemaire and P. Lacomte. The foundation was decided upon in 1968, the year of widespread student unrest. In order to avoid the creation of a university ghetto, it was intended from the onset to build an entire town. In order to avoid a uniform and monotonous project, almost 50 architectural offices and several small firms of builders

240. Groupe Urbanisme-Architecture (overall planning). Louvain-la-Neuve. Begun 1970.

241. Rolf Keller and others. Seldwyla Estate, Zumikon near Zurich. 1975–78.

242. Paolo Soleri. Arcosanti, Paradise Valley, Arizona.
Begun 1969.

were commissioned with the realization of a
variety of relatively small buildings; in order
to avoid discontent among future users, a
citizens' council was elected whose task it
was to represent the interests of the inhabi-
tants as early as during the planning stage.
For a university population of 10,000 and a
permanent population of 20,000 a complex
high-density settlement was built, consisting
mainly of four- to six-story houses with slop-
ing roofs, oriels, and often unexpectedly ar-
ranged balconies and terraces. Vehicular
traffic is channeled from an outer circular
road to its destinations so that the problem
of through traffic does not arise. The main
road designed as urban space is reserved for
pedestrians. The unity of the town with re-
gard to the size of buildings, distances,
streets, squares, and material (mainly brick)
is reminiscent of medieval towns. The for-
mal idiom, too, with its emphasis on small
dimensions, its artificial nooks and crannies,
and its somewhat forced search for atmo-
sphere suggests a regressive utopia that is
not without charm.

A similar yearning for the lost "center"
characterizes the much more innovative,
even near-utopian city planning work of
Paolo Soleri. Together with his adepts, who
attempt to revive the mystical pioneering
spirit in the loneliness of the desert of Ari-
zona and in the footsteps of Frank Lloyd
Wright and the American hippies as por-
trayed in the film *Easy Rider*, he has been
engaged in building the futuristic city of Ar-
cosanti at Paradise Valley, Arizona since
1969. The settlement—most of which is
below ground—is a bizarre mixture of Ex-
pressionism, science fiction, Mayan motifs,
and historicizing crafts romanticism. In a
way, it represents the realization of Soleri's
urbanist macro-dreams which started in
1959 with a city on a table mountain for a
population of 2 million, and ranged from
Jersey Three (1970), a condensed megastruc-
ture with computer-controlled traffic, to
Babelnoah (1971), where 6 million people
were to have been concentrated in a multi-
functional, expressively structured gigantic
skyscraper.

# ⑨ Contemporary Movements

## Historical Development

The feverish economic upswing that affected the United States and most of Western Europe after 1945 was not without problems, despite its spectacular élan. The gross national product of the industrial nations grew at an enormous rate, and in the context of an unprecedented wealth the consumer society was established. However, the surplus rested on an unstable political foundation, one that was balanced between the imperialist and hegemonic efforts of the two superpowers, the United States and the Soviet Union, and favored certain groups, classes, and countries at the expense of others.

The results of these tensions and differences were soon apparent. In 1962 the Cuban crisis, involving primarily the United States and the Soviet Union, had worldwide repercussions. During the same year civil strife against British troops erupted in Ireland. In 1965 the Vietnam conflict, which had started as far back as 1954, degenerated into open warfare; supported by the Americans on one side and the Soviet Union and China on the other, it lasted until 1973. In 1966 the hitherto nonviolent struggle of America's black population (under Martin Luther King) became increasingly violent and was opposed with equally violent methods. In 1967 the Arab-Israeli Six Day War was fought. During 1967–69 violent student unrest spread throughout the United States and Western Europe; stimulated by, among other things, the Chinese Cultural Revolution (1966–69), protests were directed against the authoritarian university system and against the entire capitalist and consumer-oriented establishment. In 1968 Czechoslovakia's attempts at liberalization (Prague Spring) were suppressed by the invasion of the Warsaw Pact's armed forces. At the beginning of the 1970s the phenomenon of large-scale terrorism first manifested itself in Europe. In addition, heavy conflicts occurred in the Third World where several nations began to fight against their colonial exploitation by the industrialized countries as well as against their own governments, many of which were allied with the industrialized powers.

The political struggles were closely linked with newly emerging economic problems. During the two centuries of industrialization the simultaneous growth of population and production had gone hand in hand with a mindless exploitation of the earth's raw material resources and an equally thoughtless environmental pollution. When Dennis L. Meadows published his study *The Limits to Growth* (1972), a report by the Club of Rome on the situation of mankind outlining the disastrous prospects of an ecological crisis, the general public gradually began to understand that the earth's resources are finite; that many raw materials on which man depends cannot be renewed; that the environment cannot be polluted without dire consequences; and last, that life can be maintained only if uncontrolled demographic and technological expansion is curbed and replaced by an overall ecological equilibrium. The international oil and energy crisis, unleashed by the oil-producing Arab states in 1973–74, was not only an expression of

the awakening of the Third World, but also the first tangible symptom of a new danger. It was to have severe repercussions on world economy.

Meanwhile, great technological advances were made, especially in the field of electronics. In reciprocal interaction with these advances, space travel had its first successes: in 1957 Sputnik, the first artificial satellite, was launched into orbit around the earth; in 1960 the first man traveled in space, and in 1969 the American astronaut Neil Armstrong landed on the moon.

The integrated technologies developed for such achievements fascinated architects and encouraged and substantiated new thoughts on the "gadget" house. Influenced by space capsules, numerous utopian concepts were evolved, as well as a variety of oversophisticated minimal residential cells and rationalized prefabricated kitchen and bathroom modules, the so-called heart units, that were produced ready for assembly, complete with their technical installations. At the same time, the initial romantic enthusiasm for industrialization in building, which had reached its zenith in the 1920s, sounded a more skeptical note in view of the social, technological, and aesthetic failures of the reconstruction period after the Second World War. The Israeli architect Moshe Safdie, himself an advocate of industrialized and standardized building, warned: "It is dangerous to underestimate the difficulties of introducing mass-production, closed-system techniques into housing. A house is much more complex than an aircraft. An aircraft can be clearly defined in terms of physical performance. . . . A house is a physical problem, plus a complex social problem, plus a complex psychological problem. A house has to be publicly accepted. . . ."[34]

In the cultural sphere, the visual arts, walking the narrow dividing line between aestheticism and populism, accepted the new artistic and social challenges. As early as the 1930s the American artist Edward Hopper had devoted himself, in a synthesis of realistic and surrealistic tradition, to the depiction of the "ghastly beauty" of bourgeois life in small towns. During the late 1950s the Neo-Dada movement, continuing the Dadaism of the 1920s, attempted to explore reality freely, unhampered by a system of values.

These were the two main sources of the Popular (Pop Art) movement, which emerged in the United States during the early 1960s. As a reaction to the impulsive Action Painting of Abstract Expressionism, the purely formal aims of which it rejected, Pop Art looked for its basic artistic material in the images of commercialized everyday life. The pictures and objects of the technological market-oriented consumer society, conditioned by the mass media and characterized by mass culture, found their way into the banners of Jasper Johns and the Combine Paintings of Robert Rauschenberg. These two protagonists were joined by artists like Claes Oldenburg, who arranged the first multimedia Happenings; Roy Lichtenstein, who reflected society's loss of individuality in oversized comic strips; and Andy Warhol, who reproduced in his work pin-up girls, Campbell soup cans, Marilyn Monroes, and homosexuals with the neutrality of merchandise and produced copies of them by machine. In Great Britain the Independent Group became the focal point of an individual, freer movement, which counted Richard Hamilton, Peter Blake, and Eduardo Paolozzi among its members.

Pop Art was primarily an American and British phenomenon, but it also spread to other countries. Its successor, marked by stronger social engagement and criticism, overlaps in its objects to some extent with the New Realism, which had its origins in the Actions and Happenings of the group of artists in Paris that congregated around Pierre Restany. This movement, which "freezes" reality in order to interpret it ironically and critically, combines extremely heterogeneous personalities. They range from Christo (Christo Javacheff), who wraps ob-

jects, buildings, and entire stretches of landscape in huge sheets of plastic film in order to make them aesthetically "conscious," to Gerhard Richter, whose painted photographs analyze reality as though it were viewed through a pitiless magnifying glass.

During the mid-1960s Conceptual Art developed, an art form that continues the experiments carried out by Marcel Duchamp during the 1920s, namely to declare technical and intellectual experiments works of art. These efforts went so far as to even dispense with the material realization of the creative process. Within the movement's efforts to generate impulses for a change in society through artistic activity, several variations arose: Street Art, which involves passersby in creative processes and carries out aesthetic and practical operations in the urban environment; Land Art, which covers large landscape formations with structures that change its formal image; Earth Art, which creates new spatial situations with the material earth; and Behavior Art, which aims at making processes of change visible on the human body.

At the same time, Surrealism, which originated with Giorgio de Chirico's *Pittura metafisica* (1917) and had matured through André Breton's *Manifeste du surréalisme* of 1924, developed further in the works of artists such as Max Ernst, René Magritte, and Salvador Dali.

*Theories and Forms of Building*

Contemporary architectural experiments attempt to bridge the increasing alienation that has arisen since the Second World War between building and reality. Despite their variety, and partly even despite their idiomatic contrasts, they are all in principle based on the conviction that reality must be tackled with rational means. They thus go back to the original Rationalist premise. At the same time, however, they try to delve into the background of this premise, to

widen its understanding, to thoroughly differentiate it in order to come to terms with the contradictions of a world that has developed with confusing speed and has shown itself to be considerably more sensitive and complex than could be assumed in the 1920s.

The new ways of thinking became apparent when CIAM VIII met in 1951 at Hoddesdon, England and criticized the *Charte d'Athènes*; but behind this discontent lay an intellectual and urbanist vacuum that CIAM IX, which took place at Aix-en-Provence, could not fill either. The ferment found a catalyst when a group of young architects was commissioned to prepare CIAM X. Team X, which counted Jacob Berend Bakema, Georges Candilis, Giancarlo De Carlo, Alison and Peter Smithson, and Aldo van Eyck among its members, demanded positiveness, honesty, and the acknowledgement of the responsibility of creating order through form. Team X separated from CIAM at the group's tenth meeting in Dubrovnik (1956), thus causing CIAM's collapse. A further international congress took place at Otterlo, Holland, in 1959, at which Team X engaged in violent criticism of the "old guard." Its attacks were directed against the swiftness with which the older generation was supposedly prepared to compromise, as well as against the alienated Rationalism, to which the New Brutalism was juxtaposed. The term, first coined in 1954, stood for a rediscovered and—if necessary—"brutal" intellectual clarity.

Thus the development that was to lead to new architectural experiments had been initiated. Its theoretical foundations can, as a simplification, be traced back to three common sources.

—Semiology, the theory of signs established by Charles S. Peirce in his *Collected Papers* (1931–35), was applied to architecture. Among others, Gillo Dorfles, Giovanni Klaus Koenig, Christian Norberg-Schulz, Max Bense, and Umberto Eco

pioneered in this field. Through it, in addition to structural, functional, and social aspects, the significance of the physical form (semantics) moved to the center of attention. The result was the overcoming of the functionalist approach. Whereas the latter had demanded that architecture reflect only the functions taking place inside a building, the postulate of a more sophisticated and complex expression was now raised, an expression which might even go so far as to renounce the representation of function altogether. At the same time the more in-depth reflection led away from the all too available and at times infantile allegories of Neo-Mannerism.

—After the deliberate and self-imposed asceticism of Rationalism with regard to the use of historical elements; after the fashionable purism of late Rationalism; and after the Mannerist eclecticism of the 1950s, architectural history became once again acceptable. Efforts were made to achieve a more thorough and objective critical understanding of the past. Rudolf Wittkower's book *Architectural Principles in the Age of Humanism* (1949), a new interpretation of Leon Battista Alberti and Andrea Palladio, provided a major impetus for a new historical reflection.

—The demand for architectural honesty, a postulate that had prevaded progressive architecture since the days of Carlo Lodoli, was rephrased in a different yet possibly even more radical form than during the period of Rationalism, since it now also referred to the disclosure of technical installations, building processes, and historical elements. The architectural idiom derived from these theoretical foundations is characterized by appropriate features.

—The formal vocabulary becomes more varied in order to cover the required breadth of the range of architectural meaning. The glass towers of late Rationalism, which are neutral in terms of expression and which, because of their size and complexity can only by anonymous teams be realized, are abandoned in favor of simpler and more modest buildings of a more intensive intellectual, and aesthetic effect, such as can be designed and controlled by individuals.

—In order to enrich the architectural vocabulary, the repertoire of architectural history is drawn upon, either as an abstract source of inspiration or as a reservoir of formal elements used in their original form. It is once more permissible to "quote" historic motifs as an explicit intellectual exercise in retrieving latent meaning: the preferred sources are Roman architecture, the Renaissance, Classicism, and Rationalism. In addition, attention to the historic past leads, in its search for points of reference, to greater consideration of the urban context. Architecture and city planning are again regarded as a unit, and they are seen as qualitatively the same, only on a different scale, each governed equally by historical laws.

—The renewed emergence of late nineteenth-century Historicism is precluded by the postulate of honesty: it is evident how a building is made and what function it has; or the historical "quotations" are applied where they are clearly visible and the decoration is separated from the actual building.

These characteristics give an approximate outline of the common denominators of contemporary architectural movements. However, they cannot be found in all of the relevant works, since present-day architecture is marked by a pluralism of styles, which is as pronounced as it is contradictory.

*Architecture*
The term New Brutalism, under the banner of which contemporary architectural experiments began, was coined in England

during the mid-1950s by the group associated with the husband-and-wife team of architects Alison and Peter Smithson and theoretically defined by the critic Reyner Banham. The term describes an architectural movement which aims at uncompromising honesty beyond style and fashion, without, however, renouncing perceptual stimuli. Its models are the severely formalist buildings of Andrea Palladio, the clear structures of the engineer-designed constructions of the early nineteenth century, and the works of Ludwig Mies van der Rohe and Le Corbusier. Of the latter the Unités d'Habitation and the Maisons Jaoul, where *béton brut* was used as an architectural feature, were especially influential.

In 1949–54 Alison and Peter Smithson built the Hunstanton School, in Norfolk, which is regarded as the first realized example of New Brutalism. Its plan is arranged simply but not schematically around a central space and two adjacent lateral courts. The load-bearing steel structure with glass and brickwork infill is in its severity and its emphasis on structural elements reminiscent of the style of Mies van der Rohe, but it renounces Classical proportions, perfect details, and noble materials. The dimensional relations among the individual structural parts of the building are based on pragmatic considerations; building materials are not given any specific finish; and the details are almost brusque in their immediacy. The building is characterized by a "brutal directness," which ranges from the unified but in no way pleasing overall structuring of the complex to the exposed services and installations. In this context Banham wrote: "... what has caused Hunstanton to lodge in the public's gullet is the fact that it is almost unique among modern buildings in being made of what it appears to be made of. Whatever has been said about honest use of materials, most modern buildings *appear* to be made of whitewash or patent glazing, even when they are made of concrete or steel. Hunstanton *appears* to be made of

243. Alison and Peter Smithson. Hunstanton School, Norfolk. 1949; 1952–54.

glass, steel, and concrete. Water and electricity do not come out of unexplained holes in the wall, but are delivered to the point of use by visible pipes and manifest conduits."[35]

New Brutalism is not so much an architectural style as it is an ethical attitude. Its intellectual impulses soon found an international echo. Two examples are the Istituto Marchiondi Spagliardi for problem children at Baggio near Milan, built by Vittoriano Biganò in 1958–59 as a rough assembly of deliberately plastic elements within the framework of a geometrically disciplined whole; and the St. Gallen Commercial College, built in 1960–64 by Walter Maria Förderer, Rolf Georg Otto, and Hans Zwimpfer as a complex of dissonantly dismembered reinforced concrete structures.

Other architects reflected in their work an affinity for New Brutalism, without being followers in the strict sense of the word. Among them are Louis Isadore Kahn and James Stirling. Louis Isadore Kahn, born in Estonia and trained in the United States in the Beaux-Arts tradition, worked with several other architects, among them the pioneer of American Rationalism George Howe. His first major building was not realized until after he was more than fifty years old. Between 1951 and 1953 he built the extension to the Yale Art Gallery in New Haven, which continues the aesthetics of

Mies van der Rohe in a Brutalist interpretation. On a clearly arranged open plan, which can be recognized from the outside, rise four stories, the layout of which permits functional variation. The reinforced concrete skeleton, the yellow-brown bricks of the facade, and the metal frames of the windows are displayed and formally stressed with the same boldness shown in the supporting structure of the Hunstanton School. The character of the main exhibition hall is determined by the visible framework of the ceiling, which consists of concrete tetrahedrons. A few years later, this building was to influence Paul Rudolph's Art and Architecture Building, erected in the immediate vicinity.

In 1957–61 Kahn built the Alfred Newton Richards Medical Research Building at the University of Pennsylvania in Philadelphia. The differentiation between "serving" and "served" spaces stems from Frank Lloyd Wright's early work, and in particular his Larkin Building. It resulted in the first instance in three laboratory buildings. They are joined by connecting units to a central access core and are "served" by means of attached towers housing staircases and ventilation ducts. The laboratories, which have square plans, are thus kept entirely free. This functional arrangement obtains aesthetic significance. The slender closed red-brick towers, which are reminiscent of medieval fortifications, are placed axially in relation

245. Louis Isadore Kahn. Alfred Newton Richards Medical Research Building. University of Pennsylvania, Philadelphia. 1957–61.

to the seven-story glass laboratories, and are 26 feet (8 meters) higher. The load-bearing structure of the blocks is independent of the towers; the structural principle is clearly discernible and underlines the expressive, aggressively dramatic effect of the building.

Such reversion to the past can be found throughout Kahn's work, but in his early realizations the references were still abstract and vague. Only with the buildings for Dacca (now Bangladesh), for which plans began in 1962, and for the Indian Institute of Management at Ahmedabad (1963–67), which derive their idiom from the style of the late Roman Empire, did Kahn's Historicism reveal itself openly. A wealth of types, as is apparent in the Villa Adriana near Tivoli or in Giovanni Battista Piranesi's pseudo-archaeological works, endeavors to counteract through historical solemnity the "loss of

244. Louis Isadore Kahn. Extension of Yale Art Gallery, New Haven, Connecticut. 1951–53.

the center" mourned by Hans Sedlmayr in 1949 in his book *Verlust der Mitte*.

While Kahn, with his extreme longing for the firm and orderly principles of a powerful tradition, is American to the core, James Stirling, who treats tradition with pragmatism and subtle humor, is deeply British. As early as during his training Stirling showed a marked inclination toward his country's architectural heritage. He was as much influenced by the Classicist John Soane as he was by Joseph Paxton, the creator of the Crystal Palace in 1851.

Between 1955 and 1958 Stirling realized, in collaboration with James Gowan, the Langham House project at Ham Common near London, consisting of three clearly articulated flat-roofed buildings arranged on a narrow plot of land. In the larger three-story building, which is in the immediate vicinity

246. Louis Isadore Kahn. Indian Institute of Management, Ahmedabad. 1963–67.

247. James Stirling, Cambridge University History Faculty Building, Cambridge. 1964–67.

of a Georgian brick building, the reinforced concrete skeletal structure, with an infill of masonry, is left visible with "brutalist" honesty and reveals an intellectual and formal relationship with Le Corbusier's Maisons Jaoul. Both of the two-story pavilions are more generously glazed, and their upper stories are accessible through a gallery freely suspended in the entrance hall.

Between 1959–63 Stirling and Gowan built the University Engineering Building at Leicester. The complex is divided into an extensive and mainly single-story workshop section and a vertical tower housing offices, laboratories, and lecture halls. The lecture halls are arranged in the lower part of the tower building, from which they cantilever, in line with the slope of the seats, as obliquely cut blocks. Their dimensions vary, their levels are staggered, and they are built at angles of 90 degrees from one another. The main entrance is below the incline of the largest lecture hall, which thus serves as a

248. James Stirling. Research and Development Center of Siemens AG, Munich. Project. 1969.

projecting roof. A further entrance lies on the podium above the ground floor, which is accessible by a ramp. Moreover, a glazed spiral staircase allows students arriving late to have direct access to the back rows of the lecture hall. Three access towers are grouped around the distribution area between the lecture halls, serving the nine-story glazed office tower as well as the six-story laboratory building, which is lit through bands of horizontal windows. In line with the decrease in traffic load, corridors become narrower in the upper regions, a feature that is indicated on the exterior by the cascadelike tapering of the profile of the glazing. The

workshops are laid out on an orthogonal ground plan, into which only the access area projects and which is lit through a sawtooth roof, inclined from the orthogonal grid at an angle of 45 degrees to receive the northern light. Glass is the predominant material. The frame profiles consist of standard industrial units, which are used by Stirling and Gowan to produce intensely personal crystalline forms. All continuous surfaces are clad either with red brick or with red tiles.

The building, which derives its complexly assembled shape from a rational analysis of the construction program, represents a spectacular overcoming of orthodox Functionalism. It combines semantic aspects with those of function to form an intrinsically logical and independent work that has received its largely abstract historical impulses from numerous sources, ranging from English nineteenth-century glass house architecture and Antonio Sant'Elia to Konstantin Stepanovich Melnikov and Pierre Chareau. The accuracy of the design method is noted by Stirling himself: "Every built volume has both a weight and a stability or instability, depending on its form. Complexes must be created which are stable in themselves. In the Engineering Building the weight of the tall towers compensates for the projection of the lecture halls. In other words, the degree of projection is determined by the weight lying on top; if the topmost story were removed, the entire building would collapse. There is no doubt that in the composition of stable masses as architectonic—above all, when they are asymmetrical—quality is inherent."[36]

After his break with Gowan, Stirling built the Cambridge University History Faculty

249. James Stirling. Extension of the Stuttgart State Gallery and new building for the chamber theater of the Württemberg State Theater. 1979–84.

250. James Stirling and James Gowan. Leicester University Engineering Building, Leicester. 1959–63.

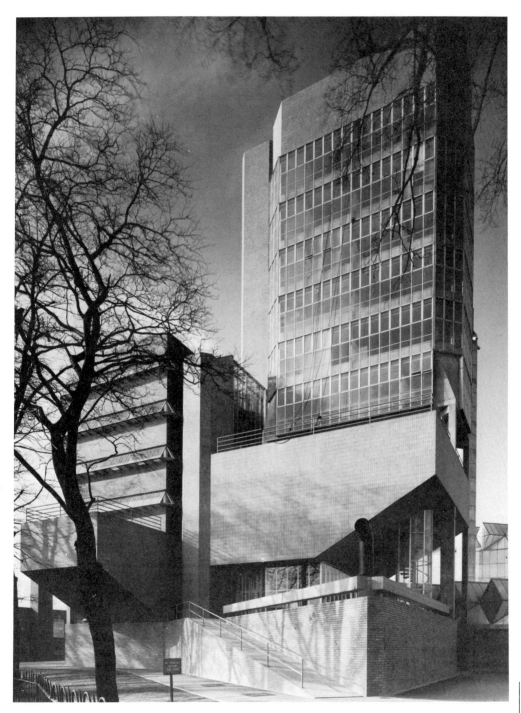

Building in Cambridge in 1964–67. Its links with the Leicester Engineering Building are obvious. Once again an expressive and at the same time rational shape has been developed; once again there is emphasis on access systems; and once again glass and brick are the main materials. The difference lies in the method of composition. Whereas in Leicester the individual elements were simply assembled with no attempt to fuse them with one another, the Cambridge complex is dominated by integration.

In 1964–68 Stirling built the students' quarters for the St. Andrews University at St. Andrews. Here, the oblique-angled rooms are oriented toward the sea; they are accessible through a glazed corridor that corresponds, both functionally and visually, to the promenade deck of an ocean liner. The four- to six-story building was assembled from prefabricated concrete elements with diagonally ribbed surfaces to stress the "skinlike" character of the walls. The joints have been left unclad so that the construction process is clearly recognizable.

The project for Siemens Aktiengesellschaft in Munich, dating from 1969, indicated Stirling's shift toward a skeptically reflected monumentalism with marked urban features. The complex, which after the

251. Giancarlo De Carlo. Students' residence at Urbino. 1962.

completion of its final stage would have provided 13,000 work places, is strictly linear and symmetrical in its arrangement. Above an angular six-story podium, sloping toward the exterior, rise two rows of five cylindrical office buildings of solid proportions. Their large glass areal walls are protected from the sun by bright orange enameled sunscreens that are computer controlled and move around the building with the sun. A tree-planted urban avenue with a colonnade and a variety of communal facilities extends along the main axis, and terraced water gardens along the outer edge separate the central area from the multistory parking structures arranged behind the complex.

The two competition projects for the Landesgalerie Nordrhein-Westfalen in Düsseldorf and the Wallraf-Richartz-Museum in Cologne (both dating from 1975) confirmed Stirling's inclination to regard architecture as an intellectual game with elemental geometries and volumes, surrealistic disturbances and interpenetrations, and explicit historic quotations. This inclination culminated in 1977 in the project for the extension of the State Gallery and for a new chamber theater in Stuttgart. On the ground floor, arranged around a circular court, in which sculptures are displayed and which is connected to an urban passageway, are a room for temporary exhibitions, a lecture hall, storerooms, and the rooms for technical installations. The café and foyer are placed in front and enclosed by gently undulating glass frontages. On the gallery level exhibition rooms of varying sizes are grouped so as to constitute a simple continuous spatial sequence that is connected to the original building by a bridge. The theater is housed in an annex on the west side. The building, which is clad with natural stone, is a collage of continuous surfaces, glazed curves, access elements, columned porticoes, pointed Gothic arches, and heavy projecting cornices. It is a sophisticated and both elegant and dissonant plastic design

that fits with gentle self-confidence into the urban setting. Construction began in 1979 and was completed in 1984.

The Italian architect Giancarlo De Carlo, like the Smithsons a member of Team X, links the ethical and aesthetic experiences of New Brutalism and the marked historical consciousness of his generation with serious political engagement. His beliefs are summed up in the following statement: "I believe that one of the tasks of a politically conscious architect lies in the development of models, of physical models, which naturally have been given a shape, as a representation of the world as it might be."[37]

In 1955 he built, at Urbino, a group of populist-inspired houses for university employees, and in 1959, at Matera, a row of residential houses and shops that is polemically distanced from the Rationalist architectural idiom and oriented toward local tradition. In 1962 De Carlo returned, in his students' residence at Urbino, to a personal interpretation of the New Brutalist aesthetics. His concern for the interests of the people affected has, since then, been reflected less in the adoption of traditional formal elements than in the development and use of considered and practical participation processes through which the users are involved in the architectural planning process.

A more marked orientation toward history appears in the work of Paolo Portoghesi, who applies the formal doctrines of the Baroque, and especially those of Francesco Borromini, to the various design levels of interior, architectural object, city, and landscape. In 1968–74 Portoghesi built, in collaboration with Vittorio Gigliotti, the church of the Sacra Famiglia in Salerno. Its geometric principle is based on a complex circular structure with five external centers. The convex interior walls "push" the introverted room "together," thereby focusing attention toward the openings between the wall segments as well as toward the center of the church, where the altar stands. Three concentrically stepped concrete vaults, left

252. Paolo Portoghesi and Vittorio Gigliotti. Church of Sacra Famiglia, Salerno, Italy. 1968–74.

253. Vittorio Gregotti, Lodovico Meneghetti, and Giotto Stoppino. Residential building for Bossi S. A., Cameri near Novara. 1956–57.

unclad and rough in the interior, continue the shape of the walls and represent the Holy Trinity. Symbolic, historical, geometric, and constructional features have been combined to form an impressive and suggestive unified shape.

For Vittorio Gregotti architecture is a craft, even when it utilizes the most modern technical facilities. His work preserves and

254. Ernst Gisel. Secondary school complex in Vaduz. 1968–73.

255. Alvaro Joaquim Melo Siza Vieira and others. Sao Vitor residential district, Porto. 1974–77.

emphasizes the individual features of material properties, proportions, symmetries, and ornamentation. These are not used to refer symbolically to something else but point only to themselves. The object of the architectural message is its own individual formal articulation, which utilizes latent and overt historical allusions. In 1956–57 he realized, together with Lodovico Meneghetti and Giotto Stoppino, the simple and elegant residential building for the firm Bossi S.A. at Cameri near Novara—a two-story symmetrical brick building with a shallow hipped roof. The sophisticated "normality" of the house anticipates some of Robert Venturi's maxims without succumbing to his philological passivity.

Ernst Gisel, who at one time worked for Alfred Roth, the pioneer of avant-garde Swiss architecture, endeavors to find a new interpretation of the Rationalist idiom, into which he introduces the principle of conflict. His statement of intent is: "The logical implementation of a formal thought alone does not necessarily lead to an artistic objective. On the contrary: an all too easily discernible order makes one suspect a purely intellectual construction."[38] Between 1968 and 1973 he built the strongly articulated school complex in Vaduz, Liechtenstein. The arrangement of the individual sections, the brick red color of which provides a picturesque contrast to the surroundings, meets not only functional but also urban compositional requirements.

In Portugal, the country with Europe's most serious housing shortage, Alvaro Joaquim Melo Siza Vieira advocates a housing reform in close cooperation with the affected segments of the population. Between 1974 and 1977 he realized, together with other architects, the Sao Vitor quarter of Porto, where existing foundations, walls,

256. Herman Hertzberger with Jan Antonin Lucas and Hendrik Eduard Niemeijer. Administrative building of the Central Beheer Insurance Company, Aperdoorn. 1968; 1970–72.

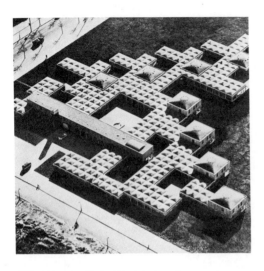

257. Aldo van Eyck. Municipal orphanage, Amsterdam. 1957–60.

and floors of old demolished houses were carefully incorporated into the new buildings. Crafts-based elements are thus contrasted with light, smooth and simple architecture and demonstrate a creative historical continuity.

A further reaction to late Rationalism and Neo-Mannerism, which was initiated by the conflict between the CIAM group and Team X, found its expression in the movement of architectural Structuralism. The movement relates back to some of Le Corbusier's de-

258. Angelo Mangiarotti. Factory building at Bussolengo near Verona. 1976–79.

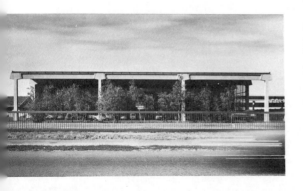

signs, such as his project of 1925 for students' residences in which buildings are arranged like a carpet over a homogeneous network of streets, and it also influences some of the work of Louis Kahn and of Alison and Peter Smithson. Its birthplace, however, is the Netherlands, and its earliest adherent is Aldo van Eyck.

The philosophy of Structuralism is distantly related to research undertaken by the ethnological structuralists such as Claude Lévi-Strauss, who in the 1960s assumed linguistic, social, and architectural "archetypal structures" behind cultural processes and carried out studies aimed at exploring such fundamental human behavior patterns. Architecture based on this philosophy also takes as its starting point the underlying "objective" structure of forms that determine, as archetypes, the entire history of architecture. Designing is thus nothing but a creative search for archetypal solutions. Structuralist architects reject the neutrality of Rationalism, since it leaves the user with a too unlimited and sterile freedom of choice, and they also reject the formal richness of Mannerism as being too emotional and subjective. As an alternative they advocate a multilayered order that controls geometrically, through several transformation stages ranging from the construction system to the urban structure, everything that is built; within the framework of such a disciplined, nonhierarchical but stimulating raw texture, each user is given the opportunity to make an individual choice.

Aldo van Eyck, a member of both CIAM and Team X, built the municipal orphanage in Amsterdam in 1957–60. In his search for "labyrinthine clarity" he thus created the first Structuralist building. Within a geometric grid based on the square, he developed a complex yet simple composition of basically identical small-scale elements. The large and the small, the interior and the exterior, the individual and the group form a complete synthesis. Van Eyck himself wrote in this context: "The building was conceived

as a configuration of intermediary places clearly defined. . . . it implies a break away from the contemporary concept (call it sickness) of spatial continuity and the tendency to erase every articulation between spaces, i.e., between outside and inside, between one space and another. Instead, I tried to articulate the transition by means of defined in-between places which induce simultaneous awareness of what is significant on either side."[39] By going back to a demand first raised by Leon Battista Alberti, he thus put into practice the analogy of city and house. "A small world in a large world. A large world in a small world. A house like a city. A city like a house. . . ."[40]

The Dutch architect Herman Hertzberger produced, in 1966, the project for the town hall of Valkenswaard, a geometric composition of small-scale square elements. In a related explanatory note he outlined the principles of his architectural work: "The town hall must be essentially antimonumental in the sense in which it is linked with power. The town hall must be essentially monumental in the sense in which monumentality is linked with democracy."[41] In the administrative building of the Central Beheer Insurance Company at Apeldoorn, designed in 1968 in cooperation with Jan Antonin Lucas and Hendrik Eduard Niemeijer and realized in 1970–72, Hertzberger was able to put his ideas of a user-related architecture into a concrete form. The complex, based on the principle of composition of adding regular vertical and horizontal cuboids on a square plan, can be extended on all sides. Moreover, it is entirely nonhierarchical in its structure; not even the entrances are emphasized. In keeping with a somewhat naive democratic myth, individual position and status in the business are not evident from the size, arrangement and furnishing of the rooms. In contrast to the open plan system common in other organizations, the office landscape is arranged so that each employee has his own private "island" but nevertheless maintains visual and acoustic contact with

his colleagues. The whole office area is intersected by bridges and semipublic covered internal roads which, together with a great variety of communal facilities—bars, kiosks, clubs, small shops, a restaurant, and a day nursery—give the building the characteristics of an urban structure *en miniature*. The basic load-bearing structure of the building was assembled from prefabricated reinforced concrete units and infilled with a form of unrendered lime-sandstone. The offices, too, were not completely furnished so as to stimulate the future "inhabitants" to finish their place of work according to their own ideas.

Pieter (Piet) Blom, self-taught and a pupil of Aldo van Eyck, built in 1975 three Dwelling Trees at Helmond in the Netherlands, as prototypes for an entire estate. The cuboid houses, angled at 45 degrees and balanced in a seemingly precarious way on one corner, which is attached to an access shaft, achieve stimulating spatial effects in the interior.

Only distantly related to architectural Structuralism is the work of Jacob Berend Bakema, who worked under Cor van Eesteren at the Amsterdam Municipal Building Department and entered into partnership with Johannes Hendrik van den Broek in 1948.

In 1973–74 Bakema and van den Broek built the psychiatric hospital Centre Hernesser at Middleharnis on the island of Goeree-Overflakee. The individual buildings are spread over the land as an orthogonal macrostructure that has been disassembled according to functional principles. Long bridges made from Cor Ten steel and resting on reinforced concrete supports form a continuous network of pedestrian pathways raised off the ground. The pavilions for a total of 350 patients (to be enlarged to 500 patients) are at ground floor level. The undisguised construction and the emphasis on the access system indicate the influence of New Brutalism.

The tenets of new Brutalism and Structuralism also influenced, at least in part, "tech-

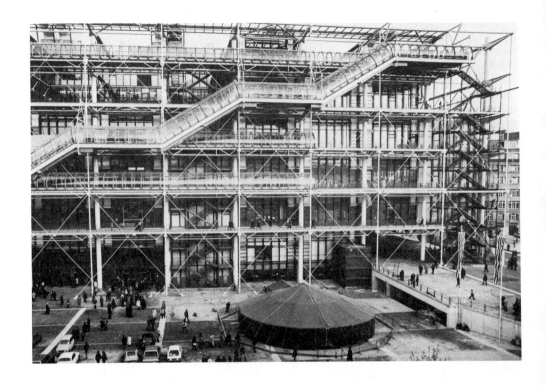

259. Renzo Piano and Richard Rogers. Centre National d'Art et de Culture Georges Pompidou, Paris. 1971–77.

nological" architecture, which adopted the principles of structural honesty and geometric control of form. Despite the sobering realization that the earth's resources are limited and despite the shock caused by the energy crisis of the 1970s, it attempts to keep pace with and utilize contemporary industrial developments in order to build more quickly, cheaply, and effectively. Skepticism toward progress, however, contributes to the fact that the best of the new buildings do not, as do those of late Rationalism, highhandedly celebrate their own spectacular technology. Instead, they use it in an objective and confident way to demonstrate how and of what they have been made, while at the same time making aesthetic capital out of that very demonstration.

Among the most paradigmatic examples of this attitude is the work of the Italian architect and designer Angelo Mangiarotti, whose technical and sensory experiments with prefabricated reinforced concrete structures take up the heritage of Pier Luigi Nervi. Mangiarotti too, combines highly developed technologies with architectural quality and a creative understanding of tradition. In 1957 he built, together with Bruno Morassutti and A. Favini, the church Mater Misericordiae at Baranzate near Milan, in which concrete columns with X-sections determine both the front views and the interior space; their simple poetry reinterprets the reductionism of Mies van der Rohe. In 1976 Mangiarotti designed a prefabricated prestressed concrete structure for factory buildings, realized, among other examples, in 1979 at Bussolengo near Verona. It is marked by slender dimensions, elegant proportions, and subtle formal sophistication.

Within the field of structural steelwork the Centre National d'Art et de Culture Georges Pompidou, designed and built at the Plateau Beaubourg in Paris by Renzo Piano and Richard Rogers between 1971 and 1977, became the emblem of modern technological building. The six-story, 544.5-foot- (166-meter-) long and 195-foot- (60-meter-) deep building houses a national museum for modern art, a public reference library, a crafts center, and a number of subsidiary facilities (a movie theater, a multipurpose room, meeting and conference rooms, restrooms, and a restaurant), while areas for supplies and parking facilities spread over three subterranean floors. Below the piazza adjacent to the building lies the Institut de Recherche et Coordination Acoustique/Musique (IRCAM), distributed over five floors.

The load-bearing steel structure consists of a combination of supports, trussed girders, cantilevering members ("gerberettes"), and diagonal wind bracings. The building was almost entirely erected by the system-building method. Its outer skin, which consists mostly of glass, lies behind the support structure, which is shown with uncompromising radicalism. Equally visible are the installation pipes, painted in bright primary colors, and the vertical access units. An escalator, wrapped in transparent plastic tunneling, rises, in four sections, to the fifth upper floor along the main facade. Inside, the six stacked halls, each of which covers the area of an entire floor and is spanned over its entire width of 157.5 feet (48 meters) by unclad lattice trusses with no additional support, offer maximum functional flexibility. The marked emphasis on elements signaling movement—escalators, elevators, and service units—endow the enormous public apparatus with the aesthetic of Soviet Constructivism and of the utopians of the British Archigram group, and moreover represents a dynamic understanding of culture. It is, indeed, its object to make art accessible to all strata of society through its thematic

260. Norman Foster and Associates. Administrative building for the Willis, Faber & Dumas Insurance Company, Ipswich. 1970–71; 1973–75.

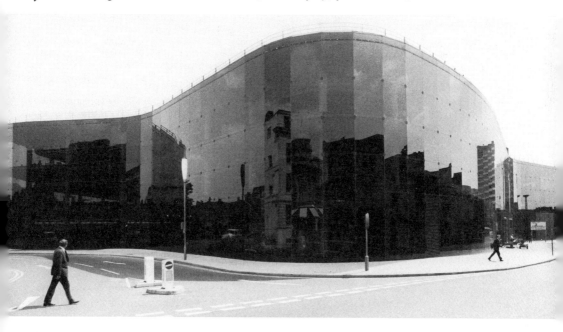

links and its special outer design. The technical form is no more than a—stimulating—wrapping, enclosing the processes taking place inside without harnessing them.

Next to Piano and Rogers, the British architect Norman Foster is one of the most consistent representatives of a technical as well as sensual architecture. He and his interdisciplinary team are less concerned with the final form of a building than with the process that results in the form; their aesthetic relates mainly to the making of architecture.

In 1973–75 Foster built the administrative building (planned in 1970–71) of the Willis, Faber & Dumas Insurance Company at Ipswich, a four-story compact organism with flowing outlines, enclosed by a smooth curtain wall of dark solar glass. The stories open inside onto a light well illuminated through a sawtooth roof. Escalators, their mechanisms visible behind transparent screens, are used for vertical access; even the computer and air-conditioning installations are visible. Despite its floor-to-ceiling glazing, the building is highly economical from the point of view of energy. In the evening the interior lighting transforms the seemingly hermetic, monolithic building into a light, transparent structure pulsating with life.

Between 1974 and 1978 Foster Associates built the Sainsbury Centre for the Visual Arts at the University of East Anglia in Norwich. A white spatial structure made of a single-span portal frame of welded steel tubes spans a width of 114.8 feet (35 meters) over almost four times that length. The end walls of the huge hall are entirely glazed, while the roof and the side walls consist of glass and aluminum panels that are easily interchangeable. Inside, a double layer of adjustable, finely perforated gray aluminum louvers sheds a muted light over the flexibly arranged exhibition walls. The radical building is an example of a sensitively used technology from which an aesthetic develops seemingly unintentionally.

A complete breach with the principles of New Brutalism, Structuralism, and technological architecture is shown by the work of the American Robert Venturi, who was employed for a number of years in the offices of Eero Saarinen and Louis Kahn. His relationship to history is similar in intensity to that of the Estonian-American master or to that of James Stirling, but his underlying philosophy is fundamentally different. Whereas Kahn and Stirling use historical elements to creatively change reality, one by reintroducing a traditionally legitimated order, the other by ironically questioning it, Venturi basically accepts the world as it is. His method of proceeding is one of philology rather than of synthesis, and it is no coincidence that he was at first less well known for his buildings than for his books.

In his work *Complexity and Contradiction in Architecture*, published in 1966, Venturi developed his philosophy of design from a deliberately subjective historical architectural survey that—not coincidentally—favored a deliberately subjective historical architectural Mannerism.

I like complexity and contradiction in architecture. I do not like the incoherence and arbitrariness of incompetent architecture nor the precious intricacies of picturesqueness or expressionism. Instead, I speak of a complex and contradictory architecture based on the richness and ambiguity of modern experience, including that experience which is inherent in art. . . .

Architects can no longer afford to be intimidated by the puritanically moral language of orthodox Modern architecture. I like elements which are hybrid rather than "pure," compromising rather than "straightforward," perverse as well as impersonal, boring as well as "interesting," conventional rather than "designed," accommodating rather than excluding, redundant rather than simple, vestigial as well as innovating, inconsistent and equivocal rather than direct and clear. I am for messy vitality over obvious unity. . . .

But an architecture of complexity and contradiction has a special obligation toward the whole: its truth must be in its totality or its implications of totality. It must embody the difficult unity of inclusion rather than the easy unity of exclusion. More is not less.[42]

In 1960–63 Venturi built, in partnership with John Rauch, the senior citizens' home Guild House in Philadelphia, a symmetri-

261. Robert Venturi and John Rauch. Guild House, Philadelphia. 1960–63.

262. Robert Venturi. National Football Foundation Hall of Fame, New Brunswick, New Jersey. Project. 1967.

cal six-story complex comprising 91 apartments, which at first glance seems no different in any way from the usual American commercial buildings: it has simple materials, a conventional structure, and a largely banal form. Indeed, the refinements are as subtle as they are intellectual. The upper part of the frontage is detached from the actual wall, thus underlining the role of the facade as a public mask; the name plate is incorporated into the architectural design as a Pop element; the golden fake television aerial on the roof is a friendly and ironic symbol of the main occupation of elderly people in an industrialized society. The retracted entrance is accentuated by a large, centrally situated, black granite column. The shallow rounded arch above the balconies, a feature borrowed from Mannerism and from Louis Sullivan, also recurs in other works by Venturi.

The unrealized project for the National Football Foundation Hall of Fame in New Brunswick, New Jersey, a paradigmatic reflection of Venturi's concept of the building as a "decorated shed," dates from 1967. In front of the plain barrel-vaulted exhibition building is an oversized screen-wall onto which pictures of American football heroes can be projected. Conceptually, this building reverts to nineteenth-century Historicism in its clear separation of expression and function. The modernistic demand for the unity of interior and exterior, form and function, beauty and utility has thus been rejected. Not without scorn does Venturi identify this unity, in which the total form assumes an aesthetic and symbolic function, with the "duck house" of his Pop architecture repertoire.

In 1974–75 Venturi and Rauch built Tucker House in Katonah, New York, a timber building that exaggerates on the

263. Robert Venturi and John Rauch. Tucker House, Katonah, New York. 1974–75.

exterior the formal elements of the popular regional style, while the interior mocks, in its Mannerist attitude, the "white architecture" of the International Style. With its imitation of a sharply overhanging roof and its circular, centrally situated mirror, the fireplace in the living room is a witty, kitsch-laden miniature depiction of the house itself. Venturi's repeated attempts at an interpretation of banality and his resigned, even cynical renunciation of the pursuit of a utopia, result in the creative energy of his work lagging behind its intellectual energy. His experiments, which are always on an idiomatic and never on a technological plane, have nevertheless been decisive for architectural developments during the 1960s and 1970s because they acted as cultural catalysts and paved the way for new experiments.

A more creative and innovative Mannerism than that of Venturi marks the work of the Austrian Hans Hollein. His Retti Candle Shop, built in 1965–66, continues the tradition of assembling formal elements and of arranging meanings that has determined the architectural production in the Austrian capital since the days of Johann Bernhard Fischer von Erlach.

The Abteiberg Municipal Museum at Mönchengladbach was designed in 1972 and realized in 1976–1982. The dissonant complex with its multiple formal disturbances and deliberately varying elements is tied into the adjacent garden area through terraced and planted building components. Severe, intact geometries are juxtaposed with Manneristically consumed volumes and organically curved forms. Inside, within the framework of a complex neutrality, multifaceted situations are created which provide an impetus for intense contemplation of the displayed works of art.

Venturi's postulates only appear to be absolutely contradicted by the works of the New York Five Architects, a loose grouping of approximately contemporary American architects tied by friendship and common artistic interests, including Peter Eisenman, Michael Graves, Charles Gwathmey, John Hejduk, and Richard Meier. Their purism, as well, is not due to any social, functional, or technological leanings but solely to an exaggerated cult of form. The difference, therefore, is only one of content. Whereas Venturi aims at a "nonstraightforward architecture," the Five Architects demand an almost metaphysical clarity. Whereas the former looks to Mannerism for his aesthetic models, to the nineteenth century, and to the "hybrid" Pop culture, the latter draw upon Rationalism and above all Le Corbusier and the rigorist Italian architecture of the 1930s revolving around Giuseppe Terragni. Their intellectualist experiments lack any of the social engagement that initially characterized the architectural idiom they adopted. Their contribution, however, lies in the further syntactic development of that very idiom to its highest degree of perfection. The ethic of the New York Five's attitude is found in the consistency of their aesthetic efforts.

In 1967–68 Peter Eisenman built House I, the Barenholtz Pavilion for antique toys in Princeton, New Jersey. Exploiting the freedom of the typologically not strictly binding function "museum," he investigated, beyond the relation of form to function and form to meaning, the structure of form "per se." On a plan derived from a severely geometric system, he developed a complex spatial organization, in which elements such as white supports, round stainless steel columns, beams, and joists have no load-bearing function but merely that of establishing an abstract order. The wooden pattern on the floor of the ground floor, which suggests the trace of a support that has been spirited away, evokes associations with the architecture of ruins and mysterious manifestations of erosion.

Eisenman's contempt for function reached its climax in the red staircase of

264. Hans Hollein. Abteiberg Municipal Museum, Mönchengladbach. 1972; since 1976.

265. Peter Eisenman. House I (Barenholtz Pavilion), Princeton, New Jersey. 1967–68.

House VI, built in 1972 as Frank Residence in Cornwall, Connecticut. It is impassable and leads to a story which does not exist. These houses however, numbered like pictures or sculptures, are not intended to meet any needs; on the contrary, they aim at shaking man up and away from his requirements. Eisenman's subtle Mannerism disregards in an elitist fashion the expectations of the potential builder in order to criticize them.

In 1967–68 Michael Graves built Hanselmann House in Fort Wayne, Indiana, a three-story building that is more considerate of functional aspects than Eisenman's "cardboard architecture" and that is held in a cool, semantically drained Le Corbusier-like idiom. In 1969–72 Graves built Snyderman House, also at Fort Wayne, in which the Cubist grammar is once again used for an unresolved, tension-laden dialectic. The decompositional method employed in its structure is reminiscent of the Neoplasticism of Piet Mondrian and Gerrit Thomas Rietveld, and the soft pastel colors recall Juan Gris.

Graves's tendency toward a "graphic" architecture, in which the question of realization retreats into the background, became progressively more marked in his subsequent work. Projects such as the eclectic "warehouse conversion" of 1977 thus take on the characteristics of a painting, sensually celebrating the sublime decadence of an over-refined idiom through subtly fragmented compositions and melancholy shades of autumnal color.

In 1966–67 Charles Gwathmey built his own house and studio at Amagansett, New York, an arrangement of four timber structures with sharply defined volumes distributed at random intervals over the building site.

In 1966 John Hejduk designed the project for House 10. Four pavilions, developed from completely different geometries, are attached on an unusually long, narrow connecting element. The interior walls are to be painted white, the outer ones to consist of stainless steel or chromium, and the composition is to be completed by generously proportioned glazing. The One-Half House project dates from the same year; it is a purely formalist creation consisting of a half square, a half circle, and a half diamond.

Richard Meier, the most prolific of the Five Architects, built Smith House (now Littlefield House), in 1965–67, at Darien, Connecticut, on the shore of Long Island Sound. The architectural object, which is simultaneously simple and complex, reveals a sophisticated interplay of private and public family rooms: one group of rooms manifests itself on the exterior by largely continuous timber walls, into which windows have been sharply incised, while the other rooms exhibit a transparent glass skin, with timber bars taking up the rhythm of the internal supports. The white color dematerializes the structure and transforms it into a semantic abstraction.

In 1970–76 Meier realized the Bronx Developmental Center in New York, a large multiarticulated complex for handicapped children, where small individual units interspersed with internal courtyards produce an appropriate scale and emphasize the close relationship between form and program. The facades are assembled from regular aluminium modules, into which windows with rounded corners have been punched.

In 1971–73 he built Douglas House in Harbor Springs, Michigan, a white, purist,

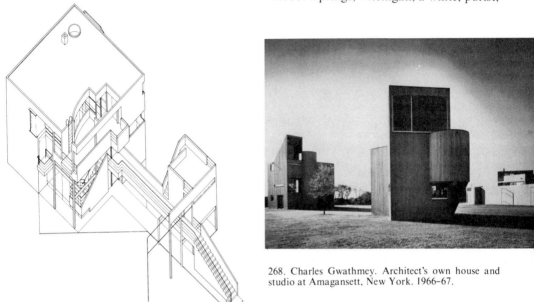

268. Charles Gwathmey. Architect's own house and studio at Amagansett, New York. 1966–67.

266. Michael Graves. Hanselmann House, Fort Wayne, Indiana. 1967–68.

267. John Hejduk. House 10. Project. 1966.

269. Richard Meier. Douglas House, Harbor Springs, Michigan. 1971–73.

and singularly elegant building. It rises, in deliberate artificiality, from the dense woodland of a steep shore dominating Lake Michigan and takes its noble idiom from nautical architecture. The interior presents itself as a boldly differentiated and structured spatial complex.

Meier's project for the Museum für Kunsthandwerk in Frankfurt am Main, submitted in 1980, confirmed his ability to react sensitively to urban and architectural premises and in this way to achieve a surprising poetical intensity. The building is to be completed in 1985.

In its explicitly formalist approach, the work of the Five Architects is distantly related to an equally formalist movement that emerged in the second half of the 1960s: Rational Architecture. The latter, however,

relates to the New York Five as Enlightenment does to Mannerism. The term Rational Architecture, which in its essence had been theoretically outlined by the Italian architect Aldo Rossi in 1966 in *L'architettura della città*, was first used in 1973, when Rossi and other authors published the book *Architettura razionale* on the occasion of the Milan Triennale XV.

Rational Architecture does not aim at a simple revival and continuation of the Rationalism of the 1920s and must be distinguished from it, as it attempts to rediscover architecture *tout court*. Among other things, it refers to the typological studies of the Classicist Jean-Nicolas-Louis Durand and attempts to comprehend architecture as an independent science, with inherent and largely objective and ahistorical rules and thus also its own formal legitimation. These rules can be mastered rationally by studying the architectural types, historically unchangeable original elements, and original compositional rules of building. To this purpose, building morphologies, especially those that have been declared taboo, must again be laid bare. Continuous surfaces, openings, columns, villa-types, and towerlike prisms are combined in accordance with the rules of linear or complex addition, of axis, and of symmetry to form geometrically controlled ground plans, seemingly infinite rows of windows, and surrealistic arcades. In a theoretically thoroughly considered attempt, the alienation between man and built structures is to be overcome. In this context, functionalism, which necessarily supports the division of labor-oriented production laws of capitalism by its tendency toward fragmentation, is rejected in favor of formalism, which opposes such laws and which is capable of reviving the aimed-for unity.

Aldo Rossi designed the square in front of the Segrate Town Hall in 1965. With its extremely simple fountain, consisting of elemental geometric bodies and its wide steps and hermetic truncated columns, it evokes the atmosphere of Giorgio de Chiri-

co's *Pittura metafisica*. Only a section of the project was actually realized.

As part of the residential complex Gallaratese 2, which was realized in the Milan housing estate of Monte Amiata under the direction of Carlo Aymonino, Rossi built a four-story linear apartment building (1970–73) of light rendered reinforced concrete, 597 feet (182 meters) long and 39.4 feet (12 meters) deep. The entire building is raised off the ground so that a continuous one- to two-story-high colonnade on two different levels is formed beneath by slabs and columns spaced at regular intervals, the rhythm being broken only at the front side of the main volume by four heavy round columns. Access to the apartments is by galleries connected to staircase cores. Each apartment has one or two loggias. The formal idiom is reduced through radical asceticism to a very small number of typical elements, with the renunciation of any forced search for originality and the achievement of clarity, understandability, and dignity as its object. It is derived from the critical and historical study of traditional urban building, the elementary rules of which determine, through various transformation stages, the entire architecture from the individual residential unit to the territorial

270. Aldo Rossi. Town Hall Square, Segrate. Project. 1965.

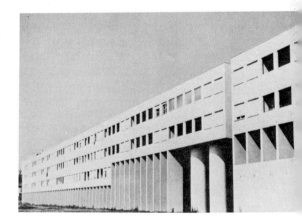

order. In this respect, a connection exists with Structuralism. Rossi himself stated: "In my projects for residential houses I relate myself to the basic types of dwelling, which have formed themselves through a long process of the architecture of the city. Thus, by analogy, each corridor is a street, the court is a square, and a building reproduces the places of the city."[43]

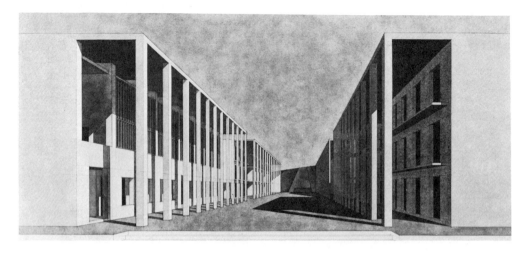

272. Giorgio Grassi and Antonio Monestiroli. Students' residence at Chieti. 1976; since 1979.

In 1971 Rossi produced, in cooperation with Gianni Braghieri, the project for the San Cataldo Cemetery in Modena, a complex axial arrangement that articulates itself in uniform covered walks and monumental geometries. In the House for the Dead the silence of Mies van der Rohe is once again realized, but without technological ambition. The project was revised twice, in 1973 and 1976, and realized between 1980 and 1983.

In an even more radical way than Rossi, Giorgio Grassi turns against individualism, fashionable experimentalism, and the forced search for the new in architecture. It is no coincidence, therefore, that he models his work on the style of the Rigorist Heinrich Tessenow, as well as on the traditional architecture of the large, clearly structured farms of Lombardy. In his project for the conversion of Castello Visconteo at Abbiategrasso into a town hall (1970) he juxtaposes historical forms with neutral monumentality. His search for a collective and largely objective idiom results, too, in a silence with a tragic note.

In 1976 Grassi produced, together with Antonio Monestiroli, the project for the

Chieti students' residential building, one section of which has been under construction since 1979. The two- and three-story complex, part of which is raised from the surrounding landscape by a horizontal podium to underline its artificiality, consists of students' residences, a dining hall, and communal facilities. The buildings outline a straight "agora street" faced by slender square pillars behind which lie filigrained covered walks providing access to the dormitory rooms. The simplicity and clarity of this arrange-

273. Franco Purini. Students' residence. Project. 1978.

ment hides its intellectual sophistication, a sophistication that becomes apparent in, among other things, the delicate proportions, which are further emphasized by the dematerialization of the individual building forms.

Franco Purini, who began work on a classification of architectural systems as early as 1968, regards his own patient work as a search for "truth" in architecture. His dreamlike projects, in which the past seems to reflect itself without, however, moving clearly into the foreground of quotations, are nothing but the coherent application of abstract typological research to a specific place.

A more concrete connection with the history of architecture and its repertoire characterizes the work of the Luxemburg architects Leon and Robert (Rob) Krier. Leon Krier, a former assistant of James Stirling, has been predominantly engaged in the development of monumental city planning projects. Rob Krier, the elder of the two brothers, built Haus Dickes in Luxemburg-Bridel (1974–76), an almost cuboid, introverted structure, with a deep recess cut in at one corner and covered by bar-lined glazing. A heavy, ironically treated column, which vastly exaggerates the structural reason for its existence, supports the cantilever and marks the house as a cellular unit that can be added to horizontally and vertically to form urban blocks.

In Germany, Oswald Mathias Ungers, who built a vaguely Brutalist-inspired five-story residential building at Nippes outside Cologne in 1956 and a huge block of apartments at the Märkisches Viertel in Berlin in 1963, advocates a "visionary architecture of remembrance." His project for the Wallraf-Richartz-Museum in Cologne, dating from 1975, is marked by a sequence of three squares: an entrance square made of pink marble, a space enclosed by glass, and finally a sculpture court, where four ironic equestrian statues of Kaiser Wilhelm have been placed. A "stairway into nothing" op-

274. Robert (Rob) Krier. Haus Dickes. Luxemburg-Bridel. 1974–76.

275. Bruno Reichlin and Fabio Reinhart. Casa Tonini, Toricella. 1972–74.

ens toward the Rhine. The museum has been designed as part of an urban landscape that through its surrealistic exaggeration—nowhere does a "friendly gesture" alleviate the coldness, and even the trees are shaped geometrically as spheres, cubes, or pyramids—acts as intellectual provocation.

276. Oswald Mathias Ungers. Wallraf-Richartz-Museum, Cologne. Project. 1975.

Josef Paul Kleihues, who regards himself as a "poetical Rationalist," built the first stage of the main workshop of the Municipal Sanitation Department in Berlin between 1972 and 1974 (project: 1969–73), followed by a second stage between 1977 and 1980 (project: 1975–76). The complex, where vehicles for refuse collection and road cleaning are repaired and maintained, consists of three naves. The central nave houses the workshops, storage spaces for supplies and spare parts, and the social facilities, while the two side aisles are divided into a series of bays, into which the vehicles can be directly driven. The unclad precast concrete elements and the large areal glazing are controlled by severe geometric principles that are reminiscent of Karl Friedrich Schinkel's Berlin Building Academy (1831–35) and at the same time of Peter Behrens's industrial architecture.

The Ticino School, which made an independent contribution to the development of Rational Architecture, arose at the cultural interface between Italy and the German-speaking countries. Mario Botta, who worked for a short time for Le Corbusier and then briefly for Louis Kahn, built a house at Riva San Vitale in 1972–73. The relationship between the building and the landscape is made problematic by the extreme artificiality of the building, a tower-like structure on a square ground plan. A lightweight metal bridge, painted red, links the upper story of the brick building to a raised access road.

In 1972–77 Botta realized the school at Morbio Inferiore, a two- to three-story straight linear building made of unclad concrete that, with its addition of modules, intersects the countryside as an artificial ordering element but at the same time absorbs and elaborates its visual impulses. At the point where the main building meets the gymnasium at an acute angle, and in unre-

277. Josef Paul Kleihues. Main workshop of the Municipal Cleaning Department, Berlin. First stage 1969–73; 1972–74. Second stage 1975–76; 1977–80.

278. Mario Botta. School at Morbio Inferiore. 1972–77.

arch, which acts, ironically, also as a chimney. The underlying esoteric play of mathematical laws and proportions gives the spatial arrangement of the house a subtle harmony.

solved contradiction, an amphitheater assumes the function of a central hinge.

Bruno Reichlin and Fabio Reinhart, both former assistants of Aldo Rossi, built Casa Tonini at Torricella (1972–74), an intellectual celebration of the numerical and geometric essence of the Palladian villa conceived for a mathematics teacher. The ground plan is in the form of an almost square oblong, with slightly out-of-balance symmetries and an emphasized center, while the structure developing above it is a smaller, simplified, and abstract replica of the Villa Rotonda. The entrance is marked by monumental stairs and a freestanding

## City Planning

Contemporary city planning movements are characterized by the endeavor to achieve a further radical development of the urban models and realizations of Rationalism and late Rationalism without reverting to regional or empirical tendencies. In this, the guidelines are largely identical with those of architecture: freer idiom, exact historical architectural and urbanistic research, and cultural honesty.

Such experiments are necessarily based on a lively theoretical discussion of the problems of city planning. In this spirit the Charter of Machu Picchu was drawn up in 1977 in Lima and Cuzco, a supplement to and further development of the *Charte d'Athènes*. The Charter of Machu Picchu is, among other things, an attempt to complete and expand certain points that were not contained in the categorical enlightening theses of the *Charte d'Athènes*. Its demands are summed up in eleven points.

1. The dynamic unity of town and country must be restored.
2. In view of the ecological crisis, the energy crisis, and food shortages, urban growth both in industrial countries and in the Third World must be controlled and restricted.
3. In contrast to the separation of the functions of living, working, recreation, and traffic, as propagated by the *Charte d'Athènes*, urban functional integration must be aimed at.
4. Subsidized housing must be regarded as an effective means of social development and must be furthered accordingly.
5. Systems of public transportation must be given priority over individual forms of transportation (the automobile).
6. Effective legislation must facilitate measures of expropriation in order to permit comprehensive town planning.

7. Aspects of energy and hygiene (environmental pollution) must be taken into account.
8. In order to maintain the identity and character of towns, historic monuments must be protected and integrated into the living urban process.
9. Technological progress must be put to the service of urban planning; not to create sophisticated artificial environments but to resolve social problems within the overall context of growth problems (for example, recycling).
10. Government and the architectural profession must not only plan but also realize flexible measures.
11. The architectural idiom must be renewed by aiming at the continuity of the urban texture and at the unfinished rather than at self-contained individual objects.

The programmatic debate on new urban planning was complemented by the work of a number of groups who developed utopian urban alternatives. An important critical function with respect to both the late Rationalist capitalist city and the various forms of Regionalism was assumed by the British group Archigram. It was founded in 1961 by Peter Cook, Mike Webb, and David Greene and consisted, as a changing association of individual personalities bound together by common interests, of a core group that in addition to the founders included Warren Chalk, Ron Herron, and Dennis Crompton. Their "heroes" were Dan Dare, Flash Gordon, and Superman; their architectural models the Italian Futurists and the Soviet Constructivists; and their philosophical source of inspiration the Anarchists. The members of Archigram, in fact rejected preconceived disciplined systems of order as a means of shaping the environment. Their urban utopias, which are not free from the influence of New Brutalism, took the development of a profit-dictated technocracy to its ultimate conclusion, parodied it with a

279. Peter Cook. Plug-in City. Project. 1964.

mercilessly unmasking irony, and presented alternatives that were both imaginative and amusing. In 1963, at the Living City Exhibition, Archigram defined its ideology and idiom. Its repertoire, which was subsequently extended and perfected, mainly absorbed aesthetic themes from space research, computer technology, and throwaway industry.

In 1964 Dennis Crompton devised the project of a Computer City. During the same year Ron Herron designed his Walking Cities, huge high-technology zoomorphous residential monsters on telescopic legs or air cushions, which gave a new science-fiction form to the myth of nomadic existence. Also in 1964, Peter Cook produced his highly diversified utopia, Plug-in City, a creation based on the modular plug-in system. Here, too, variability and mobility are the main themes. The residential cells are interchangeable in accordance with the laws of a consumer society; access and transport elements such as elevators, highways, overhead railways, and cranes determine the aesthetic of the conurbation. The useful life of each element is preprogrammed so that the installation cells have to be replaced every three years, the residential cells every fifteen years, the car silos every twenty years, and the remaining urban structures every forty years.

After the energy crisis of 1973–74 the former members of the by then dissolved Archigram group reversed their center of interest from technology to sociology. In 1978 Peter Cook presented his Arcadia project, a dream city and modern spiritual successor to Vergil's mythical Arcadia, in which technology and nature are dialectically united. In an illusory kingdom, far from any reality, the admonitory "1984" specters are transformed into a harmless poetry that is more concerned with life-style than with a social utopia.

The development of the Italian group of architects Superstudio, founded in 1966 by Adolfo Natalini together with Cristiano Toraldo di Francia, Piero Frassinelli, and Alessandro and Roberto Magris, took a different course. They juxtaposed the "concrete" utopias of Archigram with "negative" utopias as lyrical metaphors; in other words, the technocratic incentive to activity with

the subtle incentive to contemplation. The catalog for the 1973 exhibition Fragments From a Personal Museum lists five subjects: life, education, ceremony, love, and death. It presents, in the form of enigmatic surrealistic graphics, ironically visionary alternative models of "radical architecture." In 1978 Superstudio concluded that its refined criticism of capitalist architecture—a criticism that was intended to be subversive—would not succeed at toppling that architecture and consequently ceased its utopian production.

The Office for Metropolitan Architecture (OMA), which was active from the early 1970s and formally established in 1975 with the Dutchman Rem Koolhaas as its principal representative, advocates—in contrast to the Marxist urban criticism of Superstudio—a new "metropolitanism." In the view of the group, which was initially active in New York, the modern big city is the culmination of the sociotechnical adventure of modern civilization, with Manhattan as its celebrated symbol. As machineries that aim at the perfection of man according to their own plans, the gigantic metropolises of OMA's utopias reproduce the natural mechanisms in a more intensive, accelerated, and improved form. In the artistic exaggeration of imaginative visions OMA advocates a philosophy of progress that rejects

280. Rem Koolhaas and OMA (Office for Metropolitan Architecture). Building plan for Roosevelt Island, New York. Project. 1975.

the idea that the experiment begun by the Industrial Revolution should be prematurely terminated.

In 1972 Rem Koolhaas conceived, together with Zoe Zenghelis, the project for The City of the Captive Globe. On individual blocks, orthogonally arranged on a regular street grid, the most varied architectural styles are placed, ranging from the Rationalist glass towers taken from Le Corbusier's Plan Voisin and Expressionist scenes from the film *The Cabinet of Dr. Caligari* to the Constructivist Lenin Speaker's Platform of El Lissitzky and the abstract glass Homage to Superstudio. In the center of the city lies the globe. This highly intellectual image symbolizes the capacity of the metropolis to act as an incubator for the most contradictory forms of philosophy, science, art, and "forms of madness" and to project them onto the world.

At times alongside and at times closely interrelated with such theories and utopias, numerous urban projects have been planned and realized within the framework of contemporary architectural movements.

The Russian-born Greek Georges Candilis, the Yugoslav Alexis Josic, and the American Shadrach Woods founded, in 1955, an urban planning group that shared with the Smithsons the experiences of Team X and was active until 1970. From CIAM they adopted the maxims of minimum standard housing of the separation of vehicular and pedestrian traffic, and of generous green zones, but they abandoned the idea of functional zoning and of huge residential buildings that had marked, for example, the Grands Ensembles in France. Instead, they attempted to develop, through the nonadditive assembling of the individual basic units of the city, mixed structures made from repetitive elements. This concept was reflected in the plan, dating from 1961, for the suburb of Toulouse-Le-Mirail. The settlement, designed for a population of 250,000, aims at the restitution of density and scale; the geometrically and spatially remarkably differentiated access system with its variety of branches creates varied urban spaces. With their plans for the city centers of Toulouse and Stuttgart (1963) and their project for the Free University in Berlin-Dahlem (1963–65), the first stage of which was realized between 1967 and 1973 in cooperation with Manfred Schiedhelm and with Jean Prouvé as consultant, Candilis, Josic, and Woods returned to a simple orthogonal grid.

In 1956 Louis Isadore Kahn produced the plans for the city center of Philadelphia. Taking the analogy of streets and rivers as a starting point, he came to the conclusion that both need "docks" and designed large circular complexes with inner courts, which were to include parking facilities, as well as offices and hotels. The city thus becomes a "served" space. In the same way that a medieval town protected itself against the enemy through towers, the modern metropolis, in Kahn's nostalgic vision, repels the automobile by fortresslike megastructures. In reality, neither the traffic of individuals nor of capital could be prevented from penetrating into the city center of Philadelphia. Expressways increasingly intersected the urban texture, while the Pennsylvania Railroad, which endorsed the proposal of the City Planning Commission (founded in 1942) for the restructuring of part of the city center, allocated housing construction a marginal role.

It was in the Third World that Kahn was given an opportunity to realize his "city planning of longing." In 1962 planning work began on the then capital of East Pakistan, Dacca (now Bangladesh), which was realized between 1973 and 1976, that is, mainly after Kahn's death in 1974. The buildings are arranged around an idealized circle. In the center of this layout lies the government complex, a castlelike structure built on a square plan. Around the centrally placed National Assembly Building the mosque, offices, and conference rooms, as well as the staircases, are arranged on the axes of a

virtual octagon. Square and cruciform residential buildings for the ministers, secretaries, and members of the National Assembly are arranged diagonally on either side of the government complex, forming a perspective backdrop and a spatial accent. The structure has a monolithic and monumental aspect, its architectural idiom full of historical reminiscences. The ground plans are based on decorative and multiply symmetrical geometries, with function being subordinated to symbolic content. The constructions, with their load-bearing brick walls into which mainly circular and arched apertures are incised, refer back to old architectural patterns, their expressive dignity being more important than their structural and constructional transparency. The forms are simple, forceful, and self-contained. The meanings are at the service of a mystical order that must control each element of the architecture in order to be able to appropriately speak through it.

James Stirling and James Gowan built a residential estate at Preston, England, in 1957–59. The three- and four-story Georgian-inspired rows of houses, made of unclad masonry and covered with slightly inclined roofs, are arranged in the shape of a horseshoe around a communal garden. Five irregularly arranged two-story houses on square ground plans for elderly people are nearby. The strong color and texture of the industrial brickwork, which contrasts with

wooden window frames painted white, provide the settlement with uniformity of idiom. At the same time, the atmosphere and style of the working-class residential quarter realized in the nineteenth-century, parts of which had to be demolished to make room for the new development, have been largely maintained.

In 1967–74 Stirling built the residential area at Runcorn New Town, comprising 1,500 units of varying size and arrangement, which are distributed evenly over the settlement to ensure a social mix. Five-story linear rows of identical houses follow a housing pattern found frequently in Great Britain, and enclose square or rectangular inner courts of varying sizes planted with evenly spaced rows of trees. The houses, built by the local authority as part of a subsidized housing program, are largely made of prefabricated parts. The floors and walls are made of diagonally ribbed concrete, while the facade units are made of fiberglass-reinforced plastic. The living rooms open onto a garden or a terrace and have large areal glazing, while the bedroom windows consist of circular "bull's-eyes." Vehicular access is by cul-de-sacs to avoid through traffic. Separate from it, pedestrian access is provided by walkways located on the second-floor level and protected from the weather by the backward cantilevering upper story and by colonnades. Bridges lead to the shopping and entertainment areas of

281. Louis Isadore Kahn. National Assembly Building, Dacca. Begun 1962; 1973–76.

282. Adolfo Natalini and Superstudio. 1973. From Fragments from a Personal Museum.

283. James Stirling. Residential area in Runcorn New Town. 1967–74.

the city center. The open corner spaces between the rows of houses are intended for communal facilities.

In Switzerland Atelier 5 (founded in 1955 by Erwin Fritz, Samuel Gerber, Rolf Hesterberg, Hans Hostettler, and Alfredo Pini and joined later by other architects, among them Niklaus Morgenthaler and Fritz Thormann) attempted to augment Rationalist and Brutalist concepts by Regionalist features. In 1955–61 the firm built the Halen estate at Stuckishaus near Berne, a hillside development of terraced houses that presents the prototype of linear housing settlements in a condensed, urban, and idiomatically highly sophisticated new form. The

two- and three-story dwellings, complete with inner courts, are arranged around a central "village square."

In Italy, Bologna became the venue of a city center redevelopment that aroused worldwide attention. During the late 1950s and early 1960s large-scale demolition of the old city center had taken place in order to adapt it to new traffic requirements. As a reaction to the renewal euphoria, the plan for the preservation and redevelopment of the historic center was produced in 1969. The work on it had been initiated in 1962 by methodical studies undertaken by the architectural historian Leonardo Benevolo, and its realization had been subsequently made possible by temporary legislation in 1967 blocking all major building projects. A two-fold measure stipulated whether individual buildings should be restored, made sound,

284. Atelier 5. Halen Estate, Stuckishaus, near Berne. 1955–61.

or demolished. A "utilization" plan determined the new use of buildings, in order to keep the functional structure of the city center as intact as possible. A "traffic plan" reduced the possibilities of thoroughfares. Five overall goals were formulated.

1. The historic center is to be retained and protected.
2. The artistic, historical, and cultural heritage is to be incorporated into the social and economic conditions of our age; the historic center must therefore be given an active and compatible role.
3. Large administrative units are incompatible with the structure of the historic center; new administrative zones are therefore to be established outside the center.
4. In the historic center necessary public facilities must be provided.
5. Traffic must be reorganized; pedestrian areas must be established.

Based on these maxims the historic city center was restored and redeveloped. The project covered an area of over 988.4 acres (400 hectares) and involved 80,000 inhabitants. The *Legge sulla casa No. 865* provided for extensive compulsory purchases "in the public interest" and the use of public funds for the restoration of old city centers. In the

case of Bologna, however, its implementation was limited almost entirely to the second provision. In the case of municipal property the authorities financed and carried out the work themselves; private owners received grants. "Precinct councils" were involved in the planning process and advised the affected inhabitants. The majority of buildings were restored throughout, with modern techniques being used for floors and utilities, and traditional materials and methods for everything else. Renovation work proceeded in stages; the inhabitants were put into temporary accommodations during the building process and then moved back to their restored houses after completion. It was thus possible to maintain not only the architectural but also, and above all, the social structure of the city center.

The Bologna project is not free of contradictions. Because it was impossible to enforce compulsory purchases de facto, coordinated and efficient planning was thwarted. The traffic plan contributed little to reduce individual traffic; the size and equipment of the dwellings are often meager; and the parking provisions for cars are not even near adequate. Nevertheless, the destruction of the historic city center has been effectively prevented.

Within the framework of new Italian housing developments, Carlo Aymonino, in collaboration with other architects, designed between 1967 and 1970 the complex Gallaratese 2 for a total of 2,500 people as part of the Monte Amiata estate outside Milan. The project was realized between 1970 and 1973. The linear buildings, rising up to seven stories high—one of the buildings was designed by Aldo Rossi—are geometrically and spatially related to a center shaped like an amphitheater. Through the severe and yet expressive variety of formal elements, an attempt has been made to restore urban qualities to a dreary suburban area.

From 1970 to 1974 Giancarlo De Carlo planned and realized, in cooperation with

Fausto Colombo and Valeria Fossati, the first stage of the Matteotti workers' estate at Terni. The previous estate of the Terni steel enterprise, which was old, in disrepair, and which did not efficiently utilize the available ground, was demolished and replaced by a new, highly concentrated organism, which includes communal facilities, green zones, and separate, finely differentiated facilities for vehicular and pedestrian traffic. The social structure has been retained, and speculation is prevented by maximum utilization of the grounds. The three-story buildings, made from unclad concrete, are arranged in four rows that are interconnected by footbridges. Two hundred residential units, each with a garden or garden terrace, have been varied so as to provide forty-five ground plan alternatives. Planning was carried out in close cooperation with the inhabitants, whose wishes (such as for a small garden next to the house, in which flowers and vegetables could be grown) were taken into consideration. The typological variety is re-

286. Giancarlo De Carlo, Fausto Colombo, and Valeria Fossati. Matteotti workers' estate, Terni. 1970–74.

285. Carlo Aymonino with Maurizio Aymonino, Giorgio Ciucci, Vittorio De Feo, Alessandro De Rossi, Mario Manieri-Elia, and Sachin Messaré. Residential complex Gallaratese 2, Monte Amiata, Milan. 1967–70; 1970–73.

flected by the formal idiom, which combines Rationalist simplicity with a Regionalist-inspired poetry of interpenetration.

Working in the methods of architectural Structuralism, Piet Blom built the Kasbah Estate at Hengelo in the Netherlands (1965–73), "an experiment with average apartments for average people with average purses."[44] The lively design of the housing settlement, the name of which suggests an intellectual and spatial relationship with the fortified Moroccan sultans' palaces, is based on a geometric grid, permitting expansion in all directions. Within this grid, two-story single-family houses with saddleback roofs are arranged along streets and courts and raised off the ground by concrete supports. The actual accommodations are in the upper stories, while the ground-floor level is reserved for subsidiary facilities, traffic, or simply for spontaneous activities by the inhabitants.

Between 1952 and 1954 Jacob Berend Bakema and Johannes Hendrik van den Broek planned and built the Lijnbaan shopping street in the war-damaged center of Rotterdam. The clearly structured and partly covered urban space is surrounded by low, unobtrusive buildings, reserved for pe-

287. Pieter (Piet) Blom. Kasbah Estate, Hengelo. 1965-73.

288. Georgia Benamo, Christain de Portzamparc. Residential complex rue des Hautes-Formes, Paris. 1975-79.

destrian traffic, and realizes a simple dialectic of exterior and interior.

In 1964-65 Bakema and van den Broek developed the plans for the Pampus district in Amsterdam, in which they gave physical shape to their five principles for a "lively and dynamic" building:

1. Internal flexibility of the buildings, which permits identification and change.
2. External flexibility, which permits urban growth.
3. Grouping according to optical units consisting of different buildings arranged in clusters.
4. Linear and radial expansion of cities from the center to the country.
5. Three-dimensional structures ensuring the continuity of traffic, the transition from public to private areas, and the spatial interrelations among the functions formulated in the program.

This is what we have called *architecturbanism*.[45]

The Pampus district was intended for a population of 350,000 that would have lived on four islands. Directly next to an axis comprising a fourteen-lane highway and a suspension railway line are the offices, while residential and recreational zones are oriented toward the sea. The project is largely characterized by a separation of functions.

Within the framework of Rational architecture, Rob Krier demonstrated in 1973 through the example of the city center of Stuttgart, the rebuilding of destroyed urban spaces. In his bold utopian project he attempted to reunite areas that had become separated by traffic-imposed building after the war, and to make the center accessible to pedestrians again without banning the car altogether. In this process Krier concentrated on urbanistically prominent places and "filled" the gaps opened in the historical texture by speculation and by the specter of the "car-suited" city. In accordance with his central thesis that each new urban project should be subdued to the order of the overall

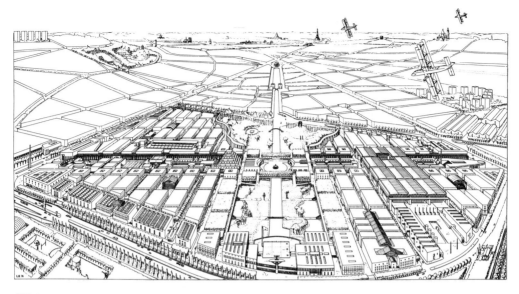

289. Leon Krier. Quartier de la Villette, Paris. Project. 1976.

urban structure and through its shape respond to the form of the existing urban context, he developed his concepts after extensive historical studies and an analysis of the requirements of urban design in the areas concerned. His plans provide for monumental axes, tree-lined avenues, long colonnades, and geometric buildings and aim at transforming the emptiness that generates "collective sadness" into urban spaces that can be experienced by the inhabitants.

In 1974 Leon Krier proposed the reconstruction of the residential urban block in his project for the Royal Mint Square in London. A street lined with mighty colonnades diagonally intersects the complex, indicating the diagonal track of the underground railway beneath. Subtle spatial relations are established, and axially disturbed by a backdrop of arches, a row of cypress trees, various monuments, stairs, and other superstructures.

The plans for the Quartier de la Villette in Paris, a "city within the city" for a population of 15,000, were drawn up in 1976. In contradiction to the recommendations of the *Charte d'Athènes* the individual func-

tions of living, working, recreation, and traffic are integrated within a monumental urban structure. A hierarchy of connections, ranging from the Grand Boulevard through avenues and streets to passages, articulates the compact quarter, in which the necessity of the automobile is eliminated. The buildings are based on historical archtypes and formal elements. Old-fashioned biplanes circle leisurely over the nostalgic "total work of art."

In 1975–79 Georgia Benamo and Christian de Portzamparc realized the residential complex rue des Hautes-Formes in Paris. Two hundred nine apartments, consisting of 18 different types and 100 variations, are housed in 6 buildings grouped around a recreated urban street with a small central square. The sparse idiom, which is distantly but unmistakably influenced by Rational Architecture, is marked by severe orthogonality and gives way to Mannerism in only a few details. The off-white faces are neither an expression of the internal organization nor an aesthetic backdrop. They are primarily the delineations of a public space of high quality.

245

# Notes

1. Otto Wagner, *Die Großstadte: Eine Studie über diese* (Vienna, 1911), in Sigfried Giedion, *Space, Time and Architecture*, 5th ed. (Cambridge, Mass.: Harvard University Press, 1970). p. 782.
2. Thaddeus Hyatt, U.S. Patent 206112 (July 16, 1878).
3. Filippo Tommaso Marinetti, "Manifeste du futurisme," *Le Figaro*, February 20, 1909.
4. Adolf Loos, "Ornament und Verbrechen" (Ornament and Crime, 1908), in Ulrich Conrads, ed., *Programmes and Manifestoes in 20th-Century Architecture* (Cambridge, Mass.: MIT Press, 1971), p. 70 (hereafter cited as *Programmes and Manifestoes*).
5. Ludwig Münz and Gustav Künstler, *Der Architekt Adolf Loos* (Vienna and Munich, n.p., 1964), p. 121.
6. Theo van Doesburg, *Neue Schweizer Rundschau* (1929), p. 536, quoted in *De Stijl* (exhibition catalog), Stedelijk Museum, Amsterdam, 1951.
7. Heinrich de Fries, *Wohnstädte der Zukunft* (Berlin, n.p., 1919), p. 56.
8. Otto Kohtz, *Gedanken über Architektur* (Berlin, n.p., 1909), p. 3.
9. Erich Mendelsohn, "Die internationale Übereinstimmung des neuen Baugedankens oder Dynamik und Funktion" (lecture in Amsterdam, 1923), in Erich Mendelsohn, *Das Gesamtschaffen des Architekten* (Berlin, n.p., 1930), p. 26.
10. Frank Lloyd Wright, "To the Young Man in Architecture," from "Two Lectures in Architecture," 1931, in Frank Lloyd Wright, *Writings and Buildings* (New York, Horizon Press, 1960), p. 247.
11. Hugo Häring, "Wege zur Form," *Die Form*, no. 1, in Heinrich Lauterbach and Jürgen Joedicke, eds., *Hugo Häring: Schriften, Entwürfe, Bauten (Dokumente der Modernen Architektur*, vol. 4) (Stuttgart, n.p., 1965), p. 14.
12. Hans Scharoun, "Address upon the Conferment of the Erasmus Prize," (1970), in Edgar Wisniewski, "Hans Scharouns letztes Werk für Berlin: Ein Bericht über den fertiggestellten Bau," *Bauwelt*, no. 1 (January 5, 1979), p. 15.
13. Walter Gropius, (Programme of the Staatliches Bauhaus in Weimar), in Conrads, *Programmes and Manifestoes* p. 49.
14. Statements from declaration for CIAM 1, 1928, in Wolfgang Pehnt, ed., *Encyclopedia of Modern Architecture* (New York: Harry N. Abrams Inc., 1964). pp. 71–72.
15. *Deutsche Bauzeitung*, 1926, p. 512.
16. Le Corbusier and Pierre Jeanneret, "Les 5 points d'une architecture nouvelle," in *Le Corbusier et Pierre Jeanneret: Oeuvre complete de 1910–1929*, W. Boesiger and O. Stonorow, eds., (Zurich: n.p., 1946), p. 128.
17. Walter Gropius, "A Plan for Forming a Company to Undertake the Construction of Dwellings with Standardized Component Parts," in Giedion, *Space, Time and Architecture*, p. 501.
18. Ludwig Mies van der Rohe, Inaugural Speech as Director of the Architectural Division of the Armour Institute of Technology (1938), in Philip C. Johnson, *Mies van der Rohe* (New York: Museum of Modern Art, 1978).
19. Le Corbusier, *Ausblick auf eine Architektur* (translation edited by author) *(Bauwelt Fundamente*, vol. 2) (Berlin, Frankfurt am Main, and Vienna, n.p., 1963), p. 106.
20. Le Corbusier, "Maison Citrohan," in Boesiger and Stonorow, *Le Corbusier et Pierre Jeanneret: Oeuvre complete de 1910–1929*, p. 45.
21. Le Corbusier, *Ausblick auf eine Architektur*, p. 38 (translation edited by author).
22. "Block-Manifest," in *Die Baukunst*, no. 4, 1928, p. 128.
23. Paul Bonatz, "Welchen Weg geht die Deutsche Baukunst?" *Baugilde*, no. 15 (1933), p. 834.
24. Friedrich Naumann (around 1903), in Peter Bruckmann, "Die Gründung Des Deutschen Werkbundes des 6. Oktober 1907," *Die Form*, no. 10 (1932).
25. Rudolf Pfister, "Paul Schmitthenner und seine Arbeit," *Die Baukunst*, no. 6 (1931), p. 329.
26. Adolf Hitler, "Kulturrede auf dem Reichsparteitag 1937," in *Baugilde*, no. 26.
27. Adolf Hitler, in Anna Teut, *Architektur im Dritten Reich: 1933–1945* (Berlin, Frankfurt am Main, and Vienna, n.p., 1967) *(Bauwelt Fundamente*, vol. 19), p. 13.
28. Vladimir Ilyich Lenin, *Gesammelte Werke*, vol 31 (East Berlin: n.p., 1971).
29. Benito Mussolini, "Il 1926," *Scritti e discorsi* (Milan:, n.p., 1934), pp. 453, 454.
30. Adolf Hitler, in Teut, *Architektur im Dritten Reich: 1933–1945* p. 251.
31. Frederick Gutheim, ed., *Frank Lloyd Wright on Architecture* (New York: Duell, Sloan, and Pearce, 1941).
32. Friedensreich Hundertwasser, "Verschimmelungs-Manifest gegen den Rationalismus in der Architektur" (Mould Manifesto Against Rationalism in Architecture), 1958, in Conrads, *Programmes and Manifestoes*, p. 157–159.
33. Frederick Kiesler, "Magische Architektur" (Magical Architecture), 1947, in Conrads, *Programmes and Manifestoes*, p. 151.
34. Moshe Safdie, *Beyond Habitat* (Cambridge, Massachusetts: MIT Press, 1970), p. 114.

35. Reyner Banham, "New Brutalism," *Architectural Review*, vol. 118, no. 708 (December 1955), p. 357. See also Peter Smithson, Alison Smithson, Jane B. Drew, and E. Maxwell Fry, "Conversation on Brutalism," *Zodiac*, no. 4 (1959), pp. 73–81.
36. James Stirling, *Bauten und Projekte: 1950–1974* (Stuttgart, n.p., 1975), p. 21 (translated from German).
37. Giancarlo De Carlo, "La reconciliation de l'architecture et de la politique," *L'Architecture d'Aujourd'hui*, no. 177, (January/February 1975), p. 32.
38. Ernst Gisel, in Erdmann Kimmig, "Über das neue evangelische Gemeindezentrum in Stuttgart-Sonnenberg," *Werk*, no. 2 (1967), p. 83.
39. Aldo van Eyck "Place and Occasion," *Progressive Architecture*, Sept. 1962, p. 155.
40. Aldo van Eyck, "Place and Occasion," *loc. cit.*, p. 156.
41. Herman Hertzberger, in Arnulf Lüchinger, "Strukturalismus," *Bauen + Wohnen*, no. 5 (May 1974), p. 210.
42. Robert Venturi, "Complexity and Contradiction in Architecture" (New York: The Museum of Modern Art, 1977), p. 16.
43. Aldo Rossi "Analogien," *Bauen + Wohnen*, no. 6 (June 1977), p. 216.
44. Piet Blom, "Anmerkungen zur Kasbah," *Bauwelt*, no. 37 (October 1974), p. 1219.
45. Jacob B. Bakema, quoted in "Jacob B. Bakema: La recherche de l'identité à travers l'espace," *L'Architecture d'Aujourd'hui*, no. 177 (January/February 1975), p. 54.

# Bibliography

The following bibliography lists the most important general, international, and historical surveys of twentieth-century architecture and city planning. These are in chronological order. Where the years of publication coincide, books are listed alphabetically according to the author's name.

Julien Guadet. *Eléments et théorie de l'architecture. Cour professé à l'Ecole nationale et spéciale des beaux-arts*. Paris, 1901–04.

Banister Fletcher. *A History of Architecture on the Comparative Method*. London, 1896; 1961.

Cornelius Gurlitt. *Handbuch des Städtebaus*. Berlin, 1920.

Walter Gropius. *Internationale Architektur*. Munich, 1925 (*Bauhausbücher*). Mainz 1965 (*Neue Bauhausbücher*).

Ludwig Hilberseimer, *Großstadtbauten*. Hanover, 1925 (*Neue Architektur*, Volume 1).

Adolf Behne. *Der moderne Zweckbau*. Munich, 1926; Berlin, Frankfurt, and Vienna, 1964 (*Bauwelt Fundamente*, Volume 10).

Ludwig Hilberseimer, editor. *Internationale neue Baukunst*, Stuttgart, 1927 (*Die Baubücher*, Volume 2).

Peter Meyer, *Moderne Architektur und Tradition*, Zurich, 1927.

Gustav Adolf Platz, *Die Baukunst der neuesten Zeit*, Berlin, 1927.

Johannes Gerhardus Wattjes, *Moderne architectuur in Noorwegen, Zweden, Finland, Denemarken, Duitschland, Tsjecho-Slowakije, Oosternrijk, Zwitserland, Frànkrijk, Belgïe, Engeland en Ver. Staten von Amerika Bijeengebracht en van inleiding voorzien*, Amsterdam, 1927.

Ludwig, Hilberseimer, *Großstadt-Architektur*, Stuttgart, 1928 (*Die Baubücher*, Volume 3).

Henry-Russel Hitchcock, *Modern Architecture: Romanticism and Reintegration*, New York, 1929.

Lazlo Moholy-Nagy, *Von Material zu Architektur*, Munich 1929 (*Bauhausbücher*); Mainz, 1968 (*Neue Bauhausbücher*).

Günther Wasmuth, editor, *Wasmuths Lexikon der Baukunst*, 5 volumes, Berlin, 1929–37.

Sheldon Warren Cheney, *The New World Architecture*, New York, 1930.

Myron Malkiel-Jimounsky, *Les tendances de l'architecture contemporaine*, Paris, 1930 (*Bibliothèque de la vie artistique*).

Bruno Taut, *Die neue Baukunst in Europa und Amerika*, Stuttgart, 1930 (*Bauformen-Bibliothek*, Volume 26).

Maurice Casteels, editor, *The New Style: Architecture and Decorative Design; Its First Phase in Europe and America*, London, 1931.

Henry-Russell Hitchcock and Philip Johnson, *The International Style: Architecture since 1922*, New York, 1932.

The Museum of Modern Art, *Modern Architecture: International Exhibition*, 1932. With essays by Alfred H. Barr, Jr., Philip Johnson, Henry-Russell Hitchcock, and Lewis Mumford.

Alberto Sartoris, *Gli elementi dell'architettura funzionale. Sintesi panoramica dell'architettura moderna*, Milan, 1932. 2nd edition, 1935; 3rd edition, 1941.

Emil Kaufmann, *Von Ledoux bis Le Corbusier*, Vienna 1933.

Reginald Blomfield, *Modernismus*, London, 1934.

Nikolaus Pevsner, *Pioneers of the Modern Movement: From William Morris to Walter Gropius*, London, 1936.

Agnoldomenico Pica, *Nuova architettura nel mondo*, Milan, 1936.

Walter Curt Behrendt, *Modern Building: Its Nature, Problems and Forms*, New York, 1937.

Francis Reginald Stevens Yorke and Colin Penn, *A Key to Modern Architecture*, London, 1939.

Talbot Faulkner Hamlin, *Architecture Through the Ages*, New York, 1940.

James Maude Richards, *An Introduction to Modern Architecture*, Harmondsworth, 1940.

Alfred Roth, *The New Architecture: Presented in 20 Examples*, Erlenbach/Zurich, 1940.

Sigfried Giedion, *Space, Time and Architecture: The Growth of a New Tradition*, Cambridge, Mass., 1941.

Nikolaus Pevsner, *An Outline of European Architecture*, London, 1943.

Alberto Sartoris, *Introduzione all'architettura moderna*, Milan, 1943.

Piero Bargellini and Enrico Freyrie, *Nascita e vita dell' architettura moderna*, Florence, 1947.

Alberto Sartoris, *Encyclopédie de l'architecture nouvelle*, 3 volumes, Milan, 1948–57.

Franz Schuster, *Der Stil unserer Zeit. Die fünf Formen des Gestaltens der äuseren Welt des Menschen. Ein Beitrag zum kulturellen Wiederaufbau*, Vienna, 1948.

Neville Conder, *An Introduction to Modern Architecture*, London, 1949.

Hans Straub, *Die Geschichte der Bauingenieurkunst. Ein Überblick von der Antike bis in die Neuzeit*, Basel, 1949 (*Wissenschaft und Kultur*, Volume 4).

Arnold Whittick, *European Architecture in the Twentieth Century*, 2 volumes, London, 1950–53.

Bruno Zevi, *Storia dell'architettura moderna*, Turin, 1950; revised edition, Turin, 1975.

Sigfried Giedion, editor, *A Decade of New Architecture*. Zurich, 1951.

Talbot Faulkner Hamlin, *Forms and Functions of Twentieth-Century Architecture*, 4 volumes, New York, 1952.

Pierre Lavedan, *Histoire de l'urbanisme*, Volume 3: *Epoque contemporaine*, Paris, 1952.

Charalambos Ath Sfaellos, *Le fonctionnalisme dans l'architecture contemporaine*, Paris, 1953.

Gillo Dorfles, *L'architettura moderna*, Milan, 1954.

Libero Guarneri, *L'evoluzione dell'architettura moderna*, Milan, 1954.

Reinhard Jaspert, editor, *Handbuch Moderner Architektur: Eine Kunstgeschichte der Architektur unserer Zeit vom Einfamilienhaus bis zum Städtebau*, Berlin, 1957.

Jacobus Johannes Vriend, *Nieuwere architectuur*, Bussum, 1957.

Henry-Russell Hitchcock, *Architecture: Nineteenth and Twentieth Centuries*, Harmondsworth, 1958 (*The Pelican History of Art*).

Jürgen Joedicke, *Geschichte der modernen Architektur*, Stuttgart, 1958.

Udo Kultermann, *Baukunst der Gengenwart: Dokumente des Neuen Bauens in der Welt*, Tübingen, 1958.

John Peter, *Masters of Modern Architecture*, New York, 1958.

Pierre Francastel, editor, *Les architectes célebres*, volume 2, Paris, 1959.

Udo Kultermann, *Dynamische Architektur*, Munich, 1959.

Reyner Banham, *Theory and Design in the First Machine Age*, London, 1960.

L. Benevolo, *Introduzione all'architettura*, Bari, 1960.

Leonardo Benevolo, *Storia dell'architettura moderna*, 2 volumes, Bari, 1960.

Peter Blake, *The Master Builders: Le Corbusier, Mies van der Rohe, Frank Lloyd Wright*, New York, 1960.

Ulrich Conrads and Hans Günther Sperlich, *Phantastische Architektur*, Stuttgart, 1960.

A. Dorgelo, *Modern European Architecture*, Amsterdam, 1960.

Jane Jacobs, *The Death and Life of Great American Cities*, New York, 1961.

Fritz Jaspert, *Vom Städtebau der Welt*, Berlin, 1961.

Cranston Jones, *Architecture Today and Tomorrow*, New York, 1961.

G.E. Kidder Smith, *The New Architecture of Europe*, New York, 1961.

Lewis Mumford, *The City in History: Its Origins, its Transformations, its Prospects*, London, 1961.

Vincent Joseph Scully, *Modern Architecture: The Architecture of Democrary*. New York, 1961 (*The Great Ages of World Architecture*).

Jean Ache ånd Bernard Champigneulle, *L'architecture du XXe siècle*, Paris, 1962.

Reyner Banham, *Guide to Modern Architecture*, London, 1962.

Gerd Hatje, editor, *Knaurs Lexikon der modernen Architektur*, Munich and Zurich, 1963.

Udo Kultermann, *Der Schlüssel zur Architektur von heute*, Vienna and Düsseldorf, 1963.

John Donat, editor, *World Architecture 1*, London, 1964.

Peter Collins, *Changing Ideals in Modern Architecture*, London, 1965.

John Donat, editor, *World Architecture 2*, London, 1965.

Udo Kultermann, *News Bauen in der Welt*, Tübingen, 1965; 1975.

Sherban Cantacuzino, *Great Modern Architecture*, London, 1966.

John Jacobus, *Die Architektur unserer Zeit. Zwischen Revolution und Tradition*, Stuttgart, 1966.

John Flemming, Hugh Honour, and Nikolaus Pevsner, *The Penguin Dictionary of Architecture*, Harmondsworth, 1966.

Dennis Sharp, *Modern Architecture and Expressionism*, London, 1966.

Franco Borsi, Giovanni Klaus König, *Architettura dell' espressionismo*, Genoa, 1967.

Ernst Egli, *Geschichte des Städtebaus*, Volume 3: *Neue Zeit*, Erlenbach/Zurich and Stuttgart, 1967.

Udo Kultermann, *Architektur der Gengenwart*, Baden-Baden, 1967 (*Kunst der Welt. Die Kulturen des Abendlandes*).

Dennis Sharp, *Sources of Modern Architecture*, London, 1967.

Waclaw Ostrowski, *L'urbanisme contemporain. Des origines à la charte d'Athènes*, Paris, 1968.

Nikolaus Pevsner, *The Sources of Modern Architecture and Design*, London, 1968.

Paolo Portoghesi, editor, *Dizionario enciclopedico di architettura e urbanistica*, 6 volumes, Rome, 1968–69.

Reyner Banham, *The Architecture of the Well-tempered Environment*, London, 1969.

Werner Hofmann and Udo Kultermann, *Die Baukunst unserer Zeit. Die Entwicklung seit 1850*, Essen, 1969 (*Baukunst der Welt*, Volume 4).

Jürgen Joedicke, *Moderne Architektur. Strömungen und Tendenzen*, Stuttgart, 1969 (*Dokumente der modernen Architektur*, Volume 7).

Heinrich Lützeler, *Europäische Baukunst im Überblick, Architektur und Gesellschaft*, Freiburg, 1969.

John Winter, *Great Buildings of the World: Modern Building*, London, 1969.

Giulio Carlo Argan, *L'arte moderna 1770–1970*, Florence, 1970.

Paolo Sica, *L'immagine della città da Sparta a Las Vegas*, Bari, 1970.

Carlo Aymonino, *Origini e sviluppo della città moderna*, Padua, 1971.

Philip Drew, *Die dritte Generation. Architektur zwischen Produkt und Prozeβ*, Stuttgart, 1972.

Michel Ragon, *Historie mondiale de l'architecture et de l'urbanisme modernes*, 2 volumes, Paris, 1972.

Dennis Sharp, *A Visual History of Twentieth-century Architecture*, London, 1972.

José A. Dols and Christopher Alexander, *Función de la Arquitectura Moderna*, Barcelona and Lausanne, 1973.

Charles Jencks, *Modern Movements in Architecture*, Harmondsworth, 1973.

Wolfgang Pehnt, *Die Architektur des Expressionismus*, Stuttgart, 1973.

Nikolaus Pevsner and James Maude Richards, *The Anti-Rationalists*, London, 1973.

Kurt Rowland, *A History of the Modern Movement: Art, Architecture, Design*, New York, 1973.

Bruno Zevi, *Spazi dell'architettura moderna*, Turin, 1973.

Renato De Fusco, *Storia dell'architettura contemporanea*, Bari, 1974.

John W. Cook and Heinrich Klotz, *Conversations with Architects*, New York, 1973.

Arnold Whittick, *European Architecture in the 20th Century*, Aylesbury, 1974.

Reyner Banham, *The Age of the Masters. A Personal View of Modern Architecture*, London, 1975.

Leonardo Benevolo, *Storia della città*, Bari, 1975.

The Open University, *History of Architecture and Design 1890–1930*, 12 volumes, 1975.

Manfredo Tafuri, Francesco Dal Co, *Architettura contemporanea*, Milan, 1976.

Norval White, *The Architecture Book*, New York, 1976.

Udo Kultermann, *Die Architektur im 20. Jahrhundert*, Cologne, 1977.

Wolfgang Pehnt, "Architektur" in Giulio Carlo Argan, *Die Kunst des 20. Jahrhunderts 1880–1940*, Berlin, 1977 (*Propyläen Kunstgeschichte*, Volume 12).

Herbert Ricken, *Der Architekt. Geschichte eines Berufs*, East Berlin, 1977 (*Schriften des Instituts für Städtebau und Architektur*).

Paolo Sica, *Storia dell'urbanistica. Il Novecento*, 2 volumes, Bari, 1978.

Arthur Drexler, *Transformations in Modern Architecture*, New York, 1979.

Jürgen Joedicke, *Architektur im Umbruch. Geschichte, Entwicklung, Ausblick*, Stuttgart, 1979.

Kenneth Frampton, *Modern Architecture: A Critical History*, London, 1980 (*The World of Arts Library*).

Manfredo Tafuri, *La sfera e il labirinto. Avanguardie e architettura da Piranesi agli anni 70*, Turin, 1980.

Adolf Max Vogt with Ulrike Jehle-Schulte Strathaus and Bruno Reichlin, *Architektur 1940–1980*, Frankfurt, Vienna, and Berlin, 1980.

Willima J. R. Curtis, *Modern Architecture since 1900*, Oxford, 1982.

Wolfgang Pehnt, *Das Ende der Zuversicht. Architektur in diesem Jahrhundert. Ideen-Bauten-Projekte*, Berlin, 1983.

Illustration Credits

Esto Photographics Inc., Mamaroneck, N.Y. 77, 82, 188, 191–195, 202, 206, 220, 269
Reinhard Friedrich, Berlin 87
Y. Futagawa, Tokyo 130
M. Garcia Moya, Madrid 209
Alexandre Georges, New City, NY 111, 1878, 201
Photo-Atelier Gerlach, Vienna 37–39, 51
G. Gherardi-A. Fiorelli, Rome 207
Giraudon, Paris 14
Artists Press Urs + Rös Graf, Bern 43, 134
Julien Graux, Paris 218
Manfred Hanisch, Mettmann-Metzkausen 181
Hedrich-Blessing, Chicago 11, 66, 103, 107, 109, 190
Louis Held, Weimar 19
Lucien Hervé, Paris 118, 119, 122
Heydebrand-Osthoff 61
Hoechst Aktiengesellschaft, Frankfurt am Main 36
Institut für leichte Flächentragwerke, Stuttgart 214, 215
Foto-Kessler, Berlin 112
Balthazar Korab, Birmingham, Ala. 229
Kunstgewerbemuseum Zurich 21, 23
Landesbildstelle Berlin 143, 147, 160
Landesbildstelle Württemberg, Stuttgart 152
William Lescaze, New York 139
Luckhaus, Los Angeles 136
Tod Lurdy 228
Más, Barcelona 26
Massachusetts Institute of Technology, Cambridge, Mass. 93
F. Maurer, Zurich 254
The Mews, New York 138
Milton Keynes Development Corporation, Milton Keynes 235
Lucia Moholy, Zollikon-Zurich 101
Joseph W. Molitor, Ossining, N.Y. 203
Werner M. Moser, Zurich 74
Museum für Hamburgische Geschichte, Bildarchiv 64
The Museum of Finnish Architecture, Helsinki 90, 157, 161; Kari Hakli: 92; H. Havas: 158; Iffland: 170; Eino Mäkinen: 91, 96
The Museum of Modern Art, New York 65, 231
National Buildings Record, London 17
Österreichische Nationalbibliothek, Vienna, Bildarchiv 22
Van Ojen, The Hague 24, 52, 128
Wolfgang Pehnt, Cologne-Weiden 62
Ivan Pintar, Cosanti Foundation, Scottsdale, Arizona 242
Jeremy Preston 239
Publifoto, Milan 182, 224
Rijksdienst v.d. Monumentenzorg, Zeist 46, 47, 69
H. Roger-Viollet, Paris 4, 5, 31
Manfred Sabatke, Stuttgart 222
Oscar Savio, Rome, 183
Helga Schmidt-Glassner, Stuttgart 1
Hugo Schmölz Cologne 150
Gerhard Schwab, Stuttgart 73
Julius Shulman, Los Angeles 137, 186
Hans Sibbelee, Amsterdam 70, 71

Stadtarchiv Frankfurt am Main 146
Stadtarchiv Lemgo 53
Rudolf Stepanek 28
George H. Steuer, Chicago 110
Stiftung Preußischer Kulturbesitz, Berlin, Bildarchiv 155
Dr. Franz Stoedtner, Düsseldorf 20, 54, 57, 59, 72
Roger Sturtevant, San Francisco 221
Strüwing, Copenhagen 176, 177
Ateljé Sundahl, Nacka 124
Trans World Airlines, Inc. New York 197
Eberhard Troeger, Hamburg 178
Monika Uhlig, Cologne 205
Gerhard Ullmann, Berlin 89, 163, 217, 259, 277
University of California, Santa Cruz, Calif. 234
USIS Photo Unit, American Embassy, Bonn-Bad Godesberg 75, 76, 78–80, 172, 196, 211
Vasari, Rome 208
William Watkins 261
D. Willems, Hengelo 287
A. Winkler, Bern 284
Robert Winkler, Stuttgart 121
Zeiss Ikon AG, Berlin, Fotoarchiv 86
Hilde Zenker, Berlin 83

All illustrations not credited above are the property of the architects or of the archives of Verlag Gerd Hatje.

# Index